Joan Miró

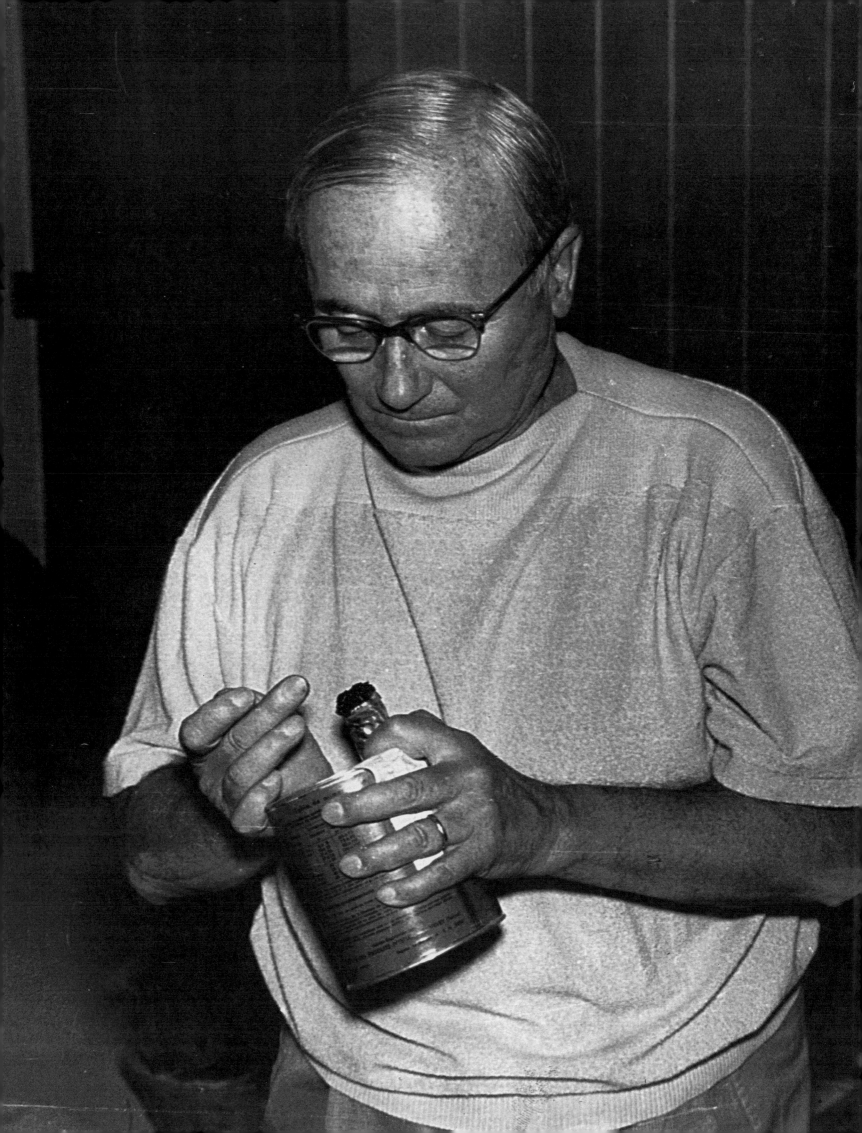

Joan Miró

1893–1983

The Man and His Work

With a commentary on Miró's late works
and notes on his paintings by Hajo Düchting

TASCHEN

KÖLN LISBOA LONDON NEW YORK PARIS TOKYO

ILLUSTRATION PAGE 2:
Joan Miró in his Studio in Mallorca, 1958
Photographed by Walter Erben

© 1998 Benedikt Taschen Verlag GmbH
Hohenzollernring 53, D–50672 Köln
© 1993 for the illustrations: VG Bild-Kunst, Bonn
Edited and produced by Ingo F. Walther, Alling
English translation: Text: © by Prestel-Verlag, Munich
(Walter Erben, Joan Miró, 1959), Captions and Appendix: Hugh Beyer
Cover design: Angelika Taschen, Cologne

Printed in Spain
ISBN 3–8228–7217–2

Contents

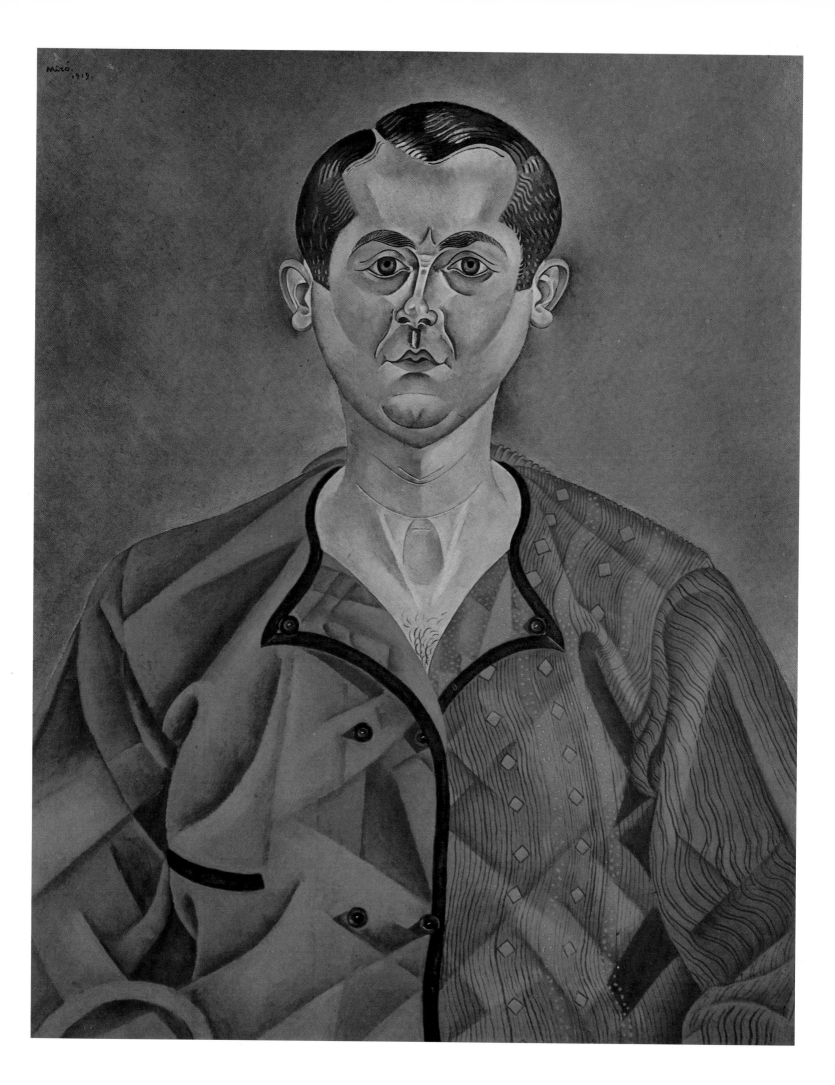

Rendezvous with Miró

"Son Abriñes, Calamajor, Palma de Mallorca" was the address on Miró's writing paper. I inquired the way to the painter's house from a number of different people. Among them was the owner of the hotel, a smartly dressed gentleman smelling of lavender, who collected antique furniture and Mallorcan landscapes painted in all the colours of the rainbow.

"Miró?" he shook his white-haired head. "There are plenty of Mirós round here, but I don't know a painter of that name." The Palma telephone directory listed a dozen Mirós; they were craftsmen and merchants.

I put myself in the hands of a taxi-driver. It was eleven a.m. The driver donned his uniform cap and switched on the taximeter. "Son Abriñes, *si, si!*" He nodded eagerly; but I soon realized that his appearance of confidence was misleading. Palma, Terreno, Calamajor – one town led on into the next. "Son Abriñes?" he inquired again, to make sure I had got it right. "I'll ask my friend the porter at the Nixie's Palace Hotel, he knows everyone in Calamajor."

Soon after this, we became a link in an unbroken chain of private cars, buses and fat-bellied tankers carrying drinking water. In between trundled high-wheeled carts drawn by donkeys. A red-painted miniature tram crawled along as slowly as the donkey carts. Sun-tanned holiday-makers wearing dark glasses and the minimum of clothing squeezed their way along the edges of the street. To get from Palma to Calamajor took us half an hour, although the distance is only a couple of miles.

The driver went to ask his porter friend and returned to the taxi as ignorant as before. He inquired from many other "friends", always with the same result. The heat in the closed taxi increased with every stop. Finally the taxi turned resolutely off the metalled highway onto a rising sandy track. The engine whined, the wheels flung the thick layer of dust into the air; after fifty yards of this, we came out onto a wider road flanked by massive walls as high as a man.

The passage from one road to the other constituted a transition from civilization to almost unspoilt nature. Alongside the road we had left, heaps of garbage smothered in swarms of flies alternated with incrusted cactuses and telegraph poles painted with tar and plastered with posters. The hum of the engine was drowned by the roar of welding

This self-portrait forms part of a series of paintings in which Miró paid extremely close attention to individual details, combining them in the form of colourfully ornamental and imaginative scenes. The portrait is wonderfully radiant with tranquility and clarity. The artist's gaze is permanently fixed on the imaginary person opposite him – his mirror image. Psychological self-revelations were very popular at the time. However, unlike so many other artists, Miró does not display the slightest trace of self-torture, but rather a certain aloofness, calmly rejecting all probing questions with his clear, penetrating gaze. The angular, crystalline surface hides all the struggles and conflicts which Miró had to undergo, particularly during his first years in Paris. In this painting Miró seems to be as solid as a rock against a stormy sea, unaffected by the stylistic experiments that made other paintings of that time so heterogeneous. There may be a faint touch of Cubism here, though in a form that is hardly perceptible and very unobtrusive.

Miró's self-portrait bears witness to an unshakable will to establish his identity as an artist. This puts it in the tradition of portraits of the great masters – a modern equivalent of Dürer's "Self-Portrait" with which it shares the same unwavering conviction of being on the right path. This may be the reason why Picasso valued this picture so much and why he never wanted to part with this gift from Miró. It is now at the Musée Picasso in Paris.

Self-Portrait, 1919
Autoportrait
Oil on canvas, 75 x 60 cm
Musée Picasso, Paris
(formerly Pablo Picasso Collection)

torches that blazed day and night on the tall petrol tanks going up along the river bank.

As soon as we reached the road that lay like a sunken track between its high walls, a new world began. Silence lay over everything, the few visible objects were steeped in immobility. The sun was poised directly overhead. Behind the walls brooded whitewashed country houses, of which only the roofs could be seen, at intervals the motionless fronds of a palm, outspread agave blossoms like inverted umbrellas, and the huge sails of windmills, which today were still.

None of the many doors in the walls bore a name-plate. Within me, anticipation struggled with a slight feeling of depression, with which my unconscious was preparing itself for possible disappointments ahead.

It was true that I had in my pocket a letter from the Galerie Maeght in Paris, informing me that "Miró felt flattered by my interest in his work and would be pleased to have a talk with me, if I came to Palma".

The Peasant, ca. 1912-1914
Le paysan
Oil on canvas, 65 x 50 cm
Aimé Maeght Collection, Paris

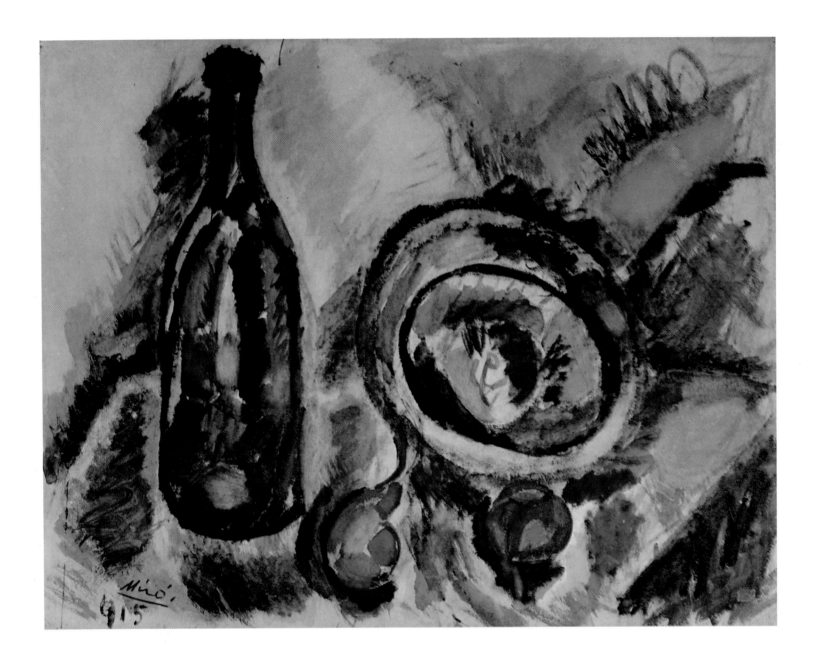

Fruit and Bottle, 1915
Fruits et bouteille
Oil on paper, 48 x 61 cm
Private collection

But I had met such expressions of conventional politeness before, and I did not delude myself that this letter was any guarantee that Miró would see me.

Moreover, a friend living in Paris had written to tell me that it was uncertain whether Miró was at present in Paris, Tarragona or Mallorca. Letters I had written to Miró were rarely answered by the painter himself, and I had not made a definite appointment to visit him. In the course of telephone conversations with Picasso's secretary in Cannes I had been given to understand that it was better to leave such meetings to the luck of the moment.

I had also been informed that Miró was no conversationalist. A journalist who interviewed him in Paris compared him to the albatross in Baudelaire's poem, which, though a king in the air, cut a helpless figure on the ground. All he had brought away from his meeting with Miró were a hesitant "Yes" or "No" or a shrug of the shoulders in reply to his carefully devised questions. And yet French was this journalist's mother tongue, whereas my own French was just about sufficient to make myself understood.

9

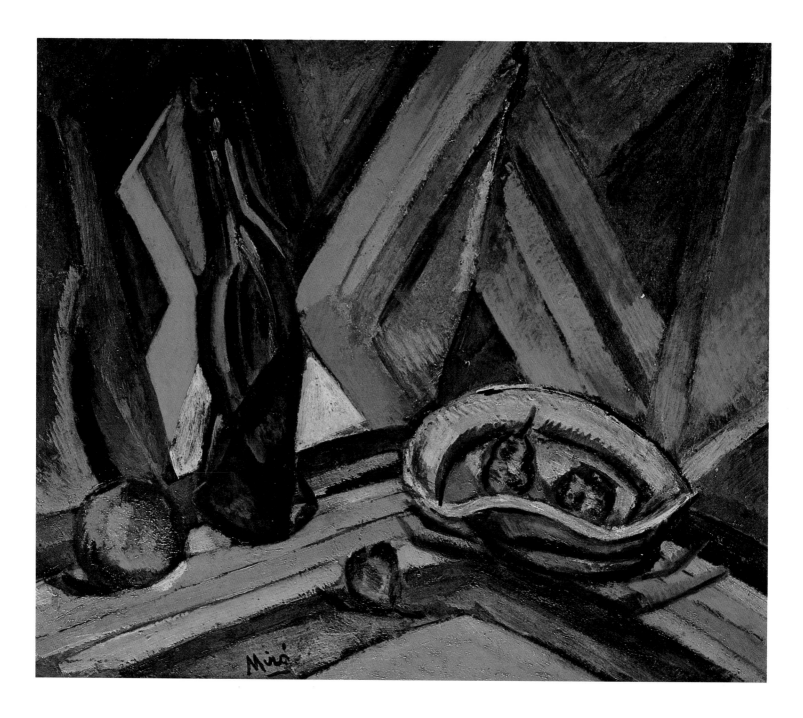

The Blue Bottle, 1916
La bouteille bleue
Oil on cardboard, 57 x 68 cm
Aimé Maeght Collection, Paris

It was not my intention to question Miró in the manner of a reporter. My desire to make his personal acquaintance was inspired by a curiosity whose roots lay deeper. To me, artistic experiences were simultaneously human experiences; what came to me from the work of art was not restricted to the realm of aesthetics. It was impossible for me to regard the work of art as a phenomenon detached from its creator. In an age of passports and questionnaires, when all human contacts have become suspect, I saw in art a form of expression that dispensed with the normal inadequate channels of communication and replaced them by its own absolute medium of contact.

Naturally, I also wanted to ask the painter questions. Not everything in his work had been clear to me, towards many of his creations I had been compelled to remain critical. Only the painter himself, I believed, could give me the answer; if not in words – from these I did not expect very much – then through the communication that lies beyond speech and comes from a person's actual physical proximity.

At the end of the road, almost on the crest of the mountain that over-hangs the bay, we finally met a shabbily dressed trader leading a team of donkeys. "Son Abriñes, *si, si."* He pointed to a doorway a few yards behind us. We had just driven past it.

The wide, solidly built door was of pale-coloured oak. Not a crack revealed what lay behind it. The door was not locked and opened at a slight push. As it swung back it rang a small bell suspended from the door-post.

Still-Life with Rose, 1916
La rose
Oil on cardboard, 77 x 74 cm
Private collection, Switzerland

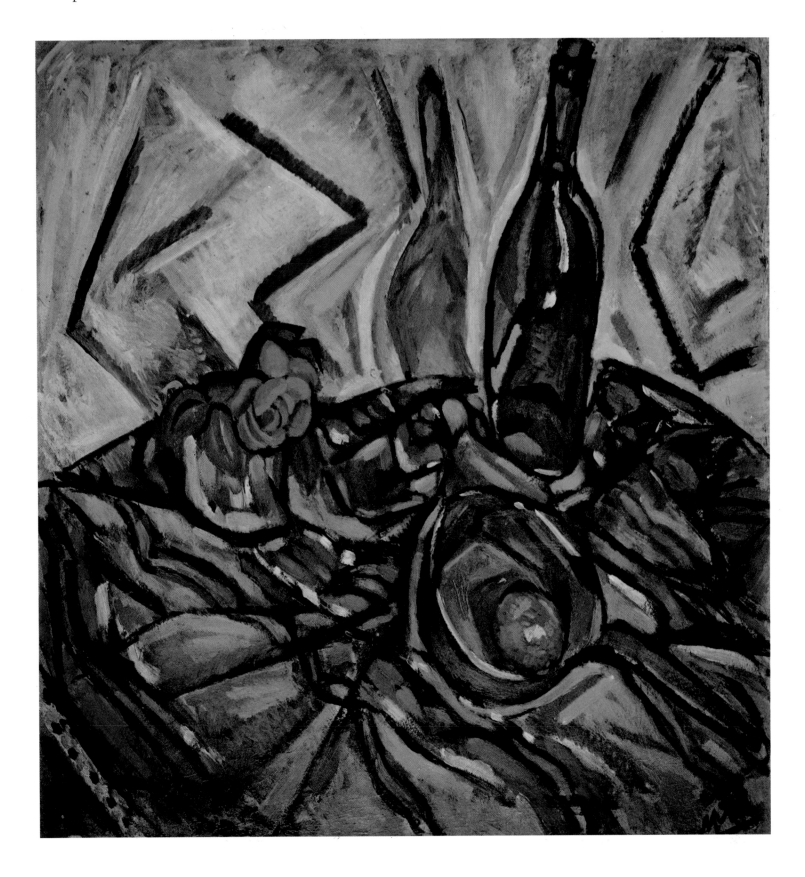

The rhythmic succession of colours is reminiscent of the colourful rhythmic patterns of the Delaunays who were in Madrid at the time – Sonya Delaunay was rapidly becoming famous for her art-and-craft products. Miró changed the landscapes into abstract, converging patterns which nevertheless still correspond to the imposing contours and tensions of the rugged scenery. There is a geometrical gradation which goes as far as the horizon, thus leading up into the cool, iridescent blue of the sky.

Miró was to use this upward movement again and again – as a symbol of man's yearning for transcendence and salvation.

Ciurana, the Path, 1917
Ciurana, le sentier
Oil on canvas, 60 x 73 cm
Tappenbeck Collection, Paris

Spread out before me was a broad, gravelled forecourt. Some twenty yards away glowed the white, low front of a medium-sized modern country house. The door stood in the shadow cast by its projecting porch. A pergola ran up to the right-hand wall of the house; by the left-hand wall rose a frame carrying a wind-wheel. The thin wooden sails were painted alternately blue and red. The lawns were a vivid green rare in these parts. Between the darker shadows of cedars and pepper trees I caught a glimpse of a gardener's straw hat.

I looked round; nothing indicated that this house was occupied by a painter. True, the vermilion pumpkins lying in the sun on the stone bench beside the front door looked extremely picturesque – Matisse has painted them in many of his still-lifes – but these decorative fruit are a common sight on the window sills of Mallorcan houses. A long, bleached palm frond had been drawn through the black-painted bars of a window grating. The only thing that distinguished these premises from all the others I had so far seen on the island was the air of bourgeois orderliness that pervaded house and garden. It was hard to ima-

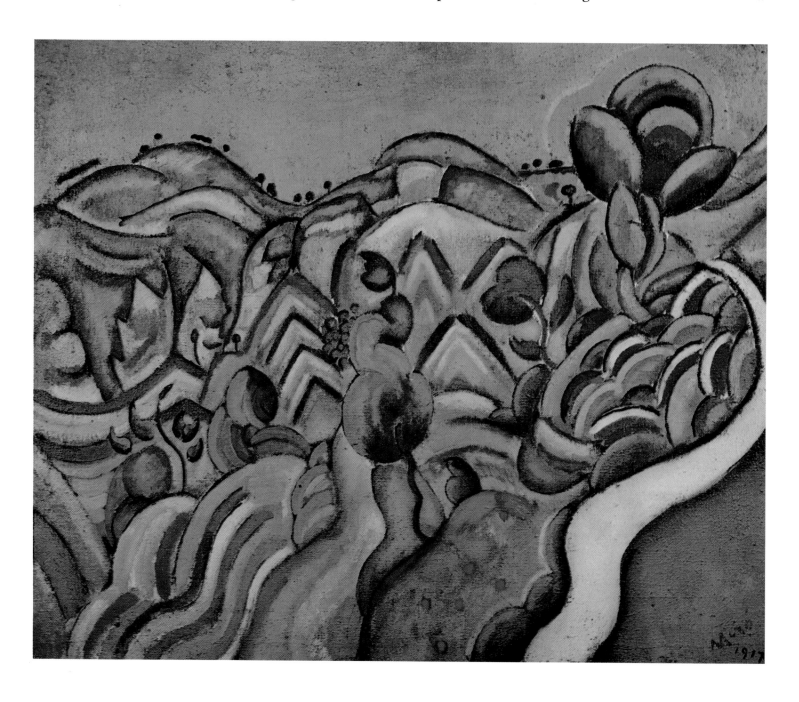

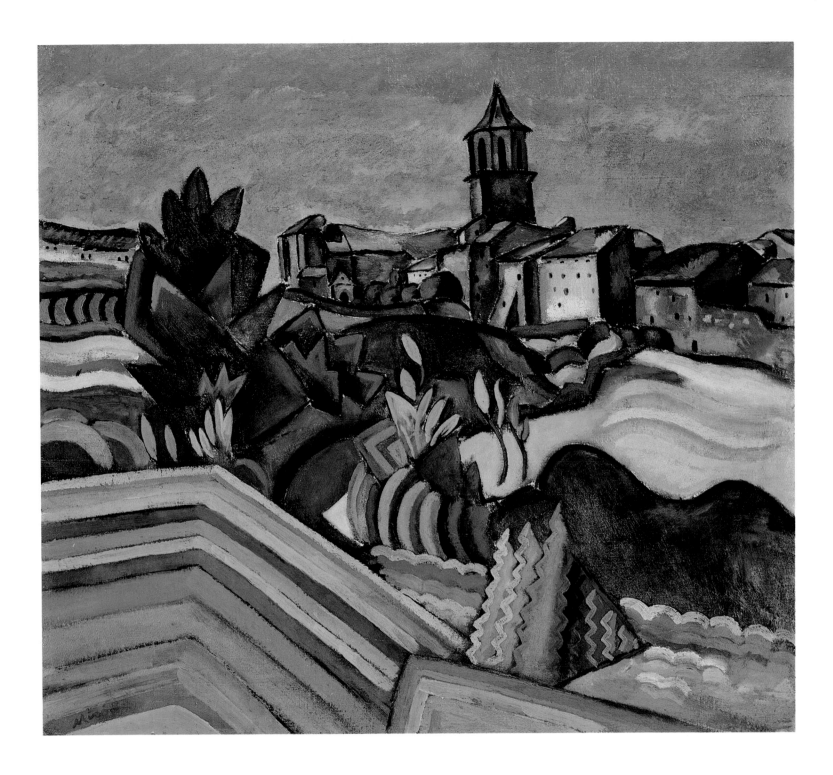

gine that these were the precincts within which a painter created such unusual works as Miró's, that shocked the true bourgeois. The whole place looked more like the summer residence of a Swiss watch manufacturer.

The few steps across the broiling hot forecourt had so sapped my energy that I automatically made straight for the porch, and once in its shadow drew a few deep breaths to calm my excitement, before pressing the brass knob of the bell. I could hear the shuffle of footsteps from the hall, but a few seconds passed before a shadow became visible through the door of reeded glass. The door opened and an old serving woman appeared. I handed her my letter from the Galerie Maeght. Before the old woman had time to give me an answer, I had already received it from my first impression of the shady entrance hall

The Village of Prades, 1917
Prades, le village
Oil on canvas, 65 x 72 cm
Solomon R. Guggenheim Museum, New York

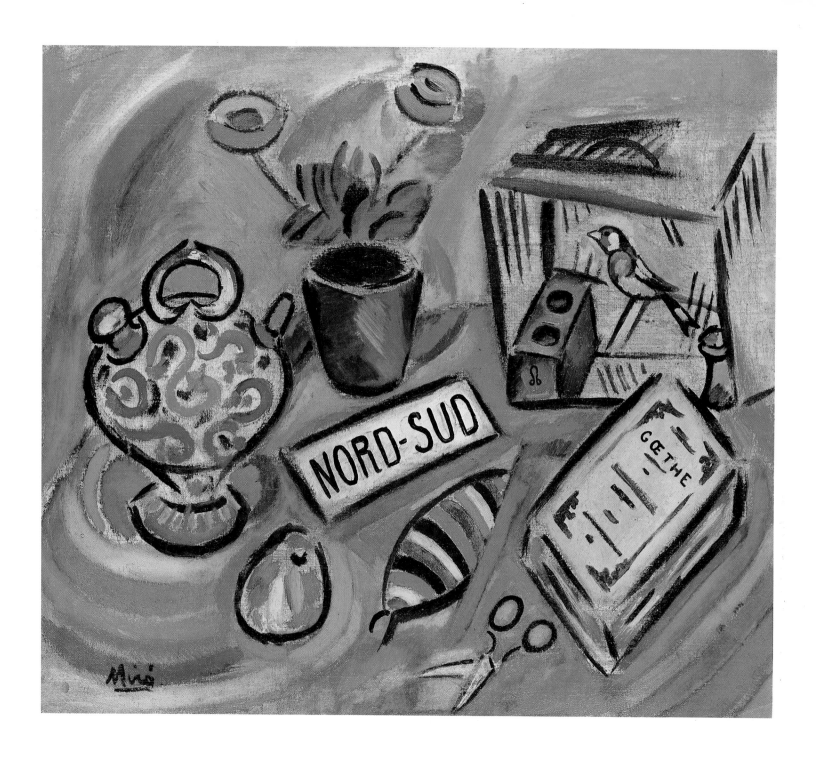

North – South, 1917
Nord – Sud
Oil on canvas, 62 x 70 cm
Aimé Maeght Collection, Paris

Portrait of E.C. Ricart, 1917
Portrait de E.C. Ricart
Oil and colour print on canvas,
81 x 65 cm
Marx Collection, Chicago

in front of me. Rococo furniture stood in the corners; over a green silk divan hung a large Indian picture painted on a white background. I noticed a colour reproduction of a painting by the Douanier Rousseau and over by the stairs a high, narrow picture with Chinese-looking signs painted with broad brush strokes on a green ground. No doubt about it: I was in Miró's house.

Meanwhile, the old woman had grasped what I wanted. She motioned to me to take a seat on a small armchair standing by the door. But first I had to pay my driver. When I returned, the servant was still standing on the same spot, and she did not move until I had actually sat down in the armchair.

It was a considerable time before I heard footsteps and the banging of doors. On the wall facing me hung an old etching of the island of Mallorca. I curbed my desire to examine everything closely, and con-

14

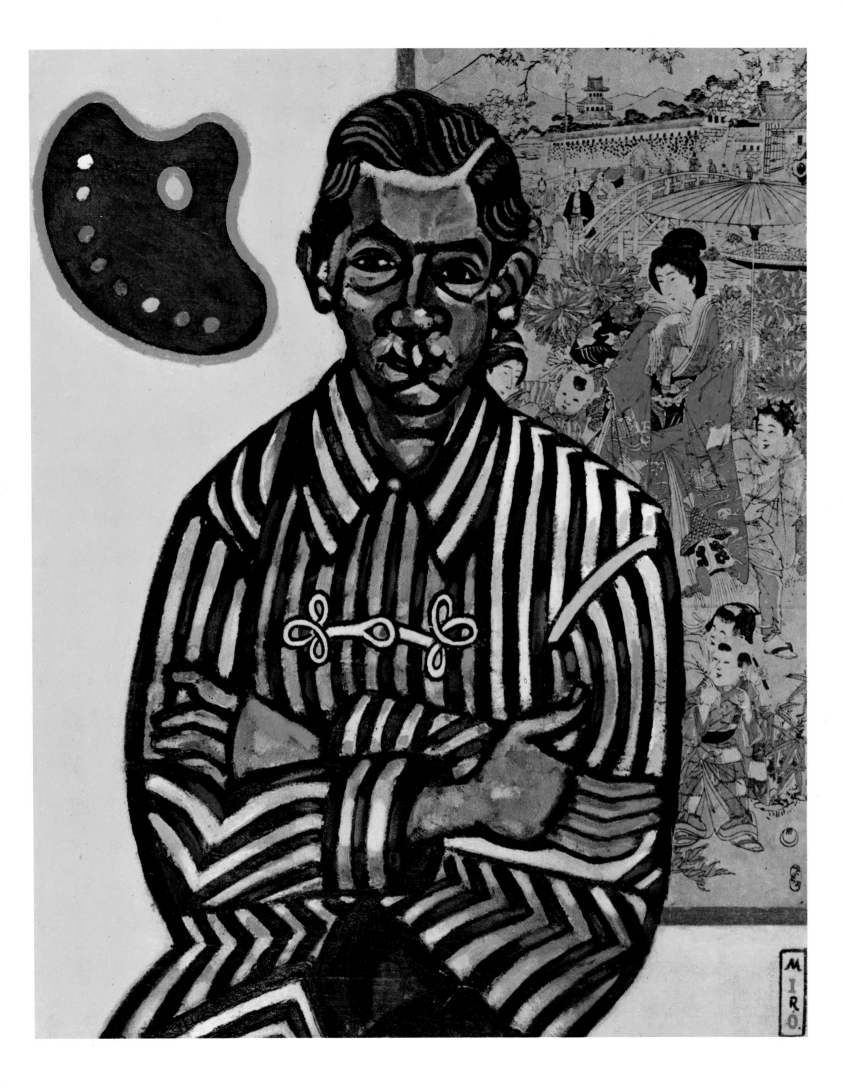

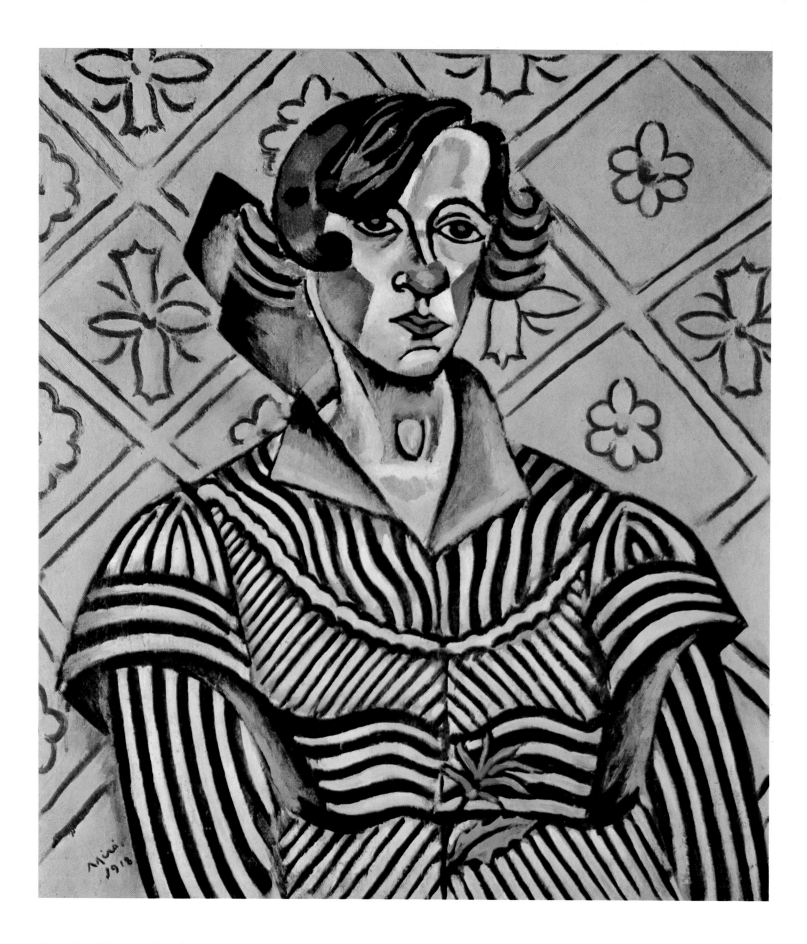

Portrait of Juanita Obrador, 1918
Portrait de Juanita Obrador
Oil on canvas, 70 x 62 cm
Art Institute of Chicago, Chicago

centrated on preparing a few sentences of French with which to greet Miró.

Suddenly he was standing in front of me: a short, thickset man who hardly looked his sixty years. He was wearing blue linen trousers and a coarsely woven white linen shirt with an open neck and short sleeves.

16

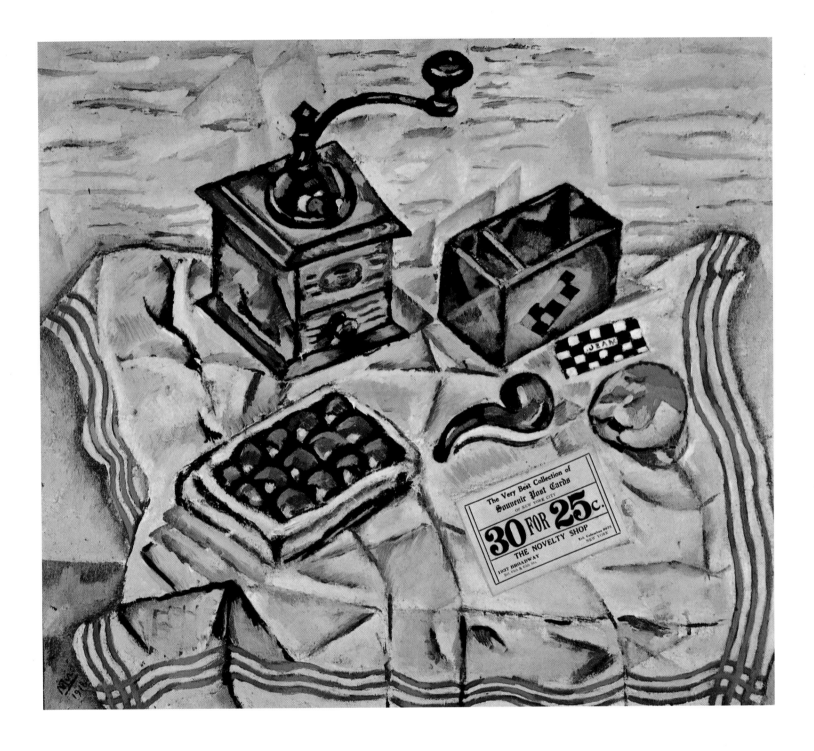

On his feet he had straw sandals. In his left hand he was holding Maeght's letter. He extended his right hand and welcomed me. His round, rugged face with the sleek grey hair and exceedingly lively eyes inspired confidence. The words he spoke were those of commonplace politeness, yet there was immediately established between us that pleasant tension which links people who already know one another and are happy to be meeting again after a longish separation. I had no need to fall back upon my laboriously contrived sentences.

Miró signed to me to walk ahead. We entered the large room opening out of the hall, where Miró showed me to a chair. He suggested that some refreshment would do us good and asked me what I should like to drink. He then left the room for a moment. I had time to look round. Beside me hung a tapestry woven after the picture *Snail, Woman, Flower, Star*. I was familiar with the draft for this tapestry, an

Still Life with Coffee Mill, 1918
Nature morte au moulin à café
Oil on canvas, 62.5 x 70.5 cm
Aimé Maeght Collection, Paris

This painting is undoubtedly one of most irritating pictures of Miró's early period. The nude figure, with her doll-like face, seems to have been chiselled harshly out of granite, thus creating a sharp contrast with the flowery ornamental surface. Instead of merging nicely into the ornamental rhythm, this alien body in its shell refuses to yield to the temptation of turning into an organic creature. The listless posture and the shell-like appearance of the figure have nothing in common with the graceful sensuality of, say, Henri Matisse's nudes. Rather, a traumatic mysteriousness seems to be hidden in these pictures – a mysteriousness which was to continue in his later works.

Standing Nude, 1918
Nu debout
Oil on canvas, 153 x 120.7 cm
St. Louis Art Museum, St. Louis (Mo.)

oil painting. The woven threads exactly reproduced all the colours and shapes of this picture. The intertwining figures in deep black, picked out by patches of brilliant vermilion and white, danced and soared across the background veined in brown, green and blue, and interpenetrated the ribbons of poetically significant words written across the composition in playful, flowing letters.

The painted draft had always seemed to me an instructive example of the natural way in which Miró blended together the various poetic elements belonging to his "classical" period. But the tapestry had lost some of the direct and exciting quality of the draft; it was as though a difficult and origi nal musical score had been transposed into a form that was merely "in good taste". This was no longer *peinture sauvage,* but an over-intensification of the rococo element noticeable here and there in this house. Isn't the term rococo derived from *rocaille,* pebblework? It would never before have occured to me to compare the paintings of the Catalan artist with an artistic style dating from the eighteenth century. But this almost imperceptible lightening of the tones, this rounding off into an arabesque of contours to which, in the original, the brush had imparted a sharply defined outline, were enough to take away the depth and turn the menacing masked dance into a charming revue.

The long wall consisted entirely of windows reaching up to the ceiling. The fanlike Venetian blinds were down, but enough light filtered into the room through the narrow slits to show how bright the landscape outside must be. In the centre of the room, on a pale-coloured raffia mat, lay a big, multi-coloured child's ball.

Miró came back with a tray bearing a carafe of water with large blocks of ice floating in it, a bottle of anisette and two glasses. He poured out and raised his glass to me.

"Some time ago you wrote me a letter", he began. "I was very pleased to receive it, even if I didn't find time just then to answer it. You wrote that you had been trained as a painter, that you were interested in pictures from the point of view of how they came to be painted, which means more than the mere technical process. I think that is the right attitude to painting. I don't read much of what the critics write about my pictures. They are more concerned with being philosophers than anything else. They form a preconceived opinion, then they look at the work of art. Painting merely serves as a cloak in which to wrap their emaciated philosophical systems."

"This preconceived opinion", I replied, "is like Procrustes's bed: sometimes the victim's legs are too long, sometimes too short, but they are always made to fit. In this case the victim is painting!"

I tried to explain to Miró what his painting meant to me, the date from which it had preoccupied me and what I had gained from my encounter with it. I elaborated my thesis that the picture calls for inner concentration on the part of the spectator, that art involves human as well as aesthetic criteria. I told him that this was what had prompted me to become personally acquainted with him and the landscape in which he worked and lived. To me, objective art criticism represents the sum of a number of subjective confessions; but I believed that I

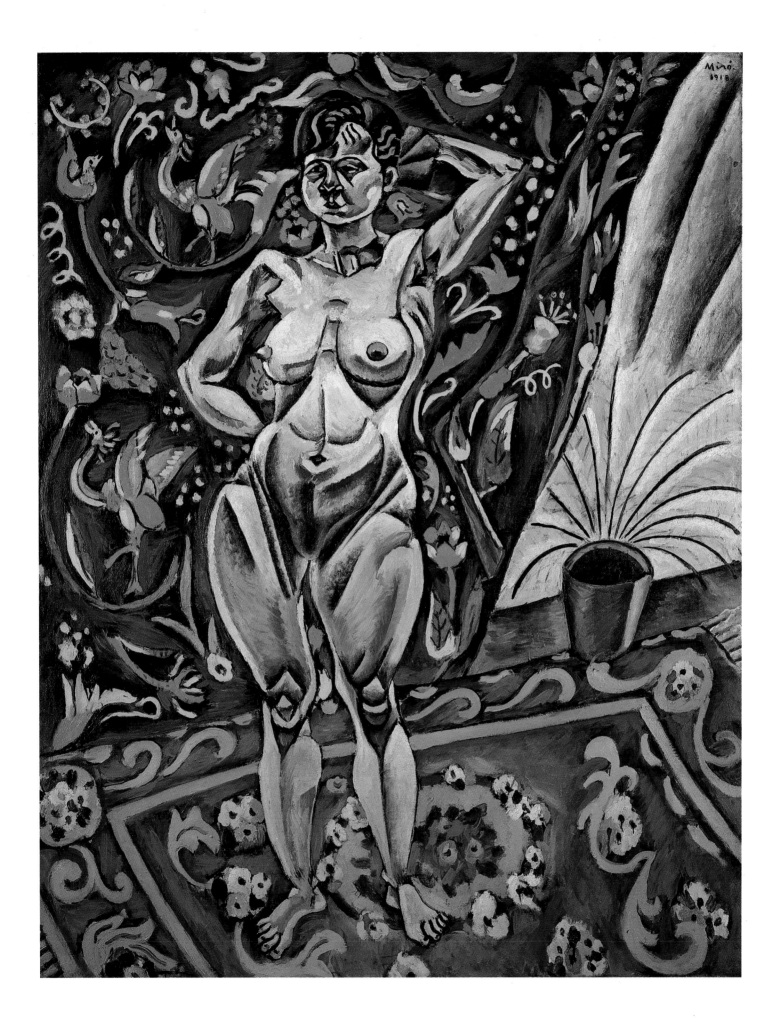

should not get out of my depth, so long as I gave pride of place in my reflections to the actual process of painting.

Miró had been listening attentively. "It is good to describe the working process. A painter clings to the visible, to the objects and materials available to him. The landscape is important, more important than anything else. If critics would only realize that the effort demanded by his work leaves the painter no time to think of things that have nothing to do with painting, there would be no crisis in painting. I do no more than what my forbears did on this Catalan soil. They were mostly craftsmen and potters. What they made they tried to make well. They didn't think of themselves as artists, but they took a pride in their work. They were aristocrats of handicraft, *oui, des artisans aristocrates!"*

Miró had risen. He walked round the room with me and pointed out the various examples of folk art that stood either in glass cases or on the mantelpiece and chests of drawers – vases, of artistically blown glass or modelled and fired in clay, wrought and chased objects of use and ornament, an extravagant arrangement of artificial flowers under a glass dome.

Finally, he picked up a small box made of glossy black wood and asked me to press a protruding silver knob. The lid jumped up and out popped a devil dressed in red silk. Miró laughed: "That is also part of it, isn't it?"

"Wasn't this jack-in-the-box the model for all the dancing and hopping figures composed of boxes and containers that appear in your

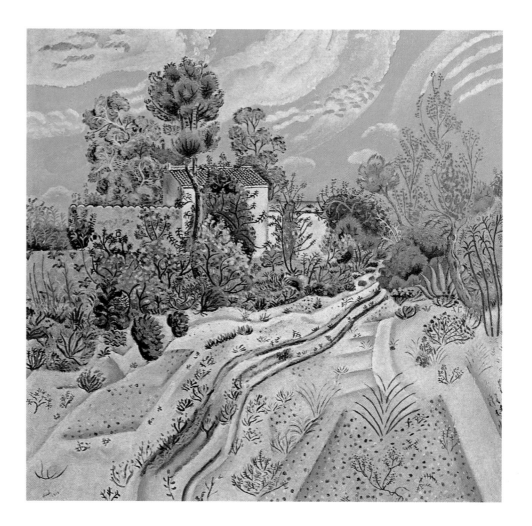

Cart Tracks, 1918
L'ornière
Oil on canvas, 75 x 75 cm
Stern Collection, New York

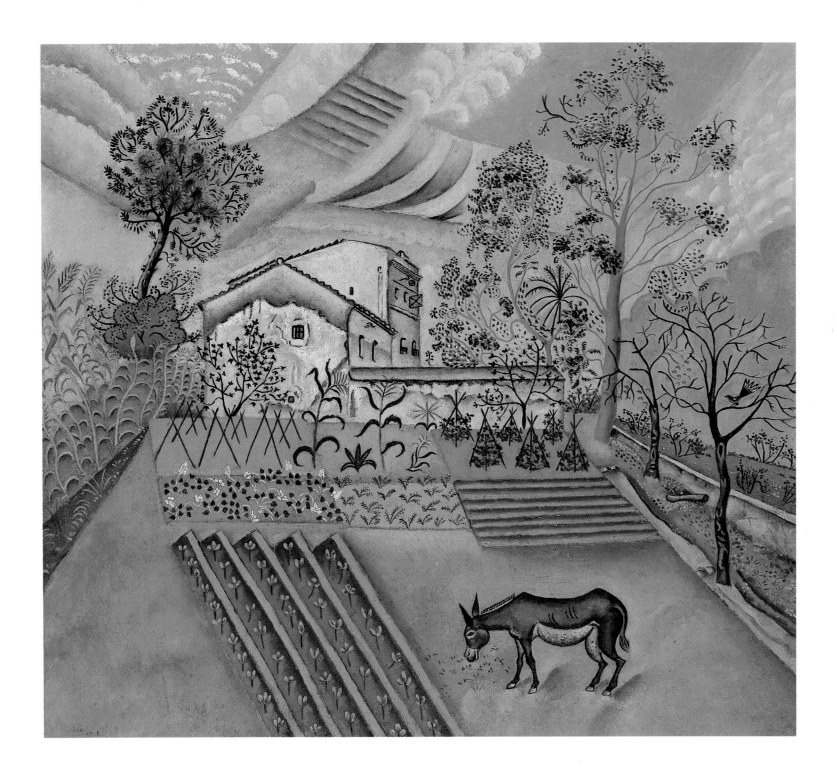

pictures? The influence comes out not so much in terms of form and colour as in the element of surprise, of burlesque movement ... " The few minutes I had spent with Miró had shown me that he liked to see himself in the rôle of the attentive host, that he preferred to act as the silent guide through a private museum rather than to entertain his guest with words. He spoke only when asked a question. I therefore sought to draw him out by questioning him. Perhaps this was merely the outcome of a certain diffidence aroused in me by the fact that I was dealing with a man about whom a newspaper had stated a few days earlier that he was at the height of his fame. In the event, however, I found myself in the presence of a man whose natural and uncomplicated demeanour took me by surprise.

Vegetable Garden with Donkey, 1918
Le potager à l'âne
Oil on canvas, 64 x 70 cm
Moderna Museet, Stockholm

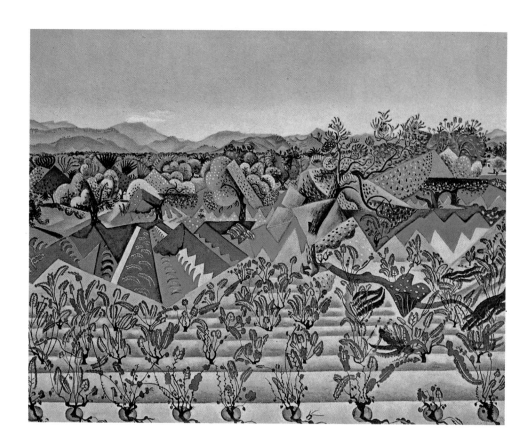

Montroig, Vines and Olive Trees, 1919
Montroig, vignes et oliviers
Oil on canvas, 72 x 90 cm
Block Collection, Chicago

Miró used to love the village of Montroig, and his rendering of the walls and the church at the centre show his immense power of observation, which verged on photographic precision. By contrast, the scenery that stretches out in front of it seems rather stylized and ornamental. The finely drawn vines, which are also shown in the picture above, lead us towards the lovingly painted background of his native village and the blue sky. "As soon as I start painting a landscape," says Miró, "I can feel myself beginning to love that scene with a love that springs from a gradual understanding. I gradually begin to comprehend the enormous wealth of nuances – a concentrated wealth which is a gift from the sun. It is the joy of being outside, in the country, and waiting for an understanding of a blade of grass - why should one despise this blade of grass, which is as beautiful as a tree or a mountain? Except for primitive tribes and the Japanese, nobody has ever really taken any profound interest in these divine things. People only ever look for and paint masses of trees or mountains, without listening for the music that pours forth from tiny flowers, blades of grass and little stones by the side of one's path."

Montroig, Village and Church, 1919
Montroig, l'église et le village
Oil on canvas, 73 x 61 cm
Dolores Miró de Punyet Collection, Palma de Mallorca, Mallorca

The answer he gave me after a longish pause by-passed my question. "This red is very pretty – *il est tres joli* – and so is the expression of the face, isn't it?" That was all. He squeezed the red-clad man with the long nose and furrowed brow back under his lid. The figure of the devil, which had just jumped out at the spectator, doubled up, caving in and folding together at every joint and vertebra. At the same time, the wide, laughing mouth remained unchanged. He surrendered to his fate with a crafty expression. Did not the faces of the *personnages* in Miró's pictures display the same serene fatalism?

"Every shape, every colour in my pictures is derived from a piece of reality. The concepts 'pure colour' and 'pure form' mean absolutely nothing to me. This thing here is colour and form, but at the same time it is surprise and life, isn't it? Our ancestors before us loved this toy."

"Bergson devoted a whole paragraph to the jack-in-the-box in one of his philosophical treatises", I replied. "He certainly wouldn't have done so if he hadn't loved the object as a child!" I tried to expound Bergson's theory of the comic, according to which we find comical all those concatenations of actions and events that give us simultaneously the illusion of life and the distinct feeling that a mechanical contrivance is at work. I added that I often stumbled upon books which proved of special importance to me at a particular moment, and that this philosopher had formulated ideas about perception which might be of value in considering pictures.

Miró nodded agreement. "Every poet is a philosopher, and I think many philosophers have a poet's gifts. Klee was a poet and a tremendous thinker! You sent me the book with his sketches – thank you very much for it. I found it tremendously interesting, even though I

couldn't read the text. All those sketches! *C'est très fort, en effet!* Some of them I knew. Grohmann showed them to me when I was in Berlin." Seeing my expression of astonishment, he went on: "That was in the thirties. Things like that couldn't be exhibited in Germany then, could they?"

"I have been told", continued Miró, "that Klee was always working, and that even when he was talking to friends his drawing hand was busy", he made the movement of doodling, "wherever there was a scrap of paper."

While I was at the Düsseldorf Academy, I had studied under Klee for a time. I had plenty of opportunity to watch him. I never noticed him drawing while talking to friends. On the contrary, absent-minded and unapproachable as he appeared when alone, he gave his concentrated attention to anyone he happened to be talking to in his studio, a café or his large room in the boarding-house beyond the Academy garden. Every word he uttered, even his witticisms, bore witness to profound thought. I never heard Klee chatting conversationally.

I told Miró how I used to be able to look from my studio at the Düsseldorf Academy, which was on the third floor, into the window of Klee's studio in a projecting section of the building one storey lower. I often used to see him sitting there bent over his work. His drawing-table was close to the window. He could spend hours at it, looking, meditating, drawing. Every movement was made slowly, as though every fraction of an inch cost him an effort.

Miró looked at me approvingly. "I could never believe it. Everything in his work looks prepared and planned. The painter must be alone while he is working, mustn't he? He needs a quiet room – and order. I need order, otherwise I can't do anything. When I think of Picasso's studio ... !" He clapped his hands together. "What chaos!" He drew a deep breath. "That would be impossible for me!"

Miró closed the sliding door of the glass show-case. "Klee would have enjoyed that too, don't you think?" He pointed again to the jack-in-the-box.

"Klee liked everything that could be set in motion with a secret mechanism", I replied. "He wrote about it in a *Bauhausbuch,* irrespective of whether they were jumping Jacks, cork tumblers and toy animals or real animals and people. In the case of the latter, too, the problem was to find the 'inner mechanism'."

Miró had pulled up the Venetian blinds. We stood bathed in light. The sudden brightness hurt the eyes. Miró signed to me to walk ahead. We moved a few paces out on to the terrace. For the first time, I looked down at the blue bay spread out below us. The terraces dropped down to the rocky shore like a waterfall. The border of white villas and hotels hid the road that lay between.

"C'est joli, hein?" asked Miró. His eyes were shining, as though he too was seeing this spectacle for the first time. It took me a few seconds to focus my thoughts. Was Miró an adroit showman, who let the phenomena speak at the moment a question was put to him? What now poured in upon me was too magnificent to absorb immediately. The nearness of the painter gave it added significance. Was this instant a

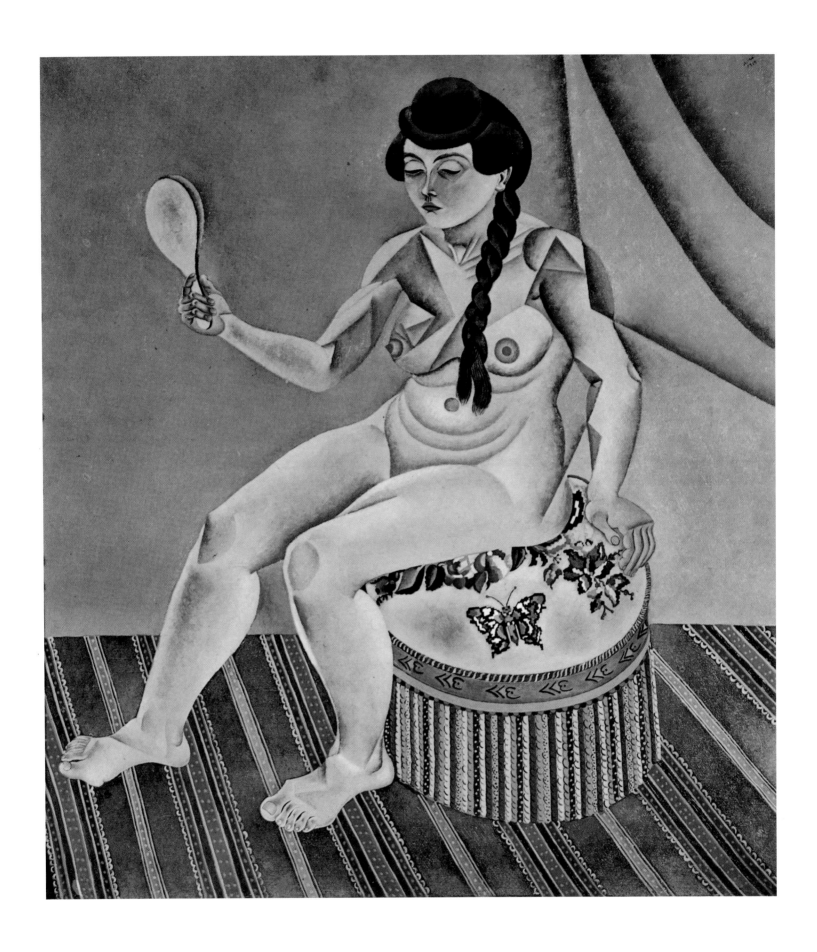

good omen for all our future meetings? Below us flashed the aluminium-coloured, undulating roof of a building that looked like a hydrographic station. *"Ah, oui, c'est l'atelier!"* Would you like to see it?"

Nude with Mirror, 1919
Oil on canvas, 112 x 102 cm
Kunstsammlung Nordrhein-Westfalen,
Düsseldorf

25

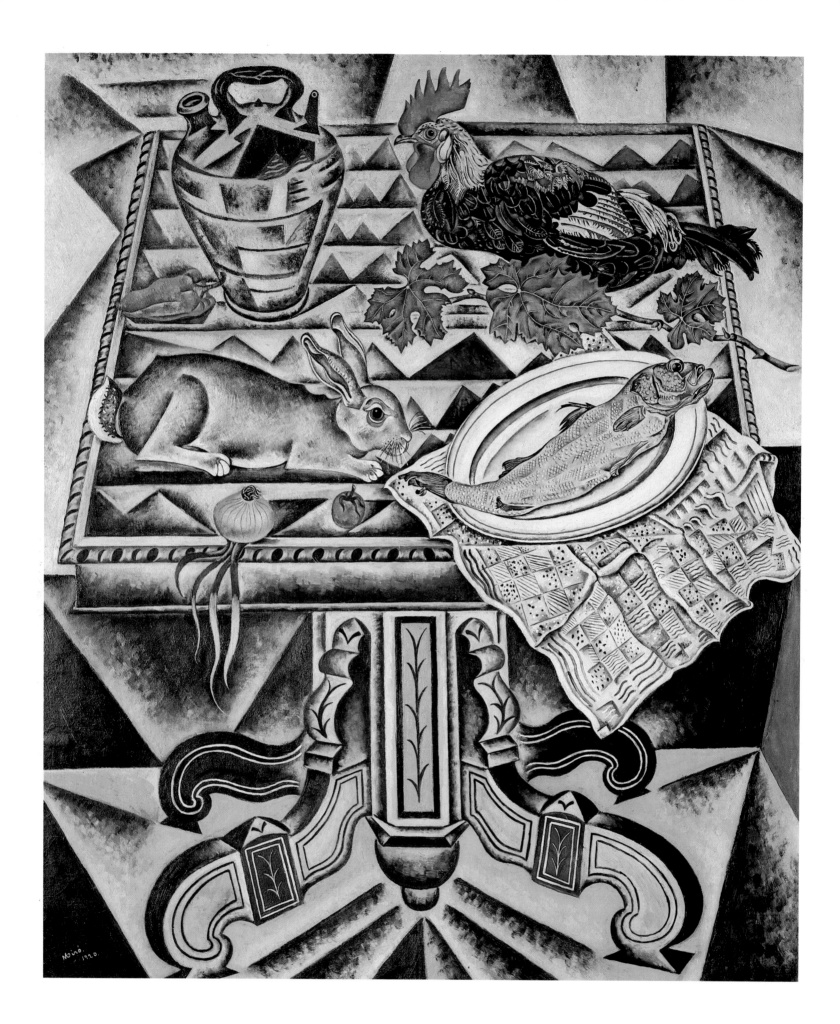

The Studio

I had seen many painters' and sculptors' workshops in my life, but never a building like this. It must have been about sixty feet long and thirty feet wide. The contour of the roof matched the undulating outline of the distant mountain ranges. The eccentric shape of this roof reminded me of Cretan buildings with their curving U-shaped monuments resembling bulls' horns. I couldn't conceal my surprise. I asked who had built the studio.

"My friend Sert", replied Miró, "a Catalan who is now teaching at Harvard University. But the roof wasn't shaped like this for aesthetic reasons. The undulations leave space between the sections for the various light and air shafts, which act as ventilators, so that even on hot days the temperature inside is quite bearable."

There was no direct path from the terrace to the studio entrance. We had to go down a broad stone stairway to the garden. From there we came to a green-painted wooden gate with an iron bolt concealed on the far side, which Miró laboriously pushed back. "We had to put the bolt on, because of my grandson", explained my companion. "Otherwise I could never have been sure of working undisturbed."

The gate was carefully bolted again. Then we walked over a kind of foot bridge to a door painted in a bright blue. Inside the building, stairs led up to the studio proper. This upper section seemed to be set aside for graphic work. It contained a number of drawing-tables with electric lamps clamped to them, as in an architect's office. From the end of this upper room a narrow gallery ran along the side of the studio. Miró motioned me to lead the way. Apart from an occasional *"Passez, s'il vous plaît!"* he had little need of words; here he could let objects speak.

From the gallery I had a general view of the picturesque ensemble of the lower section of the studio; large and small easels, ladders, tables, on one of which a pencil-sharpening machine was screwed, all kinds of stools, including old three-legged milking stools with legs curving outwards, were dotted about the floor, while canvases stood in piles or leant against the walls.

The flagstones at the rear end of the studio were covered with large paper cut-outs, weighted down with stones or jugs to prevent them from being shifted by the draught. These pieces of paper had Miróesque "signs" drawn on them. He seemed to enjoy placing these cut-out

This is one of the last pictures in which Miró makes use of Cubism, on the one hand, and a painstaking, naturalist style with close attention to detail, on the other. Miró has incorporated two modes of expression – the Cubist mode, derived from Picasso and Braque, and his native, naturalist manner as an expression of his joy in telling a story. However, the two do not merge. Unlike the pictures of Synthetic Cubism of that time, where direct references to real life were incorporated into Cubist structures - as, for example, in Gris' paintings or Braque's collages - Miró opened up an unbridgeable gap between those two different worlds.

On a table, which is realistically drawn to perspective but has a Cubist inlay, there are a number of objects, some very much alive and others dead. On the far right there is a dried fish on an immaculately painted plate, with an oddly pattered tablecloth underneath that incorporates within its pattern the discrepancy between the two styles. On the left, there is a rabbit that looks as if it is about to jump forward, further back there is a highly stylized Spanish wine jar, and in the top right-hand corner, to crown it all, a rooster, magnificently decked with feathers and watchfully alert. The magic quality of this still life is enhanced by a few equally realistic vegetables and a sprig of vine leaves. The entire painting is surrounded by Cubist facets which are meant to suggest space.

The Table (Still-Life with Rabbit), 1920
La table (Natur morte au lapin)
Oil on canvas, 130 x 110 cm
Gustav Zumsteg Collection, Zurich

symbols on the floor, pushing them this way and that, creating new arrangements, until finally he produced the constellation that provided the stimulus for a fresh pictorial composition. In spite of the picturesque arrangement of these very varied objects and pieces of equipment, an atmosphere of sobriety prevailed. I felt as though I were looking down into a factory workshop that had just been tooled up for a new production run. There were no pictures on the easels, no sketches on the tables, no evidence of work in hand. Only the "signs" on the floor bore witness that something was in the process of development. But these scraps of paper, so thoroughly weighted down, seemed to have been lying there a long time. The paper was dusty, the "signs" looked as though they had been painted on years ago.

Did I feel disillusioned? I believe so, but I hesitated to put my feeling into words. Then I noticed that the way things were arranged down below was by no means as fortuitous as I had supposed. It seemed to me more as though the tools and equipment and meagre working furniture formed a composition, as though everything had been deliberately placed in the position it occupied. This applied even

The Carbide Lamp, 1922/23
La lampe à carbure
Oil on canvas, 38.1 x 45.7 cm
The Museum of Modern Art, New York

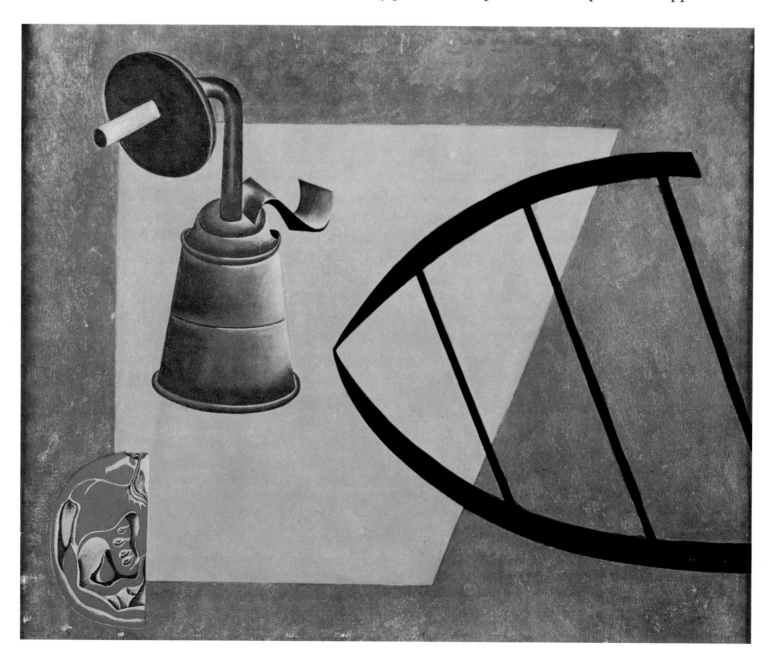

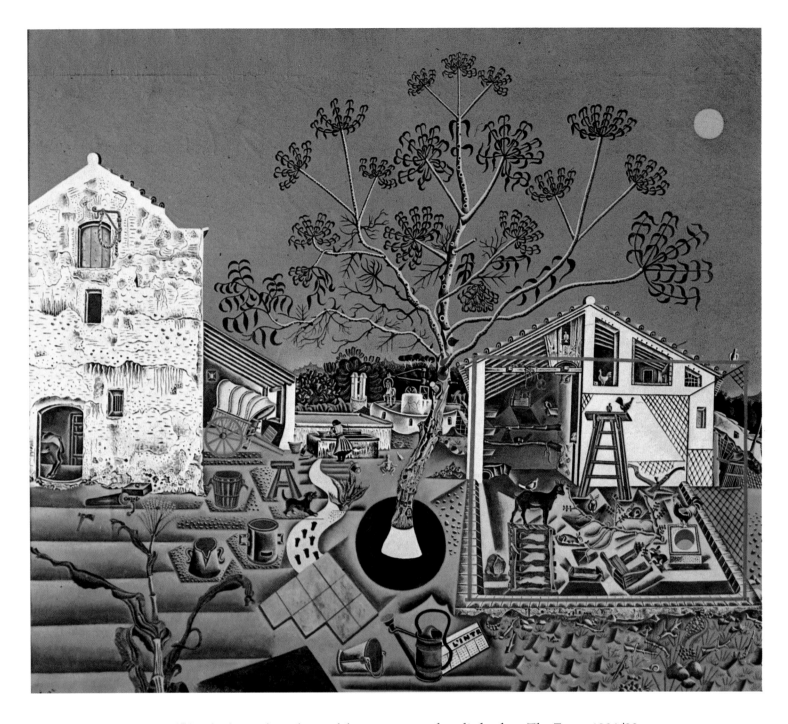

to the arrangement of the little, pale-coloured bast carpets that linked one object with another.

I also felt that Miró, although he must have seen all this countless times, was not indifferent to what was "taking place" down below. The way he looked, scrutinized – his whole demeanour was full of eager attention. When I communicated my discovery to him, he nodded in agreement. *"Tout cela s'arrange bien, c'est frappant.* I didn't arrange it like that consciously, it just happened."

"The scenery is in place, the show can begin!" I cried. "And the producer knows what is coming. Will you soon start painting?"

Miró shrugged his shoulders. "Possibly", he rejoined. "That is something I never know for sure. First I have to go and see Artigas at Gallifa, to finish off the ceramics for the Unesco building." – "But I suppose it looks different here when you start painting?" I asked. Miró threw up his hands. "It certainly does!" he exclaimed.

The Farm, 1921/22
La ferme
Oil on canvas, 132 x 147 cm
National Gallery of Art, Washington
On loan from Mary Hemingway

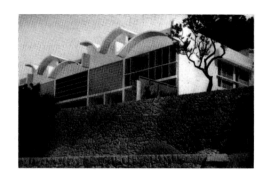

Miró's studio in Mallorca, designed by the Spanish architect Sert.

The Farmer's Wife, 1922/23
La fermière
Oil on canvas, 81 x 65 cm
Madame Marcel Duchamp Collection,
New York

As we strolled along the gallery, I finally came upon an easel bearing a canvas in a bare deal frame. It showed a grotesque face with a single eye in the centre of the forehead and a mouth with bared teeth. The paint was smeared on roughly, the brown resembled the colour of an earthy potato, the broad black outlines looked as though they had been painted with lamp soot.

"Is that a new painting?" I asked full of curiosity. "It's quite old", answered Miró, "but I often take out earlier works. I should like to paint, to produce, something as direct as nature. Immediate, you know, with nothing in between … " He clenched his right hand and made a clicking sound with this tongue. This gesture seemed to express, better than any words, a willingness to redouble his efforts.

At the end of the gallery a sun with eyes, nose and mouth, plaited out of thin strips of wood, hung from the ceiling by a string and swung in almost imperceptible circles. This construction, a piece of Mallorcan work, was more than three feet across, excluding the long, protruding rays. My eyes wandered back to the room with the drawing tables. Now I noticed a shelf on the wall in front of me, also filled with peasant craft-work of the kind still produced on the island. Among the objects, I spotted some of the famous *xiurells,* those pottery figures painted white and decorated with green and red lines, crosses and dots.

Miró put one of the figures to his mouth. They had pipe-like mouthpieces at the back. A high-pitched, penetrating note whirred through the room. "Soon there will be a fiesta here, a popular festival with a small fair. You will see figures like these on sale there, they only cost a few pesetas. These figures possess extraordinary importance for me", he continued. "Just look at the expressiveness of the face and the posture!"

He held in his hand the figure of a woman with her hands on her hips.

The face was modelled in the simplest possible way. Two or three impressions made with the tip of the thumb rendered the eye-sockets, nose and mouth. Two dots dabbed in with a brush produced the lively eyes. According to the way in which the light fell upon the salient shapes of the face, the expression of the figure varied from doll-like to grotesque.

"I have to keep looking at them", declared Miró. "Each figure has its own physiognomy, although they are produced by the hundred. They are very popular, especially with children!"

I told Miró that while glancing through an archaeological magazine I had come across an article on the history of these pottery figures and that the author described them as Phoenician in origin and pointed to their affinity with Cretan pottery. There were supposed to be particularly remarkable examples in Ibiza.

"Ah oui", replied Miró vivaciously. "I know the museum at Ibiza, the director is a friend of mine. Furthermore, you will find an excellent private collection at Genova, up above Bonanova – that's the name of the settlement in which my house is situated. There you will also see examples from prehistoric times."

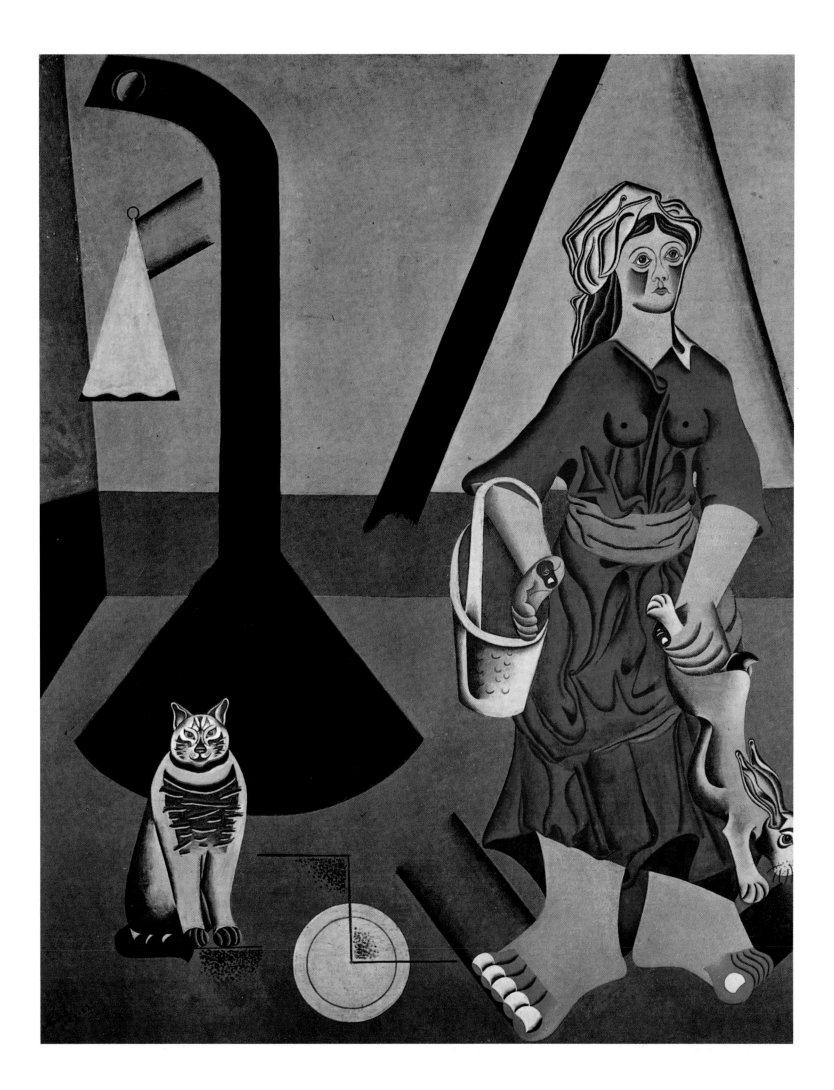

During the decisive years 1923 and 1924 Miró eventually found a new pictorial language, thus translating his detailed observation of nature and his magic evaluation of objects into a free poetic system of symbols and colours. This transformation of Montroig objects into an independent symbolic language was still very incomplete in *The Tilled Field* (below), whereas in *Catalan Landscape* (opposite) the world of objects has indeed been reduced to a few rudimentary symbols. The picture can be divided into two zones that display a variety of geometric figures as well as some small, abstract shorthand which represents certain objects. The only object by which we can identify the Catalan peasant is his pipe. Everything else has been reduced to a small number of wavy, dotted or angular lines. The peasant is shown on his return from a hunting expedition: on the right, the pointed cone with the small flame at the end

The Tilled Field, 1923/24
Terre labourée
Oil on canvas, 66 x 94 cm
Solomon R. Guggenheim Museum, New York

Miró handed me several of these figures one after the other. After the woman came a man with a horned head-dress, then a rider on a horse and finally a man on a bicycle and even an aeroplane.

This popular art form had proved capable of digesting the technical forms of our civilization without giving rise to those bastard constructions, those realistic imitations of technical appliances, about which there is generally something rather inartistic.

Had Miró not also developed a sign language that was reminiscent both of the products of archaic art and the shapes of planetary monsters? Did not his symbols resemble both prehistoric hieroglyphs and the rows of half erased mathematical ciphers left behind on the blackboard in a lecture room?

I could have asked the painter a good many more questions about these pottery figures, but I felt that he wanted to show me the ground-floor section of the studio too. How I should have liked to look at the books and art publications that lay about in piles on the low shelves. What purpose did they serve? Did he look in them for stimulus or vindication? What was he occupied with at the moment?

Miró, who was already standing by the stairs that led down into the studio proper, invited me to precede him. From the last few steps, before we descended into the spacious studio, I was able to glance

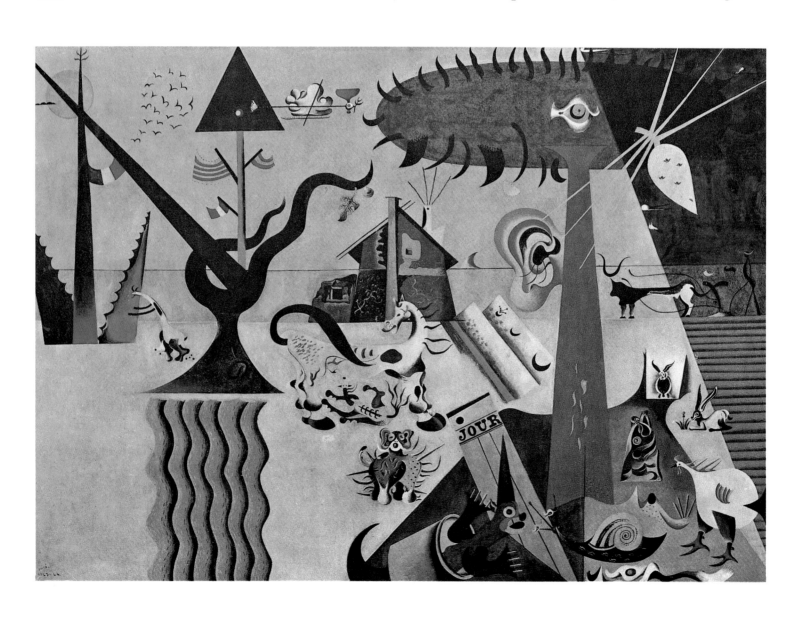

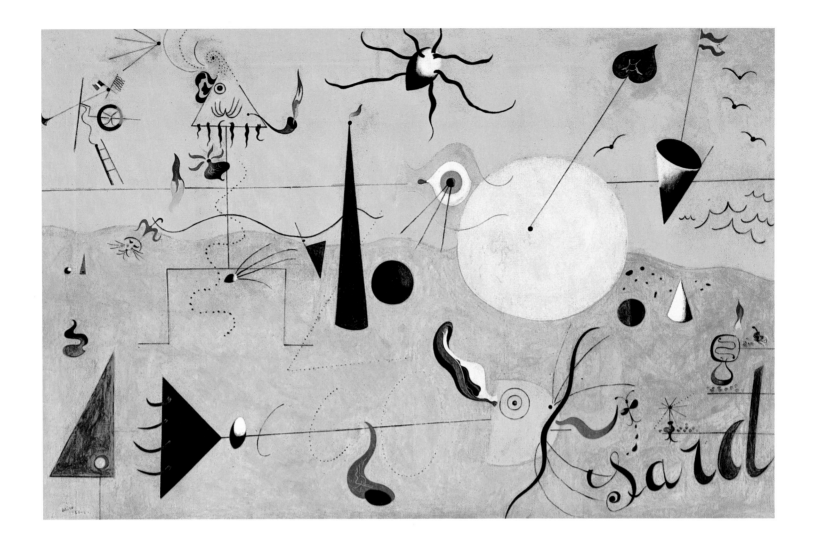

Catalan Landscape: the Hunter, 1923/24
Paysage catalan (Le chasseur)
Oil on canvas, 64.8 x 100.3 cm
The Museum of Modern Art, New York

into an alcove enclosed by a wooden partition and containing all kinds of lumber – rolls of paper, sheets of music, parts of an electric bell and a basket-work standard lamp, a large white glove and a false nose of papier mâché with a red moustache and brass-rimmed spectacles. As I looked at the glove, I immediately thought of the outspread hands that appear so frequently in Miró's pictures. Did the painter employ a model even in these surreal fantasies?

We walked through the wide, airy room, which was filled with light although the linen curtains were drawn and the Venetian blinds lowered. On a stool lay a large stone, of the kind frequently found on the beaches of the Bay of Palma, covered with cavities and protuberances.

The holes in this stone might have been eyes, nose and mouth. Suddenly it seemed to me as though the head and the comical outward-curving legs of the stool were growing together into a Miróesque figure, a *personnage*. I pointed this out to him. He nodded. "Everything you see in my pictures exists!" he declared with a smile.

A number of drawing-boards stood leaning against the wall with paintings on sheets of paper pinned to them. I hadn't seen these from the gallery. One sheet showed a monumental object painted in sepia, umber and ochre, an enormous tuber with projections and hollows that gave the illusion of a shapeless face. I went closer to the picture. The brown of the face vibrated with subtle variations of tone and seemed to be the result of prolonged and strenuous work. The areas of

stands for the gun, and on the left a hare is indicated. The geometric figures have taken on the function of representing the inanimate, the inorganic, while the vivid lines have been reserved for animate objects.

The painting is a great ode to Miró's native area, and particularly its myths. The abbreviation *sard* in the right-hand corner allows two possible interpretations – it could either be a Catalan dance called *Sardana* or it could be a reference to the *sardine* which provides an important income for the inhabitants and is also a well-known fertility symbol. Numerous sexual symbols in this pictures, such as the round bulge on the right and the almond-shaped symbol, with its stylized hair, hovering above the round shape, direct our attention to the myth of Woman, so deeply rooted in Mediterranean cultures. Indeed, eyes and almond shapes, individual hairs and star-shaped clusters of hair pervade Miró's entire work with their latent sexual symbolism.

colour were broken by shapes and lines like Martian canals and enriched by countless streaks and incrustations. The coarse epidermis of the furrowed countenance, which was yet so richly textured, was breathing; I imagined I could feel the living organism and the substance of the flesh behind it.

Above this large cartoon, on the edge of one of the many picture crates pushed back against the wall, stood a pen and ink drawing with touches of water-colour depicting the sun, moon and stars. To the right and left of these two works shone two other paintings on pasteboard with a white background, each of them bearing what looked like a Chinese calligraphic character. These four sheets, so different in expression, suddenly combined into a single picture, as the various phenomena in nature fuse into the unity of a landscape.

"That ought to be shown in an exhibition!" I exclaimed. "Yes, I should like that", replied Miró, "but art dealers always think in terms of "periods". Up to now, none of them has ever taken the trouble to come here." "Look", he went on, pointing to another great lump of

The symbols in this picture are suspended precariously above an area consisting of delicate shades of grey, and although the wriggly little creatures are struggling to get away from the menacing sway of a pair of breasts, they are inextricably linked to them. Instead of evoking associations of maternal comfort, the gigantic, black pendulum – a mother's womb – reminds one of the bizarre stories of Edgar Allan Poe. The reduction of the symbolic language in this picture gives it even more precision, thus opening a deeply symbolical dimension and expressing the fears and anxieties of early childhood – feelings which have a fundamental, formative effect on a human being, because of his long period of dependence and powerlessness.

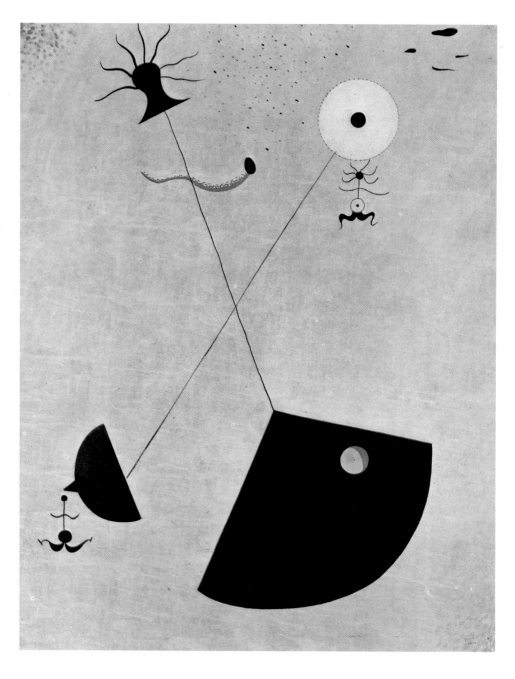

Motherhood, 1924
Maternité
Oil on canvas, 91 x 74 cm
Roland Penrose Collection, London

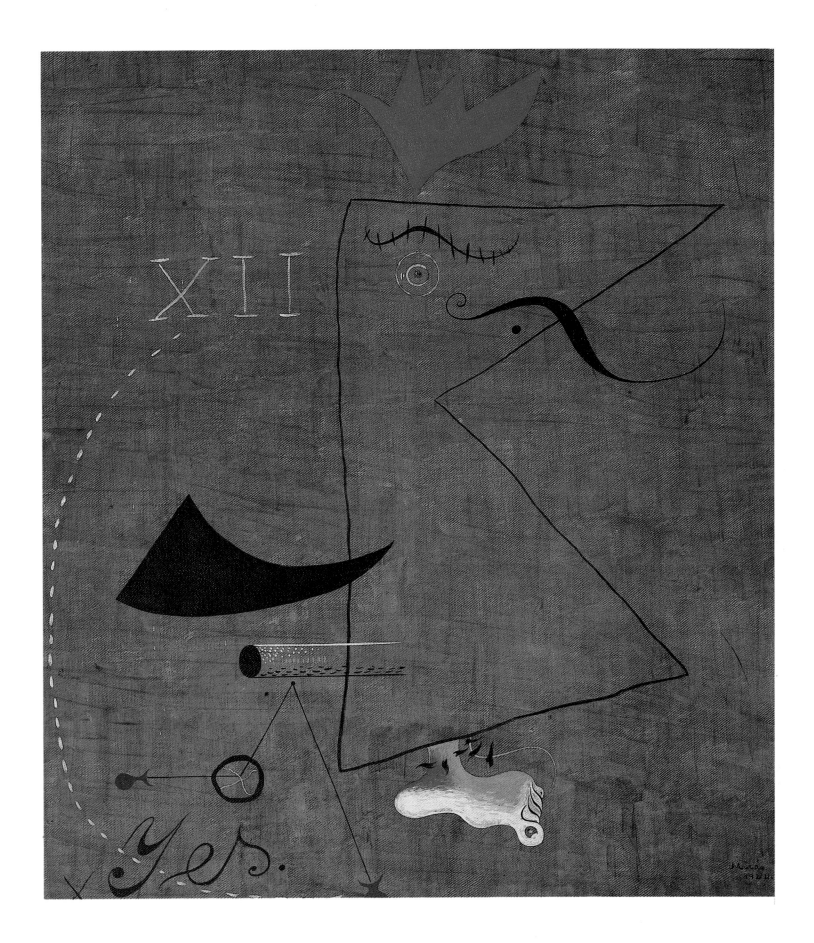

stone that swelled up out of the corner of the studio like a growth. "There's something frightful about that thing!" He looked round and fetched a pale-coloured earthenware jug, decorated with arabesques of flower and leaf shapes. Such jugs can often be seen as ornaments on the mantelpieces of Mallorcan houses. "And this is the embodiment of

The Gentleman, 1924
Le Gentleman
Oil on canvas, 52 x 46 cm
Public Art Collection, Kunstmuseum, Basle

35

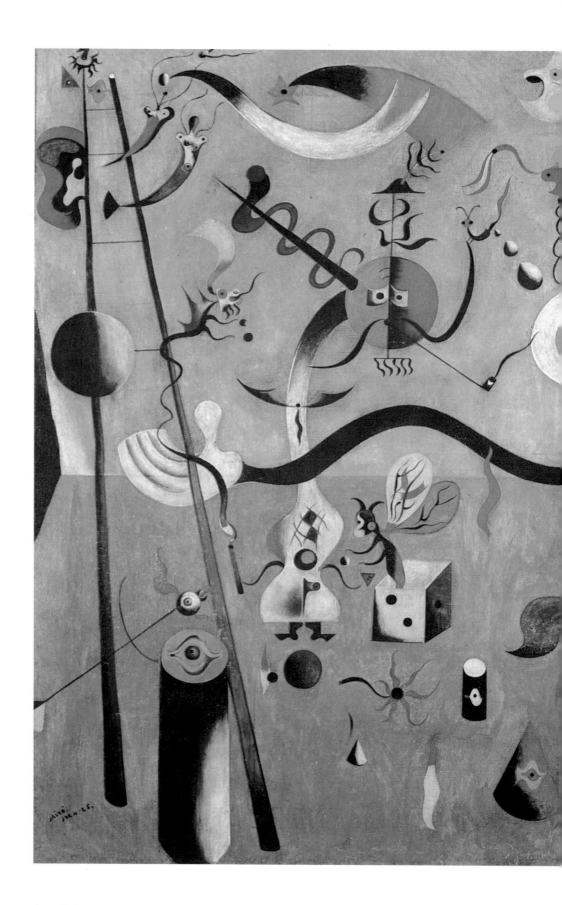

the delicate, playful, useless. The two go together, the brutal and the intimate, you find them in this landscape as well as in my work."

My eyes followed the painter's movements, as he replaced the jug almost tenderly against the wall. Complete silence reigned in the studio. The picture crates against the walls bore vermilion labels with the word "Fragile". These labels were suddenly shimmering all round me. From time to time their whispered cry seemed to grow louder.

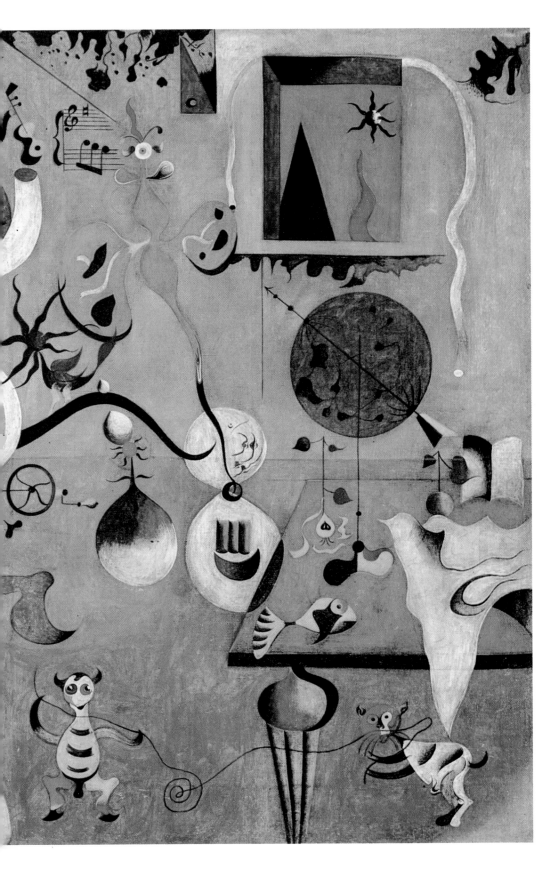

Miró had thrust aside one of the many curtains and raised the Venetian blind. Before us glowed an azure-blue noonday sky. Miró pushed open the French window. "No doubt you would like to see the terrace, *passez donc, s'il vous plaît,* we still have a little time left."

Miró had placed both hands on the red-painted iron balustrade. *"C'est bon, hein?"* came from his lips. But he did not seem to expect an answer, for he did not take his eyes off the line of the horizon.

The Harlequin's Carnival, 1924/25
Le carnaval d'Arlequin
Oil on canvas, 66 x 93 cm
Albright-Knox Art Gallery, Buffalo (N.Y.)

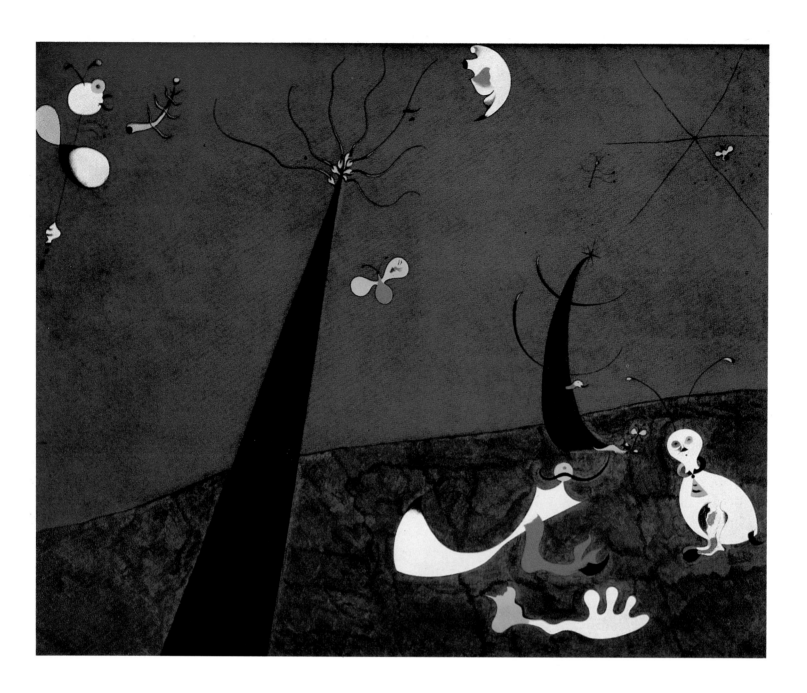

Dialogue of the Insects, 1924/25
Le dialogue des insectes
Oil on canvas, 65 x 92 cm
Private collection, Paris

There was something uncanny about the intensity of his gaze. It created a silence between us that surpassed the silence of surrounding nature. His silence was like a wall, it created a distance that made it difficult for me to speak either. I had often seen painters and sculptors looking in this way. Chagall stared fixedly at the bed of red roses against the dark-green of a cypress grove in his park-like garden at Vence on the Côte d'Azur. Henry Moore gazed out from his studio in Hertfordshire at the amber-yellow shapes of his Reclining Figures, which he had placed at the edge of a field of stubble bordered by hills. Old Emil Nolde looked across the glowing tropical brilliance of beds of phlox and dahlias at the dykes and storm-clouds of the Jutland plain.

Always this silence had reigned, and I had felt a ferment at work within these men, vindicating what they had done or preparing the way for something new. In these artists I saw the affinity between the physiognomy of the landscape and the artist's work, each of which helped to illumine the other.

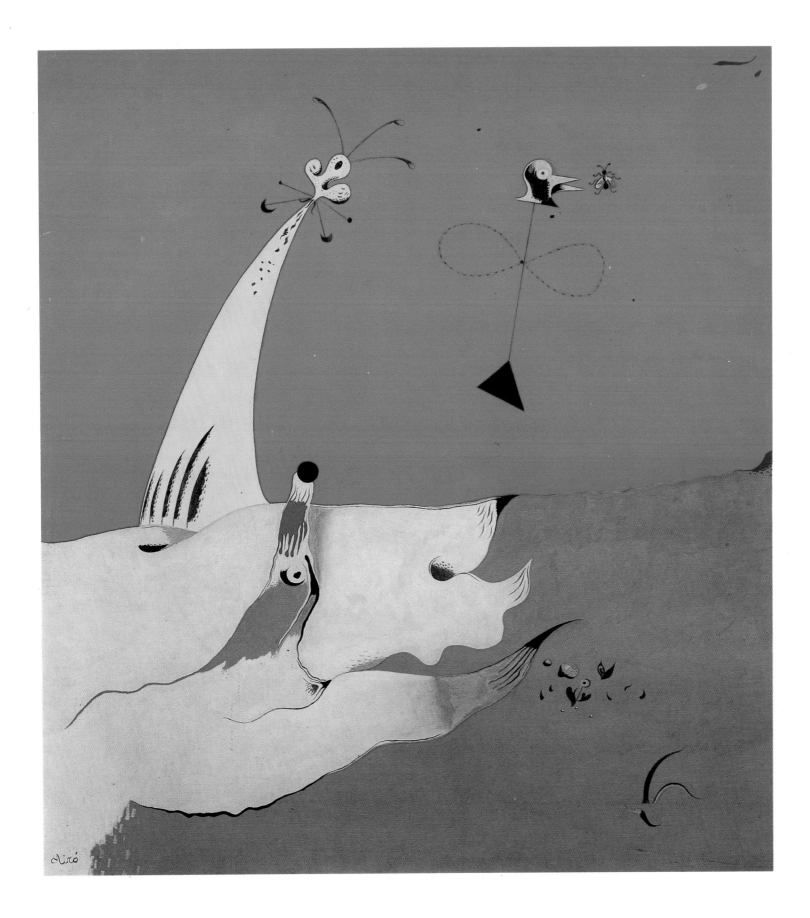

In Miró's case there was no immediate correspondence between work and landscape, or only in a higher sense which I could dimly perceive but could not yet put into words. I had already noted the similarity between the reflections which the light cast upon objects on this island and those which appear in his pictures, the resemblance between the structure of his lines and the silhouettes of the mountain

Landscape
Paysage
Oil on canvas, 47 x 45 cm
Folkwang Museum, Essen

ranges. But what did I learn from these minutes of contemplation? Was Miró looking at the landscape with the eyes of the Impressionists?

At moments he breathed more heavily, as though finding difficulty in absorbing the fullness of experience. Then again he nodded his head and compressed his lips. I felt my tenseness disappear and make way for a calm that did not come from within myself, but from the landscape in front of us, as though the landscape were expressing with ever increasing fervour what I was feeling at that moment. And as the gradations of colour grew clearer and more definite and the forms more solid, the stillness within me also gained substance.

Touched by the breath of a rising breeze, the big wind-wheel at one end of the house began to turn. It seemed to be grinding more loudly because of the dryness which the prolonged heat had produced in the timber frame, the red and blue sails, the dusty cogs and iron axles.

Miró looked at the rotating wind-wheel. "It pumps water for us on these hot days", he explained. But the next moment he seemed to have forgotten the technical purpose of the wheel, he looked at it more as a

Bathing Woman, 1925
Baigneuse
Oil on canvas, 73 x 92 cm
Michel Leiris Collection, Paris

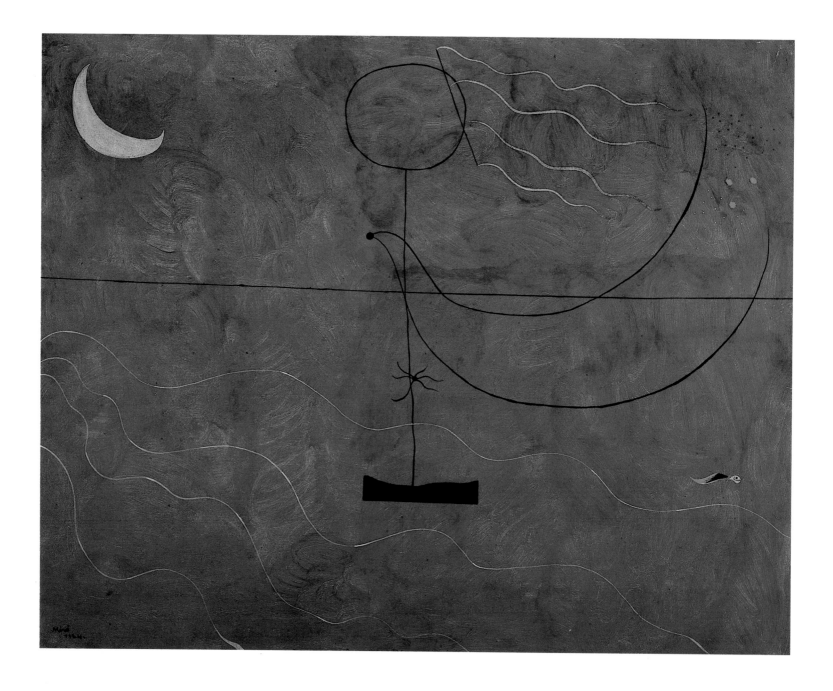

mobile monument, an "object" rising at once senseless and menacing against the pale sky. It was at such a wind-mill as this that Don Quixote once tilted.

Miró caught sight of the book I had put down on the parapet. *"Ah, le catalogue de Maeght!"* He raised his hand slightly and smiled at me, as if he were glad to know I had it. I opened the book. It showed a colour reproduction of a *"paysage"*. A glassy, translucent blue laid on in several layers, above it a soaring trapezium, a patch of velvety black, a grained area of yellow ochre with a vermilion line winding inside it. Was it not the portrait of this moment? Did not its colours and forms express at once gaiety and melancholy, both held in suspense by that sense of an over-alert intelligence which seems to bestow life and breath upon objects by the sea?

Just as I held the picture up against the landscape, a speedboat shot out over the water from the Bay of Terreno below. It described a curve of foam. The blue of the picture was also marked by the signs of many movements and forces. Was not the trace left by the draughtman's pencil on the white surface an equally hazardous adventure?

Siesta, 1925
La sieste
Oil on canvas, 97 x 146 cm
Musée National d'Art Moderne, Centre Georges Pompidou, Paris

41

The washed-out surface with its subtle shades of blue only bears a small number of symbols from Miró's repertoire. Everything has been reduced to mere hints, flashes from the subconscious mind. The peasant's head is no more than a tiny fragment of Miró's dream work, which led him to produce a series of highly poetic paintings in the mid-1920s. Intellectual interpretations are almost superfluous here: the subconscious expresses itself in different symbols and different spheres, it is impenetrable but at the same time as seductive as the mysterious blue which forms the basis of most of the pictures in this series.

Head of a Catalan Peasant, 1925
Tête de paysan catalan
Oil on canvas, 146 x 114 cm
Bonnier Collection, Stockholm

Head of a Catalan Peasant, 1925
Tête de paysan catalan
Oil on canvas, 91 x 73 cm
Roland Penrose Collection, London

Did it not encircle an imaginary space that differed in no way from the space surrounding it? A fine game, in which the non-existent acquires life through taking upon itself the appearance of that which exists and in which the inner spectacle, not the events recorded by the eye, become reality – that is to say, poetry!

I had clothed my observations in my clumsy French. *"Ah, c'est juste!"* nodded Miró in agreement. "Everything comes from the visible, the object claims my interest more and more, even if it serves only as a point of departure. There is nothing abstract in my pictures!"

It was getting on for one o'clock when Miró brought me back along the many paths, terraces and alleys and across the wide forecourt to the great door in the wall. After the cool in the studio and on the shady terraces, the blazing heat of midday poured down upon us. "Shall I get you a taxi?" inquired Miró. I asked him not to; the car would have taken me too quickly back to Palma and its bustle of tourists. By walking, I should be able to ruminate on what I had seen and

heard as I made my way down to the broad coast road. I thanked Miró for his patience towards me and apologized once more for my imperfect French.

"Mais que voulez-vous", he replied consolingly, *"moi aussi je ne suis pas Français, n'est-ce pas? La langue que nous parlons, je la comprends très bien.* You will come again! It will be best to ring first. I think six in the afternoon will be a suitable time; I shall have finished work by then, and the cooler air of evening will allow us to stay out of doors." I told him I had looked in vain for his telephone number. He told me the number and I made a note of it. "I suppose you have good reason to keep your number secret?" I asked him. He threw up his hands, as though to ward off an assailing phantom, and answered: "The tourists get so bored down there, it might even occur to them to accept me and pay me a visit. Besides, there's an artists' colony on this island …"

He opened the door in the wall and held out his hand. The expression on his face showed none of that non-committal joviality which eminent hosts put on like a mask when they say goodbye to a visitor. The feeling that I towered more than a head above him made him smile. As I took the first few steps down the road, I sensed that he was watching me. I turned round and waved to him again. At this he disappeared, the door closed, the little bell tinkled tinnily. Nothing remained of the house and the studio save a very vivid recollection.

I was familiar with the route from the outward journey in the taxi, but now it all seemed quite different to me. Apart from the rhythmic song of the cicadas in the branches of the pine trees concealed behind the high walls, there was not a sound to be heard. I was still a considerable distance from the main road along the shore and its noise did not reach me. I should have liked to take refuge in one of the houses hiding behind the walls. I resolved to find quieter lodgings in a more secluded part of the island as soon as possible.

I found pleasure at one moment in putting my hand on the burning hot stones of the wall, and at another in letting the stream of icy water from a spring at a crossroads splash over my wrist. Again and again my attention was caught by the emerald lizards that were sunning themselves on the roadway or in the middle of the sunlit wall. I enjoyed watching their metallic bodies dart forward, remain motionless for an instant as though in a trance and then scuttle away like lightning as I drew closer.

The veining of the reddish stone, the organic structure of the wall, the signs painted in the azure of the noonday sky by the agave masts projecting above the top of the wall, and the silhouettes of the windmills, all this impressed itself upon my consciousness. With every step I took my environment, which changed from yard to yard and yet remained essentially the same, seemed to express what I was feeling at that moment. Its shapes were tangible and distinct. And yet I felt no temptation to name them. The real was at the same time unreal, the visible its own mystery, outward appearance and inner essence were fused into one.

The shapes of the stones of which the walls were built suddenly reminded me of the shapes in Miró's pictures. Even the heat that was

During the twenties, which were so important for Miró, he also produced his so-called *picture poems*, pictures in which he combines colours and words. In this one, two smears of white paint cover a spotty, brown surface, connected by two red arches with black dots. There are two breast-shaped blue eyes in the right half of the picture, with reddish yellow "tongues" that protrude from their sides and are linked to each other by a line of white paint. Another white line trickles down from above, forming a cross with the first line. The entire picture is covered with the hand-written words of a popular folk song: *Le corps de ma brune* …. The different elements of the painting form three levels of space which are related to one another in a way that fluctuates: because of its vague colour structure, the brown surface seems to be the most spacious of all, followed by the icon-like, semi-transparent way in which the paint has been applied, and finally the firm, black words which seem to be asserting themselves quite confidently. This economy of means makes for a stunning effect of spaciousness and an interesting overall structure. However, there is also the poetic dimension of the picture, because word and colour are mutually suggestive, just as colours and vowels are related to femininity in Rimbaud's famous poem *Voyelles.* And so *The Body of My Brunette* can be seen both literally and symbolically, e.g. in the shapes of the breasts and the veil of colour which can be understood as hair.
Not only do Miró's *picture poems* form part of one of the most interesting traditions in modern symbolic language, but they are also among his most multi-faceted and most beautiful paintings.

«**Le corps de ma brune …**», 1925
Picture poem
Oil on canvas, 130 x 96 cm
Private collection, Paris

45

Miró's *Dancer* of 1925 is one of his sparsest but at the same time most poetic pictures. Having primed the canvas with brown paint, the artist then applied a layer of ultramarine blue in such a way that the brown colour was still visible in the form of an edge. The blue layer was added in broad, rapid movements, leaving spots and traces of the paintbrush to indicate the sweeping movements of the painter's hand.

Movement is also indicated by the blue lines that have been added to the blue surface on the left. There are dotted circles which add up to a surging spiral, and the impression of movement is further enhanced by a wavy line at the top. The direction of the dance is indicated by a straight, uninterrupted top-to-bottom line. The *Dancer* herself, on the right, has been indicated quite wittily: a ball-shaped head, modelled in light and dark shades, linked by a thin line to a flashy, red heart, with symbolic genitals attached to its tip. The whirling feet seem like stylized notes and may have a musical meaning.

In a letter to the art collector Rosengart, who now owns the picture, Miró describes how he came to paint it. The idea first came to him when he was spending his Christmas holiday in Barcelona, where he watched a dancer at a bar called *Eden Concert* which was quite well-known at the time. Having drafted a few small sketches, he set to work as soon as he was back at his studio in Rue Blomet, Paris. Miró himself was very fond of this painting which marked the beginning of an important phase in his development as an artist.

Dancer, 1925
Danseuse
Oil on canvas, 115.5 x 88.5 cm
Rosengart Collection, Lucerne

making me sweat, and the fine, all-pervading dust that my lungs were breathing in, were expressions of the natural world out of which the painter I had just left had created his works.

That afternoon I felt an urge to explore the quieter part of the island, and above all to find new lodgings for the rest of my stay on Mallorca. Miró had mentioned the name Genova, a village on the slopes of the mountain that rose behind Palma. I had also caught sight of the word Genova on the front of the old-fashioned red tram that links Palma with its "suburbs". What could be more natural than to let this airy vehicle take me on a journey into the unknown? So I travelled back in the tram part of the way I had driven in the taxi that morning. Immediately after Terreno, however, the tram crawled at walking pace up a winding road. On the left towered crags; the opposite side, especially at the bends, yielded views of the bay of Palma with the cathedral rising up out of the city. The higher the road climbed, the rarer grew the now more exclusive boarding-houses and hotels. Finally the tram – it seemed to me almost a far-fetched surrealist fantasy – clattered straight through a grove of almond and carob trees. We had reached the summit. Not far away rose a wooded hill with the mediaeval fortress of Bellver on its summit.

Once more houses appeared, this time of a rustic type. They were white washed, the shutters freshly painted, their walls decorated with shell-work pressed into the plaster; I had often seen the trowel that threw the plaster on to the brickwork leaving behind a pattern of regularly repeating bands. Here and there tiles had been arranged to form African-looking ornamentation. Everywhere there was evidence of an urge to create light-hearted shapes that were in strange contrast to the gravity of the mountain massif that rose on the far side of the plateau. Then I saw the first houses of Genova, clinging like swallows' nests to the stony hillside. They were ochre-yellow. In the centre of the village stood a church resembling a basilica.

At a spot outside the village that looked particularly inviting, I jumped down from the tram, which was now going at a snail's pace. I had caught sight of a house with a grocery, the windows and door of which were shaded by an awning of bast mats. On a bench near the door stood the white pottery figures, the *xiurells,* which Miró had been so anxious to show me. Inside there were a number of earthenware jugs and pots that also aroused my interest. Since I had no bag with me in which I could have put these treasures, I promised the woman who owned the shop, who spoke a few words of French, that I would come back. She accompanied me out into the street. I asked her if she knew of a room in this neighbourhood where I could stay. She walked with me round the house and pointed to a building on the crest of a nearby ridge, approached by a winding path. "That house belongs to a German woman, she always has guests", she told me.

I thanked her and climbed up towards the house. It took a quarter of an hour, and then I was standing before the gateway built of large blocks of hewn stone. A dog started barking. I crossed the wide, well-kept forecourt. A slim, fair-haired woman appeared in the doorway. "It's true that we often have guests", she explained, "but they are

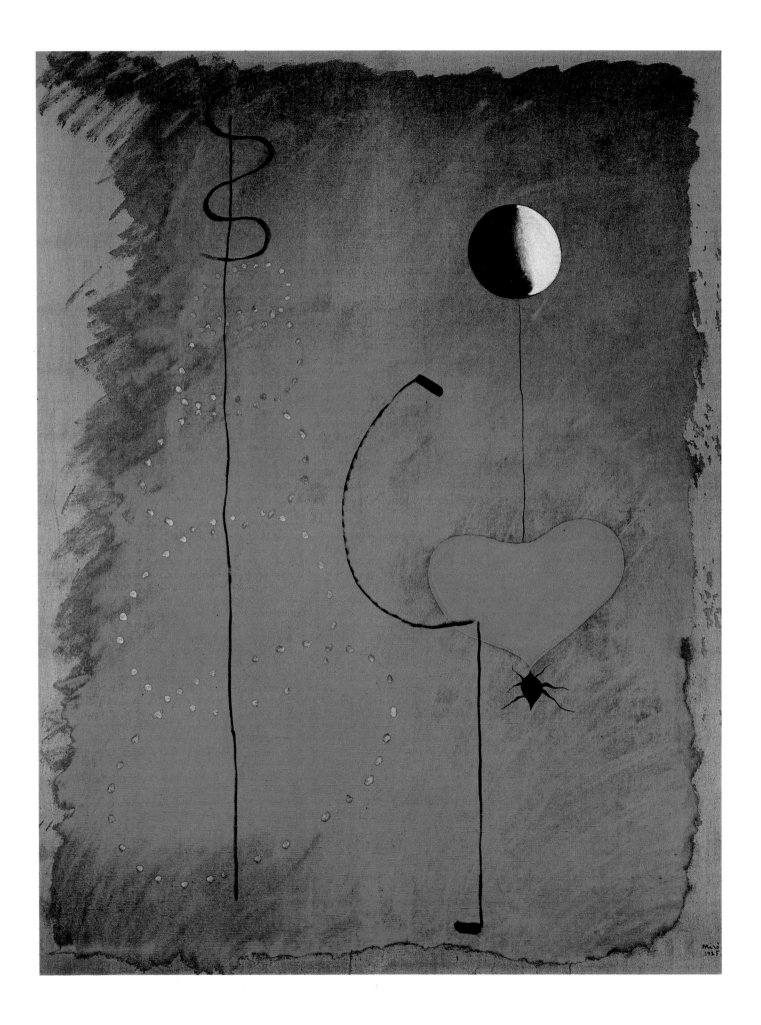

Dog, Barking at the Moon, 1926
Chien aboyant à la lune
Oil on canvas, 73 x 92 cm
Philadelphia Museum of Modern Art,
Philadelphia

friends and relations, who spend their holidays with us." I learnt that she was a Baroness Münchhausen. She invited me to have a look at the big entrance hall. On the high walls hung portraits of Prussian officers. On a mantelpiece stood Dresden china and an Empire candlestick. The longhaired hound proved to be a playful young animal.

"If you're not too fussy, I could make a room free for you." This was an unexpected offer. We climbed the wide stairs. In the upper hall an old refectory table stood in front of a tall glazed door. Through the muslin-curtained windows gleamed the green of the palms. The lady of the house opened the door to a spacious room. I had seen at a glance that this room might have been made for me. We went out through a second door onto a terrace. Below us stretched another blue bay.

I was so excited by the prospect of living in this room and working at the big table in the hall that I could only stammer my thanks. When I asked how soon I could move into this room, the Baroness said to me: "At once, if you like." It took me rather less than two hours to have

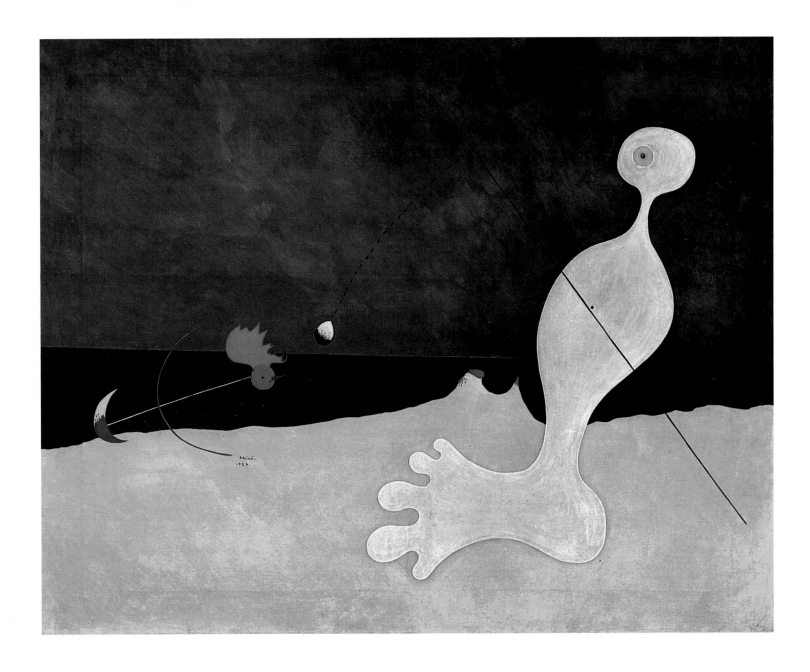

my luggage brought from the hotel to Son Boter, as the house was called. Shortly before sunset I had made myself at home. When the Baroness saw my portable typewriter on the vast table, she asked whether I was a journalist. I replied that I wanted to write a few notes about a painter who lived on the heights of Calamajor. "What is this painter's name?" she inquired with a smile. I told her his name, but added that I was sure she had never heard of him. I was thinking of the officers' portraits and the Dresden china. "Miró?" she replied smiling. "Come out onto the terrace for a moment."

The ball of the sun had touched the rim of the mountain that enclosed the bay to the south. The air was filled with a rosy glow. My companion pointed over the wall of the courtyard that separated her estate from the one below. I couldn't believe my eyes. Fifty yards away from our house glittered the roof of Miró's studio. The trip by tram through unknown country had put the island's topography out of my mind. After a long and unplanned detour, an incredible coincidence had made me Miró's neighbour.

Person Throwing a Stone at a Bird, 1926
Personnage lançant une pierre à un oiseau
Oil on canvas, 73 x 92 cm
The Museum of Modern Art, New York

The *Landscapes* which Miró painted in 1926 show the artist as a great master of colour. Most of these scenes are simply divided horizontally and include very few fantasy figures, such as the head-and-foot figure above (a motif from children's drawings), standing aggressively and throwing a stone at a rooster. The surface colours – ochre and chromium-dioxide green – are deeply saturated, so that the fiery red comb and the blue head of the cock are rendered very effectively indeed. The head-and-foot "figure", on the other hand, remains rather crude, like plasma - an empty space which the viewer has to fill himself.

49

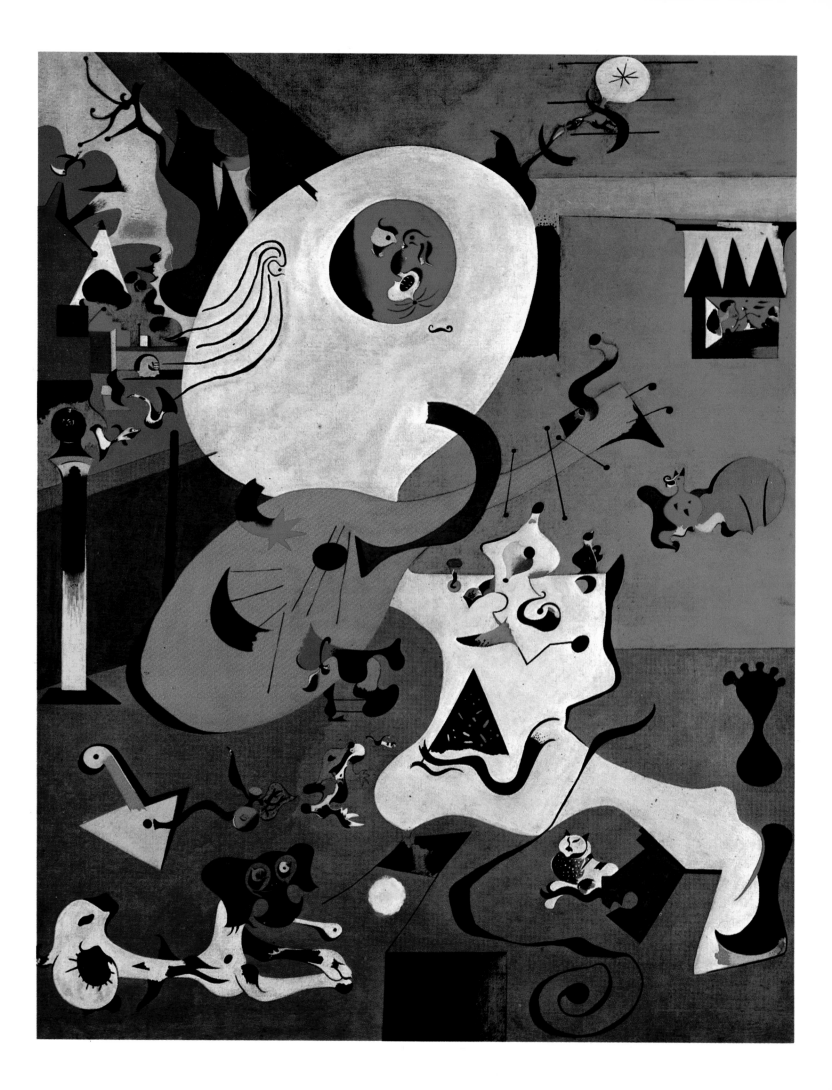

The Desire to Join in the Game

There was no telephone at Son Boter, so we agreed during my second visit that he would send me notes to say whether and when he had time to see me. This second visit, a few days after the first, served only to inform Miró how close I had moved to him. I had feared that it might irritate him to feel that I was so near by, but it didn't seem to worry him at all. On the contrary, he found my Münchhausen adventure amusing – he knew the book about the lying baron – and he praised the situation of the house and the amiability of its occupants. "I even thought of buying the property myself, before I set about building my studio. Son Boter is an exceptionally fine old Mallorcan manor house. "Of course it will be a good thing if we can arrange beforehand when you are coming to see me. *Il faut s'organiser, n'est-ce pas?* I have a lot to do just now", he went on. "My head is full of it!" At these words he put the palms of both hands against his temples, to indicate what demands this work made upon him.

As he was leading me through the studio on my third visit, I couldn't help thinking of his last sentence. Apart from the arrangement of objects and equipment, which I had observed during my first call, no signs of work or preparations for work were visible in the studio.

"Doesn't the planning and drafting take place here, in this room?" I asked him. "Don't you make the first drafts for your pictures with a pencil or a brush in your hand? Would it be correct to conclude from this that the discoveries, the inventions and the suggestions don't come to you while you are drawing or painting? There are some composers who compose at the piano and others who put the notes down on paper without any instrument." As I made this latter comparison I realized that I had not conveyed my meaning to him. Before I could think of a better example, Miró began to speak.

"I haven't started to paint yet. There are the new canvases, there are the fresh brushes, paints and pencils. I don't plan my pictures with a brush in my hand", he continued hesitantly. "I think, I ponder, I make written notes, sketches in pencil or charcoal, little drawings if you like. But I never use a sketchbook on my walks. A scrap of paper I happen to find in my pocket is enough to preserve a thought, a sudden idea."

Miró took a piece of paper from the table and tore it into pieces, which he put back on the table and moved this way and that like dominoes. "A piece of paper like this", he said, picking one up bet-

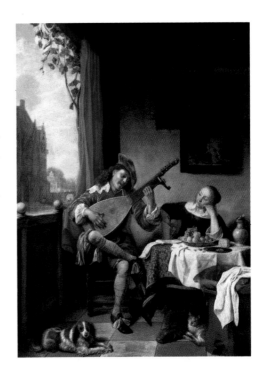

Hendrick Martensz Sorgh:
The Lutanist, 1661
Oil on wood, 51.5 x 38.5 cm
Rijksmuseum, Amsterdam

Dutch Interior I, 1928
Intérieur Hollandais I
Oil on canvas, 92 x 73 cm
The Museum of Modern Art, New York

51

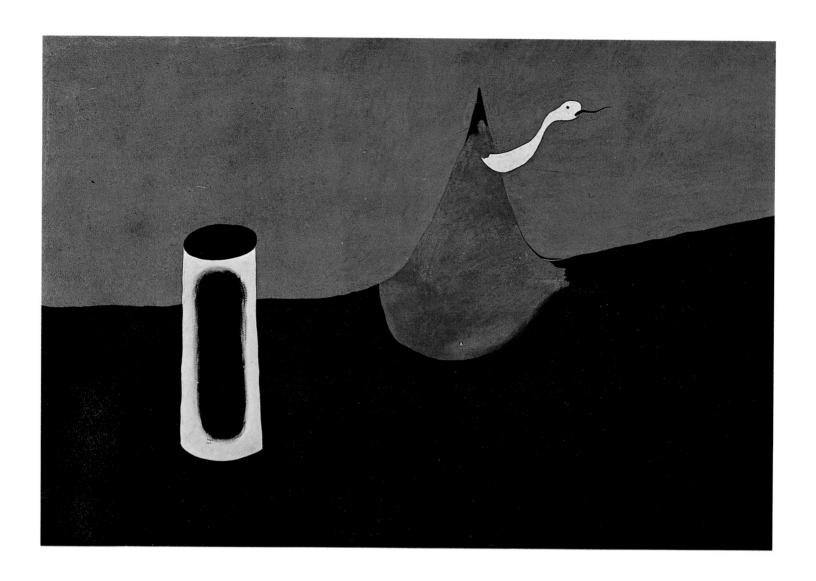

Landscape with Snake, 1927
Paysage au serpent
Oil on canvas, 130 x 195 cm
Private collection, Paris

ween thumb and forefinger. It formed an irregular trapezium, one side of which was ragged. It might have been the outline of a head. "At a given moment a shape like this may arouse or confirm a mental image in me. I collect these scraps of paper, I have thousands of them, envelopes, tickets, bits of menus. Sometimes it is simply a peculiarly shaped stone, a feather, perhaps even a rusty sardine tin ..."

"Do you mean that you never invent a shape, but are always inspired by something you have found? In that case, how does the process of transformation take place? I am not so ingenuous as to suppose that you copy these shapes, that you simply transfer them to the canvas."

I told him what I had seen in a town in Provence, in the studio of the young French painter D-, who has since become famous. He used to collect butterflies and stick the wings of the dead insects on a piece of cardboard in the manner of a jigsaw puzzle. He then slavishly transferred the resulting shapes and colours to the canvas. I asked the painter in what way his procedure differed from that of a realistic painter, who also copies what he sees. I pointed out that it really made no difference whether the object copied was a landscape, a bunch of flowers or butterflies' wings pasted on a card.

Miró made an impatient gesture. "Of course that is not the way I paint a picture. The notes or objects I collect produce a kind of shock in me. Perhaps they recall shocks I have received from quite different

52

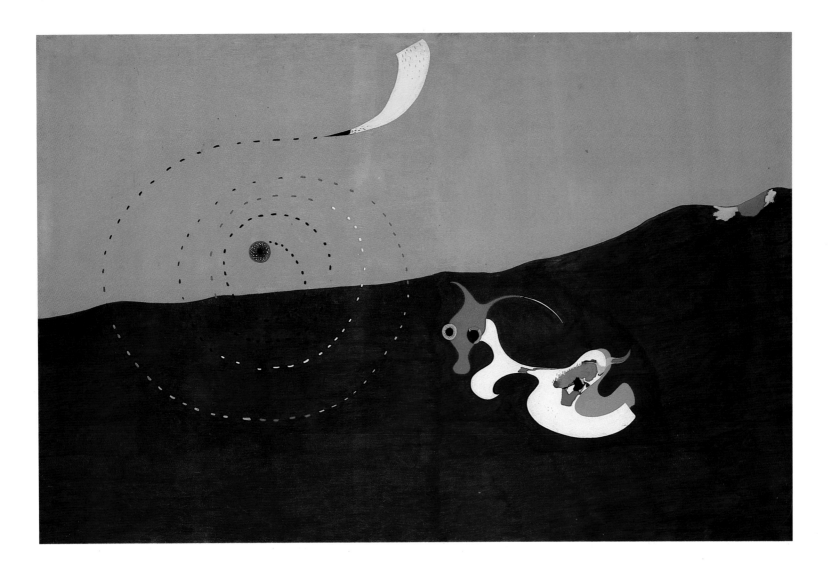

things. The moment I begin to work these notes or objects lose their significance for me. Whether the shocks I have undergone have the power to engender sensations of a painterly nature has then to be decided in front of the canvas."

"You pursue an idea", I cut in, "that is doubtless partly dependent upon the results of your last paintings; and these experiences in turn are the outcome of still earlier works. Do you think that since you finished your last pictures, in the course of a long pause during which you haven't painted, your experiences and ideas have been deepened by the objects you have found, the feelings inspired by the landscape?"

"Perhaps it's like that, perhaps it's different." Miró shrugged his shoulders. "That is something which cannot be put into words. I hope that I shall have thought out my future paintings sufficiently clearly to start painting in about a month. Then things will look different here." He glanced round. "I intend to paint some really large pictures. But first I must have a few days' rest. Next week I'm going to a place near Tarragona, where I hope to spend a few days in peace and quiet. I shall be coming back on October the 1st. Then I shall start painting."

A rest? Was not this patch of ground on which Miró had settled one of the last areas of a Paradise in which repose was really possible? The painter's idea of relaxation could only be to escape for a time from the pressure of the perpetual suggestion, the ceaseless promptings that

Landscape (The Hare), 1927
Paysage (Le lièvre)
Oil on canvas, 130 x 195 cm
Solomon R. Guggenheim Museum, New York

53

After a trip to Holland in 1928, Miró felt inspired to paint his *Dutch Interiors*. His picture No. II was based on a post card replica of Jan Steen's *Cats' Dancing Lesson*. However, Miró was not so much concerned with imitating or even interpreting the original. In his study sketches he gradually changed every single detail into a fantasy figure in its own right, and indeed in such a way that their origin could no longer be recognized. The final painting combines the individual sketches in the form of a large-scale composition. The movements of the creatures dancing to some strange, inaudible tune now follows the rules of a different painter's universe.

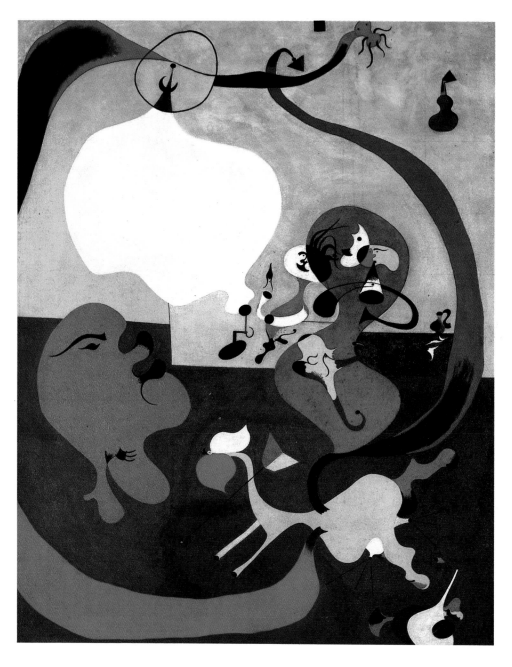

Dutch Interior II, 1928
Intérieur Hollandais II
Oil on canvas, 92 x 73 cm
Peggy Guggenheim Collection, Venice
Solomon R. Guggenheim Foundation

came to him here from an environment steeped in his searches and researches.

The date October the 1st was no doubt part Miró's endeavour to work to an orderly plan. The same orderliness was evident through the whole material framework of Miró's life. Every scrap of paper, every pencil had its proper place on the desks. Had he not proudly shown me, on the occasion of my first visit, a little piece of Japanese bamboo bearing small notches in which the tips of brushes could be placed, as knives and forks used to be placed on a knife-rest so that the table-cloth shouldn't get dirty?

At first glance it seemed impossible to imagine the author of such visionary pictures leading such a bourgeois existence. But the example of Paul Klee had shown me that an orderly external life is not inconsistent with a wealth and breadth of artistic visions. Perhaps the ceaseless pressure of images, dreams and visions demands this contrast.

The more I tried to question Miró, the more clearly aware I became of the fruitlessness of such an interrogation. I realized that the essential

mystery, the transition from project to execution, could not be solved by the reporter's method of question and answer. It would have been tactless to say to Miró: "Show me your sketches, let me see your notes!" Was it not inevitable that the decisive act of creation should take place in secrecy? Could the outsider ever have any inkling of what tensions filled Miró at the moment he stood in front of the canvas?

Had I any reason to feel ashamed that I could advance no further? Was not the distance that remained, in spite of all the personal warmth and candour, in fact necessary? Did it not teach me to grasp things that were more important to an understanding of his pictures, did it not show me that a man's whole existence is an embodiment of the intensity that speaks from his work? There was nothing here of the popular superstition that the artist is a bohemian who from time to time, preferably in a state of artificially induced intoxication, pours himself out into his works. I remembered a choreographer once saying

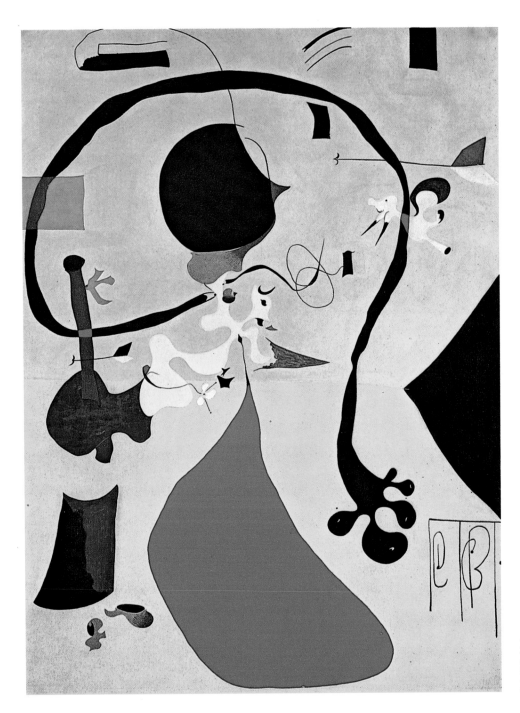

Dutch Interior III, 1928
Intérieur Hollandais III
Oil on canvas, 130 x 96 cm
Marx Collection, Chicago

This is another *Nude* which still has a lot in common with dream paintings. Like Arcimboldo's pictures, it consists of a variety of different objects. The woman's body is formed by a white fish, the left breast in profile is reminiscent of a pear, whereas the right one – seen from the front – resembles an orange, and her pubic hair looks like a green leaf with black veins. The large suspended head with its green aura has a red eye with a fixed stare. Above it there is her veil-like auburn hair, which seems to be blowing in the wind. The general compositional context makes the objects seem ambiguous, leaving only the erotic suggestiveness of the woman's body, with its female attributes.

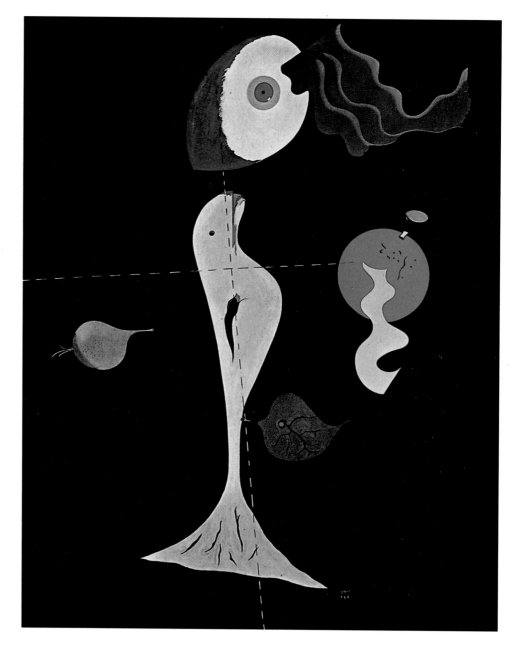

Nude, 1926
Nu
Oil on canvas, 92 x 73 cm
Philadelphia Museum of Art, Philadelphia

Portrait of Mrs Mills in 1750 (after Constable), 1929
Portrait de Mrs. Mills en 1750 (d'après Constable)
Oil on canvas, 116.7 x 89.6 cm
The Museum of Modern Art, New York

to me that at the very moment when the public thinks the ballerinas are soaring in self-forgetfulness, the dancers are actually most coolly aware of the steps and movements demanded of them by the choreography.

Outside, the sun had set. Miró pulled the linen curtains aside, so that the picture of the bay became visible again, like an ever-recurring *leitmotiv*. I made as though to say goodbye, fearing that I might occupy too much of his time. "No, no", he said, coming up to me and placing a hand on my shoulder. "I have set this evening aside for you. Shall we go out on the terrace?"

We crossed the wide studio and passed through the antechamber with the big, black couch. On a low wooden shelf at the end of the antechamber lay carefully arranged folders made of newspaper, once again weighted down with stones. Along the top edge ran Spanish words in Miró's handwriting. As I looked at them curiously, Miró opened one of the newspaper folders. "These are my notes", he remarked casually, flipping through the pages. They were covered with

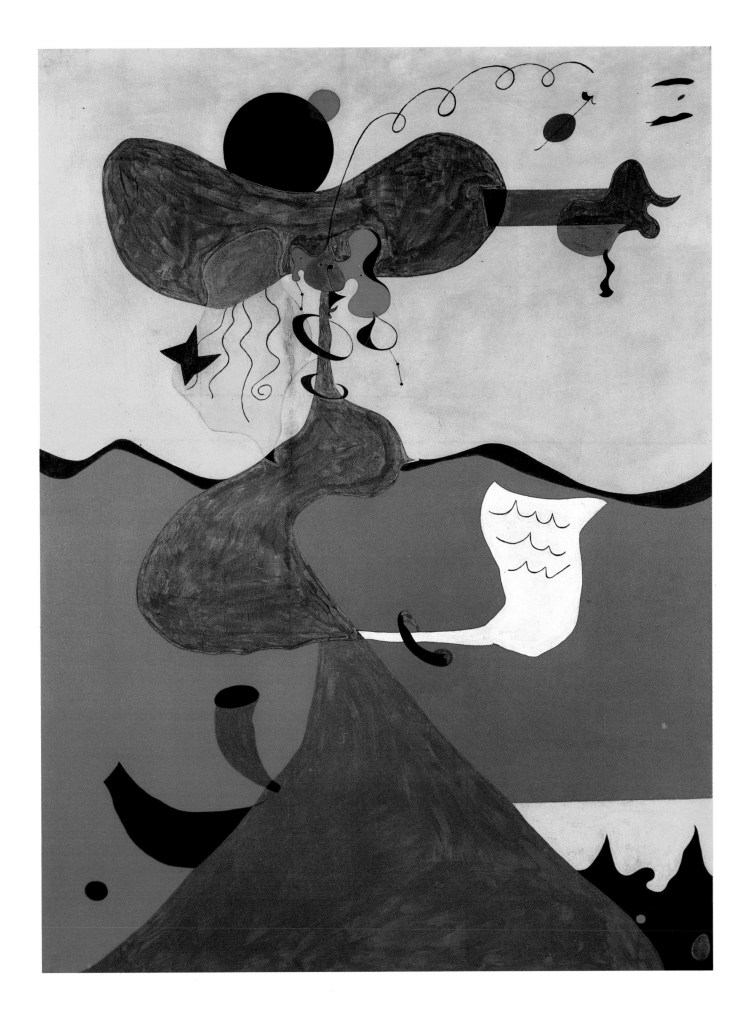

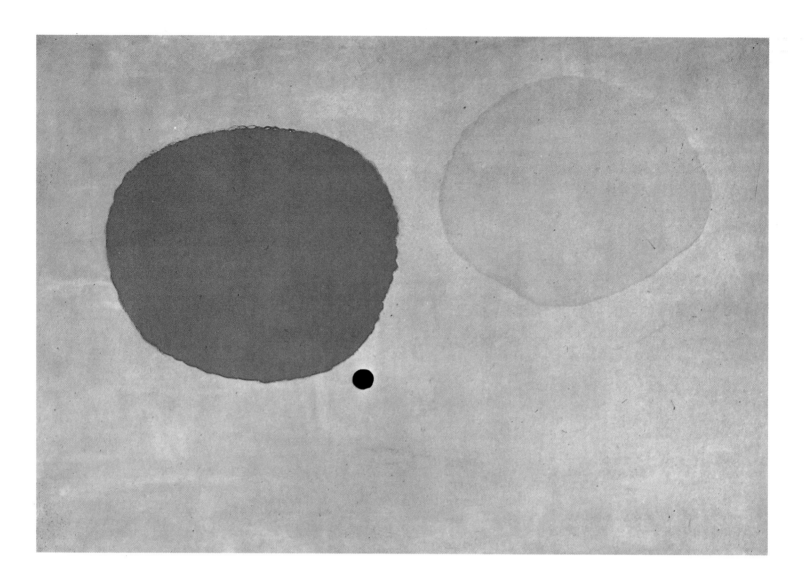

Painting, 1930
Peinture
Oil on canvas, 150 x 225 cm
Private collection, U.S.A.

In 1929/30 Miró went through a serious artistic crisis which led him to a kind of "anti-art". The collages he produced at that time (right) bear no resemblance to the clever subtleties of the Cubists or the humorous playfulness of the Dadaists. There is a peculiar lack of sensitivity about Miró's collages. A few dull bits of paper overlap, and have been placed on a dead canvas, together with some wire and pieces of cloth, but without adding up to any recognizable formal context. There is the occasional quick drawing – remotely reminiscent of Miró's aestheticism – only to give way again to the insipid dreariness of an aesthetic concept that seems rather forced.

neatly written notes. He had already taken another step towards the big glass door.

"Klee also used to make notes. He studied every possible problem of painting and drawing, he planned his pictures with the scrupulous exactitude of a scientist. But the moment he had the sheet of paper or the canvas in front of him, he cast these studies aside. Perhaps he only needed this preliminary research in order to create a resistance".

I could not give up my attempts to stir Miró to an answer.

"Everyone has his methods, hasn't he?" Miró replied. "But fundamentally it comes to the same thing. Everyone is swayed by his driving impulses".

"Has it not been said that painting is the fruit of action, not of meditation?" I said, seeking to draw him out. Miró put his right hand to his head. "It begins here", he answered. "Then it goes on into the arm, bit by bit, then into the finger tips, then into the brush and from there onto the canvas." He illustrated with both hands the movement he was describing. "The idea and its realization — where does one end and the other begin? It is all a process of circulation, isn't it?"

"Didn't you want to take some photos of the 'objects'?" asked Miró as I picked up my camera on leaving the studio. He led me into a kind of patio formed by the wall of the studio and the wall of the terrace. No doubt we had passed through this interior court during my first

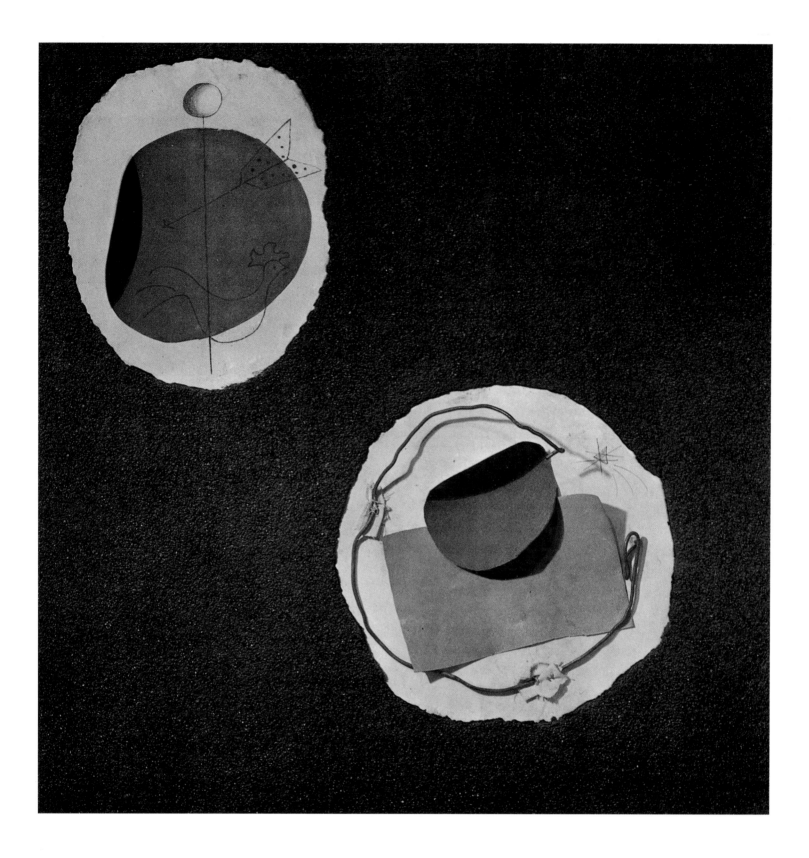

visit, but I had not had time to look closely at the "objects" assembled in it.

Against the terrace wall built of large stones leant the man-high wooden wheel of a draw-well, such as are to be found in all the olive and almond groves on Mallorca. This wheel looked hundreds of years old, the timber was split and bleached white. In a corner stood a monumental rusty anchor and a huge black rudder made of thick planks. I also discovered an enormous yoke of the type worn by draught oxen on the island, the frame of an old iron plough and the

Papier collé, 1929
Sheets of paper, string and rags on plywood, 107 x 107 cm
Private collection

59

Miró's *Constructions* which were produced between 1929 and 1930, belong to the critical stage in the artist's creative career. As he himself put it, he wanted to "murder art", i.e. "oil-and-vinegar" art, what was called *bonne peinture*, in order to retrieve a set of primaeval values of expression – if necessary even against the normal rules of aestheticism.

Miró created this construction from a number of simple, ordinary materials, such as bits of wooden boxes, nails and paper clips. Only the shapes still remind us of Miró's biomorphic picture language. However, the crude and unpretentious style of the entire object eliminates all aspirations of sublime poetry and puts it firmly back where it originated, i.e. the sphere of the do-it-yourself man whose problems begin with the hammering of nails.

Construction, 1930
Construction
Wood and metal, 91 x 70.2 cm
The Museum of Modern Art, New York

disintegrating stem of a giant cactus. Then there were stones like grimacing faces, twisted and deformed branches, shells and vases covered in calcareous deposit, and pieces of machinery. I photographed a few things, assisted by Miró's comments.

A few "objects" had been piled up behind a timber partition by the door. I took these out one after the other and stood them on a cornice. First came a heavy stone with a brass band attached to it. At the tip of the band was a wardrobe hook that looked like a parrot's face.

This combination produced a "mobile": the least touch set the thin bird's neck oscillating to and fro. A rounded stone, picked up on the beach, wore a thick nose of papier mâché and a bristling red moustache From a tall wooden frame hung a white mask painted with red and green stripes — a mourning Chinese on stilts. The monumental was combined with the arabesque, pathos with buffoonery.

All at once I saw in front of me the pot-bellied or skinny figures in bathing trunks and straw hats with enormous sun glasses perched on their peeling noses, the mute or raucous supernumeraries of the beach scenes in our holiday carnivals. In these objects the tragi-comedies of civilization were resurrected and interpreted, the fortuitous was transmuted into the lasting. I remembered the way silent films in the twenties sometimes used to stop, causing the moving pictures to freeze into a still photograph, with an effect that was at once comic and profoundly disturbing.

Many of these *objets trouvés* had a Miróesque appearance even in their raw state, as though nature had fashioned them according to Miró's specifications. The origins of the individual components were forgotten: the household fixture deprived of its use combined with the material of the stone that had been formed by the millennia. One was nourished by the proximity of the other, the dumb began to speak, that which had been thrown away gained renewed value, it vibrated, twitched with life, and yet the new monument retained something of the former existence of its parts. The mythic bird or panic cobold, which owed its existence to the combination of two such divergent forms and materials, now maintained the sphinxlike silence of the stone that constituted its body, while it gazed out with the hypnotic power that the objects of our everyday environment exercise over us.

Where the fusion of forms, materials and structures did not take place spontaneously, Miró had painted on or chiselled in a "sign" that brought about the unity. Miró spent a long time in contact with things, before they yielded their secret to him. He left nothing to chance, to the spontaneous action of a passing mood. In a similar manner, the mystics sought by perpetual observation and meditation to grasp the inner state of things and beings.

One "object", which I had great difficulty in placing on the wall encircling the courtyard, struck me as particularly suitable for photographing. I was anxious to photograph it with the landscape as a background. Its shapes blended with the blue mountains in the distance and seemed to give them new meaning.

A huge stone served as the base for a vertical rod from which a long strip of rusty sheet-iron projected horizontally like a weather vane.

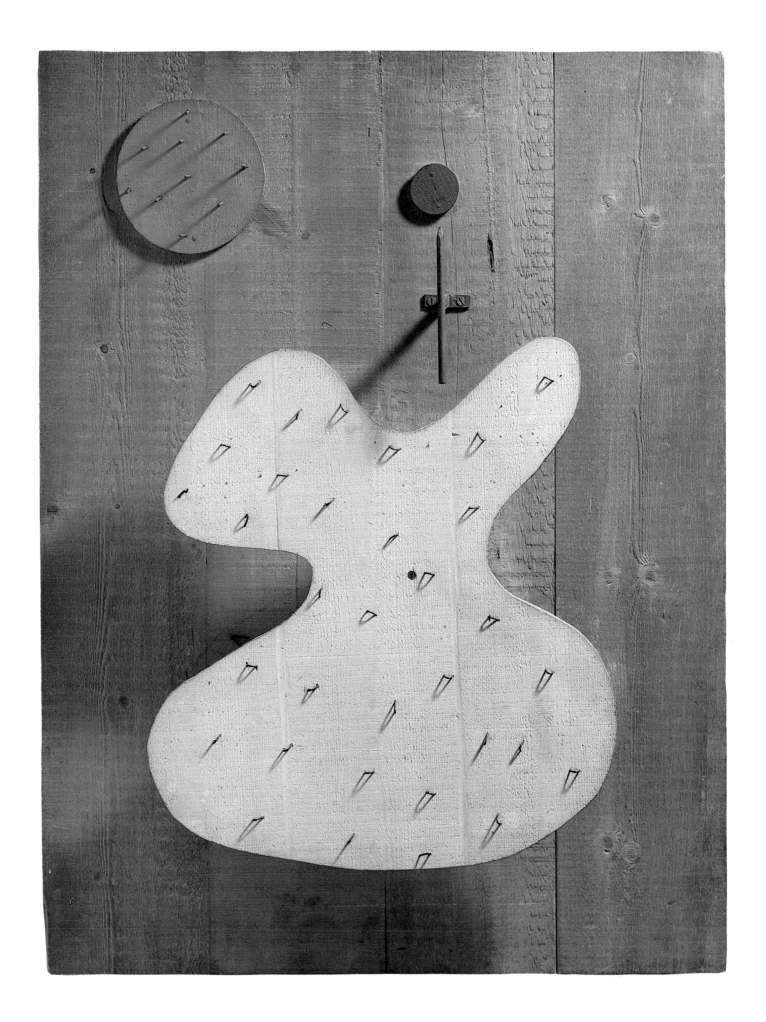

This "signal" rising in silhouette against the pale background imposed upon the landscape a law, to which it willingly submitted, without thereby losing character or expressiveness. On the contrary, the contrast between constructed and natural form brought out the specific quality of each more clearly.

Did not this procedure repeat the action of primitive peoples, who confronted the chaos of their environment with their "signs", that is to say with an order with whose aid they gained power over the unknown and unnamed, without depriving it of any of its magic? Similarly, the familiar landscape of Calamajor was rendered strange and new by the challenge of Miró's "object" and in this way became truly visible for the first time.

While I was posing and photographing the objects, Miró sat on a red-painted iron chair watching me. From time to time, he nodded his approval. When I had taken a series of photographs, I felt the desire to build a similar surreal monument myself with the materials lying around, to join in the game played with these suggestive objects. I looked round in the courtyard and then in the studio and gathered together the most heterogeneous collection of articles.

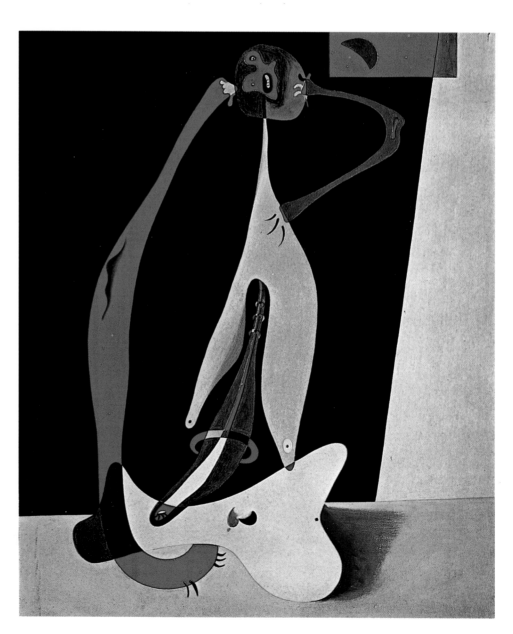

Seated Woman, 1932
Femme assise
Oil on wood, 46 x 38 cm
Private collection, New York

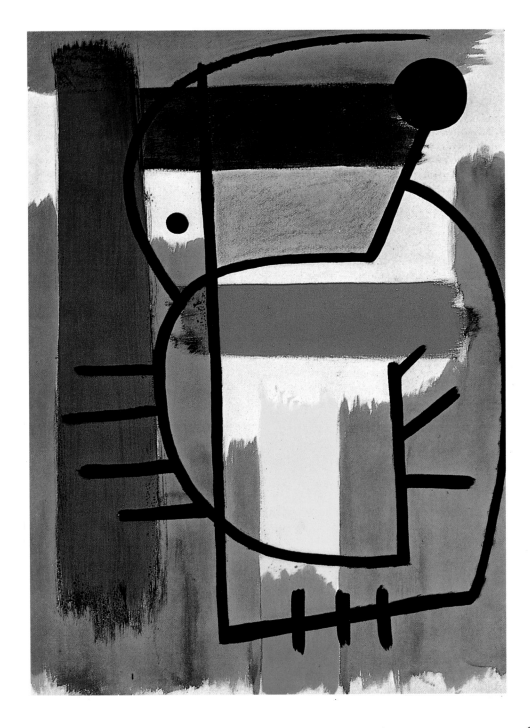

First came a six-foot lamp-stand of basketwork, an art nouveau monstrosity from the year 1910. Its four slender, bent arms, which had once carried the shade, stretched emptily into space. Then I found an old wooden compass, bleached by wind and weather, the legs of which were three feet long, the back of a chair with thin, turned bars and a cane seat attached, a broom, a red false nose with brass-rimmed spectacles and a moustache. To these I added a strip of motor-car tyre with wavy grooves, an old white glove, a sheet of music bearing part of a waltz for piano solo, a clothes hanger, various scraps of brightly coloured fabric and a forked branch resembling an antler.

With these things I constructed a dramatic scene. I stuck the lower end of the broomstick into the cane seat of the chair and hung the false nose on the top; I slipped the glove over one end of the clothes hanger and allowed the empty fingers to run across the harp of the chair-back. The open compass provided the sharp-pointed legs of the

Seated Woman, 1931
Femme assise
Oil on wood, 63 x 46 cm
Private collection, Palma de Mallorca

63

During the summer of 1932, in Montroig, Miró painted a number of small pictures on wood. They give the impression of being very abstract and use large colourful overlapping areas in which a few sparingly placed symbols enable the viewer to establish a vague relationship between pictures and titles.

The space of the picture, broken up into two-dimensional areas, has been occupied by a single large yellow shape, with a number of smaller, red ones attached to it. The tiny mouth on the left is open, as if giving a scream, and tilted backwards in a dancing movement. A little red flame hovers before the intense green surface. As in other paintings, there seems to be an element of subliminal erotic symbolism that complements the powerful colour scheme.

Flame in Space and Female Nude, 1932
Flamme dans l'espace et femme nue
Oil on wood, 41 x 32 cm
Fundació Joan Miró, Barcelona

monument that had developed into a grotesque figure. Beside it rose the lamp stand, now upside down and standing on its four slender legs; on this I placed a lobster basket to form a head, which I crowned with the antler of the forked branch. Two long paint brushes served as outstretched arms, at the ends of which fluttered scraps of cloth. I stepped back and surveyed my handiwork. "That is for you, Monsieur Miró", I commented. "We will leave it to the dealers to think of a title for this work of art."

Miró approached smiling and walked round the monument. *"C'est très joli, cela... c'est un vrai théâtre!"* He sat on the wall opposite and studied my improvized sculpture for at least a minute. *C'est très intéressant, en effet, je l'aime beaucoup!"*

When I was about to take the "sculpture" to pieces — I had learnt of Miró's love of order and had felt a trifle apprehensive as I gathered the things together — Miró raised his hand. "No, that must be left as it is, I want to see it again tomorrow morning!"

"But the wind, *monsieur!"* I pointed out to him. *"Ah, oui..."* he answered and looked round rather helplessly, "We will make it fast in sailorly fashion!" I suggested. I went back into the studio, sought and found a length of rope and lashed the whole thing in place with what looked like rigging.

As I was walking along with Miró later across the various courtyards and terraces towards the door in the wall, he came to speak of my "monument" again." That was a good idea", he exclaimed. "We must make something like that together often!" — "What will happen to your objects now?" I asked him as we said goodbye. "I'm thinking of using them for models for some large bronzes", he replied, "several yards high. I think that will make a powerful impression. Just imagine a sculpture like that in this forecourt!"

I saw it in my mind's eye, like a huge Easter Island idol, towering above the walls and terraces that succeeded one another in steps down to the sea and giving them a countenance, which fundamentally expressed nothing else than the original physiognomy of this area of land. This sculpture would be visible from the sea, it would be at once engaging and threatening and it would remain when the thin canvas of the hotel and Coca-Cola advertisements had long since fallen victim to time and wind.

As soon as I stepped out of my large room at Son Boter onto the terrace, or went out of the lower hall through the huge doorway into the wide forecourt, I had Miró's estate before my eyes. His human and artistic presence was continually with me as a result of the study I had undertaken. But there is a difference between approaching a phenomenon in imagination — no matter how many facts are to hand — and hourly measuring the progress and findings of one's researches against the reality under investigation.

The house and the studio were known to me, although both were to appear still more familiar after every visit; so were the gardens, the terraces, the paths and the walls — everything, that is to say, which constituted Miró's estate. That many of the objects within this domain had a Miróesque appearance no longer surprised me. Above and

beyond the "correspondences" between work of art and environment that had arisen by chance, or with Miró's aid, there were elements in the topography of the estate — such as the arrangement of the paths, the shapes of the patches of lawn and the beds of cactuses and tropical plants — that had been planned by Miró and bore unmistakable signs of his style. Miró may have been aiming at a kind of comprehensive unity that would embrace both his own creations and the environment. Finally, the spectator was compelled to regard the distant mountainridges as forming part of this unity.

In all the ensuing weeks, I never caught sight of Miró himself in the gardens and courtyards of his extensive estate for more than a brief moment. He was too busy to go for walks. But I knew how fond he was of strolling through these surroundings, I used to see him in my mind's eye climbing up or down the various paths that led from his property to the sea on one side and into the olive-grown valley or the village of Genova and the mountains beyond on the other. Next to the village of Genova a vast stone quarry stood out white among the mountains. This quarry repeatedly drew Miró's attention.

Miró's imagination was perpetually active; the finds he brought back from his journeys of discovery bore witness to this activity. However far I went from the house in which I was living, and hence from Miró's house, I kept coming across objects that formed part of Miró's larger "workshop".

I spent hours on end exploring the remotest parts of the island — the many lonely, picturesque villages, the three or four small towns, which barely merited the name when one considered the number of inhabitants, but which were certainly towns by virtue of their dignity, beauty and antiquity. Every trip that took more than half an hour by car brought me into contact with the island's three striking topographical features: the fertile plains criss-crossed by irrigation canals and filled with almond and olive plantations, the rocky bays, and the paths leading up into the mountains, many of them going to a height of two or three thousand feet.

Civilized as the landscape appeared in even its wildest aspects, I always felt that I was on an island of entirely non-European character. Even the colour of the grass, a pale bluish-green, formed an unfamiliar contrast with the red earth gleaming through from underneath it. In regions not reached by the network of irrigation canals, where the underlying rocks thrust up through the soil, there was something African about the landscape. The burnt, dry red-ochre, the dusty maize-yellow with the few scattered patches of dull green and the metallic cerulean blue overhead, struck a nerve-stirring chord, heightened here and there by the red of a piece of clothing or the darker ultramarine of a road sign.

The square blocks of the village houses, from the midst of which rose the turbulent baroque forms of a church tower, the weathered monuments of the wells with their earthenware buckets, the enormous mills rising unexpectedly in the fields — all these were "startling" objects, Miróesque objects. In the borders dividing the walled fields, phallus-like columns, consisting of several earthenware pipes fitted

Even in the 1930s, when Miró was shaken by a profound identity crisis, he painted a number of very artistic pictures in which he showed his expertise as a great master in the use of colour. This picture is distinguished, above all, by a very balanced, but at the same time tense composition of coloured fields. A large black field on the left is counter-balanced by three glowing areas of colour with similar degrees of brightness, but differing in intensity. A rich field of yellow pushes its way into the picture, like a beam of light. This is followed by a zone of orange, jutting partly into the black field and tilted to the right. Finally, at the top, there is a blue-green rectangle of lesser intensity, and the point at which it intersects with the orange field, there is a flash of a small yellow wedge.

The actual theme of the picture – the young girl doing gymnastics – has been inserted into this combination of fields. However, the only recognizable detail is her head – a tiny protruberance with eye-brows, while all other extremities have dissolved into free, colourful shapes that extend far across the surface. Each inter-section with a coloured field has been marked by a change of colour. In the green field in the top right-hand corner there is a crooked bean-shaped object which could be a ball or some other piece of sports equipment.

In this painting Miró uses a very subtle combination of simultaneous contrasts, resulting from the concurrence of non-complementary pairs of colours, such as orange and green or yellow and green. The figure itself is characterized by the complementary contrast of red and green.

Girl Practising Gymnastics, 1932
Jeune fille faisante de la culture physique
Oil on wood, 41 x 32 cm
E. and C. Burgauer Collection, Küsnacht

Painting, March – June 1933
Peinture
Oil on canvas, 130 x 162 cm
Kunstmuseum, Berne

one into the other, rose to a height of six feet; they were the terminations of the system of pipes that supplied the land with water.

At many points I came upon ruins of buildings dating from Phoenician and Roman times, and elsewhere village wells and walls bearing Arabic letters. Whenever I passed through a village, shrill Arabic-sounding radio music echoed from even the poorest cottage.

In contrast to the harshness of nature and the austerity of the human settlements, the people I came upon every now and then were gentle and friendly. Many of the mule-drawn carts I met on the lonely country roads, or the more tortuous mountain paths, had a biblical look about them. The peasant driving the cart waved after the car, even if it left nothing behind but a cloud of reddish-yellow dust that immediately afterwards enveloped him and his vehicle in a cloak of invisibility for several minutes.

Man is not the product of his environment in the sense in which the phrase is generally used, but he is a part of it; his sensibility and mode of expression are nourished and fashioned by numberless encounters

68

Painting, 1933
Peinture
Oil on canvas, 130 x 162 cm
Národí Gallery, Prague

with it. A picture or a sculpture by Miró could have been placed in almost every one of these pieces of scenery, whereas a so-called realistic picture, as sold by the art galleries and memento shops on the coast, would have looked out of place.

The nearby town of Palma de Mallorca with its spacious Gothic cathedral, its mediaeval quarter and guild house, the *Lonja,* formed an essential counterpoint in the harmony of spiritual encounters. The twilight that filled the cathedral, which gave me a feeling of oppression as I entered, was shot through by flashes of crimson, gold and violet. They came from the stained glass windows designed by Gaudí. The interior of the cathedral was also enriched by wilfully exuberant sculptures and reliefs by this artist so revered by Miró. Many houses in Palma were smothered in *art nouveau* decoration.

The cathedral, the music of whose architecture greets from a distance of several miles every ship sailing into port, stands on a site encircled by cyclopean walls and first built upon by African conquerors. The museum in the shadow of the cathedral houses relics of prehistoric

69

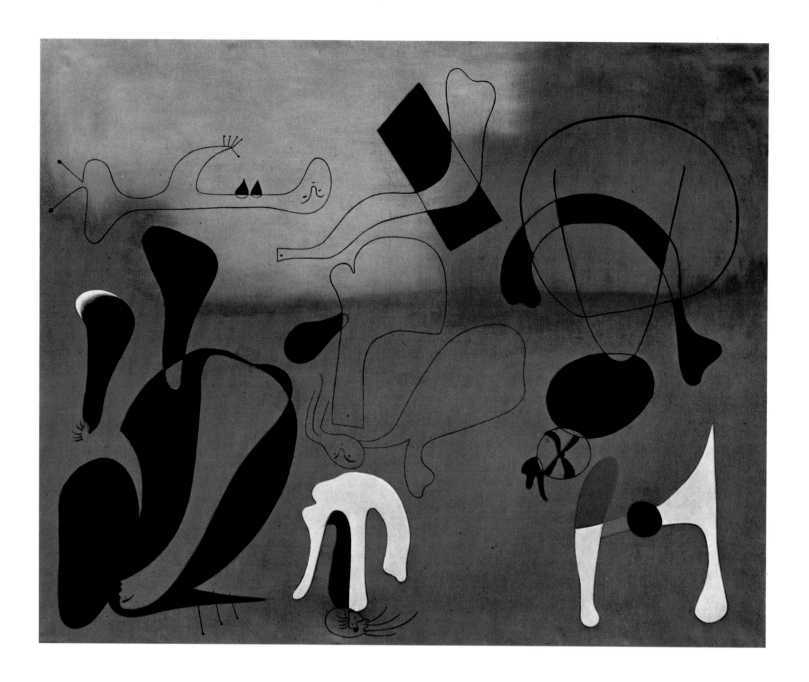

Painting, 1933
Peinture
Oil on canvas, 130 x 162 cm
Hartford (Conn.), Wadsworth Atheneum

These two pictures, entitled *Painting*
belong to a series of large, elegantly exe-
cuted works that were originally based on
several unusual collages – small cuttings
from newspapers and catalogues that
show parts of machinery and everyday
objects. This laborious way of preparing
for the actual work itself may have been
Miró's way of counter-balancing the
impetuous spontaneity which he had
allowed in his "anti-art". Although the ori-
ginal contexts of the collage pieces can
still be recognized in the final paintings,
the pictures of the collages cannot.

and antique cultures, blackened icons, fragments of Romanesque and
Gothic frescos. The Nautical Museum exhibits ancient charts and
queer navigational instruments, galleon figure-heads and fishing tackle
of strange shapes and colours. All these things might have had some
link with Miró. Time and again I visualized the young Miró wandering
through the same streets, buildings and museums with his alert feeling
for the appearance of the created object and the forces perceptible
behind it. As Burckhardt wrote, "The mind must take possession of its
memories of the different eras in world history."

A different sensation was afforded by the bull fights in the arena just
outside the town, in which the cruel poetry of early myths, the living
reality of an enthusiasm that was renewed minute by minute and the
death-defying acrobatics pervaded by the highest intellectual disci-
pline, combined to form a thrilling spectacle.

Picasso has celebrated the changing aspects of this tauromachy in
hundreds of paintings and drawings — from its colourful visual effects
to its timeless tragico-mythological core. In fact one Spanish art critic

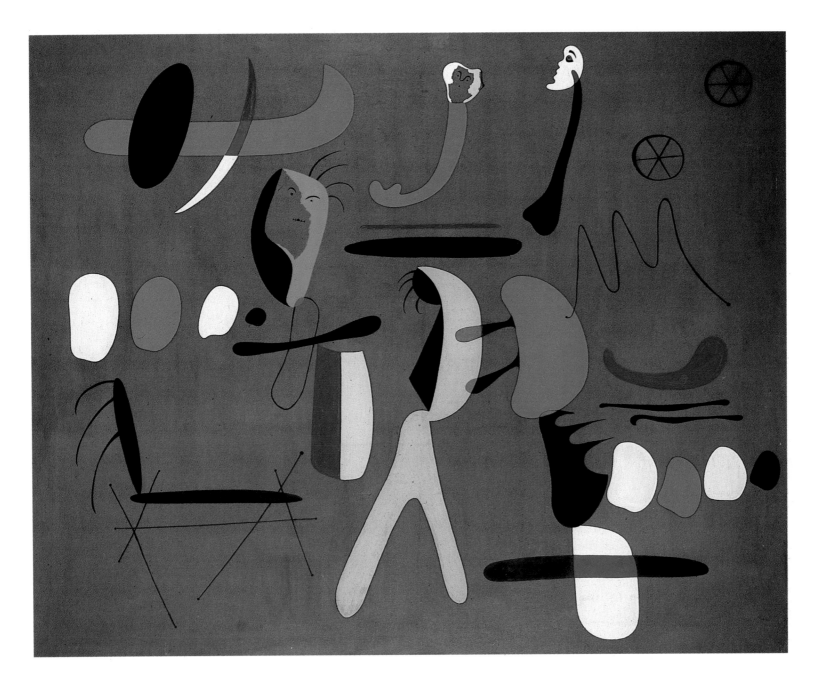

goes so far as to compare Picasso's creative *élan* to that of the toreador.

Bull fighting also has its comic side. The excitement that communicates itself to the nerves and pumps the blood faster through the chambers of the heart would be unbearable, if the humorous scenes did not — as in every great theatrical performance — frequently change the spectator's fear and apprehension into their opposite. The purifying effect of a bull fight is only to be understood as the outcome of this harmony between diametrically opposite emotions.

Miró, too, has included the bull-fight motif among his themes. Without a doubt, many of the colour harmonies in his paintings are derived from the coloristic sensations experienced in a bull-fighting arena — the luminous yellow ochre of the background, the red patches that recall the blood of the animals in the trampled sand, the silky blue and pink reminiscent of the colours of the toreros' clothes, the flapping flags and waving handkerchiefs against the noonday azure of the sky, the sensitive geometry of lines — often only hinted at — that symbolize the inventive choreography of beast and fighters — all these sen-

Painting, 1933
Peinture
Oil on canvas, 130.4 x 162.5 cm
Fundació Joan Miró, Barcelona

After cutting out the collage pieces, Miró changed them into abstract shapes with glowing colours. The colour shapes – now in sharp contrast with the surface – playfully harmonize in an unconstrained rhythmic pattern to which the linear symbols are also subject. Although this series of paintings was one of Miró's most abstract works, he refused throughout his life to be pigeon-holed as an abstract artist. For him even the most abstract pictures still express a tangible spiritual reality which is very much part of real life.

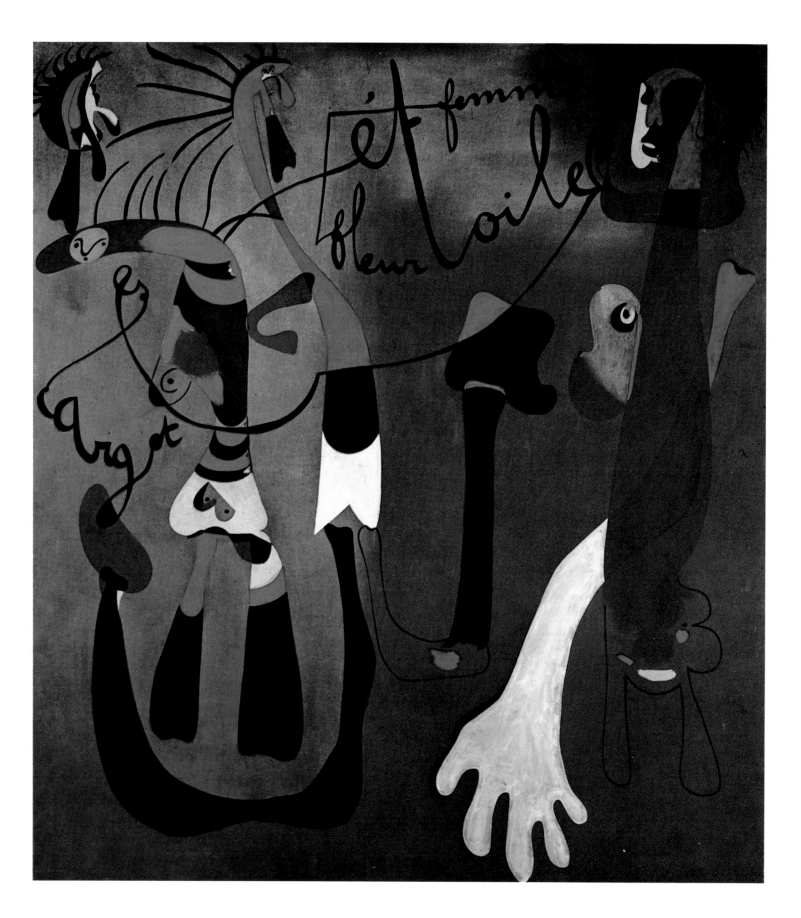

Snail Woman Flower Star, 1934
Escargot Femme Fleur Etoile
Sketch for a mural
Oil on canvas, 195 x 172 cm
Museo del Prado, Madrid

sual and spiritual vibrations animate our painter's pictorial scenery. In contrast to Picasso's pictures, the humorous and grotesque also have their place in those of his younger Catalan friend.

Finally each of these encounters must be seen in conjunction with the past and the future, if we are to appreciate the richness of the island landscape, its inhabitants and its art. The island's many little

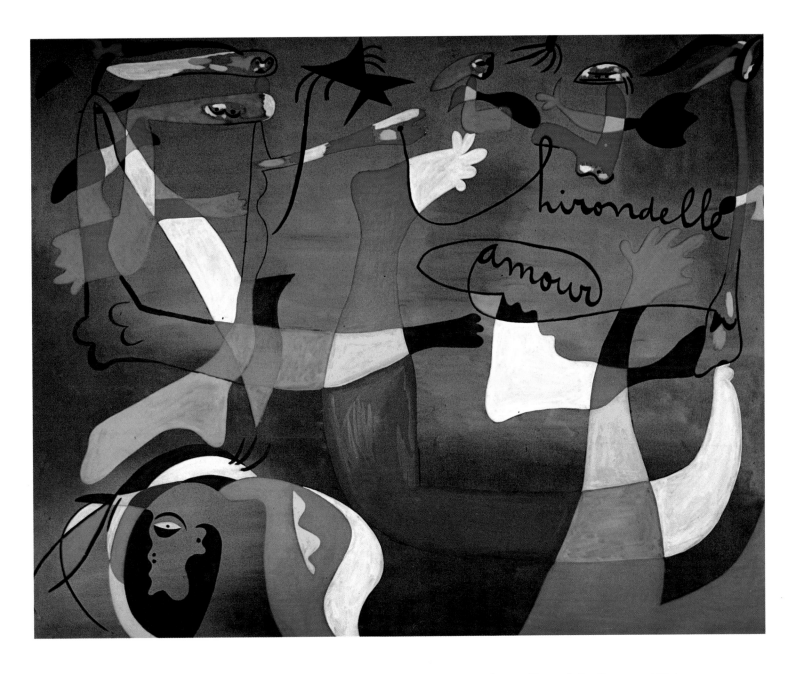

harbours are particularly beautiful. Almost every settlement on the edge of the island has its puerto. Miró knew and loved them all; many of his finds came from the vicinity of one of these harbours. When I asked one day if he would like to join me on a trip to the Puerto de Andraitx, he agreed at once. I was waiting outside his house shortly before six a.m. I calculated that we should reach our destination round about sunset. The road to Andraitx was full of bends; it ran uphill and down; then the bends grew narrower and more numerous, the car spiralled higher and higher. Along the roadside, rocky terraces planted with almond and carob trees rose one above the other. Again and again the blue of some fresh bay flashed through the greenery. The colour of the rocks changed from pale ochre to a glowing *caput mortuum,* that of the trees became emerald. Many sections of the road afforded a view of far-off chains of mountains stepped back one behind the other into the distance, like stage scenery. On the craggy peaks the light of the setting sun glistened like snow.

Miró did not utter a word; he looked hard to the left, then to the right. His attention was riveted to the mountains. As soon as we came

Hirondelle d'amour, 1934
Sketch for a mural
Oil on canvas, 200 x 250 cm
The Museum of Modern Art, New York

OPPOSITE:
Figures of intertwining lines can be seen rising against the dark surface which consists of several colour zones. The overlapping shapes have been filled with strong colours – red, golden, ochre, orange, white and black. This drawing is full of verve, and it seems that Miró was trying to enhance its effect by including a few written words, after he had experimented with picture poems as early as 1925. Here the words merge smoothly into the arabesques, enhancing the colours, lines and figures so that the general atmosphere becomes light-hearted.

in sight of them, I drove more slowly. He nodded and pressed his lips together, as though to say: "That really is something, isn't it?"

When we had reached the final heights, a refreshing wind wafted inthrough the windows of the car. The valley of Andraitx spread out in front of us; the mudcoloured houses of the village were jumbled together like toy bricks. From their midst rose a church built on the lines of a basilica, also of ochre-yellow stone. We left the village on our left and turned down a narrower road that led to the harbour. Five minutes later we came upon the first gardens, houses and mill-towers. At a well, a mule was moving in its never-ending circle, keeping the jangling mechanism in motion.

The great harbour basin opened out in front of us. The water was glittering with colours that ranged from a deep blackish-green through steely cobalt to an iridescent mother-of-pearl grey. On the left, the whitewashed fishermen's cottages, the shops and the terraces of the few hotels ran right down to the water's edge; on the right, the harbour was flanked by rising hilly ground with masses of rock shimmering violet and dark areas of foliage broken by the neat quadrilaterals of house-fronts.

I stopped the car. Beside us, like a monument, stood a fishing smack that had been drawn up on land, its deep keel painted with red lead, its rudder shaped like a fish's fin. The boat was held upright by timber props. Deprived of its proper element, the water, the boat stood out against the mountainous headland like a prehistoric sculpture. Miró nodded his head and commented: *"C'est vraiment bon, n'est-ce pas?"* I drove slowly into the road to the right. I let the car coast silently along the sandy track. The sun was now only a few feet above the horizon; it hung there like a disc of molten yellow brass. Above it, indigo-blue cloud-fish drifted almost imperceptibly past. A bridge of light divided the dark water that stretched from the horizon to the mouth of the harbour. To the right, a low harbour wall stood out

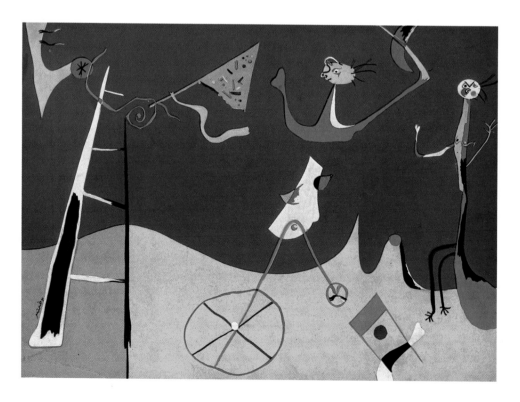

Circus, 1934
Cirque
Oil on canvas, 37 x 54 cm
Private collection

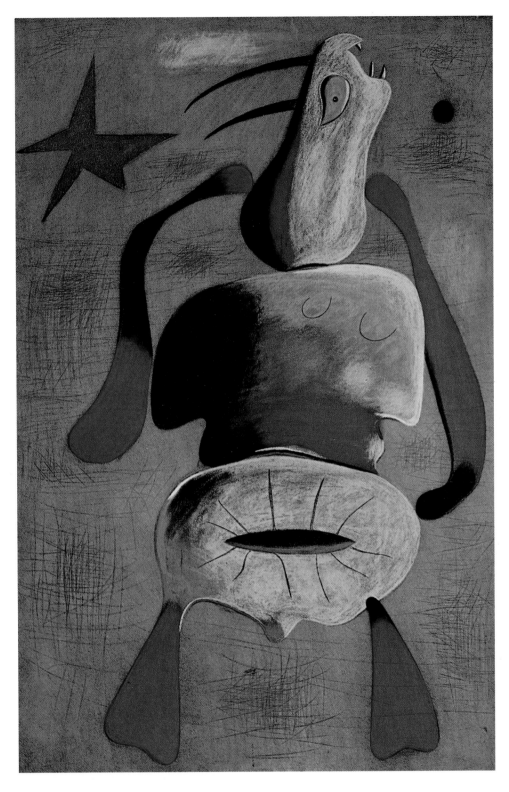

Woman, 1934
Femme
Pastel, 108.9 x 73 cm
Private collection

This painting forms part of a series of pastels on flock paper with which Miró began his "wild period".

A monstrous figure with a wide-open mouth and protruding front teeth can be seen rising against a surface which has been prepared with pastel and cross-hatched with pencil.

The individual parts of the monster are reminiscent of bones or internal organs and possibly also Hans Arp's biomorphic abstractions.

The individual components stand out in bold relief against each other, due to their contrast of light and dark and the use of colour to emphasize their volume. There is no organic flux to connect them and no outstanding colour scheme to enhance their structure. It seems as if the figure was simply stuck together and then immersed in a dim light which has swallowed all the colours. The paddle-like extremities seem more like a pre-historic being than a human figure – whose enormous genital area marks it as female.

Indeed, even though the technique is that of pastel, it has been robbed of its usual lightness and subtlety. The pigmentation seems dense and sombre, shaded in dirty smudges.

Miró himself said that he had been paralyzed at that time by terrible forebodings of the coming horrors of fascist rule. The "wild pictures" that were to follow show this terror even more clearly than this rather dead pastel. It was a terror that sprang from perplexity and broken creativity and showed itself in these monstrous configurations.

against the blue — a narrow, clearly defined strip of masonry with a small lighthouse at the far end.

On the short drive to the beginning of this mole we passed a dozen small, white fishing boats, whose boldly rising prows were aglow with names and arabesques carefully painted in vermilion and ultramarine. The poles of the masts and the filigree of the rigging were reflected in the water like the frail constructions of our thought on the surface of a dreaming consciousness. Then a large vessel with dark-brown jute sails glided in through the harbour entrance. I let the car run on to the verge with the engine off. The front wheels sank into the banked-up

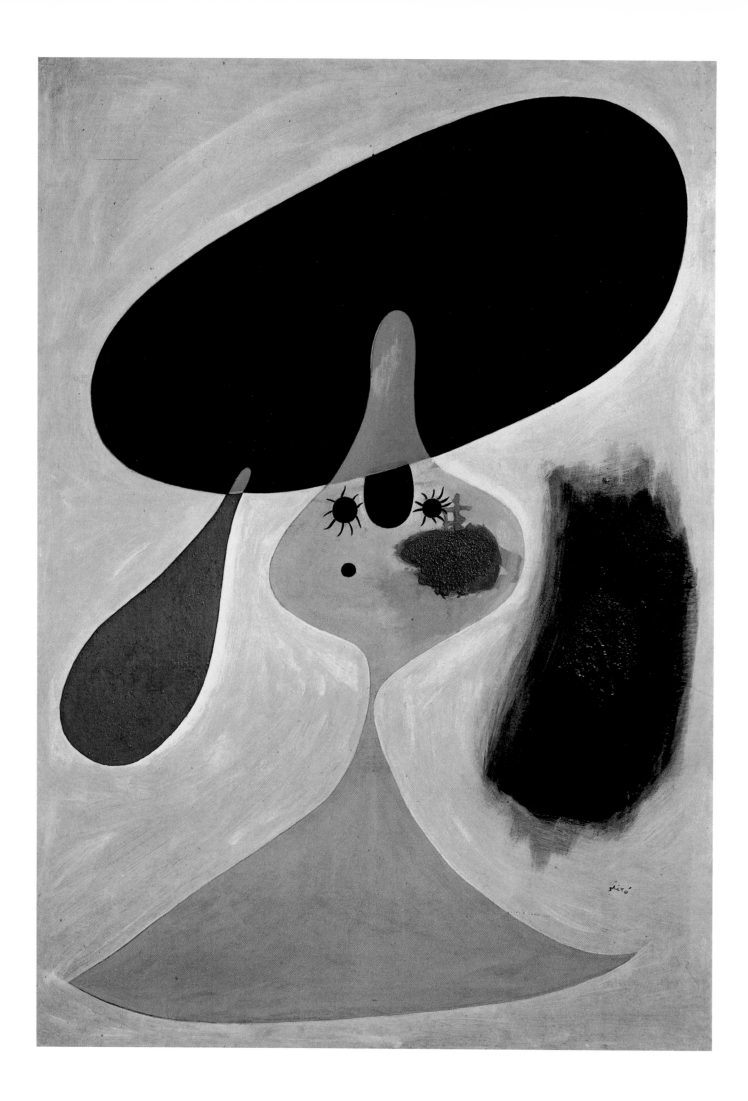

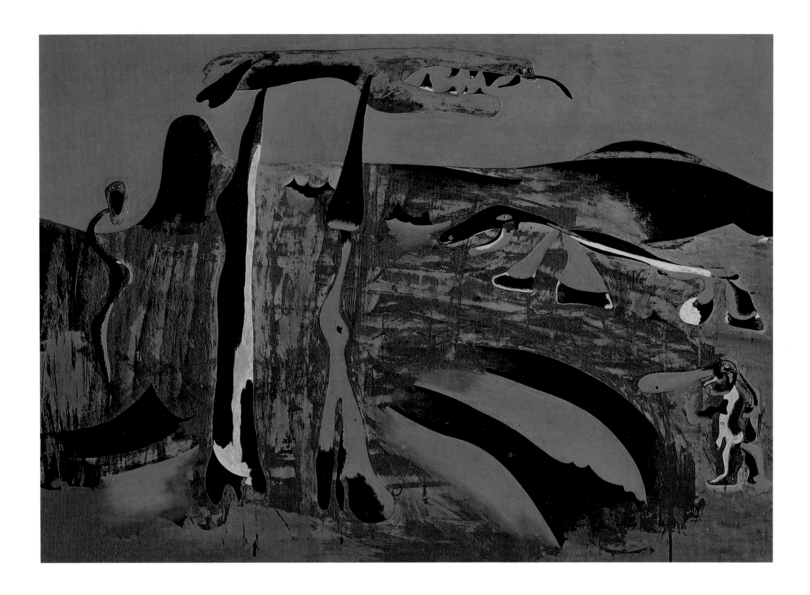

sand. We climbed out. It was as though we were entering a dream landscape.

Miró shaded the side of his face that was turned towards the light with both hands and remained standing in this attitude for several seconds. "It was a good idea to come here", he commented. *"C'est très fort, en effet!"* After a while he took his hands from his face and traced with the fingers of his right hand the line of the rocks that ran down to the water. The ball of the sun — vastly magnified and almost unbearably intense — was now touching the line of the horizon. My companion gazed through half-closed lids into the deepening glow.

The tones were changing every second. It was as if the sea was turning more and more into light and the rocks into darkness. "That is the sun in your ceramic", I said, "the idea you had of a great disc of brilliant red!" With this remark I was reminding him of his own description of his work on the two huge ceramic walls for the UNESCO building in Paris. *"J'ai cherché une expression brutale dans le grand mur, une suggestion plus poétique dans le petit."* Here, at this instant, the landscape and nature were demonstrating the two elements that Miró sought to unite in his pictures: the brutal and the delicate.

Two girls in bathing costumes were standing at the foot of the mole; in this light their bodies seemed to be lit by a glow from within; the

Personages in the Presence of Nature, 1935
Personnages devant la nature
Oil on cardboard, 75 x 105 cm
Philadelphia Museum of Art, Philadelphia

Portrait of a Young Girl, 1935
Portrait de jeune fille
Oil on cardboard, 106 x 75 cm
Kiam Collection, New York

77

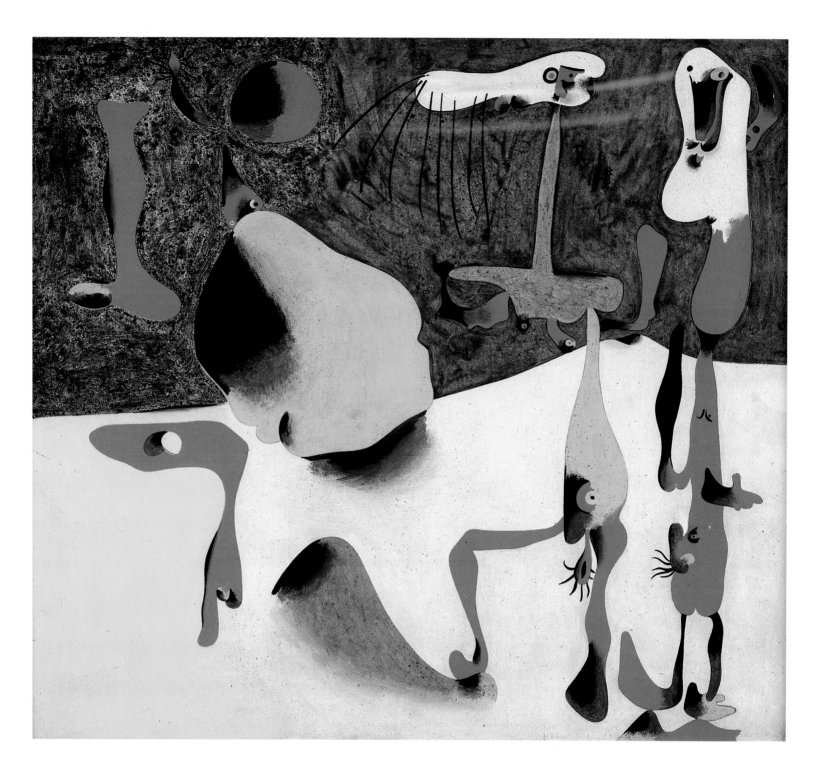

Personages in the presence of a Metamorphosis, 1936
Personnages devant une métamorphose
Egg tempera on masonite, 50 x 57 cm
New Orleans Museum of Modern Art,
New Orleans

Personages and Mountains, May 1936
Personnages et montagnes
Oil and egg tempera on masonite,
30 x 26 cm
William R. Acquavella, New York

younger one was swinging a red towel. The triangle of a white sail drifted past a few yards behind them. "Seurat!" I said. Miró seized upon this name as though it were a cue. *"Ah, oui,* the Impressionists realized that the landscape breathes, that it changes from one moment to the next — that under the influence of light every form becomes transparent and even shadows are full of life." He made with his hands the movement of drawing something out. "Nothing has changed, we simply have to see it again, that is to say, to find a new form for it."

I pointed to the two girls, to the innocent beauty of their movements. *"Le coup de grâce!"* I cried. I was thinking of Proust's description of the girls on the beach at Baalbek. Was there any sense in comparing Proust and Miró? Did the Spaniard Miró feel the delicate grace of this scene? Was not my reference to this description the product of

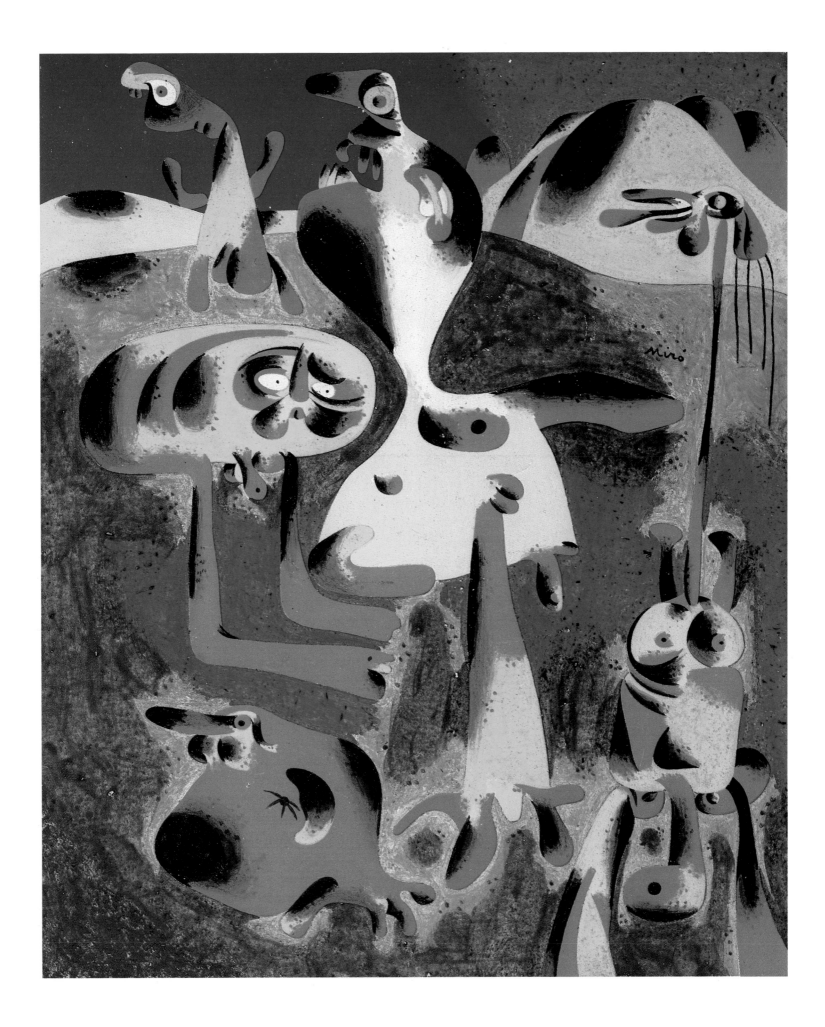

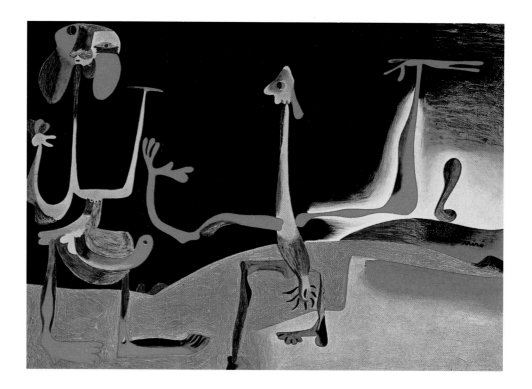

Man and Woman in Front of a Pile of Excrement, 1936
Homme et femme devant un tas d'excréments
Oil on copper, 23.2 x 32 cm
Fundació Joan Miró, Barcelona

In his "wild paintings" of the 1930s Miró conjures up a scenario of horrors. We feel as if we had been carried off into a mediaeval purgatory. There is a sultry sombreness about the colours, and a sharp light-and-dark contrast plunges the scene into a light that seems cruel and unreal. Protruding from this dark nightmare landscape are two bizarre figures with enormous genitals. Gesticulating at each other and plunged in Bengal light, they appear to be worshipping some kind of divinity. We cannot tell whether they are talking about the pile of excrement which has given the picture its title and has been put up in the right-hand corner like some pagan idol.

"I had this unconscious feeling of impending disaster. The feeling you have before it starts to rain, with aching limbs and a stifling numbness.
It was a physical, rather than a psychological sensation. I had the premonition that there would soon be a catastrophe, though I did not know which: it was the Spanish Civil War and the Second World War ... Why I chose this title? At the time I was fascinated by Rembrandt's words: I can find rubies and emeralds in a pile of dung." JOAN MIRÓ

Seated Personages, 1936
Personnages assis
Oil on copper, 44 x 35 cm
William R. Acquavella, New York

a conventional way of looking at things that sprang from a literary culture? Was not Miró, more than anyone else, trying to put an end to this conception of grace, this kind of aesthetic?

Miró looked at me. His eyes, contracted from prolonged gazing into the sun, opened, so that I could see the blue of the iris. *"Oui, le coup de grâce!"* he repeated. "One must absorb this shock, fill oneself with it!" I felt at once how he saw and interpreted the concept of grace in a different way, his way, and how our meditations were fed from different sources. "When I stand in front of the canvas," went on Miró, continuing his monologue, "the shock will be transformed into impulses — if the hour is favourable!"

A breeze had risen. At our feet, the water wrinkled up in a rhythmic movement, creating ever-changing configurations. "Do you remember Leonardo's drawing?" asked Miró, indicating with his hand the play of lines in the water. I nodded. These studies, which Klee so much admired, were well known to me. "Leonardo also says: 'The wave moves under the skin of the water'," I went on. *"C'est très poétique,"* answered Miró. "Leonardo was the greatest, the most intelligent of them all, he was genius personified! What are we, compared with him? ..."

As I try to write down the events of those minutes, I become aware how difficult, how almost impossible it is to record the intonation and the sequence of the few words we exchanged. I was already familiar with the painter's sparing vocabulary, and yet even a word I had heard before suddenly expressed something new, as one and the same colour changes its character before carious backgrounds.

We had drawn close to the lighthouse. At the foot of the squat tower a stone plaque bore the date 1912. Yet the stone, which had been bleached by the heat, the light, the spray and the winter rains, had no patina; even the metal superstructure looked new.

The girls on the boulders had slipped on their clothes. They were chattering in Catalan, but they ceased their sing-song when they heard

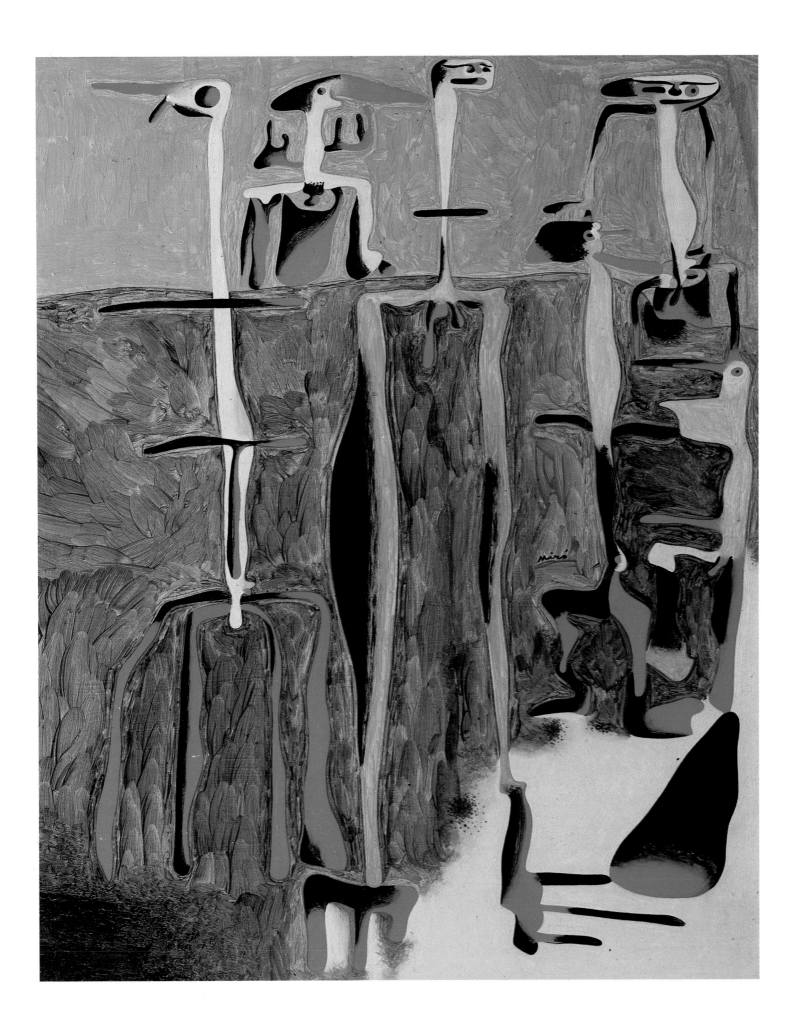

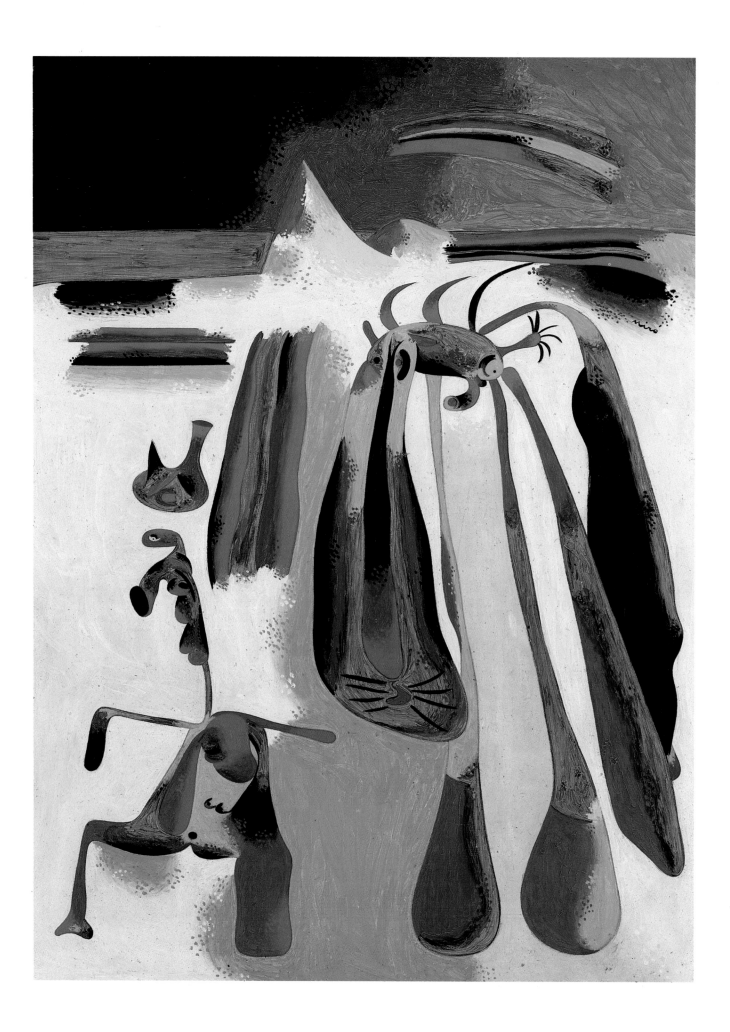

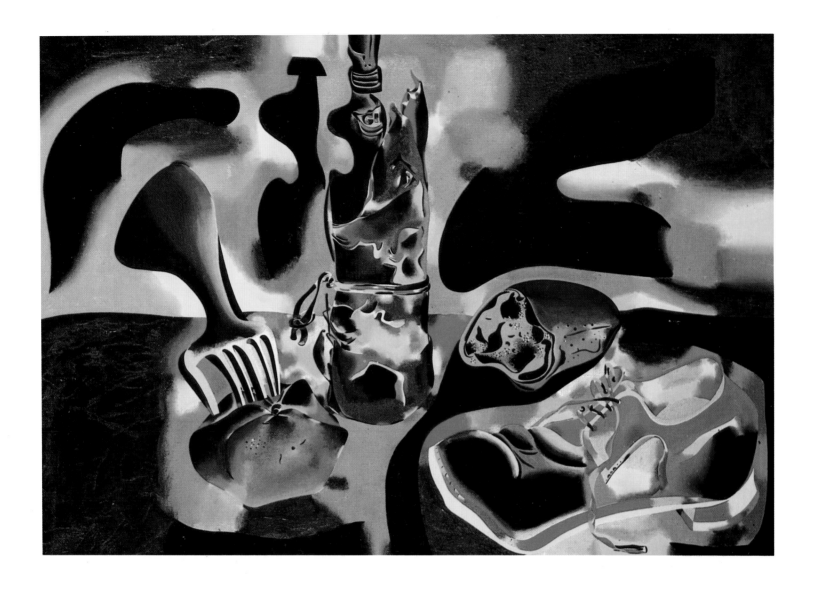

us speaking French. Then they ran along the mole, jumping from stone to stone, till they reached the coast road.

"You have painted such figures in movement, they recur in your etchings and drawings, along with the cliffs, the water, that ladder there climbing up the signal mast, and the soaring of the birds!"

Miró raised his shoulders and stretched out his arms as though apologetically. "I invent nothing, it's all here! That is why I have to live here!" He looked past me, as though his eyes had to take in the panorama once more. What we had seen a minute earlier seemed to have been incorporated in the arsenal of his experiences as a fact which it was not worth pondering further.

The sky had turned a stormy grey-blue. The breeze had freshened. A washed-out strip of linen was flapping on a ship's mast in front of us. Miró's eyes contracted, as though changing their focus from the distant to the close. He listened attentively to the sound of the moving bunting. As he did so, his face assumed a sly expression, as if he felt himself to be an uninvited listener to an intimate monologue that suddenly made us forget the pathos of approaching night.

Still-Life with Old Shoe, 1937
Nature morte au vieux soulier
Oil on canvas, 81.3 x 116.8 cm
The Museum of Modern Art, New York

A number of ordinary, everyday objects serve as motifs in this picture – a bottle on a table, a loaf of bread, an apple with a fork stuck into it, and an old shoe. However, these simple things have been changed into an apocalyptic vision. The colours blaze around the objects like glowing haloes, a ghostly light that devours everything from inside and grotesquely distorts them. It is a struggle of light and darkness, with randomly collected everyday objects thrust between them. Miró commented, "The civil war meant bombs, death, and firing squads, and I somehow wanted to capture these very dramatic and sad times – though I must admit that I was not aware of painting my Guernica at the time."

Catalan Peasant Resting, 1936
Paysan catalan au repos
Oil on copper, 36.5 x 27.5 cm
Douglas Copper Collection, New York

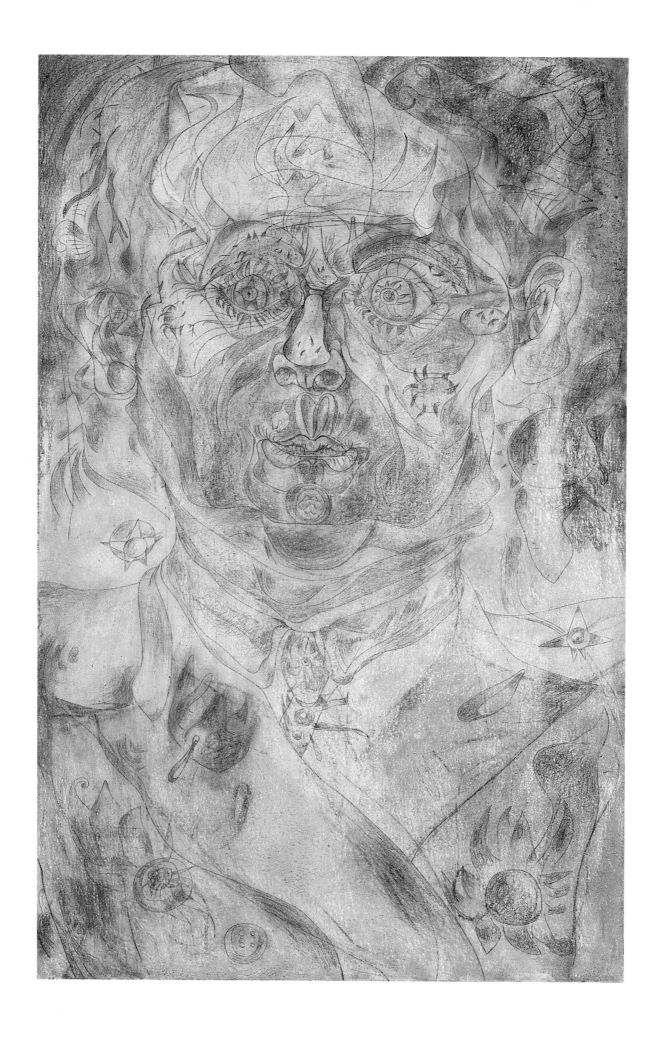

Miró Draws

I never had the good fortune to watch Miró while he was really drawing or painting. He feels the presence of a spectator during these activities irksome, so I am no exception in having been denied the experience of watching him. But I did once innocently trick Miró into doing a drawing while I was looking on. The result, a large charcoal sketch on rough packing paper, will probably never find a place in his graphic *œuvre*. But the few minutes during which he was working on it gave me great satisfaction; for the manner in which he executed this drawing corresponded exactly to my preconceived idea of his method of working.

I had asked him to draw a few lines on a piece of paper lying on the stone floor, so that I could photograph him in the process. He immediately fetched a piece of charcoal, knelt down in front of the piece of paper, as I had once seen a Japanese draughtsman do, supported himself with his left hand on the edge of the paper and began to draw a line down from the top left-hand corner of the sheet with his right.

The line formed a path that broadened out, bent and curved, as though avoiding topographical obstacles. On reaching the bottom of the paper, it turned resolutely to the right, as if to sweep back to its starting point in a vast oval. But then the line broke, the hand returned to the top left corner and cut a new path across the blind void of the surface that finally joined up with the first one near the middle of the lower edge.

The pencil sprang once more into the shape thus formed, which resembled a horned tuber, in three quick movements composed a triangle and placed a buttonlike circle in the centre of it: Polyphemus's eye stared out with a puzzled look! A fresh line shot down from the lower lid and darted out sideways to form a curved moustache, like the two beams of a pair of scales, the right-hand end of which was jauntily curled. A grid consisting of four more lines underneath it portrayed a cobold's mouth with flashing teeth. The whole was finished off with three hairs standing on end on the top of the head. The face of a quaint monster emerged from among the marks of shoe soles on a previously useless piece of paper...

Miró had certainly never intended to draw a head when he first started. But after the initial contact between charcoal and paper, a process began, the stages in which developed automatically one from the other.

The fierce time of Miró's "wild paintings" came to an end with this magic self-portrait. After months of work in front of a mirror and applying the oil very lightly and transparently, the artist managed to capture his face in such a way that it seemed to glow from within, his eyes beaming like stars. Indeed, the entire face is a starry cosmos. Catharsis has begun. The artist's senses and spirit are open to the sensitive, equivocal currents which come from the artist's creative subconscious.

In 1960 Miró had a copy made of this unparalleled artist's portrait, which he then drew over with a broad, sweeping gesture. In both cases it was a sign of a new beginning – the ritual of an artist's continuous struggle for renewal.

Self-Portrait I, 1937/38
Autoportrait I
Pencil and oil on canvas, 146 x 97 cm
The Museum of Modern Art, New York

Parallel with his brutal "wild paintings" Miró produced a series of delicate, oddly dream-like pictures which had been inspired by ideas and notes he had taken in the streets. The few splotches of colour leave most of the brown surface free, and the rapid black strokes give the impression that a spectacle is taking place on this ground, reminiscent of seals being trained.

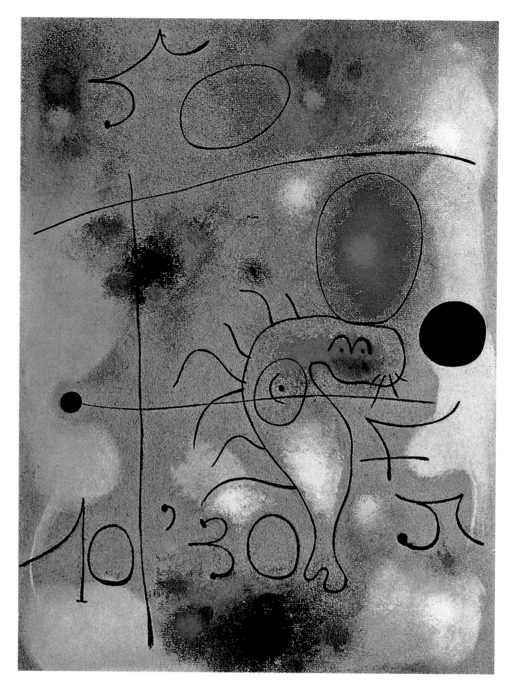

The Circus, 1937
Le cirque
Oil on celotex, 121 x 91 cm
Medows Museum,
Southern Methodist University, Dallas

Painting on Celotex, 1937
Peinture sur célotex
Oil on celotex, 121 x 91 cm
Aimé Maeght Collection, Paris

He had quickly forgotten my request that he should pose for a photograph. He took no notice of me as I crept round with the camera.

The demonstration Miró had just given me caused me no little excitement. What had happened during these few minutes was more than a mere anecdotal intermezzo. This must have been the way in which all Miró's other drawings and pictorial works had their beginning.

The affinity between Miró's graphic technique and children's drawings has often been pointed out. Has the creative work of the adult artist really anything in common with the playful activity of the child? If we consider the origin of drawing in general, we inevitably think first of a child's scribbles. Why do children draw? Whatever the initial impulse, the child playing with the lines that are coming into existence under its hand will soon identify the confusion of dashes, ribbons and spirals with some familiar object, which is subjected to a series of rapid transformations according to the child's temperament and imagi-

nation. What at one moment was an elephant turns at the next into a house, a car or a tree.

As we watch the child conjuring up concrete objects out of apparently meaningless scribbles, we can understand that the configurations of pencil lines represent to the child a source of variable suggestions and that the density and tension of the linear relationships may change in the fraction of a second. A minimum of signposting gives rise to a maximum of imaginative discovery.

If we follow the development of the child's artistic activity as he grows older, we see that the forms he draws approach closer and closer to an optically verifiable "reality", as a result of which the wealth of

Gouache on Black Paper, 1937
Size unknown
Private collection

possible suggestions is increasingly restricted by the resolution with which the child tackles the representation of an object. If we assume that the child's first scrawls and their subsequent identification take place within a magical domain, we may also conclude that this magic fades gradually as the child advances along the path towards the portrayal of a more concrete reality.

The early history of painting mirrors the stages in the realization of a pictorial idea that we have observed in the activity of a child, with the difference that painting, in the course of the ages, has not evolved towards a fixed goal, photographic verisimilitude, such as confronts the child at every step.

The dilemma of modern art, which is manifested in the endeavours of all its representatives, may stem from the fact that art has passed through a historical phase in which its aim was the imitation of natural models, and painters are now confronted with the difficult task of achieving a more intensely concentrated "reality". Thus we see many contemporary artists cutting the most extraordinary capers in their

Triptych, 1937
Triptyque
Oil on celotex, 138 x 177 cm
Private collection, Zurich
Courtesy Thomas Ammann Fine Art

To support the Spanish freedom fighters Miró painted a poster in loud, screaming colours. It shows a figure with an enormous clenched fist and a gigantic, muscular lower arm, crudely forceful and threatening to smash the enemies of freedom. In the same year, 1937, he also produced *The Ploughman* – a painting to express the horrors of war – for the Spanish Republican Pavilion at the Paris World Exhibition. It was a monstrously overwhelming combination of figures, comparable in its expressiveness to Picasso's *Guernica*.

"In the present struggle I can see, on the one hand, the Fascists as an antagonistic force, on the other, the people. And it is the people whose extraordinary creative potential gives Spain an impetus that will surprise the whole world." JOAN MIRÓ

Aidez l'Espagne (Help Spain), 1937
Poster to support the Republican Government in the Spanish Civil War
Silk-screen printing, 24.8 x 19.4 cm
Private collection

attempt to evolve a new point of departure, a new method. If the child feels compelled to approach closer and closer to photographic verisimilitude in his drawing, we can observe precisely the opposite aim among contemporary painters: their goal is the beginning, the origin.

But the history of modern painting also affords examples which show that its most powerful representatives seem to be immune to this dilemma. By virtue of their creative innocence, which is the form in which genius usually manifests itself, they remain untouched by the facts of art-historical evolution. Like the child before puberty, they too are protected from the promptings of that other "proper", but fundamentally trite reality; their aim is to create a stimulating new reality, not to copy a worn-out reality that has lost its power to stimulate.

What the child experiences unconsciously as he draws, the artist experiences with the full responsibility of his consciousness. At every stage of his drawing, he is under an obligation to control the urge of his moving hand to fill the area of pure nothingness with signs.

While the draughtsman's hand is raised in preparation for its liberating activity, it feels itself inhibited by another, more powerful force. Whether the artist wishes it or not, the awakening of his impulse releases a series of mental images, signals, suggestions advanced by "another" reality, which take possession of his playing hand. This "other" reality, which is fed from a thousand sources, is in fact identical with nature that surrounds us at every hour of the day, in the shape either of what we see or of what we dream. Whatever man seeks to fashion, he will be unable to produce any line, any relationship between various sequences and systems of strokes, that does not manifest the forms of nature, even though they may have undergone a radical metamorphosis.

When the draughtsman tries to avoid parallel lines, to turn symmetrical configurations into asymmetrical, when he senses in his fingers that a straight line should be followed by a crooked one, when he feels

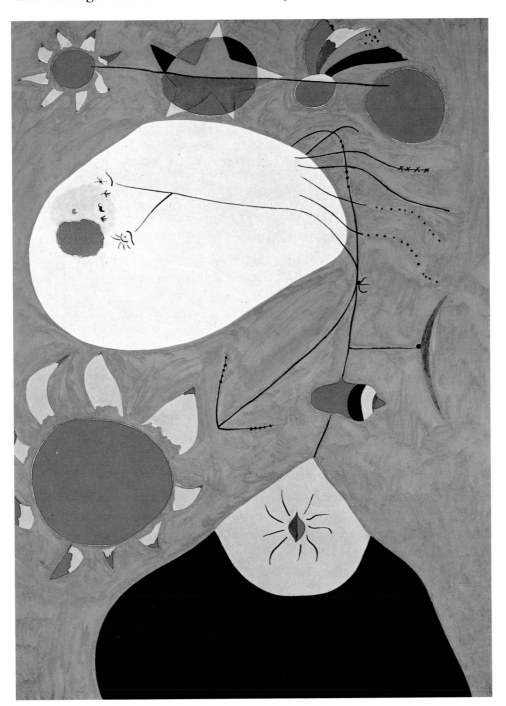

Portrait IV, 1938
Portrait IV
Oil on canvas, 130 x 97 cm
Thompson Collection, Pittsburgh

This picture, entitled *Portrait IV* is of a completely different kind, although it was painted at the same time as Miró's *Decoration of a Nursery*.
Set against a surface with smooth colours that run into each other, there are several coloured symbols – stars, suns and comets – in glowing red, yellow and green. The configuration consists of two parts: from below, a black trunk protrudes into the blue surface, bearing a yellow portion of a neck, in which we can recognize Miró's well-known almond sign as a symbol of femininity. A thin line with a number of offshoots and a colourfully patterned female breast links the figure to a large, white shape. Tiny symbols as well as red and yellow spots indicate a human body. The rich colours and the witty symbolic language make this picture a feast for the eye, while at the same time adding a new fantastic variant to Miró's repertoire of female figures.

One cannot help asking whether such spooky figures are at all suitable as a Decoration of a Nursery. There can be no doubt that Miró used some of the fearsome figures of his "wild paintings" of the 1930s.

The long, frieze-like oblong format was first primed with a blue coat containing spots of black. However, instead of scattering his cheerfully hovering symbols, Miró designed a scenario of three figures, each of them more terrifying than the other. On the left, a dark figure with a white skull and protruding teeth lunges forward to the far right, penetrating the middle figure. Through this second figure, with its round, unfocused eyes and insect-like feelers, a third figure can be seen in flight, stretching forth to the right an umbrella-like protruberance consisting of hairs or feelers, and on the left a reptile-like head with its mouth wide agape and a tongue shooting out.

The colour scheme is generally sombre, with a lot of black, white and very little yellow. Did Miró want to dispel the trauma that rested on him, or did he want to give an example of his unlimited imagination to his grandson, to whom he had dedicated this picture? Or is the painting an allusion to the polymorphous world of a child's instincts, where beauty and cruelty are often very close together?

that every movement necessarily and immediately calls for its reverse movement — as a musical phrase calls for its mirror image — he does so simply and solely at the dictates of nature, whose creature he remains, much as he might like to deny it.

Even the so-called "abstract" painter cannot escape the laws imposed upon him by the grammar of artistic creation. No matter how vigorously he may defend himself against it, nature always manages to slip into the picture and claim its rights...

Miró attached a ladder-like shape to the head to form a neck. The gravity had vanished from his face, his eyes were sparkling, as though he wanted to ask me: "Didn't I do that well?" The head on the paper looked at us half merrily, half fiercely. "Now it has become a proper drawing", I cried. "Do you like it?" asked Miró with a smile. *"Alors je vous ferai une dédication!"* As I nodded encouragingly, he wrote on the drawing in big letters: *"La mer de Majorque, les étoiles, 14. VIII. 1957."*

Miró's signature at the foot of his brief letters was always a decorative symbol; not that he thought of emulating the calligraphers of past centuries by turning the four letters of his name into an intricate tracery of lines and flourishes — as Spaniards still do nowadays. What he did was to relate his signature to the blank area on the paper. And as he expressed himself with laconic brevity there was always a considerable expanse of white paper. On one occasion, the reverse side of the small sheet had only one line written on it. For this reason Miró extended the uprights of the letter M so that they reached from the right-hand top corner to the left-hand lower corner and looked like the feelers of an enormous insect.

Decoration of a Nursery, 1938
Décoration de chambre d'enfants
Oil on canvas, 80 x 320 cm
Weil Collection, St. Louis (Mo.)

Miró and his signature! Anyone who knows the painter's work will be familiar with this sign, because it frequently constitutes a picture within a picture. During one of my last visits to Miró's studio I noticed a large sheet of drawing paper pinned to one of the many work-tables. On the left-hand lower corner, which the painter had soaked in linseed oil to give it a surface that was more alive, he had sketched out the design for a mural. A few days later, I looked at the sheet again. Miró had done nothing more to the design, but the greater part of the blank sheet was filled by the letters of his name. These letters had been carefully spaced out and the areas in between shaded and touched up with colour.

Miró has often employed his signature as a motif for posters, book jackets and illustrations. On one occasion the letters stand side by side, on another they are placed one above the other or arbitrarily jumbled together. In many of his drawings and lithographs the letters of his name stand out among a multiplicity of signs. The M has as much life and movement as the living rise and fall of the mountain ridges beyond the villages of Montroig or Genova — or it soars leisurely aloft like the Gothic cathedral in Barcelona. The I with the dot over it rises like the beam of a ladder, it hovers in space like a pair of dumb-bells, those two thick joints joined by a line that so often appears in his pictures — or it stretches up like a flower or a phallic symbol. The R is a burlesque *personnage* that strides, hops or dances, struts like a clown and is on the point of turning a somersault. The final O with the accent dabbed in over the top resembles the globe or a wellrounded head, Miró's head…

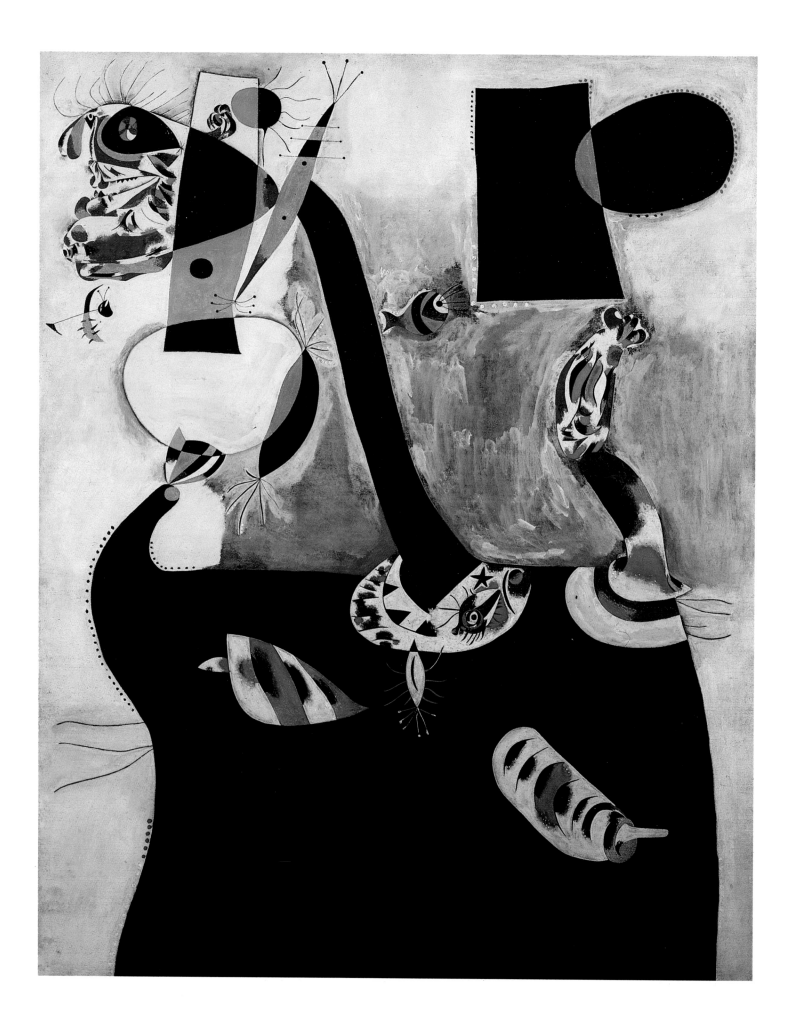

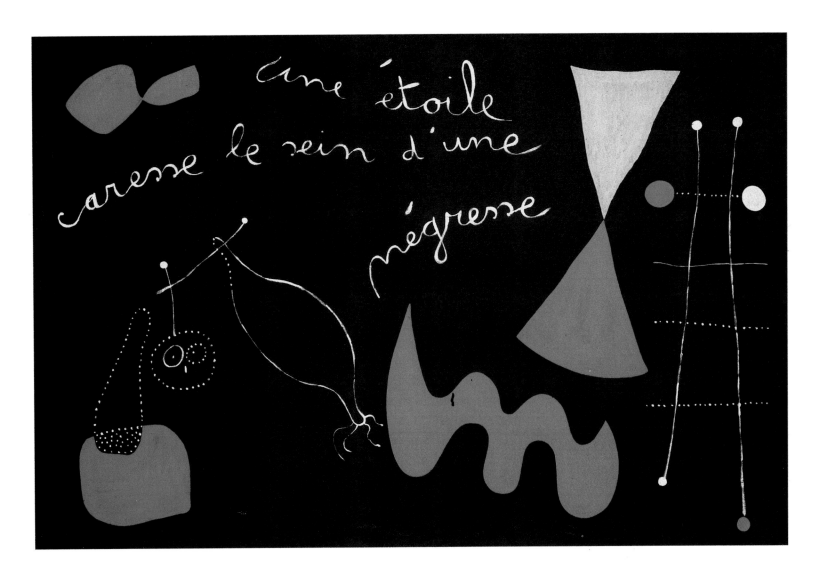

A Star Caresses the Breasts of a Negro Woman, 1938
Une étoile caresse le sein d'une négresse
Picture poem
Oil on canvas, 130 x 196 cm
Tate Gallery, London

Many painters return from time to time to the self-portrait, or set out from it, as though to or from a stock-taking that confirms who they are and what they can expect of themselves. Miró's self-portrait is his signature. To him whose art begins with a formal sign and is directed towards a symbol informed with life, this signature means more than the playful arrangement of the letters of a common Catalan name.

Looking at Miró's symbols, one is frequently reminded of Chinese or Japanese written characters. These written characters are a synthesis of a highly simplified picture, a letter and a brush stroke that has acquired a life of its own from the sensibility of the writer, a life drawn from the most varied sources of thought and imagination, sympathy and will to form. A friend of Miró's acquainted with Japanese characters succeeded in "reading" a series of Miróesque "characters" in the sense intended by the painter, which indicates that by the power of his intuitive empathy and formative instinct the painter has completed the evolution of a picture into a fully significant written character.

Mediaeval calligraphers developed the pictorial appendages to their sacred texts, the symbolic and allegorical figures and symbols, out of the pen strokes of the writing; they built up their figures out of light-hearted decorative flourishes. When these symbols later developed into drawings, that is to say into a configuration enclosed by an outline and detached from the background, they could not disown their orna-

Seated Woman II, 1938
Femme assise II
Oil on canvas, 162 x 130 cm
Peggy Guggenheim Collection, Venice
Solomon R. Guggenheim Foundation

95

A ray of hope in the darkness of the night. Such is the impression which this picture gives. A tall, erect female figure is trying to touch a brightly radiant sun with tongues of fire, in an environment that otherwise appears to be rather sombre. In her other hand she seems to be holding a red ball, or else she is trying to seize another red star. With masterly expertise, Miró has used the rhythmic structure of simple, basic shapes, such as a circle, which occurs in four variations in this picture, thus linking the stars to the woman's body and establishing an analogy between them.

Woman in Front of the Sun, 1938
Femme devant le soleil
Oil on canvas, 55 x 46 cm
Private collection, New York

mental origin and the laws arising out of it. It cost the draughtsmen of later ages a great effort to develop the power of the line, originally conceived as pure outline, to the point when it could convey all the quality of the object, including both movement and volume.

What different rôles are played in the history of drawing by the line, the patch in its graphic function, and the area formed by both of them. How determined painters have been to eliminate all indirect methods of grasping and stating pictorial facts and to raise the purely graphic element to the level of the sole medium of expression. Miró, too, had consciously or unconsciously to decide between alternative modes of expression with the aid of the innate artistic tendencies already manifest in his work as a child and a student. The position he adopted and the kind of artistic world he created are exemplified by his paintings, in which the graphic element has always played a particularly important rôle. In addition to his paintings, however, there is a large body of purely graphic work that shows the pre-eminent contribution this painter has made to modern drawing and printing.

Miró's first lithograph dates from 1930, a period when line occupied a position equal to that of colour in his formal armoury, that is to say a period subsequent to his "Dutch Interiors". It seemed at first as though Miró was striving after a re-orientation of pictorial methods in the direction of increased abstraction. In this lithograph the graphic forms, the thin lines, the massive bundles of dashes, the crossing and intersecting meanders, the spirals and cloudy patches have the expressive value of painting. This lithograph looks like a graphic exercise, it dispenses with any definable theme and yet in its structure and design it is a genuine Miró.

Two years later, in an etching, the pictorial means are extended to embrace a clearly recognizable subject: a seashore scene with a flute-playing Pan, a leaping he-goat and a naiad rising from the surf. The forms are reminiscent of Picasso, only the tensions that give the lines their life spring from different impulses. They have their origin in the mute, idol-like objects Miró found on the beach at Montroig or Andraitx, rather than in the world of baroque-antique forms. To Miró, the Mediterranean man *par excellence,* the antique was never a "subject", although his pictorial world is steeped to the last fibre in the magic of archaic Mediterranean imagery. Perhaps this etching shows particularly clearly how Miró fights against recollected form as he executes each line.

It was Miró's wish – in his graphic work as in his painting – that every form should develop out of itself, out of its medium, its material, its inner structure, even if the result called up a hundred metaphors and identifications, like the lineation on an old wall – to which Leonardo already drew his pupils' attention – or on the bark of a tree or a butterfly's wing.

The tensions that give life to Miró's signs are not representative of the human drama, as is sometimes the case in Picasso's work. Yet they are profoundly fateful in the mythological, that is to say in the poetic sense; they are filled with the fateful significance that clung to things in times when the world was still young and its expressiveness was not

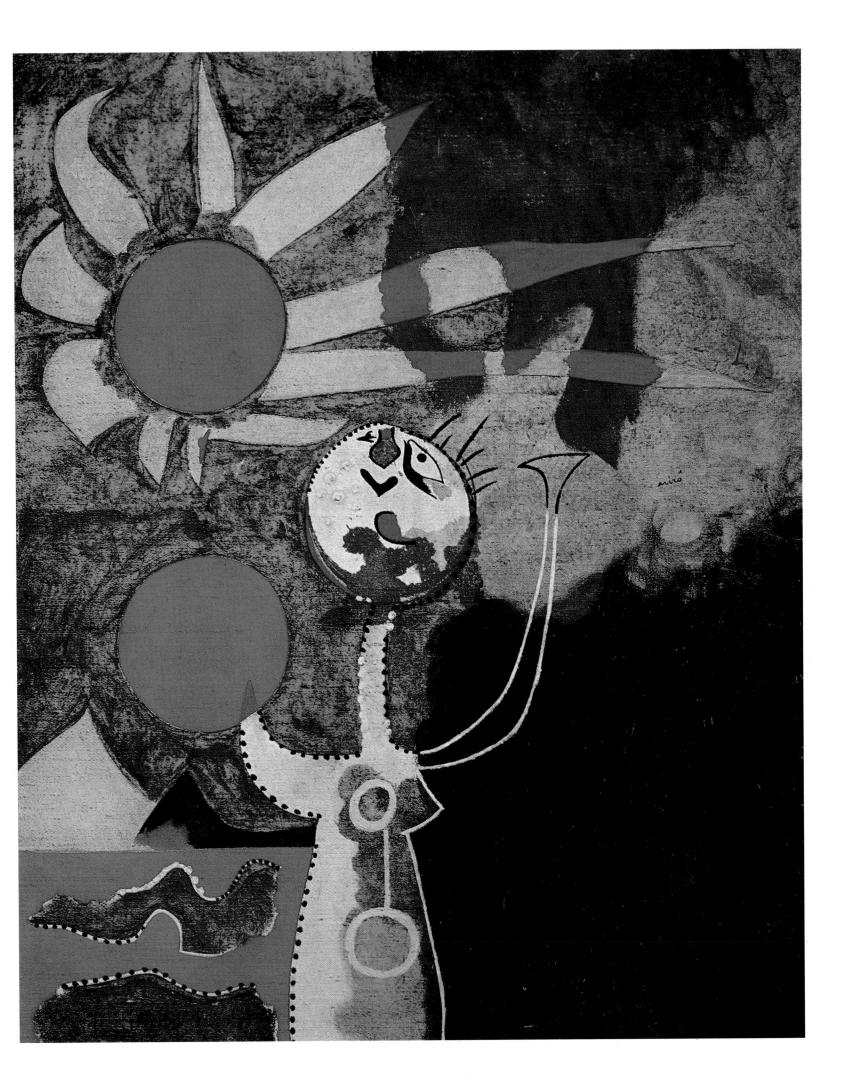

split by the afflications of reason and calculation. Nowadays, only the child can still contemplate and experience our worn-out world in this way, with astonished eyes, as a fabulous game beyond good and evil.

The poetic world remains unharmed, even when violence is done to the real world. The series of lithographs known as *Barcelona,* dating from 1944, which I saw on the walls of Prats's house, show a world that has been set reeling and wrenched out of its normal balance by the assault of demons. The graphic means have become more robust, more direct, the faces of the figures have taken on the appearance of grimacing masks, their burlesque laughter is liable to turn at any moment into hysterical screaming. But Miró's poetic world stands aloof. "I keep exclusively to the world of painting", runs one of his laconic utterances. "Lord, heap miseries upon us, yet entwine our arts with laughter low", pray the children in James Joyce's *Finnegan's Wake,* when terrified by the thunder.

The post-war years – as for other great modern artists – were particularly productive and fruitful for Miró. He tried out every possibility offered by the graphic techniques, by the lithograph, the etching, the woodcut: the linear or the painterly approach, the combination of

Personages on a Red Ground, 1938
Personnages sur fond rouge
Gouache on paper, 48 x 63.5 cm
Private collection, Spain

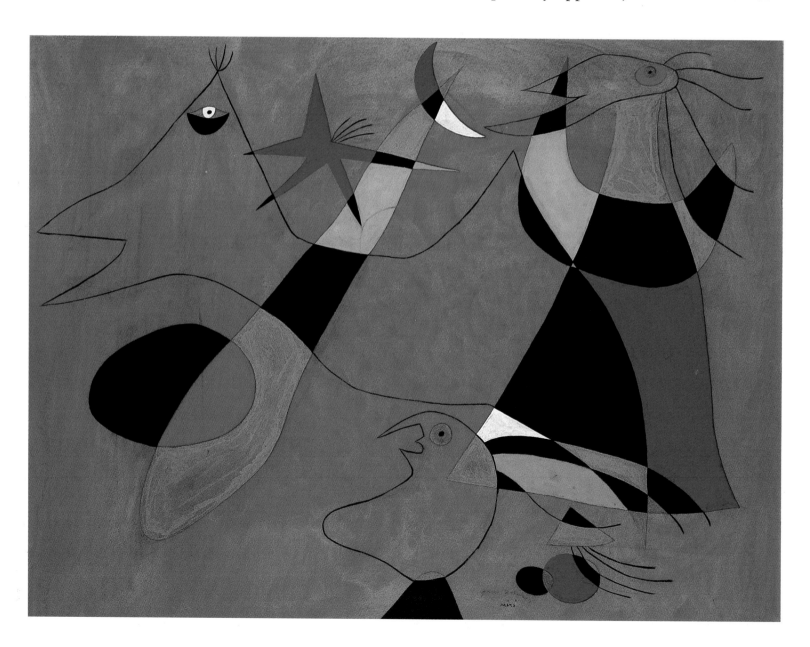

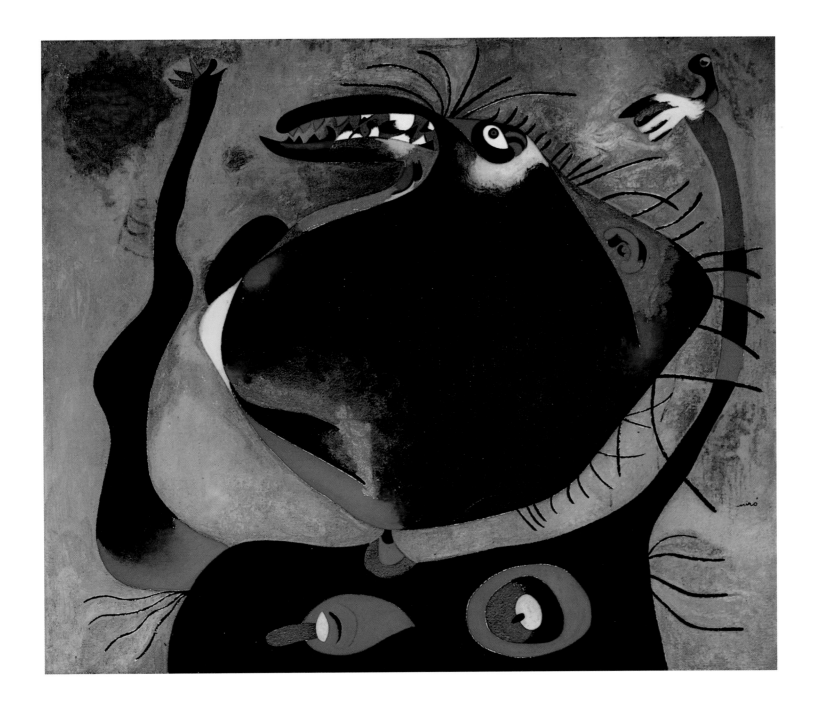

both, the amalgamation of writing and drawing, of printed types and illustration. Miró became known to a wider public in particular through his lithographs from the years 1950 – 1955, in which condensed lyrical effects are achieved with greatly simplified "signs" in pure colour. A few titles will exemplify the imagery that informs the poetic world of these lithographs: *Acrobats in the Nocturnal Garden, Little Cat in the Moonlight, Comet Catcher, Nocturnal Germination, The Cloud Swallower*. These lithographs are dominated by Miró's quiet and liberating sense of humour, which never turns into sarcasm or *humour noir*. As we look at this lyrical language of signs we feel a breath from that distant paradise, which Miró does not lament as lost but renders present with very concrete pictorial means and so regains for us. "Every grain of dust has a marvellous soul. But to understand it, we must rediscover the religious and magical meaning of things, the meaning they have for primitive peoples", remarked Miró during his conversation with Georges Duthuit.

Woman's Head, 1938
Tête de femme
Oil on canvas, 55 x 46 cm
Winston Collection, Los Angeles

A terrifying monster, a hideous old hag, grinding her rotten teeth and gnashing curses with them. This is the drastic way in which Miró depicts that other aspect of the goddess of motherhood, showing her as a horrible, devouring woman, a symbol of the destructive and disastrous element in human instincts. Both aspects of this archetypal symbol of the Great Mother – the bright, fruitful element and the dark, destructive one – are constantly present in Miró's art and express a psychological conflict from which he drew creative energy.

The shapes have become lucid again, and the colours have assumed their former rich quality. This picture shows Miró as a great master of colour again, able to use a few basic colours and produce a completely harmonious equilibrium. The archetypal stylization of the seated woman has taken the place of the cruel fragmentation and demonization of the women in his preceding paintings. The red head in the left-hand corner with its tiny little details even re-introduces a comical element, something which Miró had avoided completely within the last few years.

It is not surprising that Miró, who throughout his life has been the friend of poets and loved by them, should have become an ideal illustrator of their works; his graphic sequences constitute "poetry without words" in themselves. He has decorated poems by Tristan Tzara, André Breton, René Char and Michel Leiris with his "signs", and heightened these books of verse by an additional dimension of experience. When I once asked Miró how he "illustrated" these works, he replied that he tried to grasp the poetic essence of the verse and then wrote his figures and lineations independently, within the realm of experience created by the poetry, which substantiated his own. Thus we may regard the beginning of a poem by Tzara from the collection *Parler seul* (published 1950), as entirely in keeping with Miró's world of imagery:

que le matin opaque	*j'ai laissé mon enfance*	*je rirai la dernière*
me prenne pour racine	*aux autres petits*	*seule et sourde*
je perds mon regard	*ceut dont on rira*	*prends-moi par la main*
par les yeux de feuilles	*la bouche pleine*	*de laine molle*

This (probably untranslatable) poem, which stands slender and surrounded by light and air on the spacious white surface of the paper, is encircled by equally sensitive "signs" by Miró's hand. Do they represent a tree, a trunk with roots and a *personnage* symbolizing a little being, the child? Miró's drawings are no more susceptible of logical analysis than the poet's wandering word-play. Yet the beholder and the reader, who takes this exquisite volume of poetry in his hand, will feel the poetic shock that emanates from it and will perhaps recall Mallarmé's pronouncement, the gnomic complexity of which Kurt Wais has thus translated into a language comprehensible to us:

"The poet will readily be allowed to transgress the conventions of book printing for the sake of a unique work. And many people could no doubt be found to greet enthusiastically a book in which each page bore nothing but a single great, profound or burning sentence, printed in bold type and each time in a different position on the page, and encircled by subsidiary items that explained it or carried it further."

The poet to whom books were *instruments spirituels* would not have been disturbed by the fact that these "subsidiary items" were products of another artistic discipline. He would have found here what he yearned for all his life: "The ritual consecration of everyday words and letters by the breath of the eternal, the creation of a mobile, comprehensive play of interrelationships!"

Seated Woman, 1938
Femme assise
Oil on canvas, 162 x 130 cm
The Museum of Modern Art, New York

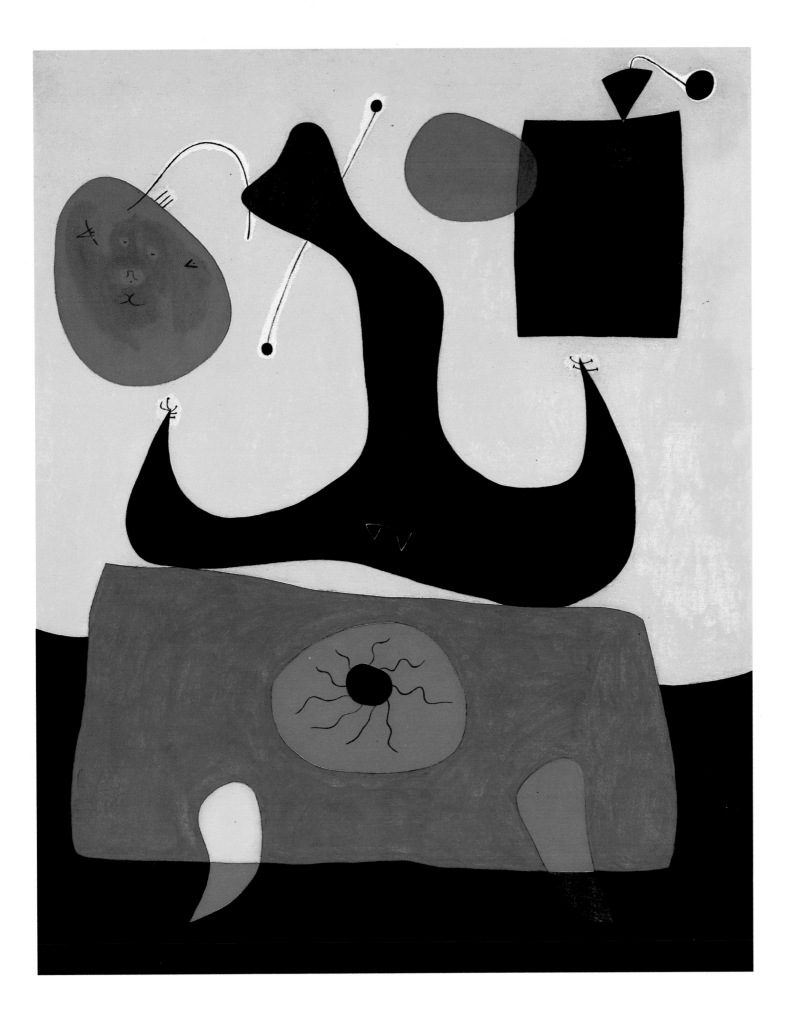

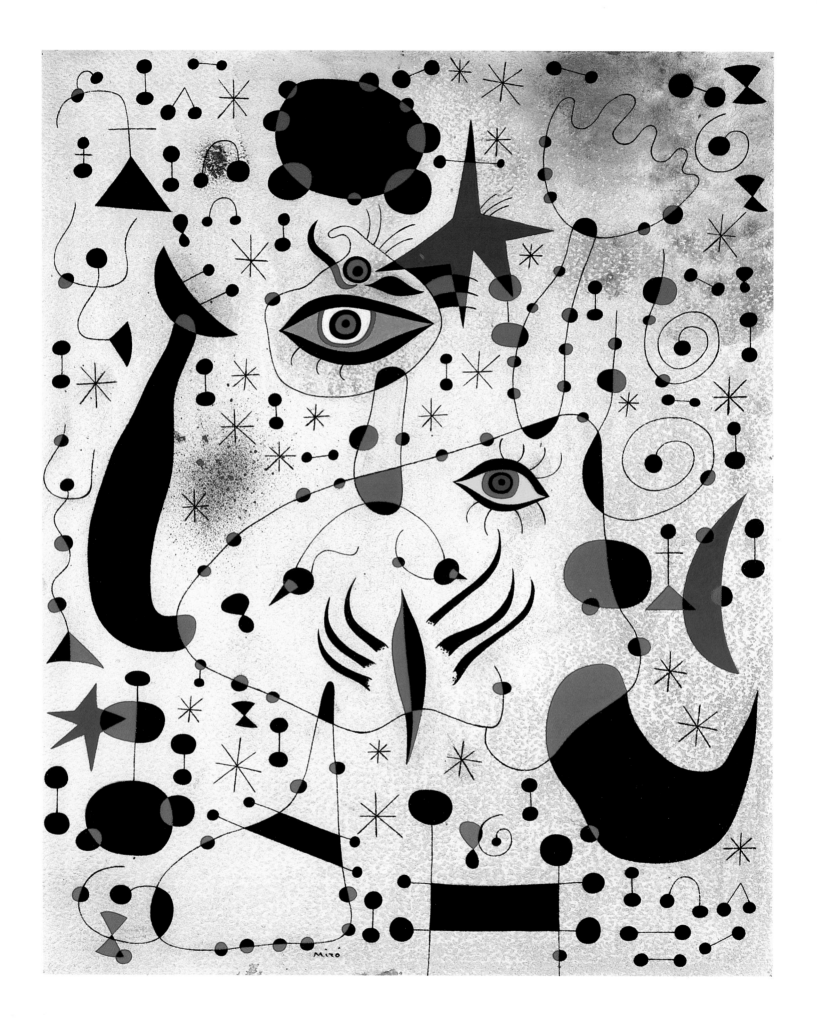

Prats and Artigas

I paid two visits to Miró on Mallorca; during the summer months of 1957 and of 1958. On one occasion I made the trip by plane, on the other by car and from Barcelona by ship. Since my goal was the meeting with Miró, I experienced everything that led up to this meeting – changes in the landscape and atmosphere, and all the lesser or greater details to which we normally pay little attention while travelling – as aspects of my past or future encounter with the painter and his work.

I had, of course, made notes while at Son Boter; but when I subsequently set about organizing these into a coherent whole, I noticed that the hours, days and weeks became displaced, the sequence of the meetings changed or underwent a shift of emphasis and unsuspected connexions were estab lished between apparently disconnected and fragmentary events. My meet ings with Miró became inseparably linked in my mind with my encounters with his Catalan friends, Joan Prats in Barcelona and Artigas at Gallifa, a mountain village about forty miles from Barcelona.

The Rambla Cataluña is considered the most attractive street in Barcelona. Its wide centre lane, shaded by plane-trees, is meant for pedestrians, for loving couples and for those who wish to sit and watch the life and movement that animates this street, particularly between the hours of six and nine in the evening. Along both sides of this promenade stand hundreds of dainty little chairs, which offer a pleasant resting place to those tired from strolling around. The scent of jasmine and camellias drifts over from the nearby flower stalls.

The air of late afternoon in which the heat still lingers, has a rosy tint. The first lights of the neon signs compete with the fading orange of the sky; the sun can still be felt at this hour but no longer seen. To the left and right of this central promenade, the traffic races past along the two white highways – yellow taxis, blue trams, green buses. The hooting, bellringing and rattling combine in one great cacophony. But the lanes are so wide that the noise is dulled by distance.

The spoken word seems to possess greater carrying power: chatter, jokes and singing can be heard in a multitude of languages. Laughter and shouts reach the ear, mingled with the rhythmic cries of the news-vendors. The atmosphere is at once Spanish and international. At the end of the Rambla, a few yards from the harbour wall, towers a seventy-foot column topped by a statue of Christopher Columbus.

In his *Constellations* series Miró devoted himself with great sensitivity to his materials. To allow the paint to soak into the fabric, he first roughened up the paper, and on this delicate but infinitely expressive ground he then scattered the figures and patterns. The numerous intersecting and overlapping lines creates a transparent pattern in which the figures seem to be embedded, as it were. The linear overlaps sparkle brightly, in pure shades of colour, and counteract the blackness. The entire painting is covered with a close network of lines, symbols and hues of colour. Everything is related and would be unthinkable without the other elements. In this space, everything is inter-related, orbiting around one another, and subject to a higher (cosmic) order. Faced with the immediate dangers of the days and nights, Miró was seeking refuge in the songs of the stars, which gave him hope for new life.

Ciphers and Constellations in Love with a Woman, 12 – 6 – 1941
Chiffres et constellations amoureux d'une femme
Gouache and turpentine paint on paper, 46 x 38 cm
Art Institute of Chicago, Chicago

Old Barcelona, with its Roman excavations, its cathedrals and the Gothic quarter of the city, is not visible from here. The squat towers of the cathedral have met pitiless competitors in the shape of modern six-storey buildings. Yet only a few paces along one of the picturesque back streets leading out of the Rambla are sufficient to re-establish contact with past centuries. History is ever-present to the consciousness.

Barcelona has been called the most European city in Europe. Perhaps this is because everything that went to make up Europe of the good old days is still present in its atmosphere. At this late hour in the afternoon one does indeed have the feeling of being carried back, of being made younger by several decades. At the same time, there is something comical about this fountain of youth; this corner of the world arouses a smile, as though one were looking at a picture of it in an illustrated paper of 1913. What was once shiny has now acquired a

The symbol of the escape ladder is a frequent motif in Miró's paintings and also occurs in his titles. When Miró painted this picture in Varengville, he was leading the life of a recluse, completely dedicated to the pursuit of art. Music, the sky and the night became metaphors of his search for an escape from the oppressive circumstances of the time – an escape ladder into the spheres of creativity. The paint would soak only very incompletely into the coarse fabric of the canvas, which is apparent as an underlying structure even where the paint was applied more thickly. This makes the creatures in the picture appear to be part of a whole, embedded in that ground of all being which Miró was trying to find as a man and as an artist.

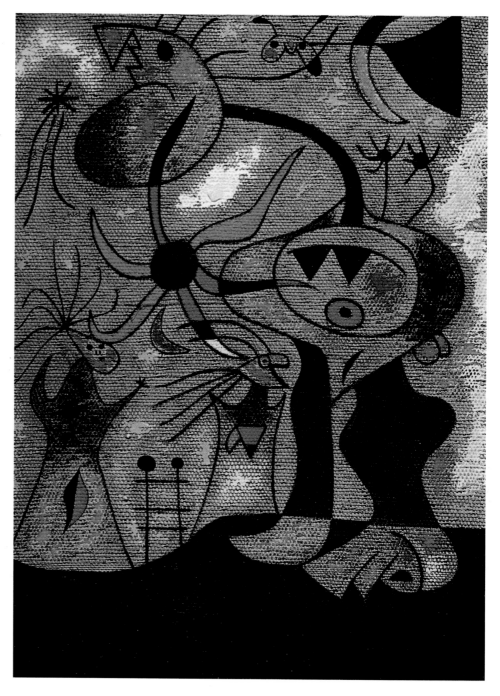

The Escape Ladder, 1939
L'échelle de l'évasion
Oil on canvas, 73 x 54 cm
Private collection, Chicago

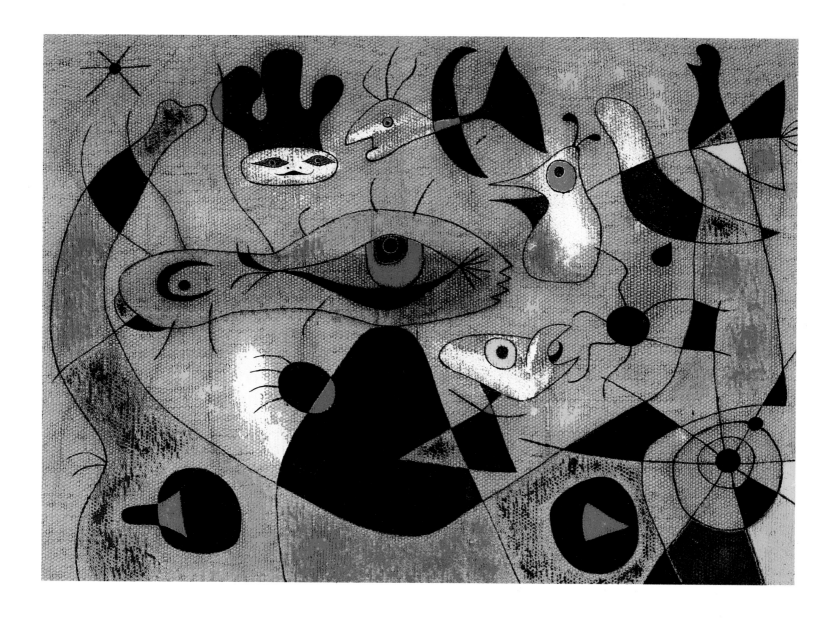

A Dew Drop, Falling from a Bird's Wing, Wakes Rosalie, Who Has Been Asleep in the Shadow of a Spider's Web, 1939
Une goutte rosée de tombant de l'aile d'un oiseau réveille Rosalie endormie à l'ombre d'une toile d'araignée
Oil on canvas, 65 x 94 cm
University of Iowa Museum of Art, Iowa City (Ia.)

patina; on closer scrutiny the most inspiring pieces of scenery prove to be rather dilapidated. The surroundings are distinctly bohemian, their air of improvisation and of being no longer quite intact encourage an attitude of *laissez-aller*.

The Rambla must have looked much the same four decades ago, when Miró, then a student at the St. Luke Academy, strolled up and down this street, an attentive listener between his more talkative friends, Prats and Artigas. Anyone on his way to or from Miró cannot help passing through it; there is no other way to Palma de Mallorca than via the Rambla Cataluña. But this street has a deeper significance for any friend of Miró; for in it stands the shop of the hat-maker Joan Prats.

Miró had given me a detailed list of addresses of the museums and the sights of the city to which he attached particular value – among them, naturally, was the address of his friend Prats. I had no difficulty in finding the hat-maker's shop; but not because a window full of hats caught my attention among the other shops in the Rambla, for the big window shaded by a yellow awning contained no real hats at all. On the other hand, it was filled with all kinds of hats modelled in wire that swung gently to and fro at the end of threads attached to almost

invisible wire clothes hangers that were also gently swaying. The whole thing was reminiscent of a Calder mobile. Behind the wide frame of the shop window, inlaid gold-leaf decorations in the *art nouveau* style sparkled in the black glass. Engraved on the big plate- glass door was the firm's coat of arms, a top hat in one half of the shield, a raven in the other.

As I stretched out my hand towards the highly polished brass handle, the grooves in which were still encrusted with brass polish, the door opened as though by itself. A khaki-clad commissionaire bowed deferentially and touched his peaked cap, on the front of which, in brass letters now slightly askew, stood the name PRATS.

The commissionaire was an old man. But his slim figure and shy ways made him seem younger. With conscious dignity, he listened to my request to talk to Señor Prats; then he turned, walked very erect through the big, empty shop laid with old carpets, mounted the four steps at the far end, and disappeared through a small door of frosted glass. I was left alone in the most famous hat shop in Barcelona.

The Escape Ladder, 31 – 1 – 1940
L'échelle de l'évasion
Gouache and turpentine paint on paper,
38 x 46 cm
Acheson Collection, New York

Women Encircled by the Flight of a Bird, 27 – 4 – 1941
Femmes encerclées par le vol d'un oiseau
Gouache and turpentine paint on paper,
46 x 38 cm
Private collection, Paris

The Nightingale's Song at Midnight and the Morning Rain, 4 – 9 – 1940
Le chant du rossignol à minuit et la pluie matinale
Gouache and turpentine paint on paper, 38 x 46 cm
Pearls Galleries, New York

Miró's *Constellations* are a last summary of his "wild period" while at the same time opening up a new poetic wealth which was to influence him for the rest of his creative life. The carefully prepared surfaces with their restless splotchiness are crowded with symbols and figures. These are all subject to a cosmic current that carries them away and imposes its own

I looked round. There were no hats to be seen inside the shop either. The walls were of green-lacquered wood decorated with vertical gold bands and flower patterns in the art nouveau manner. When I drew closer I discovered that the walls consisted of innumerable narrow cupboard doors reaching up to the ceiling. The hats must be kept behind these doors, I thought to myself.

From the dusty ceiling hung a cut-glass chandelier. A small Empire armchair upholstered in yellow stood in each corner of the room. A dainty round wooden table bore a small wooden stand topped by a fur-lined leather helmet, of the kind worn by motorists before the First World War. Beneath it lay an English periodical, *The Hat-Maker*.

The door opened. A man in a crumpled white linen suit came down the steps towards me. He was of medium height and looked the same age as Miró. There was something faun-like about his sun-tanned face and he had a cast in his right eye. Señor Prats smiled, as though he knew I had not come to buy a hat. He stretched out his right hand; in his left hand he held a letter on which I spotted Miró's handwriting.

"I'm delighted to see you", he greeted me in perfect French. "Miró told me you were coming. Did you have a good journey?" In spite of the faun's face, his features displayed a dignified composure normally met with only in retired diplomats of the old school. "I am at your disposal. Shall we go into my office?"

He motioned me to precede him. His office was only a fraction of the size of the shop. It seemed to me that I had read a description of this room before – in a Dickens novel. The walls were fitted with shelves. Those on the left carried the literature of the hat-maker: sets of *The Hat-Maker* bound by years, alongside account books and letter files with mildew on their calico covers. The shelves on the opposite wall were filled with the literature of art. I noted the most costly publications that had aroused the envy of art lovers during the last four decades.

Museum catalogues from Europe and America, literature on Gaudí, Gonzalez, Picasso and other Barcelona artists completed the collection. And then, of course, there was every book on Miró and a copy of

Personages in the Night, Guided by the Phosphorescent Tracks of Snails, 1940
Personnages dans la nuit guidés par les traces phosphorescentes des escargots
Gouache and turpentine paint on paper,
38 x 46 cm
Private collection, U.S.A.

order on them. There are only very few pure colours, but these have been placed quite emphatically at the intersections of the overlapping configurations, where they sparkle like the constellations in the night sky from which Miró derived so much comfort and inspiration.

all the books he had illustrated. These latter already filled a whole shelf. On the remaining shelves lay museum bulletins from New York and Buffalo, some of them still in their wrappers. Señor Prats's artistic connexions seemed to be world-wide.

The section of the wall free of shelves was occupied by tobacco pipes. Before Prats began our conversation, he filled one of the pipes and lit it with the care peculiar to the enthusiastic pipe-smoker. I had sat down on a narrow divan upholstered in black leather, above which hung three large photographes in black, oval frames showing dignified bearded men of mature age. "My father and my two grandfathers", explained Prats. He pointed with the stem of his pipe to the lower photograph on the right. "My paternal grandfather was the founder of our firm."

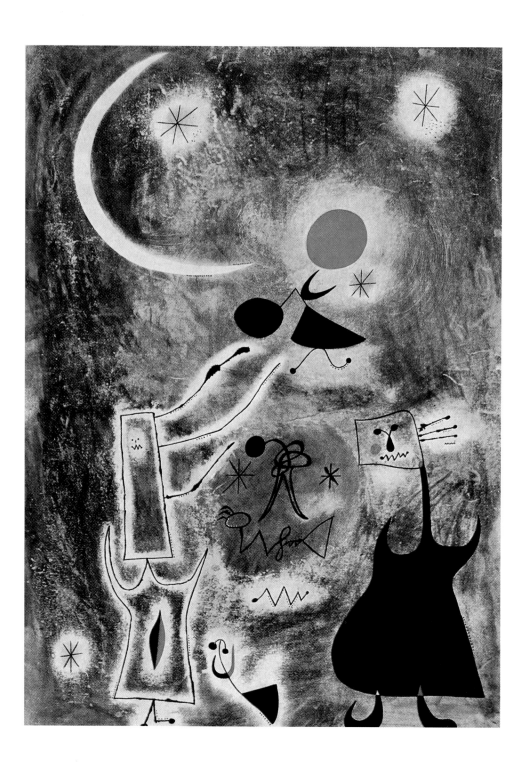

Woman and Bird in Front of the Sun, 1942
Femme et oiseau devant le soleil
Gouache and pastel, 109 x 78 cm
Art Institute of Chicago, Chicago

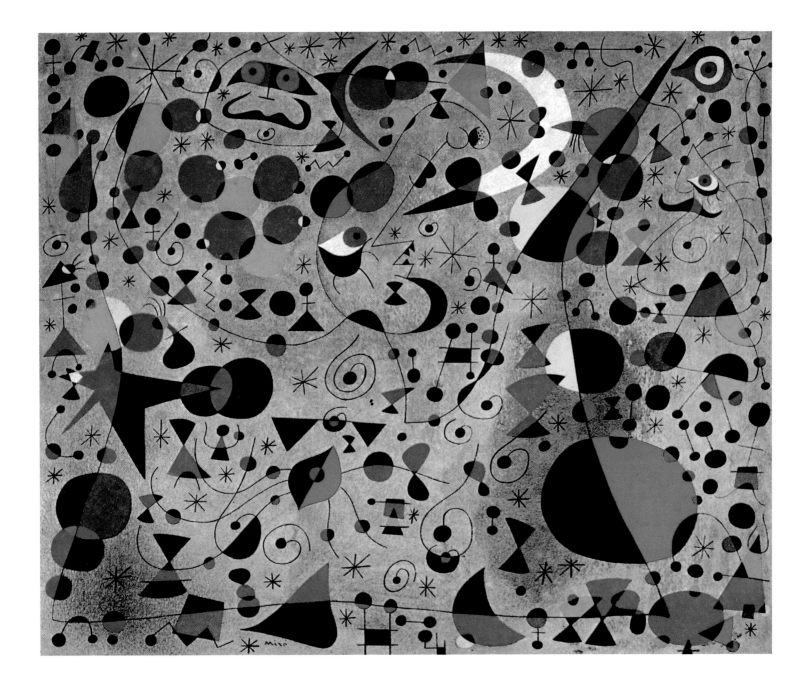

Prats had taken a seat on an armchair in front of his desk. A desk lamp with a green shade created a not over-bright island of light. The rest of the room was in semi-darkness. The office had a window, but it looked out on a dark air-shaft. This window was wide open. From the top of the frame hung a curtain made of strips of white paper, which rustled as the fresh air entered from outside. This device took the place of a fan and kept out flies.

An unprejudiced observer would have described as untidy the collection of documents, periodicals, open account books, visiting cards, pencils, pens and pipe cleaners and the various round and square tobacco tins that littered the desk. On looking closer, however, a more subtle kind of order became manifest in this disorder: the things Prats needed most frequently were always on top.

To the left of the desk, a smaller console-table carried three more wooden stands. Two of them supported men's hats, the third a white motor-racing helmet padded inside with cork. "Our firm's latest crea-

The Poetess, 1940
La poétesse
Gouache and turpentine paint on paper,
38 x 46 cm
Colin Collection, New York

"I felt the most intensive urge to break out. I deliberately shut myself off. Music, the night and the stars began to play a bigger and bigger role in my pictures as I envisaged them. I had always been attracted to music, and at the time it began to be as important to me as poetry in the 1920s."
JOAN MIRÓ

111

The artist at work on a drawing.
Photograph by Erben.

Painting, 1943
Peinture
Oil and pastel on canvas, 40 x 30 cm
Fundació Joan Miró, Barcelona

tion", declared Prats. "Racing helmets are my speciality and in particular demand in America. The other hats I supply to France, Britain and the Scandinavian countries. Though the Spanish customs are rather peculiar. If I send five hats to Paris they are quite happy, but if I send five hundred they object and make difficulties! Why is that? Well, I think their attitude is typically Spanish, because it defies all logic!"

Prats drew on his pipe of shag. When I pulled out my own pipe, he looked taken aback. "You smoke a pipe?" he exclaimed. "Why didn't you tell me so before? In Spain it never occurs to me that someone else might smoke a pipe." I replied that Spanish tobacco was not very inviting because it caught at one's throat. He smiled. "My foreign friends consider it their duty to keep me supplied with good English or Dutch tobacco. So I always have more than I need!"

"Yes, that's a genuine Miró", he said as I studied the large picture over his desk. It was a collage built up of men's hats cut out of a catalogue, attached by thin lines and tumbling through the cosmos of the white background. Every line ended in a ribbon of lettering that said, in English, "Prats is quality!" Prats nodded his head. "They're all hats from my collection, of course!"

I gradually came to speak of the purpose of my visit; for apart from the desire to meet one of Miró's most intimate friends, I wished to make a number of inquiries in Barcelona relating to his early years in this city. Miró had assured me that Prats would be able to help me with these inquires.

"Ça ira bien", replied Prats. "Miró told me all about it in his letter, and I have prepared the ground wherever necessary."

He picked up a notebook lying by his right hand. *"Ecoutez donc!* This is the programme I have arranged for you. In a minute we shall go to my home, where you can see my collection of Miró paintings. After that, we shall have supper. If you like, we can go to one of the oldest restaurants by the harbour, which is also a favourite of Miró's. The food is excellent and the dining-room is a bit of old Barcelona. Tomorrow morning at eleven they are expecting you in the city archives, where you can obtain the reproductions of ancient Catalonian art which you want. Monsieur Aynaud of the National Museum will be pleased to receive you at four in the afternoon. I shall show you the way to the archives. My commissionaire will conduct you to the Museum. Unfortunately, I have to attend a business conference at my factory at that time. In the evening I shall introduce you to my friend Gomis, who also possesses some fine Miró's."

I couldn't get over my surprise. Never before had anyone made arrangements on my behalf with such efficiency. Was all this a sign of Spanish hospitality or did Miró's own reliability, meticulousness and kindness extend to his friends? I felt quite abashed by such helpfulness.

"Miró and I are friends", said Prats in response to my protestations of embarassed gratitude. "And my friends' friends are also my friends, says a Spanish proverb."

I told Prats how kindly Miró had behaved towards me and that I had really come to understand his pictures only after meeting him in the flesh. Not that his pictures required the justification of personal

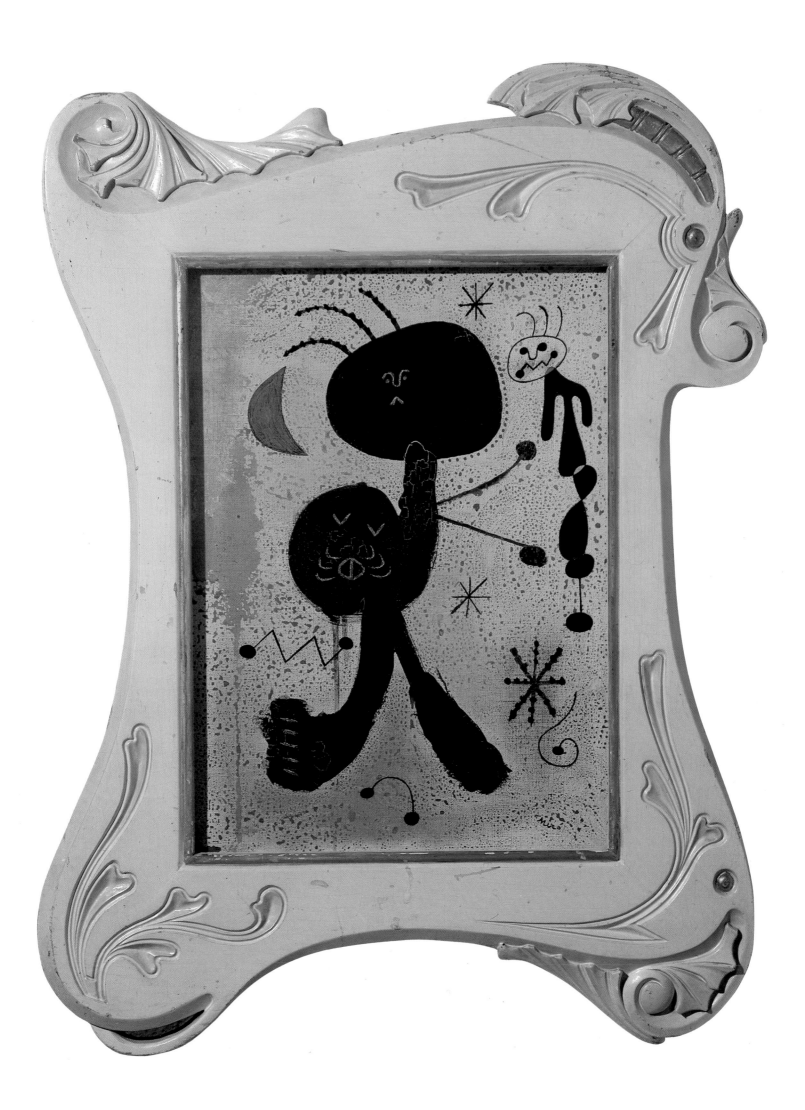

In 1944 Miró began to use canvas again. With a few exceptions, he painted small-format pictures that were amazingly light. The vibrant effect of the surface was achieved by the coarse texture of the canvas showing through the thin layer of paint in a number of places.

Miró's most important motifs come together in this picture: Woman as a symbol of life, poetry and also sexuality, a highly complex symbol, both a goddess and a demon; the bird as her light-hearted, cheerful counterpart; and the sun as a force that has defeated the oppressive darkness of reality.

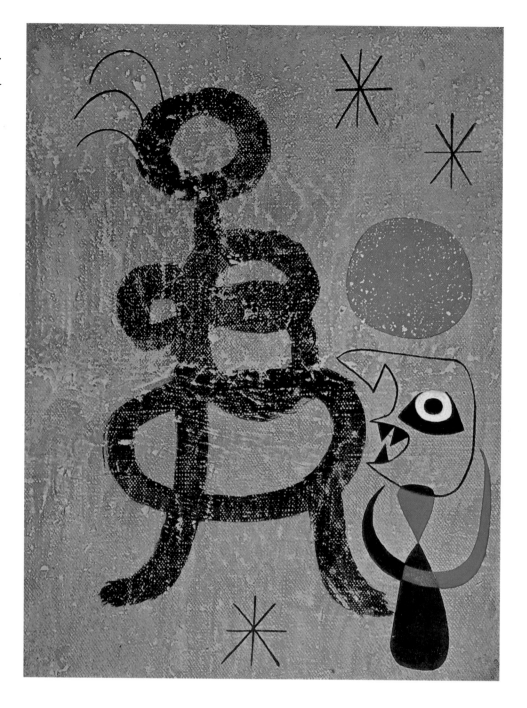

Woman and Bird in Front of the Sun, 1944
Femme et oiseau devant le soleil
Oil on canvas, 35 x 27 cm
Currie Collection, U.S.A.

contact, but it was good to know that a meeting on the human plane confirmed what the pictures had led me to expect.

"Then there's Artigas", Prats went on. "I have written to him, but he lives in the mountains; that is to say, at the end of the world. A letter takes longer to reach him than an air mail letter to New York. We shall telephone. I couldn't get hold of him yesterday; he hasn't a phone. The village of Gallifa consists of six houses, and each house stands on a different hill. So Artigas has to be called to the only telephone in the village. His house is about three hundred yards from the post office. The postmistress, who also runs a grocer's shop, shouts his name out through the door. She suffers from asthma and can't walk far. As a rule this system works."

He picked up the receiver and asked to be connected with the only telephone in Gallifa. "This will take some time; meanwhile I shall show you a few things that may interest you."

114

He opened a folder filled with photographs of Miró and his friends at different periods. Then he showed me stills from the American film about Miró made shortly after the last war, in which both Prats and Artigas had taken part as directors and actors. None of them had so far seen the film, because the reels had not yet come to Europe.

When we had spread the photographs out all over the divan, the telephone rang loudly. Prats put the folder with the snaps back on the desk and lifted the receiver. The voice of the Gallifa postmistress came over the line.

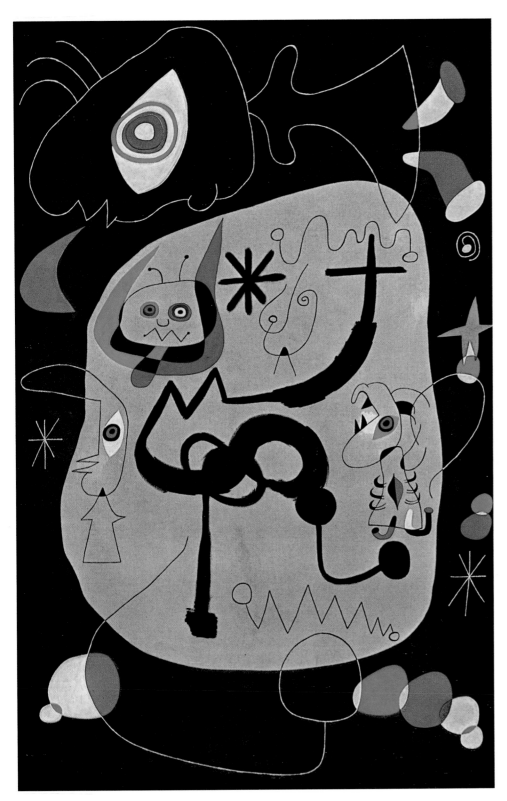

The middle of this large composition is occupied by a grey area on a surface which is otherwise black and carries as its central motif a broadly executed black symbol to indicate the female dancer, with several precisely drawn figures around her. The black surface is a swirl of stars and a creature with a large eye – sensations caused by the music. The music is linked to the central motif by means of intersections.

The white lines bordering on the grey centre turn into black ones, in order to remain visible, thus also indicating the other sphere and its transition.

Dancer Listening to the Organ in a Gothic Cathedral, 1945
Danseuse écoutant jouer de l'orgue dans une cathédrale gothique
Oil on canvas, 195 x 130 cm
Warner Collection, Norwich, U.S.A.

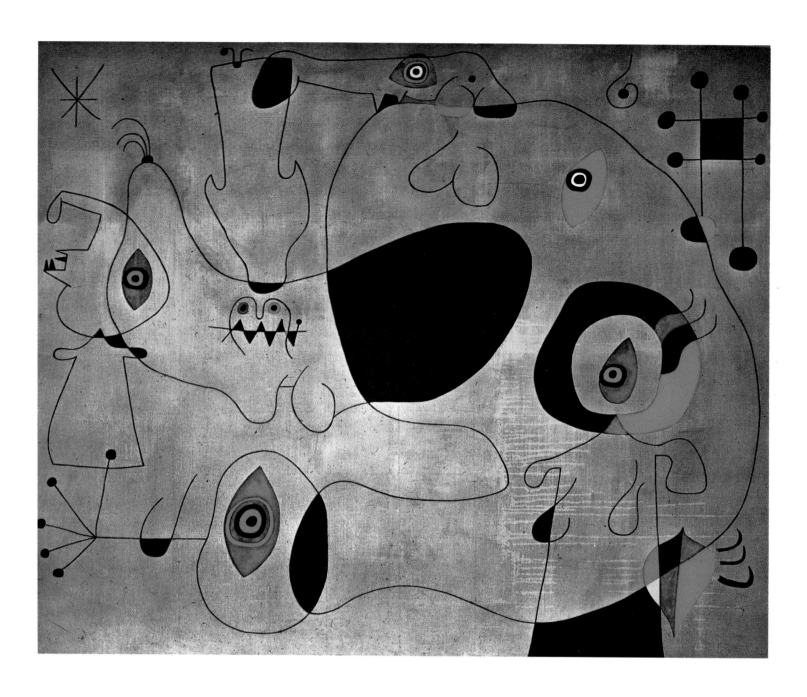

The Port, 1945
Le port
Oil on canvas, 130 x 162 cm
Private collection, New York

Prats spoke a few words to her in Catalan; then he seemed to have been cut off. *"Digi, digi, digi ... "* Prats sang into the mouthpiece, which is the Catalan form of *"Diga* – Do you hear?" I couldn't help laughing: the effect of this childish-sounding word spoken into the telephone by the grave man with the roguish face was funny. Suddenly the telephone began to crackle, announcing that the connexion had been restored. Prats held the receiver a hand's breath away from his ear. We heard the postmistress's long-drawn call: "Artigaaas, Artigaaaaas ... " Prats smiled. "That's good, isn't it – telephoning with and without a wire!" After a while, we heard the woman's voice again. Prats listened and nodded to me. "He has heard and is running over, she says; he has just reached the bridge. It's only another hundred yards. Now he must be waving. Aha, here he is!" And Prats discussed with his breathless friend whether I should come over to Gallifa the following day and which bus I should take.

The whole time Prats was speaking, I could clearly visualize the scene in the mountains. I had already seen photographs of Artigas's

116

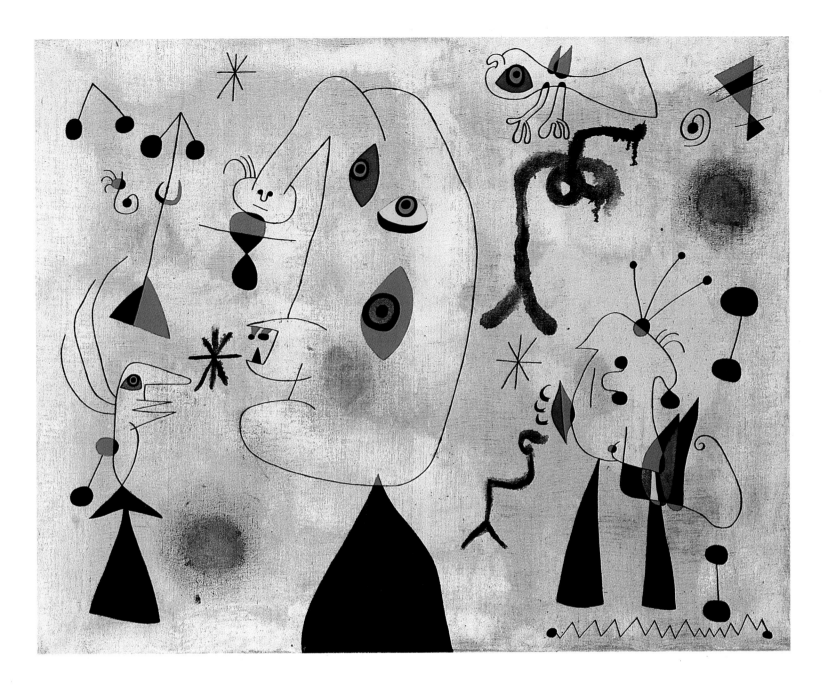

Personages, Birds, Stars, 1 – 3 – 1946
Personnages, oiseaux, étoiles
Oil on canvas, 72 x 93 cm
Marian von Castelberg Collection

house on the mountain top, a disused mill. Miró had given me a vivid description of the romantic surroundings, the upland valley and the towering cliffs of red rock. The course this telephone conversation was taking, and the lively tone of the two speakers, gave me reason to hope that in Gallifa, too, I should be a welcome guest. I had long since ceased to be surprised that everything connected with Miró, including the attitude of his friends, was full of engaging gaiety. It was as though Miró possessed the power of impressing upon his private world and his offshoots, as well as upon his pictures, the stamp of his compelling charm. In proximity to him the world became steeped in poetry, the same poetry that filled his works.

Prats put down the receiver. "The Artigas family bids you welcome. Señora Artigas will prepare a banquet; for they rarely have visitors in their solitude. You'll be able to speak German to her: she is Swiss by birth."

Prats rose and took his hat. "You don't wear a hat?" he asked me. "Prats's friends must wear hats!" He rang for a shop assistant, who

placed a curious measuring appliance on my head. He turned various knobs and made notes. "I expect you would prefer a light-weight summer hat, for Rome has the same climate as Barcelona. What colour and shape appeals to you most?" asked Prats. The assistant opened up one cupboard after another. Each cupboard was divided into several compartments and each compartment contained one model hat. As I looked undecided – it was many years since I had worn a hat at all – Prats pulled out a pale-grey hat with a narrow brim and a hatband of even paler grey. "Prats's Extra-Extra, as light as a feather. Just feel it! The

Hope, 1946
L'espoir
Oil, water-colour and pastel on canvas,
58 x 58 cm
Aimé Maeght Collection, Paris

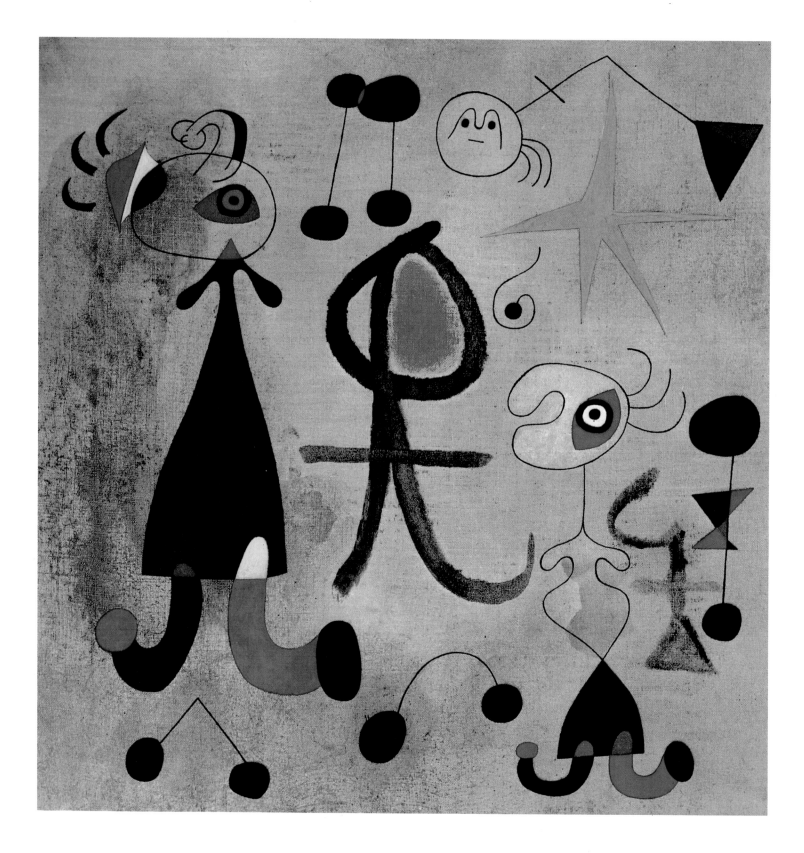

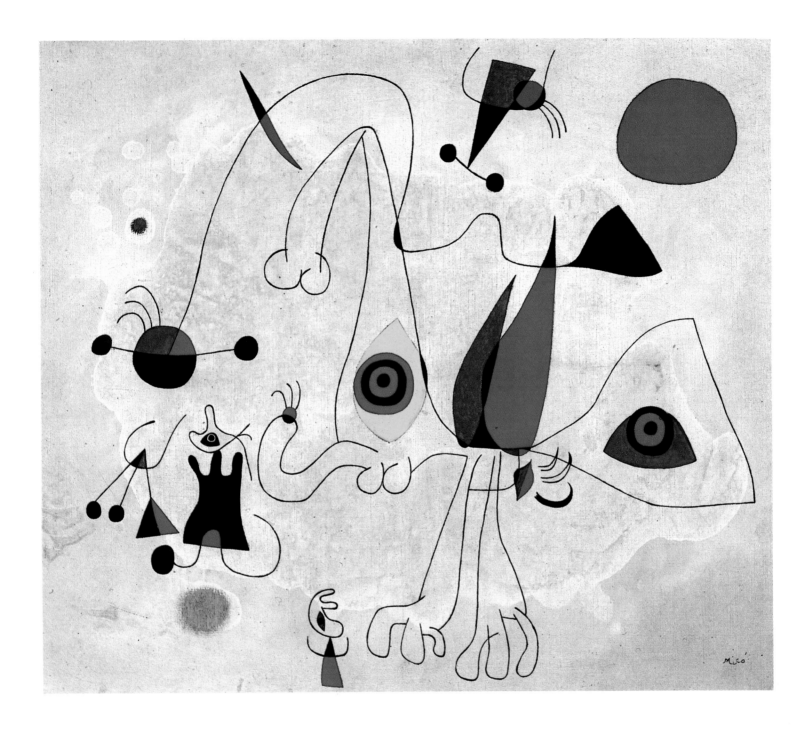

colour will go well with your suit. We shall make you a hat to measure. You're staying at the Hotel Colonn? Of course, all Miró's friends stay there. The proprietor is a friend of ours. You will be well looked after there. I'll send the hat round to the hotel."

The assistant listened to Prats's final instructions regarding the shop. Then Prats turned to me. *"D'accord!"* he cried. This was one of his favourite expressions. "Now we shall drive to my place. We shan't have to wait long for a taxi ... "

Prats's flat was situated on the outskirts of the city, in a suburb whose concrete skyscrapers enclose the jewel of Barcelona like protective fortifications. A lift took us up to the flat, which consisted of a long corridor with four rooms lying side by side. "Now that our children are grown up, we don't need so much space. Besides, I am often on my own; my wife doesn't like town life, she spends most of her time in our house on the Costa Brava." Prats led me into the large

Women and Birds at Sunrise, 14 – 2 – 1946
Femmes et oiseaux au lever du soleil
Oil on canvas, 54 x 65 cm
Fundació Joan Miró, Barcelona

After 1945 it was paintings with light-coloured surfaces that made Miró a "public painter." Many of his motifs helped him to become popular quickly. The finely textured, greyish surface shows a splotch of white paint which the artist has rubbed into the canvas so that only a cloudy shadow is left. It also limits the field of the finely drawn figures, the woman with her stylized breasts and genitals, her large shining eyes and the little birds that are fluttering around her. This mythical medley is benevolently illuminated by a large, red sun.

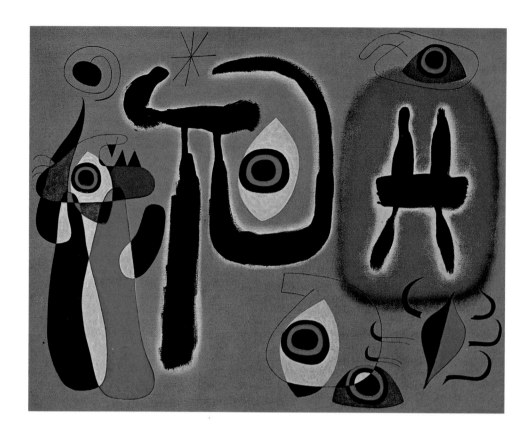

The Red Sun Gnaws at the Spider, 2 – 4 – 1948
Le soleil rouge ronge l'araignée
Oil on canvas, 76 x 96 cm
Stephen Hahn Inc., New York

Miró was never at a loss to find new poetic titles for his paintings. Very often the title and the picture are quite unrelated. They are derived from a poetic universe from which Miró derived his enormous variety of pictorial and poetic inventions. Heavy, black shapes and finely executed colour configurations exist side by side in this picture, but are totally unrelated, as if they were deeply involved in a never-ending dialogue. The picture is covered with imploring eyes that seem like alien stars looking on. A female organ clings like a spider to the red spot with the black calligraphy. Such pictures contain an atmosphere that is difficult to decipher, an element of pre-conceptual myth.

living room. The walls of the corridor were hung with pictures. In passing, I caught sight of one by Picasso and one by Léger.

The living room and the study and bedroom opening out of it were reserved exclusively for pictures, pottery and sculpture by Miró, apart from two of Calder's mobiles suspended from the ceiling. When I gave the sensitive wire frame a push to set it moving, Prats began to talk about Calder. "He is a friend of all of us, and he loves Catalonia, its people and its wines, gins and whiskies. Yes, Calder is one of the last great drinkers. He is one of the few people who appear all the more admirable, the more alcohol they consume. He is positively insatiable. You should get to know him, he would impress you too!"

On the walls, one Miró painting hung next to the other. It was the same in the study, only here they were mostly lithographs – the famous "Barcelona Series" which Prats had published in 1944. Prats was not only a hat-maker, but also a publisher, the originator of the Photoscope photographic picture books, keeper of the Gomis-Prats picture archives and a writer. Many of the paintings and lithographs bore the dedication *À mon grand ami Prats.*

While I was carefully examining each picture, Prats disappeared into the kitchen. After a while, he came out with a bottle of anisette, a soda siphon and a carafe of water with large blocks of ice floating in it. He mixed two glasses and raised his glass to me. Since the outside temperature was still seventy-seven degrees in the shade, the refreshment was welcome.

Prats joined me in front of the green pastel landscape with the chapel dating from 1916. "The chapel no longer exists", he said. "It was one of 'our' subjects, I myself still used to paint in those days, you know. When we painted from nature, we used to go together into the countryside round Barcelona. There were generally three of us — the

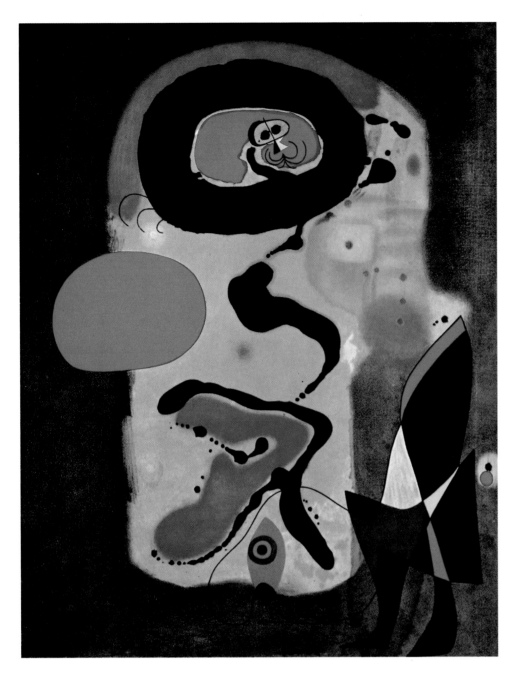

The Red Sun, 20 – 3 – 1948
Le soleil rouge
Oil on canvas, 91 x 71 cm
Private collection, Belgium

third was Artigas. In Spanish Miró means "the looker", Artigas "the artisan" and Prats "the field". Fate gave our trio the right names, didn't it? Each of us was allotted his vocation, mine was to till the field, the field of Catalonian art!"

"The picture I painted at the same time no longer exists, of course. But I remember that in those days Miró thought more of my work than he did of his own. In general, he had a very modest opinion of his ablilities at that time! When Artigas and I did a life drawing, it always turned into a kind of Michelangelo; the paper was always too small for our outsize figure. With Miró, on the other hand, the drawing seldom occupied more than a corner of the paper. As he used to say, it always turned into a frog."

"But we painted and drew, we made plans and were gay", continued Prats. We hoped everything of the future and nothing; to be honest, none of us ever wondered what would eventually become of him. We found our satisfaction in being and working together as friends. And

After his great success in America Miró started a new series of paintings, in which broad brush-strokes are set against finely drawn configurations and spots of colour are shown next to lines – a subtly balanced artistic dualism.
The Red Sun with its discreetly sonorous surface, from which a bright blue area shines like a window, is one of the most beautiful paintings of that time. Both zones are connected by a glowingly red sphere. The configuration on the blue ground has been put together very swiftly and is encircled by another red spot to which a few more brush-strokes have been added to make a cheerful little face. The other configuration has been placed in the right-hand corner of the painting from where it seems to be admiring this medley of shapes and colours.

121

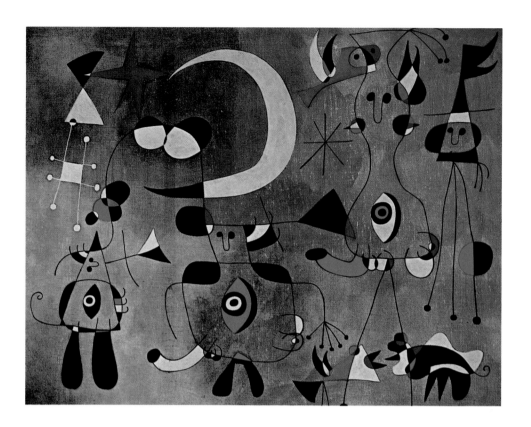

Painting (called Personages in the Night), 1949
Peinture (dite Personnages dans la nuit)
Oil on canvas, 73 x 92 cm
Private collection, Basle

Personages and Dog before the Sun, 1949
Peinture
Oil on canvas, 81 x 54.5 cm
Public Art Collection, Kunstmuseum, Basle

nothing has changed in this respect; for today we are better friends than ever, even if I no longer paint. When I was twenty, I recognized the limits of my talent and went into the family business. I have never regretted it. There are many hat-makers, but few practice their trade as an art!"

"Prats's Extra-Extra", I broke in gaily. "Prats is quality! Prats, *le chapelier artiste!*" Prats laughed too. "But we are talking about me", he objected. "That's not worth while. Let us talk about Miró! Of course, we didn't know then that he alone would make a name for himself. In those days Artigas and I were more adaptable. We could tackle a fresh task every day; we tried everything, convinced that we were going to achieve great things. Miró merely looked on with amusement. But he knew what he wanted, he had the greater intensity, he alone got there in the end; *il est arrivé, savez-vouz!"*

Prats had lit a pipe. "Miró developed like a plant that grows unobserved and at the proper time bears its fruit. It was a joy to us to be privileged to watch this development. We kept in touch with him, even when he wasn't in Barcelona. His thoughts were our thoughts; we thought and spoke in Catalan. When he went to Paris and we asked him what he was doing, he wrote back to us: "I am painting more 'Montroiginically' here than I ever did from nature." You know, Mallorca and Montroig are his true home. The consistency with which he painted picture after picture took our breath away. To us, these pictures are more than the testimonies of an esteemed friend, they are documents of this world and visions af a world to come.

"My modest collection has come into being without any effort on my part. Many of the pictures are gifts from Miró, like this *Chapel,* which was a wedding present. The child in this portrait is the daughter of the steward of Miró's farm; I bought it by instalments from a Barcelona art

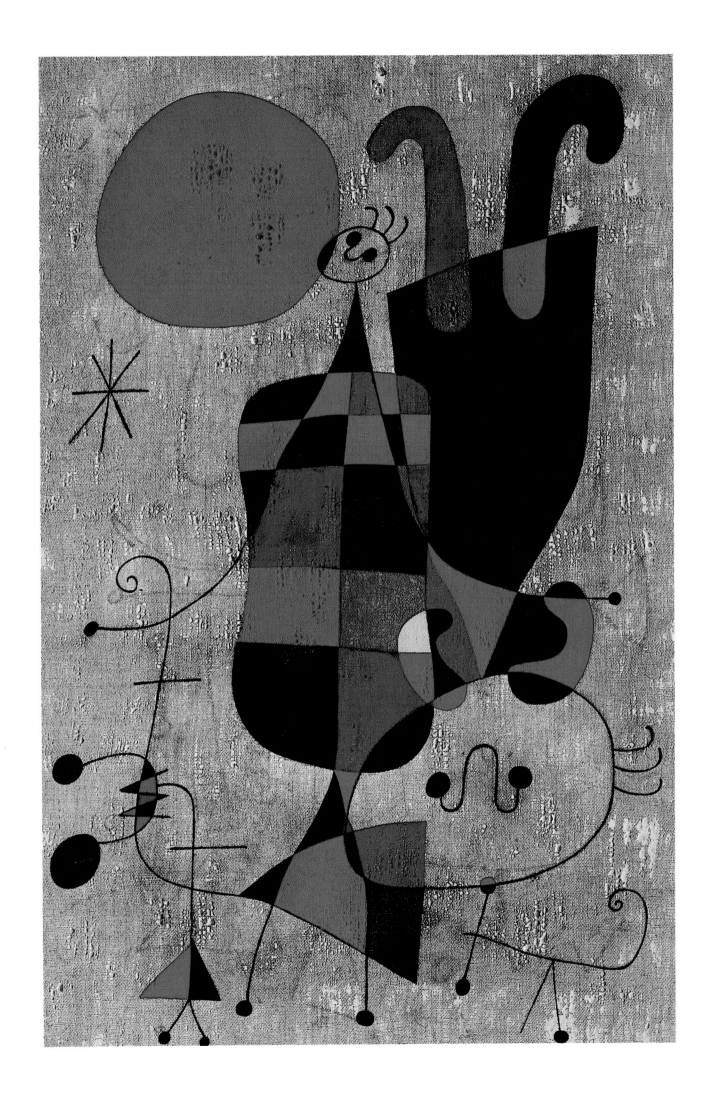

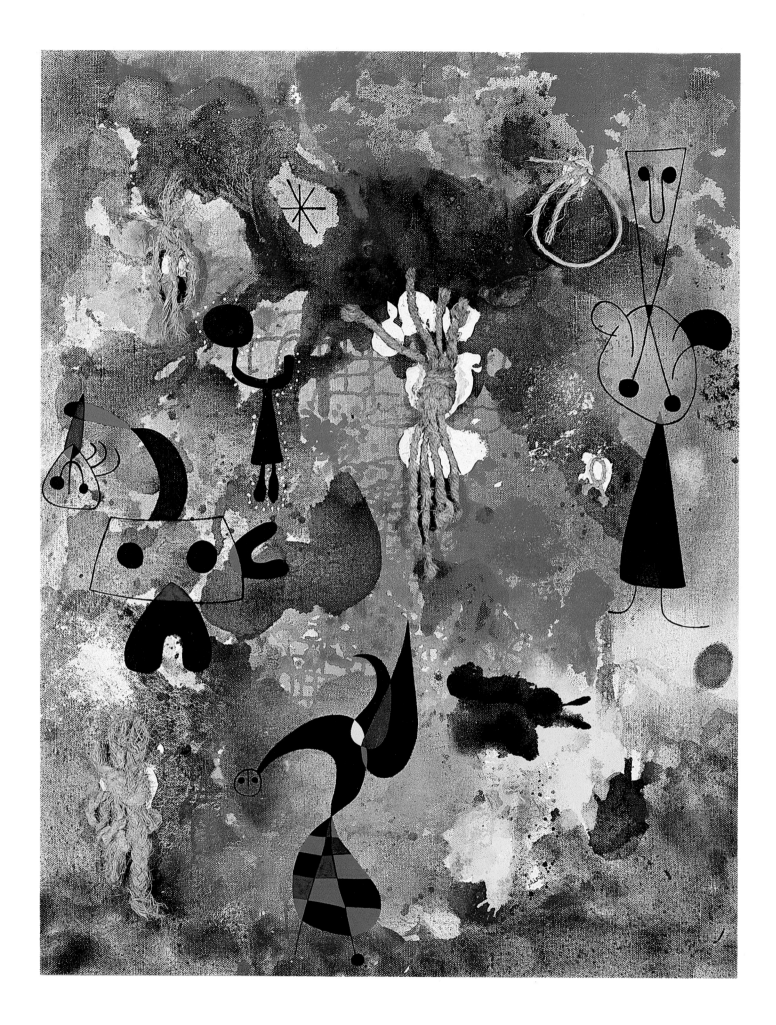

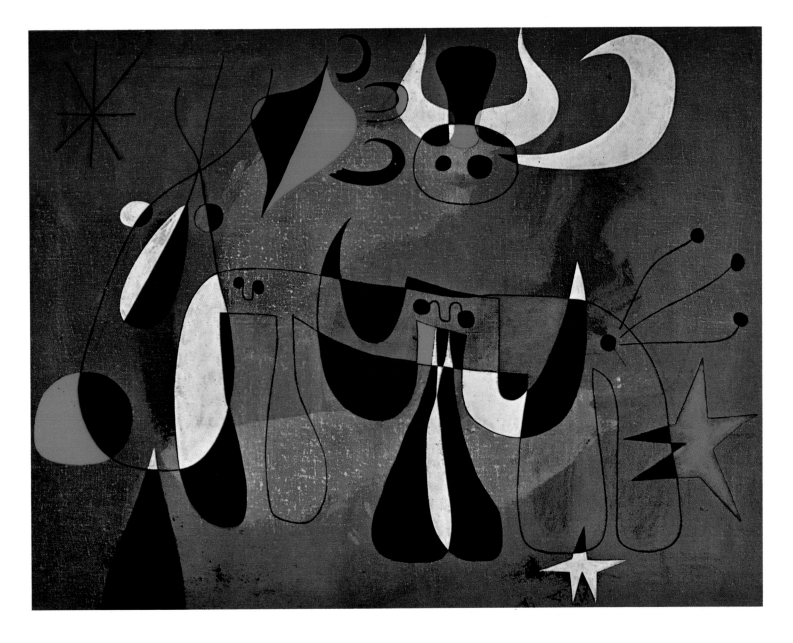

dealer." We came to a stop in front of a picture above an old-fashioned commode. It was a *paysage* from the year 1930 or 1931: abstract signs in strong vermilion, green and yellow flying across a translucent blue ground.

"This used to belong to a Jewish lawyer from Berlin, who fled from France to Spain in 1940 in the hope of getting a ship to America from here. He carried this canvas rolled up among his few possessions. As he hadn't enough money for the crossing, he tried to find a buyer for the picture in Madrid. But no one wanted it, until someone advised him: 'There's a crazy hat-maker living in Barcelona who buys stuff like that.' He actually risked the long journey to Barcelona, and I bought the picture from him — for twice what he asked. It was no trifle for me either at that time. Today the dealer Pierre Matisse in New York would give me ten, perhaps twenty times that price for it."

We had made our way into Prats's study. "All these lithographs", Prats continued his monologue, "were printed in Barcelona. I published them. They are a rarity, because there are very few other complete sets like this. During recent years, Americans have offered sums for them that represent a fortune to me. But I couldn't part with a single

Figures in the Night, 1950
Personnages dans la nuit
Oil on canvas, 89 x 115 cm
Private collection, New York

The *Painting* (opposite) shows a grainy surface, consisting of fine moiré structures and pure, glowing colours. On this restless – but by no means disharmonious - surface a number of figures from Miró's world of symbols are gathered together, which are quite capable of holding their own against the strong colourful stimuli. The ropes and cords which have been incorporated may be meant to point to the physically tangible reality of the painting – an additional optical stimulus which did not find its way into informal art until considerably later.

Painting, 1950
Oil, cords and case arte on canvas,
99 x 76 cm
Stedelijk van Abbe Museum, Eindhoven

one of these sheets. I should feel the absence of a single picture from my flat as an unbearable gap. For this reason, I have never been willing to lend my Mirós for exhibitions for even a short time.

"People may call me the mad hatter", he went on, after lighting a fresh pipe, "but the building up of this collection means more to me than a hobby or an investment; it symbolizes my friendship with Miró, and this friendship is my life. When I see these pictures, I need nothing else. They contain the whole of life. Whatever fresh emanations life may hold in store, Miró has captured it once and for all in these pictures.

"How do I reconcile art collecting with my activities as a hat-maker?" said Prats, taking up my question. "I see no contradiction in that. I do one and love the other. I wanted to become a painter myself, as I told you. That wasn't the right thing for me. What point would there have been in increasing the countless multitude of mediocrities by one more? But the love of art remained, indeed it grew stronger. The privi-

A large, black figure rises against a dark blue starry surface. The shape that forms the head contains a yellow-green eye, staring into the night and wide open, like a cat's eye. The hook-like indentations on the head may be arms or breasts; they may be raised as in prayer or ready to catch something; they are aerials stretched out into the night and belong to a mythical figure, on the same level as the ancient mother goddesses of the Mediterranean. Set against this vision, the red sun only confers a cold and fading light. These are creatures of the night.

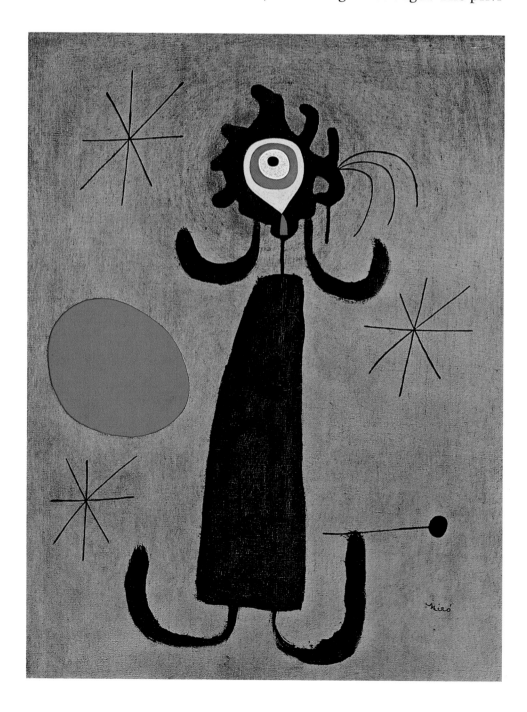

Woman in Front of the Sun, 1950
Femme devant le soleil
Oil on canvas, 65 x 50 cm
Private collection

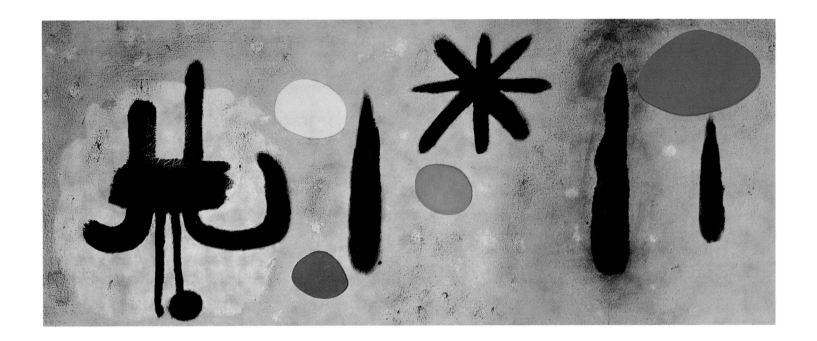

lege of being Miró's friend is a gift bestowed upon me for life. Miró has many friends, in fact it has been said that he only works for his friends and there is some truth in the remark!

"My family? Well, they accept me and treat me with patience, as people treat a man who is thought to be a bit mad. But that is also part of life. Life is motley and it is good that everyone should have his own ideas. People leave a madman in peace; what more do I want?"

Prats rose. "I haven't talked so much for a long time", he exclaimed involuntarily, filling a fresh pipe, which he had selected with great care from the mantelpiece. He pushed open the verandah door. In front of us spread a broad expanse of burnt ochre-yellow fields. The presence of the sea could be sensed on the horizon. Unfinished roads ended behind rubbish dumps and scaffolding. To the left and right towered skyscrapers. There was nothing idyllic about the landscape; it was harsh and sober. No lines of hills or groups of trees delighted the eye. After the plenitude of Miró's pictures, this poverty touched the heart with a feeling of disappointment. Above this area of suburban development arched the infinitude of a blue evening sky, upon which the sun that had long since set had left streaks of cardinal red.

Prats joined me on the verandah. The face of this man of almost seventy was drained of all vitality. The living features seemed frozen into a caricature of themselves. Only the eyes emitted a stormy gleam, the reflection of a fixed idea. These eyes did not see the undisciplined, formless quality of the landscape. They had been satisfied with other sights and needed no corroboration from the outer world.

When I returned to my hotel after our dinner, shortly after midnight, sleepy from the long day and the wine, the concierge informed me that Señor Prats had sent me a parcel, which was now in my room. On reaching my room, I immediately caught sight of the carefully packed hat box. It contained a feather-light summer hat, a "Prats's Extra-Extra". The initials of my name were stamped on the leather of the sweat-band in gold letters.

Painting, 1952
Peinture
Oil on canvas, 74 x 188 cm
Kiam Collection, New York

127

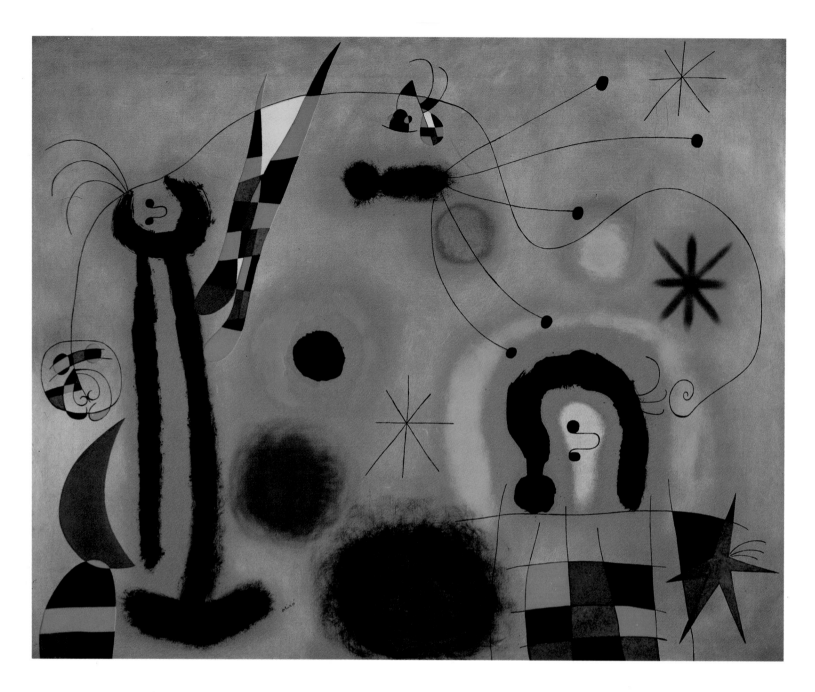

Dragonfly with Red-Tipped Wings in Pursuit of a Snake Spiralling towards a Comet, 1951
Libellule aux ailerons rouges à la poursuite d'un serpent glissant en spirale vers l'étoile-comète
Oil on canvas, 81 x 100 cm
Museo del Prado, Madrid

When I reached the village of Gallifa, after a three hours' trip by bus, the scenery that met my eye was exactly as I had pictured it. Only a melancholy haze lay over everything: this morning it was raining for the first time since my two months' stay in Spain began. Artigas was standing at the bus stop with a large umbrella. The famous master potter was thick-set and powerfully built. He was taller than his friends Miró and Prats. At first sight there was nothing Spanish about him. He looked more like an intelligent Breton peasant. He had lived for a long time in Paris and worked with Dufy. His French was fluent. He rolled his "R", which gave an added touch of joviality to his speech and intensified the impulsive and rumbustious impression made by his personality.

"It's not nice for you to be greeted with rain, but the trees I have planted here at the roadside will welcome it, particularly this poor fellow here!" He bent down to the withered branch of a poplar no thicker than a man's arm, and pulled off the dead leaves. "When we moved here five years ago, there was only a muddy path leading to the

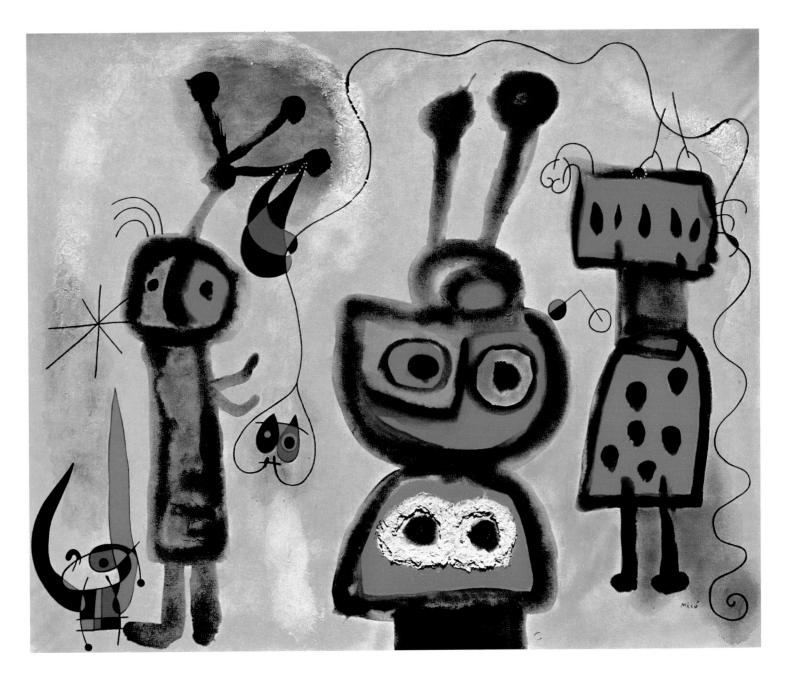

abandoned mill. The roof of the house was damaged and there was no glass in the windows. We had to install new plumbing and other services. But now it's a good place to live in; there's no one to disturb me while I'm working. The peasants accept me, even if they don't quite know what to make of me. I think they consider me some sort of secret agent, or an alchemist. Every week several cartloads of clay and timber for my pottery are delivered here. That arouses their curiosity."

We walked up the hilly path. The rain had slackened, mist was rising from brown rocks and pine trees towering some distance away. It was like one of the mountainous districts of Germany. For weeks I had been breathing a mixture of dust and ozone. Now my lungs were refreshed by the smell of earth and plants. In front of us stood the mill-house and behind it the little Romanesque chapel of unhewn stone. From a distance, mill and chapel seemed to form a single unit. Señora Artigas, an intelligent, strongly-built woman, greeted me in Swiss German. Shortly afterwards, we were joined by Artigas's son Walter, a young man of twenty with lively eyes and crew-cut hair, wearing blue

Bird, Watching Calmly, with Its Wings Aflame, 1952
L'oiseau au regard calme, les ailes en flammes
Oil on canvas, 81 x 100 cm
Private collection, Oslo

The hazy turquois surface seems as if children had left their drawings on it – grotesque little men with feelers, ladybirds on their hind legs, and in the middle a beetle woman with relief-like breasts stuck onto her, imitating the shapes of her eyes (or vice versa). Woven around the figure is Miró's well-known network of filigree lines, continuing the grotesqueness of the figures: a colourful little animal in the bottom left-hand corner, a hairy star and – thrown like a lasso – the extra long, line-shaped bird with its colourful butterfly wings. It is a picture in which Miró demonstrates his fondness of experimenting with different materials and their symbolic potential.

In this painting Miró shows the world of his images in a very cheerful vein. Hovering in the top half of the picture, there are his usual escape ladders leading into heaven – symbols of the artist's relationship with the powers of creation. In the middle there is a large grey figure which that seems to be grasping at the ladders. Two enormous claws are bent upwards, and the animal-like face is turned towards the other figure on the left, whose head is balanced on a pointed pole. This nocturnal painting shows a cheerfully musical and easy-going playfulness.

Ladders Cross the Blue Sky in a Wheel of Fire, 1953
Les échelles en roue de feu traversent l'azur
Oil on canvas, 116 x 89 cm
Private collection

jeans. He greeted me in English. I shan't have any difficulty in making myself understood here, I thought to myself.

The interior of the mill was the size of a spacious farm-house. The walls were whitewashed. I had to celebrate my arrival with a large glass of Spanish brandy, a local product, which set my throat on fire but warmed me through and through in the most pleasant manner. Father and son conducted me into the big workshop, the former grinding-room. One wall was occupied by a tall kiln that extended through the ceiling and up into the loft. Huge blocks of timber were piled up beside the kiln, which was still fuelled with wood. "It's not so easy to get hold of the wood", declared Artigas. "The local timber is no use for our purposes. We have no electric power, but in any case an electric kiln would not give the kind of heat we need for our work. To produce the hundreds of ceramic tiles for the Unesco building in Paris, we need several tons of wood and a vast quantity of clay every month."

On the wall hung the design for Miró's great ceramic. On a narrow frieze of darkish grey mingled with *terre verte* rose two elongated, divided forms resembling old ship's hulls. These forms were built up out of squares and trapezoids of intense and glowing blue, red, green and black. Even the black was felt as a colour, which shimmered when the light caught it. In the right-hand hull there gleamed a segment of yellow; it was the brightest touch of colour in the whole composition and flashed out from the patchy earthen ochre of the background like a splinter of glass on a path when a ray of sunshine falls upon it.

Above this form, a huge blue crescent moon thrust upwards. All the remaining elements in the composition seemed to be drawn into its circling movement. A thin, sensitive line terminating in a circular black head spiralled round the crescent. Despite all the power of its movement, the crescent moon yet seemed completely at rest.

The linear structures growing up out of the first major form aroused no immediate desire to identify them with reality. Keeping to the metaphor of the ship's hull, they suggested masts, sails and rigging. Almost simultaneously, however, other associations gave rise to different images. The long zig-zag line with a head at one end and a leaf-shaped tail at the other turned into the outline of a bird. The line that shot off to the left, turned sharply to the right and ended in a large white and red triangle, with curving sides and rounded angles, resembled the stem of a flower bending its head to the earth. The image of the flower then made it possible to see the lines of the bird-sign, which crossed its stem, as leaves. Between the two halves of the compositions hovered a star made up of black lines.

This picture breathed calm and power, like the night sky arched over a town. It was difficult to interpret logically the effect that emanated from it. Language, which draws its words from the well of past experience, has to create a new vocabulary and new terms of expression when confronted by an object never met before. Yet I could feel something coming to me out of the picture and communicating itself to my senses, my whole organism.

The painter is always one stage of experience ahead of the spectator. He is the more experienced, the elder. The spectator is always the less

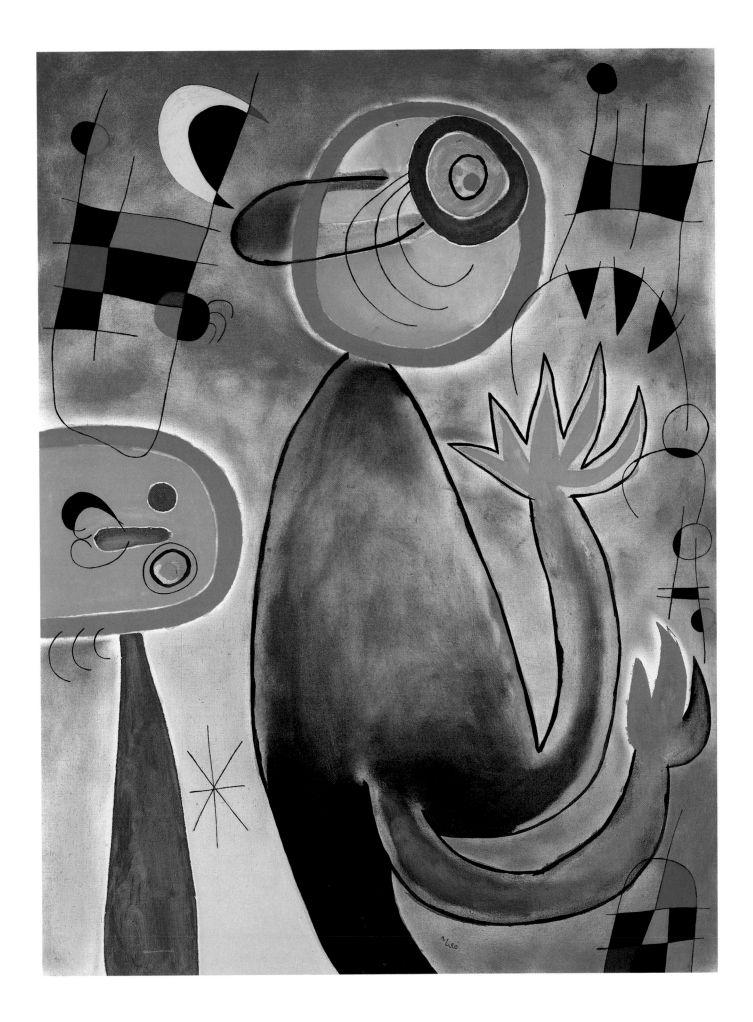

There is a wonderfully magic effect about the colours in this painting, which concludes a series of pictures of the 1950s, before Miró turned almost exclusively to printing and ceramics.

A frieze-like oblong format shows a highly complex surface, with a variety of blue-green shades, on which Miró's typical figures unfold themselves. The brightly shimmering surface allows the white canvas to contribute towards the general colour scheme, conjuring up the atmosphere of a moon-lit midsummer night. Superimposed are Miró's characteristic symbols which the artist has developed into an iconographic cosmos of its own - stars, birds, figures and constellations of connected circles.

All the signs seem to drift along, hovering on the lighter surface, although they do have their own weight and their own sphere of existence. There are some rather gloomy figures, like the one on the left, mischievous ones in the centre, and a somewhat frightened looking little chap on the far right, who seems to be hiding his face in his hands. The cheerfulness of the figures, however, is counter-balanced by the dark magic of the colour scheme. Bright colours flash up, like beams of hope – red, green, yellow and blue. It is a poetic night which expresses man's hopes, anxieties and dreams, and anything is possible in such a strange night.

experienced, the younger. Hence every new picture, acting upon us like a shock, rejuvenates us. This may account in part for the revivifying effect exercised by contact with works of art.

I tried to communicate my impressions to Artigas. "I believe this reaction of yours is what Miró hopes future spectators of his ceramics will feel", replied Artigas. "To me, of course, this design represents more than a mere picture. I have been too intimately involved in its creation. But I can no more identify myself with the picture than the midwife can identify herself with the child borne by another woman. We discussed every single phase in the genesis of the picture. We went to Paris together; we spent hours allowing the enormous concrete block of the UNESCO building to impress itself upon our minds. We studied it by day and by night, together with the other elements of the city's structure, out of which it was growing."

"We asked ourselves", continued Artigas, "how the static construction of architecture could be so vitalized that it fitted organically into its surroundings, became a part of nature, as a temple, a church in a landscape is permeated by the nature which surrounds it and which it serves and expresses. This Paris suburb is not a landscape from which architecture can expect to draw vitality! Here, the architect must see to it that something vital radiates from his building onto the surroundings.

"Miró is close to every aspect of nature", he went on. "He grasps the nature of a landscape and the nature of a skyscraper with equal intensity, reacts to them both in the same way. He accepts skyscrapers as part of our world. But he wants to show people that the sun, moon and stars determine day and night in our cities. His ceramic is an essay in synthesis, the symbol of a hope!"

Painting, 1953
Peinture
Oil on canvas, 96 x 377 cm
Beyeler Gallery, Basle

"No doubt one might also say, an essay in a new artistic humanism, an art that also portrays a moral truth", I interjected, and I told Artigas of my conversation with a painter who had called Miró a misanthrope and his work phallic convulsions and monstrosities of inhumanity.

Artigas shook his head. "Miró is a Catalan, his conception of the human is thoroughly unsentimental. More than anything else, he wants man to grasp more profoundly what being human means, he wants man to create for himself a new order that is nothing else than active, creative participation in the greater order of nature. Is this idea inhuman? Why did Miró spend months studying Romanesque frescos before he started work on the ceramics? Why did he go to Altamira to let the cave paintings sink into his consciousness? Did he not adopt the most human of all artistic techniques, ceramics, in order to express spiritual values through truly earthly material? Ceramics is a workshop technique, it demands the collaboration of workers with the same outlook. And how ready Miró was to become the servant of his craft, how eagerly he tested techniques and methods, scrapped them and started again!"

"Look at these", Artigas continued, pointing to the countless strong wooden frames into which damp clay was kneaded. Each slab was eighteen inches or more in length and three or four inches thick. "What a long road it is from idea to practical realization. Each of the two walls consists of almost two hundred such slabs! First we thought of dividing them up into regular quadrilaterals and we had already moulded, painted and fired a large proportion of the slabs. When we put them together, we realized that the monotonous uniformity of the parts detracted from the vitality of the total composition. The idea of doing it differently occurred to us while we were going for a walk,

133

Painting, 1953
Peinture
Oil on canvas, 195 x 378 cm
Solomon R. Guggenheim Museum, New
York

This great mural in the Guggenheim
Museum opened up a new path for Miró,
enabling him to leave behind the style of
the 1940s which had made him famous
but which had also narrowed him down.
Miró wanted to move away from his
"trademark" and find a new openness
that at first expressed itself in new oblong
formats. He painted this picture directly,
without sketches, and relied completely
on the broad movements of his first
impulse. Set against an emotionally char-
ged surface of blue and brown spots are
some eruptive red and black beams that
form vague figures and are linked toge-
ther by some brief symbols. The figures
were subsequently filled with glowing
zones of colour – areas in which the fami-
liar magic of Miró's cosmos could unfold.
Some little twirls of colour and rows of
dots form three mythical creatures.
As an additional decorative element Miró
then scattered some short rows of dots
around the figures and constellations.
The spontaneity of the symbolism makes
this painting appear rather crude and less
well-formed than Miró's previous pictu-
res. The expressiveness of the symbols is
therefore of a different kind altogether.
Their expressive energy imprints itself
onto the surface like writing on ancient
stone plates.

quite close to my house. I pointed out to Miró that the wall encircling
the terrace of the chapel you saw earlier on looked so alive precisely
because all the stones were different sizes. Miró caught on at once and
we set about adding to the expressiveness of our ceramic wall by
means of similar irregularities. But that was easier said than done;
it meant fresh wagonloads of clay and timber and months more work!

"Then the problems of colour had to be solved. In most pottery,
colour is a decorative accessory or its purpose is to lend colour to the
monochrome earthenware. What we needed was absolute, pure
colour. How was that to be obtained on such a scale by the usual
methods? People have said that Miró and I quarrelled over this. That,
of course, is an invention of the journalists, who don't understand the
true drama of collaboration. They imagine that a lively exchange of
views immediately means a dispute! Naturally, I tried to inform Miró
of my previous experiences with these materials, to convince him of
what can be done and where the limits lie. Miró stuck equally stubbor-
nly to his ideas, which at first appeared to me impracticable. We
carried out innumerable experiments. In the end I was forced to admit
that Miró was right. Perhaps the fact that I once made a thorough
study of Babylonian and Egyptian pottery came in useful here ... "

Artigas fetched from a shelf a number of small, angular pieces of ear-
thenware that shimmered with the translucency of agate. "These are
some of our samples. My aim was to achieve with the means provided
by the modern dye industry, which we know, the same effects we mar-
vel at in Egyptian work, the methods and formulae for which we do
not know."

He dragged over some more slabs, which he laid side by side. They
formed a scale of various reds. He picked up the one with the most

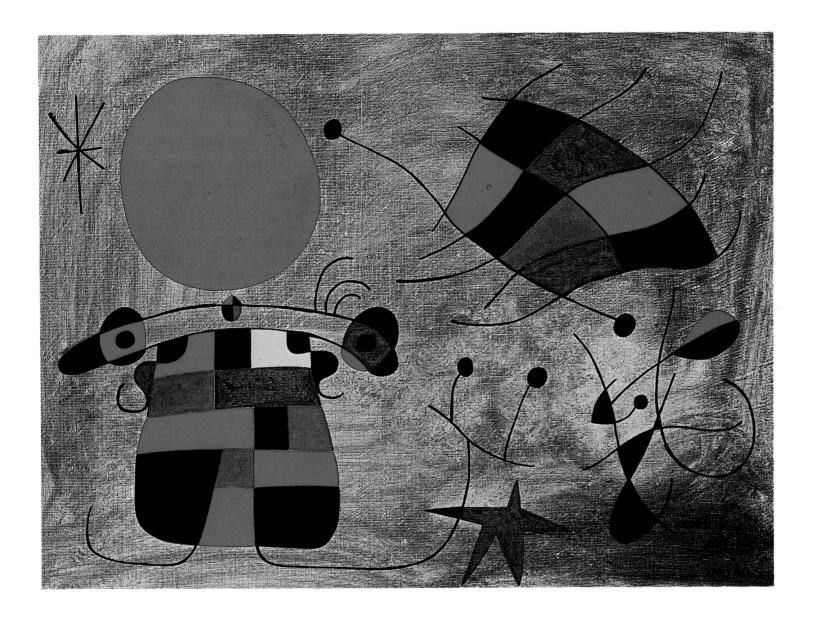

intense red and held it so that the light showed it to advantage. "That is the red Miró wanted. Like the blood of the bull glistening in the pale sand of the bull-ring on Mallorca – that was the effect he wanted. I think I've come pretty close to it. I spent six months experimenting on it. And this colour doesn't change, it will last for centuries! Miró needs Artigas, doesn't he? But what would Artigas be without Miró? Now you must see the designs!"

We all three made our way into the barnlike room next door, where a dozen huge sheets of hardboard were leaning against the wall. "Here are Miró's designs, painted in tempera and scaled down to half-size; because we haven't room here for a cartoon forty-six feet long. This one already gives us trouble. We will set the sheets up out of doors!"

All together we lugged out the sheets, which were nailed to strong supporting frames of timber and hence pretty heavy, one after the other and leant them against the wall of the building. Then we stepped back, first ten, then twenty and more yards, in order to appreciate the effect as a whole. The rain had stopped. The colour of the ochreyellow areas in the cartoon combined with that of the rocks round about. The distant dark-brown crags and the wet green of meadows and trees formed a natural frame. The colours and shapes of the car-

The Smile of Flamboyant Wings, 1953
Le sourire des ailes flamboyantes
Oil on canvas, 33 x 46 cm
Private collection, Spain

This picture is the first in a series of similarly impulsive paintings. Some even feature Miró's handprints – a pleading gesture for which he derived his inspiration from pre-historic cave drawings.
The use of materials and gestures became increasingly important factors in Miró's works. For a while he devoted himself exclusively to ceramics and developed some new techniques together with Artigas. It was with great energy that Miró subsequently took up painting again in 1960. With his new large-format paintings he picked up the thread of his series of pictures of 1953/54, while at the same time developing them further in the direction of poetic sensitivity.

135

There is a certain *pointillism* in Miró's paintings of the year 1954. To achieve this effect he used either a small stick or even his fingertips directly, so that there is a certain irregularity but also liveliness about the dots. However, Miró's rows of dots are far less sophisticated than in, say, Klee's *pointillist* paintings. Miró was contented with simple lines or arcs, to add emphasis to a figure after it had been painted.

The dominant shapes in this picture have been accentuated by means of black and white dots, applied at different intervals. However, the dots do not surround the shapes completely but concentrate on a few particularly prominent areas, thus achieving a further pattern in the composition. Set against a dark surface, these flashy dots seem to serve, above all, to bind the symbols more closely to their background and to create a greater clarity of form in the face of chromatic abundance. But this also means that the symbols, which are normally suspended indefinitely in space, are in danger of freezing and becoming immobile. In other paintings of that time these rows of dots often seem like heads of nails, pinning the symbols down to their background, which is in principle of a very open nature.

toon stood out clearly, as though they had been waiting to be confronted with nature. The landscape, refreshed by the rain, lay there with equal clarity and conviction. It accepted the proximity of the picture. Each was intensified and illumined by the other. The landscape, generally so inhuman, was pulsating with the will of man, his yearnings, his creative joy and his suffering. Art had found its way back to nature as though to its origin and its goal.

Painting, 1954
Peinture
Oil on canvas. 46 x 38 cm
Fundació Joan Miró, Barcelona

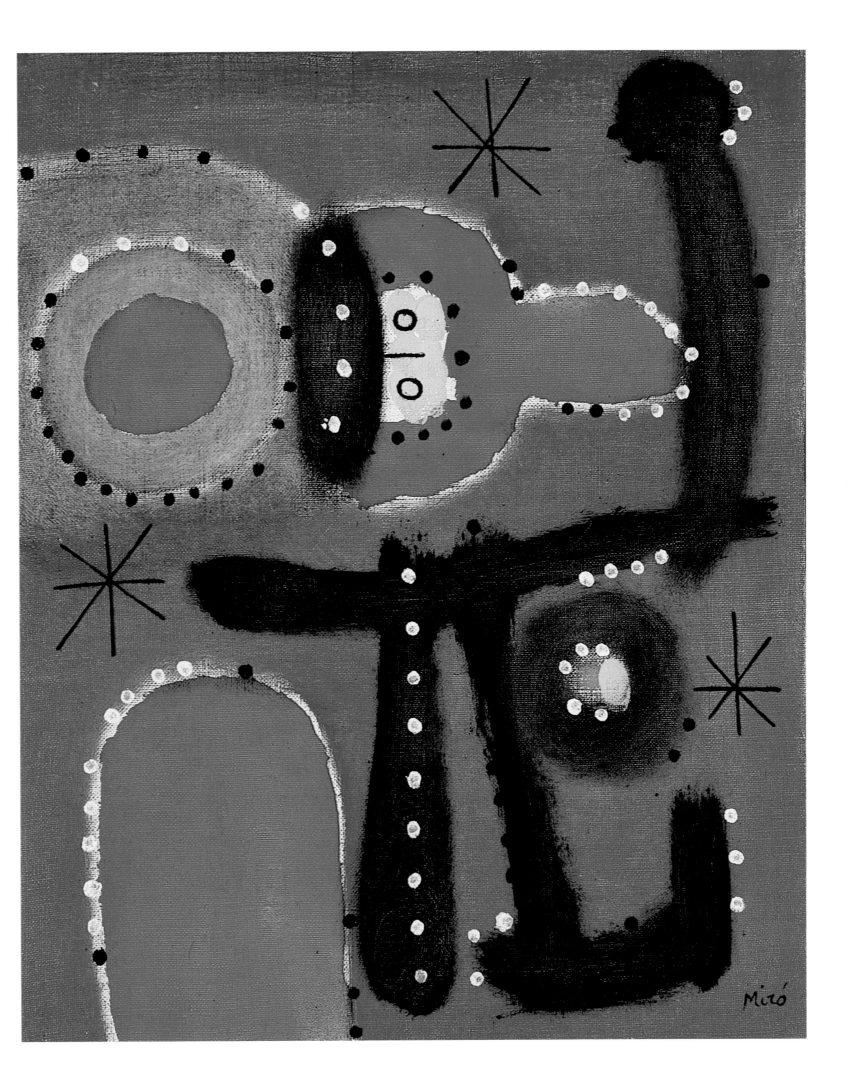

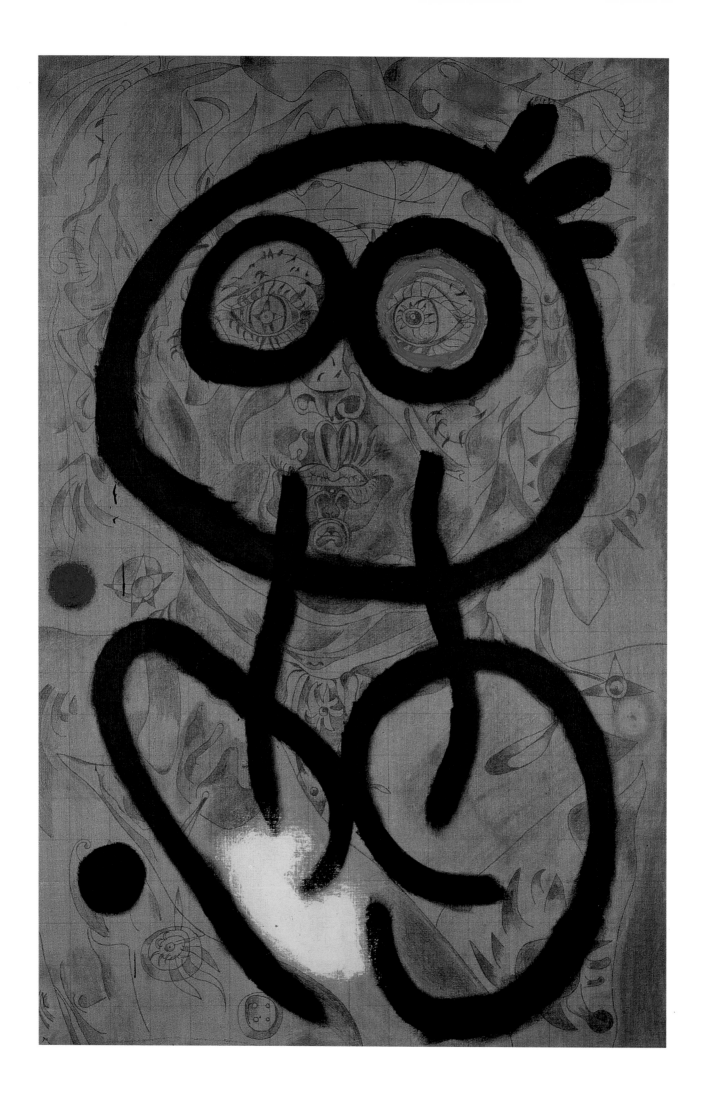

In Barcelona and Montroig

Joan Miró was born on 20 April 1893 at 4 Pasaja de Credito, Barcelona, the city that has been known since time immemorial as "the window to Europe". Joan's father was a goldsmith and jeweller. The painter continued to live in this house, which still belongs to him, at frequent intervals until his final move to Palma de Mallorca. The room in which he was born remained for decades his studio.

"The Catalonians", we read in Meyer's Encyclopaedia, "are a sober, shrewd people, physically and mentally agile, possessing great initiative and tireless perseverance." It would be facile to employ such generalizations, if they were not precisely applicable to Miró.

Miró's childhood was not limited to an urban background. His maternal grandparents lived on Mallorca, other parts of the family in Tarragona. When Miró was ten, his father bought a farm near Montroig that now belongs to the painter. From the very beginning, Miró had a love of nature and especially of his native landscape.

Drawing and painting were habitual occupations with the sensitive, silent boy. His father's hobby was astronomy. This interest communicated itself to the son, who would sit at nightfall bent over charts of the stars, or gaze at the sky through a huge telescope which, mounted on its tripod, still ornaments the terrace outside his studio at Son Abriñes. Jules Verne's fantastic novels were among his favourite books.

Naturally, only a child with marked artistic sensibility could have reacted so strongly to this environment. Biographical data alone would be meaningless, without the precondition of this creative bent, the origin of which remains a mystery. The poet, says Goethe, brings his vision of the world into life with him. The artist is born with the ability to create, as man is born with the ability to walk.

Faced at fourteen with the task of choosing a profession, Miró was at first permitted to follow his artistic inclinations: he became a student at the St Luke School of Painting in Barcelona.

I had examined in Miró's studio the work produced by the young painter under his teachers Urgell and Pascó. He had also told me of the difficulties with which he had to contend, the inhibitions and complexes induced by the realization that the evolution of his artistic language could not be furthered by an academic system. Nevertheless, during those three years of study his passion for art grew so much stronger that the difficulties he encountered only intensified his enthu-

Using a copy of a self-portrait painted in 1937, Miró sketched a figure onto it, with strong black brush-strokes and a small number of emphatic colours. This may appear to be a somewhat barbarian act because it almost completely destroyed the delicate drawing underneath it. Yet it was characteristic of a new mood, a general feeling of radical change, which made Miró embark upon a new and immensely productive phase in the early 1960s. Miró attacked, as it were, an old picture of his – his old image – and thus also an idea which people had had of him and his art for years.

The hyper-sophisticated mannerist had to give way to a new Miró who was full of fresh energy and vitality. The crude drawing with its broad, black brush-strokes was not merely destructive but also produced something totally new – a physiognomical expression, like that of an ancient mask, which had been reduced to basics and which is put on for cultic purposes to conjure up magic forces. This "new" self-portrait represents a Miró who had changed completely and who, from this moment onward, developed an even greater freedom and forcefulness. Again and again, he was to find new ways of painting, invoking art as a "magic force-field".

Self-Portrait, 1937-1960
Autoportrait
Oil and pencil on canvas, 146.5 x 96.9 cm
Fundació Joan Miró, Barcelona

siasm. One thing especially he had taken to heart, because it corresponded to his own natural instincts: the advice of his teacher Urgell that the artist should live in solitary contact with nature and his own work.

Looked at from their point of view, Miró's parents' action in breaking off their son's studies and putting him to work in an office is very understandable; they saw only the outer difficulties to which he was subjected.

The resumption of his studies in 1912, this time at the Gali School of Applied Design, gave him another three years in which to test and develop his pictorial gifts. At the outset of his evolution, every artist has to deal with the art of his day. The art life of Barcelona had received a powerful impetus from the example of Gaudí, Picasso and Gonzalez. The problems and consequences of Parisian Cubism were vehemently discussed in the studios and artists' cafés of the Catalonian metropolis. In 1915 Miró felt strong enough to embark upon his path as a free painter.

Left to his own devices, the young Miró realized all the more clearly that there was nothing to continue, that he would have to find his own pictorial language, a new grammar of signs and forms. His first pictures were exercises. The striking thing about them is that they do not display a development from an initial clumsiness to increasingly sure mastery of the tools of the trade – as might have been expected in a young painter. They are all complete works in their own right. It is difficult to imagine any one picture, each of which is executed in its own particular manner, being carried to a further degree of depth or intensity.

If we possessed nothing by Miró but these early pictures, we should nevertheless see in them the expression of true artistic gifts and recall Cézanne's statement that even a slight talent can make a good painter. That is to say, they are not breathtaking testimonies to future genius, but they do contain palpable evidence of the ability to combine colours and forms into a living, organic whole.

How many young artists have painted pictures that arouse great hopes for the future! But after the overture, the opera has failed to materialize. With Miró, exactly the opposite is the case. The true value of his early works is only recognizable in retrospect, when looked at from the vantage point of those that came later. Then the logic and unerring direction of his path appear startling. It is good to bear this in mind when we consider the early works, so as to discern in them all those features that foreshadow what is to come.

What gripped Miró when he looked at the exhibitions of modern art in Barcelona was less the exciting new artistic vision they embodied, than the striving for liberty and self-realization manifest in them, which aroused similar impulses and energies in himself.

Even more than by the revolutionary attitude of modern art – which, in spite of its deceptive appearance, is perhaps only the culmination of a historical evolution that began in the Renaissance – Miró was preoccupied by the world of his Catalonian homeland and its artistic expression. He encountered this world in the streets and museums of

Project for a Monument, 1954
Projet pour un monument
Sculptural object
Bell, iron, china hook, gouache and wax crayon on concrete, 53.5 x 13 x 17 cm
Fundació Joan Miró, Barcelona

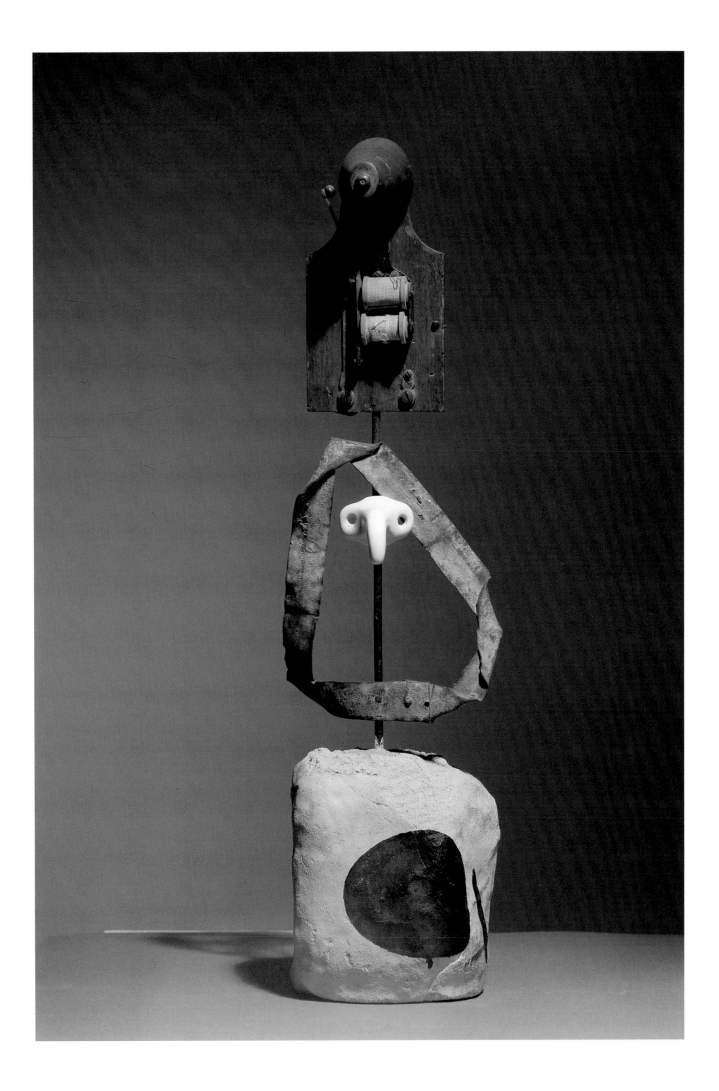

At the studio of the ceramics artist Llorens Artigas (left), 1944

Barcelona, in the churches, the houses and the implements of his environment, in the folk art whose roots can be traced back two thousand years and more. The Barcelona National Museum displayed the finest examples of Romanesque and Gothic painting, which enchanted young Miró. He was equally thrilled by the architecture of Gaudí, who gave Barcelona a new face that was basically a confirmation and resuscitation of its Catalonian character.

Of course, the young Miró realized that the products of folk art and the Romantic movement could not be repeated. He had no intention of following the prescription of the "regional painter", who tries to recapture the past by incorporating the elements of folklore in his work. What he dreamed of was a kind of painting that sprang from the same close contact with his natural surroundings and yet could compete with the works of the Fauves and the Cubists in originality of invention.

Hence his efforts during the coming years were directed towards the creation in modern terms of works that were as original and authentic as the Romanesque frescos of the year one thousand had been for the people of their day.

One of his early oil paintings, entitled *The Peasant* (p. 8), dates from 1912, the period when, after an interruption of two years, he entered the Gali Academy. We recognize the figure of the seated man in the dark suit; his hands are resting on his thighs, his eyes turned towards the painter. The outlines of the figure are blurred, the light from the background seems to be penetrating the solid substance of the body. The outlines are dissolved by nervous brush strokes and dabs. There is no question of the figure having been drawn out in perspective. What, according to the laws of perspective, ought to take place in depth, is extended laterally, distributed over a flat surface.

The man's head, sketched in with a few brush strokes and yet full of expression, gazes out from above massive shoulders. The seated man's bent legs, which have to bear the outspread mass of the torso, combine with the shapes and patches, the colours and their outlines, in a way that contradicts all the traditional laws of perspective, to create a new spatial dynamic. The dark border on the right-hand and lower edge of the picture gives the whole composition the appearance of a mirror image.

Amidst the dissolution of colour and form, the accents, the patches of colour, the areas of light and shade, nevertheless stand out clearly by virtue of the certainty with which they have been set down. The young painter was able to attain this certainty only by an intense preliminary study of the model. We witness the transformation of an observed theme into the different reality of the picture.

A new logic comes into action. Every square inch of the surface displays a different type of brushwork. At one point the paint is applied in quick dabs, at another it is laid on with flexible strokes. Since natural forms are always asymmetrical, there is no symmetrical balance in the picture. An abstract play of colour and form starts up; the surface vibrates with sensations of a painterly kind; the paint has lost its corporal character.

142

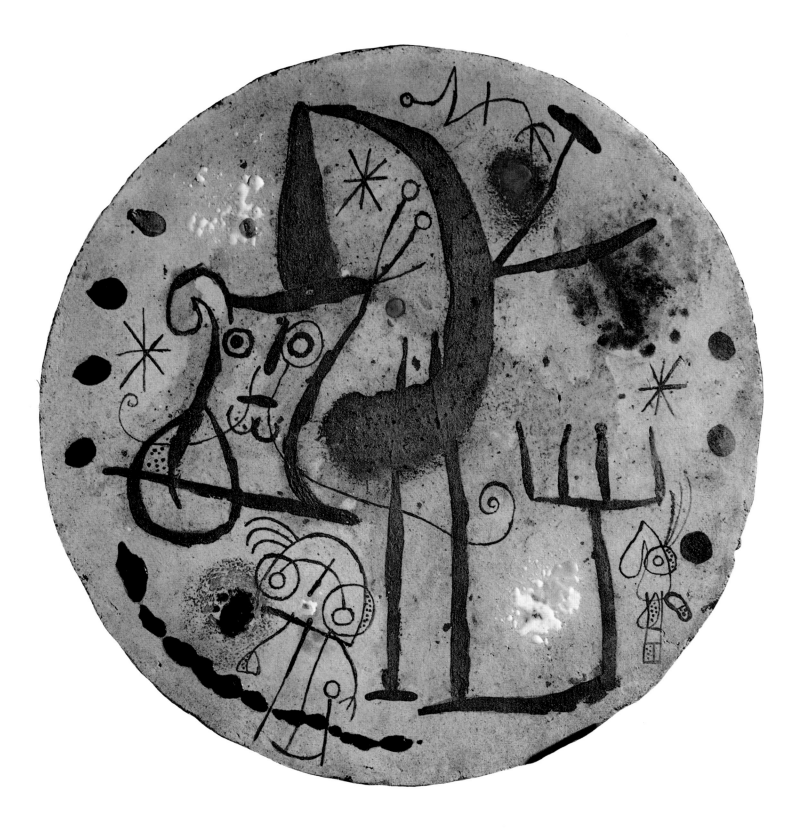

Spatial movements and relationships come into being that have
nothing to do with space as it appears in a Renaissance picture. Here
the spectator no longer feels himself to be placed at a viewpoint deter-
mined by the construction of the picture; here the expressive values of
colour, rhythm and tone are not subordinated to a preconceived intel-
lectual notion. The expressiveness of this picture is not achieved by
copying the physiognomy of the model in paint. Here the whole pic-
ture is physiognomy, a physiognomy which is derived from the life of
the colours and the movement of the forms in space, and which at the
same time reflects the psychic physiognomy of the young Miró.

Round plate, 1956
Plaque ronde
Ceramics, 36 cm in diameter
Perls Galleries, New York

A significant dialogue begins between picture and spectator. We are enabled to follow the painter's struggle to realize his pictorial idea as it were in reverse. We can see what a firm intuitive knowledge of the requirements of painting young Miró already possessed, though he was still averse from settling prematurely upon a particular manner, upon a form that had not yet become his own. To Miró, the painting of a picture is less important than painting itself – the process of active transformation.

In his still-lifes from the years 1916/17 Miró advanced to a more definite form. In Paris, the experimental phase of Cubism was already over. On the basis of the insights it had afforded, painters there were producing a series of classically balanced compositions in a spirit of friendly competition.

In Barcelona, on the other hand, every Fauvist or Cubist picture was bound to have a profound effect, but not so much because it represented something new and revolutionary to the artistic thinking of Catalan

Personage, 1956
Personnage
Ceramics, 28 cm in height
Private collection

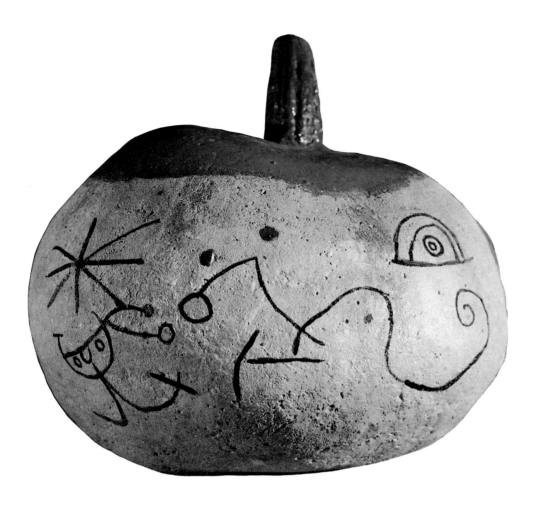

Pumpkin, 1956
Courge
Ceramics, dimensions not known.
Private collection

painters, as because, after the efforts of Gaudí and other adherents of *art nouveau,* the "wild" and "cubistic" was quite familiar to them. Gertrude Stein, a friend of Picasso's, once remarked that Cubism had been at home in Barcelona for centuries.

To draw "cubistically" was no problem for Miró. His way of seeing and comprehending forms was naturally Cubist, if by Cubism we mean the endeavour to transfer the dynamic of the spatial and chromatic tensions of three-dimensional space onto a two-dimensional surface, in such a way that the resulting distortions of form render the plastic values of objects truly visible for the first time.

The aim of the Cubists was to burst the bonds of the single fixed viewpoint imposed by Renaissance painting upon both painter and spectator. Painter and spectator were no longer intended to look at an object or phenomenon from "outside"; they were to feel themselves actively involved in a living process induced by the interaction of the picture's forms and colours.

The painters of the early Middle Ages approached the object they were celebrating by their portrayal in a spirit of pious humility. The painters of the Renaissance were interested only in the tensions linking the visible constellations of the external world. They identified themselves with the law by means of which they sought to establish the positions of things beside and behind one another in an illusory space. Visual point, horizon and vanishing points furnished a system of coordinates which they forcibly imposed upon the world as they had now come to see it. The Cubists wished to combat this system, whose creative vigour had long since been exhausted. But they, too, thought in

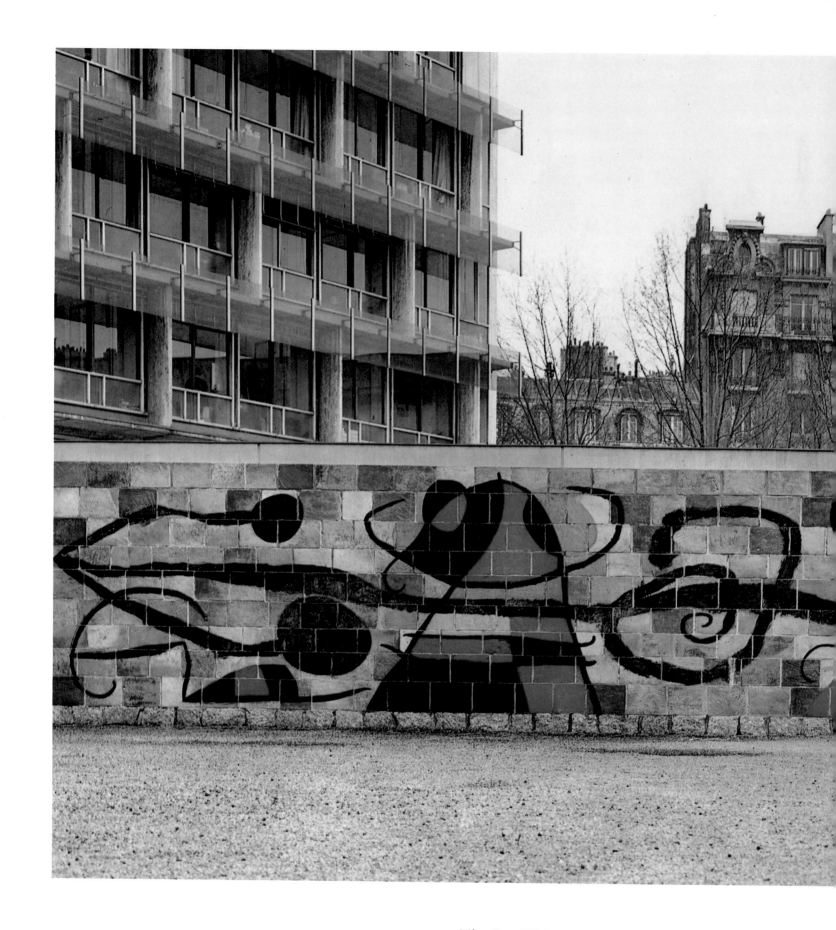

The Sun Wall, 1955–1958

At the beginning of the 1950s, Miró and his friend Artigas experimented with ceramics together. Those had to be fired at an extremely hot temperature before they could reveal the colourful luminosity of their glaze. In 1955 Miró was asked to design two walls for the

146

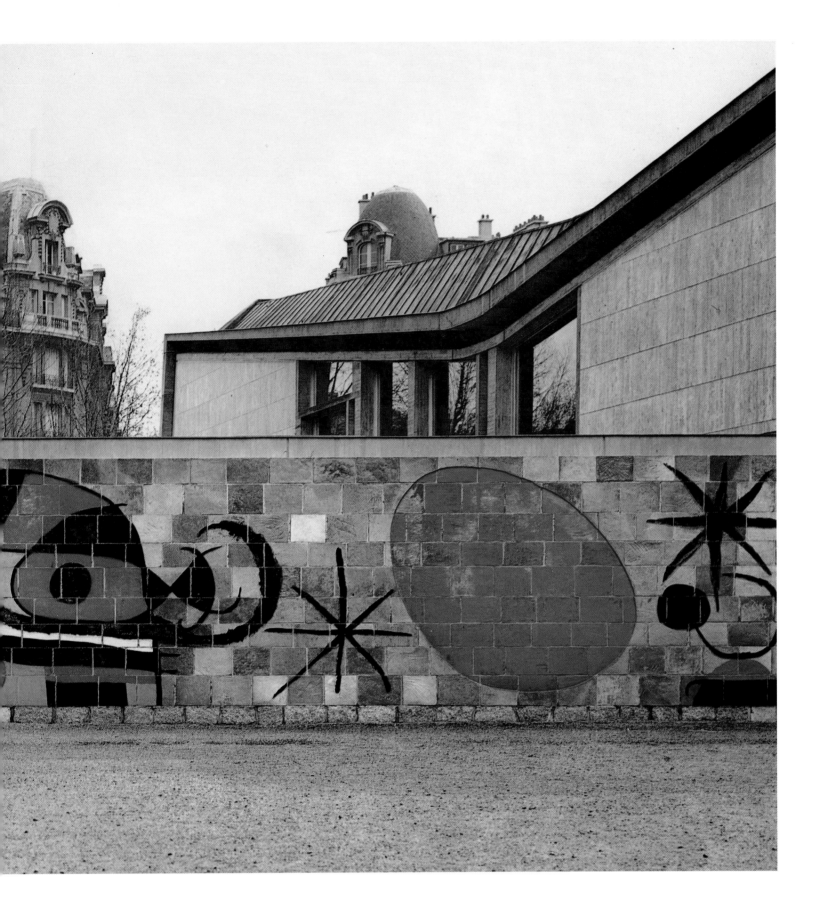

UNESCO building which was currently under construction in Paris.
Miró decided to use sharp fire ceramics, because this was what inte-
rested him most at the time. The two walls – 15 x 3 and 7.5 x 3 metres
– were to be placed in front of the conference building.

Miró first of all familiarized himself with the localities. Then he visi-
ted the building site and discussed the wall with the architects invol-

The Sun, 1955-1958
Le mur du soleil
Ceramic wall, 3 x 15 m
Unesco Building, Paris

147

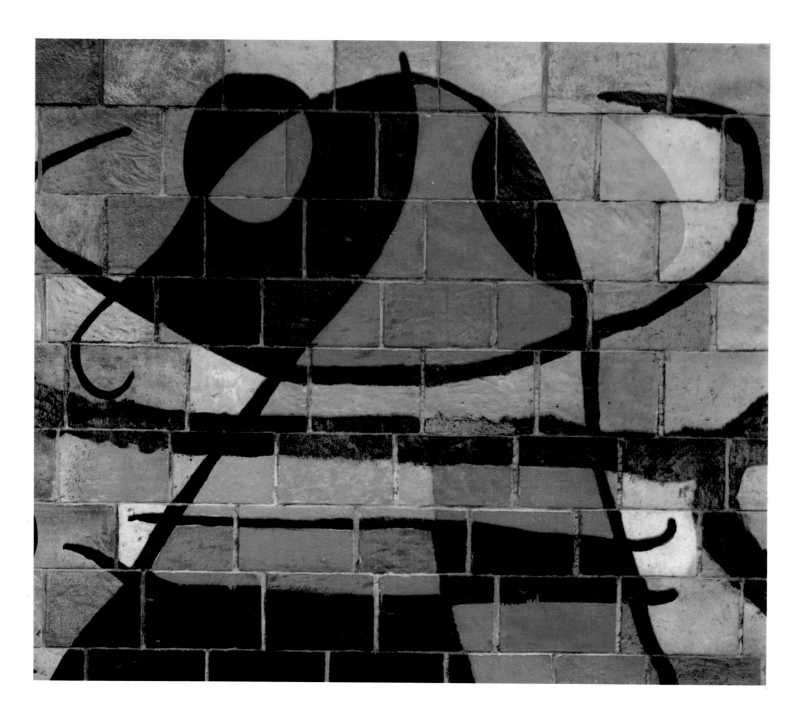

The Sun (detail), 1955-1958
Le mur du soleil
Unesco Building, Paris

ved. Unlike the surrounding concrete architecture, the walls were to be covered by a large, vividly coloured area of ceramics, to which the artist would then add large, free patterns. The one wall was to be dedicated to the sun, the other to the moon. Miró chose very intensive shades and decided in favour of a "brutally dynamic graphism" to achieve the desired contrast with the concrete: "And so the idea entered my mind that - to provide a contrast with the enormous concrete walls - I should put an intensive red disk on the larger wall. Its counterpart on the smaller wall was to be a blue crescent, in keeping with the more limited and more intimate area. I wanted to accentuate both shapes by means of vivid colours and clearly emphasized cutout portions ... I was trying to find some powerful expressiveness for the larger wall and a more poetic vein for the smaller one."

Three different models were considered. For their final decision, the painter and ceramic artist sought their inspiration from a variety of different sources: the cave drawings of Almira, the eroded walls of the

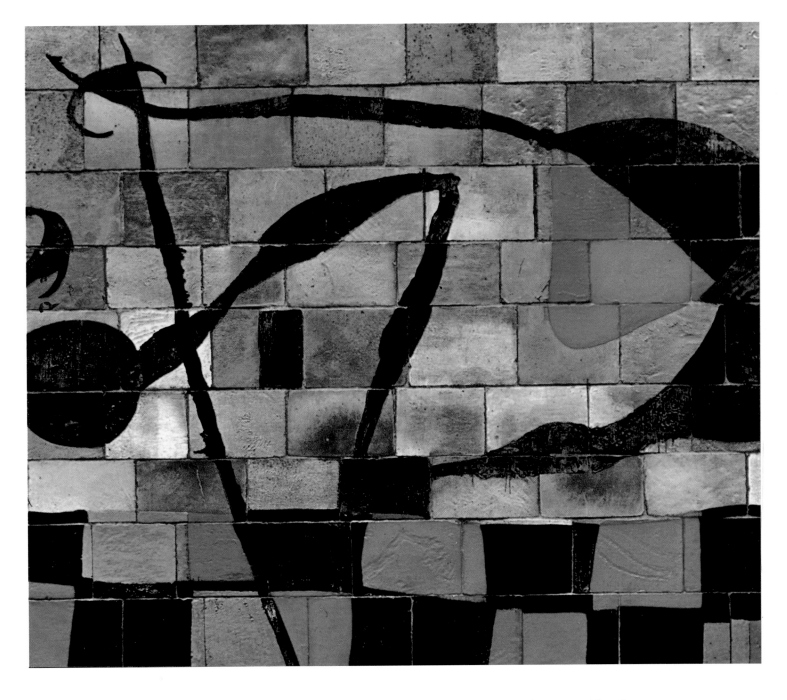

Collegiata in Santillana del Mar, the Roman frescos in the museum of Barcelona and finally Antoni Gaudí's bizarre shapes in Güell Park.

After the initial firing of the tiles, they were found to be unsatisfactory and had to be destroyed. Miró then decided that irregular tiles should be used, similar to the stones in old walls. When the tiles were finally ready, Miró's real work began, and he set to work on the large, unwieldy surface with a long palm-fibre besom. For the firing of the tiles, Miró had to rely on his Catalan friend Artigas, who was completely taken by surprise when he saw Miró plunge his besom into the paint and then draw shapes up to 20 feet long on the freshly fired tiles. After all, the slightest mistake could ruin the entire work. But Miró did create a masterpiece, with graphic symbols on glowing fields of colour, lapping round large figures like tongues of fire. The lively movements are caught by a star of hairs at one end and then deflected towards the red sun, which is so intensely colourful that it attracts all force towards itself and reflects it back again.

The Moon (detail), 1955-1958
Le mur de la lune
Ceramic wall, 3 x 7.5 m
Unesco Building, Paris

terms of tensions of an intellectual kind. They had visions of a new type of poetry, of pictorial music; but they had no more interest in the object they were depicting, in its poetic existence, than had the Renaissance painters. What they created, through misconstruing the experiments of Cézanne and Van Gogh, was an accumulation of vanishing points, which henceforth were to be sought not on the picture plane, but in imaginary planes behind and in front of it, so that the number of spatial tensions was multiplied. The spectator no longer had to opt for a particular viewpoint; he shifted from viewpoint to viewpoint, like a wanderer feeling his way along a city wall in search of a gate that will give him access to the city, but which he never finds. Hard as the Cubists tried to shake off the constraint of Renaissance painting, they remained, without wishing to, helplessly shackled to it. They carried Renaissance painting to its logical conclusion; they did not overcome it.

Miró felt attracted by the Cubists' élan. But he was not confused by their example, *"pas dérouté"* as he himself says. Miró's early still-lifes do not differ from the Cubists' *natures mortes* as regards the arrangement of the objects. Here, too, we find the obligatory table top or edge, the bowl of fruit, the bottle and the bunch of flowers. In his *Still-Life with Bottle* (p. 11), also dating from 1916/17, the form of the objects is wilfully exaggerated. The circle of the bowl spreads out into an oval around the big plump apple. The bottle bends over towards the edge of the picture; its shadow flies off in the opposite direction. The multiple folds of the table-cloth seem to open out like the leaves of a ripe artichocke.

Everything seems to be looked at from the centre of the picture plane and conceived of as being involved in a spiral rotation, to which sharp zigzag bands in the background form a vigorous counterpoint. The addition of highlights intensifies the picture's dramatic expressiveness. The colours have become independent; the green, red, yellow and brown form a restrained major chord. This is not cultured *peinture* with carefully placed shapes and textures — there is no trace here of the formal theme with ornamental variations beloved of the Cubists. Yet the forms are set down with thought; even the zigzag lines in the background gain their vigour from their significance to the composition as a whole.

The total effect is that of sculpture rather than painting. Miró handles the materials of paint and canvas as though he intended to construct a relief. This still-life reminds us that young Miró liked to handle objects he was about to draw or paint, in order to feel their shape and density.

Despite all the picture's dramatic quality, it still has about it a certain heaviness, which, however, lends the work a reassuring solidity. Some of the dominant forms are palpably striving towards a new kind of pictorial expression; a language seems to be foreshadowed here that will become more audible in future pictures.

The young painter divided his time between Barcelona and Montroig. The first part of the journey from Barcelona to Montroig is by a railway that runs along the coast. There is a change at Cambrils, a pic-

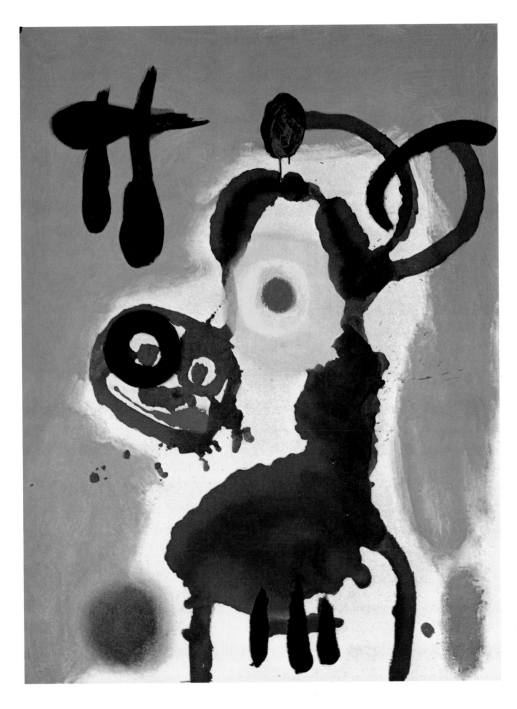

Woman and Bird, 1959
Femme et oiseau
Oil on canvas, 116 x 89 cm
Private collection

turesque little fishing village with a harbour quay, against which, as in Miró's youth, fishing boats are moored one beside the other. Today monstrous searchlights tower above the gunwales. Fishing is done at night and the fish are attracted by the glaring light. In the past, the fish were caught by day. Miró never forgets to mention that a little quayside restaurant, the owner of which he has known since childhood, will provide the traveller with a good breakfast that will fortify him for the continuation of his journey, formerly by narrow-gauge railway, but now by electric rail-car. Montroig lies a few miles inland, at the foot of the mountains. The name of the village means "Red Mountain" in Catalan. Miró's farm is situated between Montroig and Cambrils.

The hot climate in Barcelona during the summer months drew Miró's family to the more refreshing air of the mountains. Miró loved untrammelled nature. Since he was not interested in inventing the subject-matter of his pictures, he kept to what was offered by his imme-

In this painting Miró started with a blurred splodge of brown which he vaguely shaped into a symbol of a "woman" and, at the top, a symbolic "bird", consisting of three strokes. A distorted head dangles from the bent neck and is disfigured even further by the black eye ring and a mouth in the shape of a red wedge. At the point where the neck bends down there is a bright yellow star with a red dot, counterbalanced by a blue stroke in the bottom right-hand corner. The listless, shapeless figure is surrounded by a warm and vivid green, as if it were an unfinished creature protected by a membrane. What is so significant about this painting is the skilful way in which Miró demonstrates the force of chance – small, yet not unimportant for the artist. Even crude matter has an energy which the artist merely has to tap for his creatures to arise from it.

During his last creative phase Miró developed an inventive energy that was almost inexhaustible with regard to his choice of style or his combination of techniques and colours. Occasionally he went about it very cunningly and disguised the origin of his material – as he did particularly in his sculptures – whereas at other times he very generously allowed the viewer to fathom the poetic depths of his painter's mind.

In this painting Miró used an old piece of sackcloth which he may well have found on one of his walks. It is certain, however, that the heavy texture of the material as well as the printed words on it inspired his imagination. Once the sackcloth had been stretched into the right shape, there was very little else to do – a few bright spots of glowing colours, some black squiggles and some very simple shapes, perhaps one of his famous ladders into the sky – here in black and green – and a whole universe of references has become open to the viewer's imagination (provided he knows enough about Miró's imagery). And indeed, it is irrelevant whether the symbols are interpreted in a consistent way and whether one is dealing with a bird, a woman or some other symbol from Miró's repertoire. What matters is one's openness and the transparence of one's imagination, "the queen of all skills" (Baudelaire), which Miró has stimulated so inimitably, by means of his open and transparent choice of material.

Woman and Bird, 1960
Femme et oiseau
Oil on sackcloth, 75 x 37 cm
Pierre Matisse Gallery, New York

diate environment. Homely Cambrils furnished him with a multitude of subjects. An oil painting dating from 1917 is noteworthy for the gain in freedom by comparison with the earlier still-lifes painted in Barcelona. It bears the title *Cambrils Harbour*. The edges of a sunny beach converge upon the centre of the picture from the two lower corners. They are bordered by a row of sharply foreshortened houses and the trapezium of a harbour-bight with the shapes of beached fishing boats.

The sky is cloudy and — like the glittering yellow of the sandy shore — filled with that intense brightness produced by the atmosphere before a storm breaks. A tree with bare branches links the architecture of the houses fleeing towards the horizon with the side of the picture filled by the ships' masts. The rhythm of the composition is stressed by the accents of the dark gateways and open windows and by the vigorous lines of the masts and rigging.

The broad triangle of the coast road, the right-hand side of which is audaciously bent, is dotted with the figures of men and animals, which also grow smaller in response to perspective towards the centre of the picture. A female figure in the foreground recalls the life drawings Miró made the same year. Despite the lively use of colours, the drawing of the anatomy is tangibly manifest and the formal relationships of the parts are also taken into account; even in the more distant figures, the movement of each one is distinctly portrayed. An additional tension is also built up with the aid of the figures: the shadows they cast reflect their movements, but at the same time these shadows seem to be leading an existence independent of the bodies that cast them.

The Fauves had painted pictures of similar chromatic and spatial intensity ten years earlier in France. It is clear, however, that Miró was working from different premises. The Fauves sought to give increased firmness to the Impressionist style of composition by greater concentration and stress in colour and drawing. But the main source of their inspiration, as with the Impressionists, lay in the optical realm.

Miró makes use of the Fauves' inventions; yet his houses and ships, human beings and animals are filled with a different kind of life. The house fronts have acquired a physiognomy. The two open windows of the middle house gape like the dark, heavy-lidded eyes of a gnome; the open gate resembles a crooked mouth. There is something droll about the figures; the shadows have turned into flitting spectres. It is not difficult to see in the shape of the squatting shadow formed by the female figure one of the burlesque *personnages* of Miró's later work.

This picture is not the work of a painter who is trying to capture an optical experience in rapid strokes of the brush. Here we see an attempt to lend each individual form a life of its own, without losing a sense of the composition as a whole. Despite all the emphasis on the contrapuntal structure and the interrelationships between colours and graphic elements, he modulates each phrase with particular care — to retain our musical metaphor.

The picture no doubt lacks the triumphant pathos peculiar to the paintings of the Fauves. In spite of all the freshness of colour, which Miró's picture still radiates today and which gives it the appearance of

Ceramic Mural for Harvard University (detail), 1960
Ceramics, 200 x 600 cm
Graduate School, Harvard University,
Harvard (Mass.)

having been painted at a single sitting, the work simultaneously reveals a brooding melancholy, a grim humour and a kind of life unknown to the forceful stenograms of the Fauves. Here the painter identifies himself with what he sees, but at the same time he keeps that distance which the wise man requires in order, notwithstanding his inner participation, to allow the object of his experience to emerge as an independent existence, freed from his own subjective emotions.

Miró painted other landscapes. But he was not concerned with mastering a particular genre, with acquiring bravura or ease of brushwork. Young Miró was concerned with painting a picture. He selected for his subject whatever happened to be occupying his eyes and whatever he felt inwardly and outwardly drawn towards. At one point this was still-life, then landscape and later it was to be portraiture. That he did not immediately go on from one subject to the next was due to the fact that the task he set himself with each subject was not to be fulfilled by the painting of a single picture. Thus the need to work in series — which, like most painters of his day, he retained — arose out of the working process itself.

154

Painting on Torn Cardboard, 1960
Peinture sur carton lacéré
Oil on cardboard, 27 x 34 cm
Aimé Maeght Collection, Paris

Miró created naively; an inborn predisposition guarded him from analysing a task intellectually before embarking upon it. This did not prevent him from giving careful consideration to the stages in the evolution of the picture and the preparations leading up to them, in accordance with his thoughtful and methodical temperament. Hasty improvization was not his way; he did not feel an urgent compulsion immediately to translate a spontaneous pictorial idea into a work or art, as Picasso does. In the situation in which young Miró found himself at this time, painting meant above all working out with the aid of pencil and brush what a picture really is, what laws operate within it, what are the functions to be fulfilled by colour, form, rhythm and picture-space. This meant, at the same time, questioning everything he had so far been taught and everything he had seen in exhibitions and in his friend's studios.

Was colour a subordinate element in the total composition, subordinate to the more important element of drawing? Was it a factor possessing an autonomous expressive value of its own, or was its task merely to reproduce the density or transparency of visual reality?

155

The Red Plate, 1960
Le disque rouge
Oil on canvas, 130 x 165 cm
New Orleans Museum of Art, New
Orleans

Set against a dark blue, almost black sur-
face, a white splotch of paint has been
hurled out impulsively, and loses itself in
innumerable spots and spatters, a cosmic
gesture thrust against the empty void of
nothingness – almost a metaphor of the
artist's creative activity. Some spots of
colour flare up among this galaxy of crea-
tivity, of which the largest and most irre-
gular is the red one which gave the pain-
ting its title. Minute symbols are scattered
around the edges of the entire constella-
tion – stars of hair and little hooks which
give this action painting a new poetic
dimension and connect it unmistakably
with Miró's world of symbols.

The same problem arose in connexion with line. Was a line the pro-
duct of two contiguous colours, or was it entitled to enjoy equal status
with colour? What was the place of perspective in pictorial composi-
tion? Of course, every painter since the Impressionists had asked him-
self these questions. The experiences accumulated by Van Gogh,
Cézanne, the Fauves and the Cubists represented partial answers.
Kandinsky had dealt with these questions in his book *The Art of Spiri-
tual Harmony;* Paul Klee strove to provide a theoretical solution to the
problems that arose in the course of his experiments as a painter and
draughtsman. These questions were in the air; ever since the efforts
made by Gaudí and the exponents of *art nouveau* they had been dis-
cussed in the studios and artists' cafés of Barcelona.

In Miró's picture *Landscape at Montroig* (1917) (p. 13) the terraced
fields that rise up towards the village in the background seem to surge
rhythmically against the walls and houses. The jagged outlines of the
trees rise out of the ochre and yellowish-green like tongues of flame.
The cubic shapes of the village church form a reassuring contrast.
Nevertheless, these shapes and those of the houses surrounding them

are also drawn into the forceful movement of the summer landscape. The colour is striving to free itself, its outlines are themselves powerful bands of colour. Their function is no longer a graphic one, their relationship to colour is no longer that of a melody to a chord.

However ecstatically these colours and forms behave, however much they exaggerate movements visible in nature, they remain "natural" in their functions, they represent vigorous translations of something really seen. At the same time, we observe the care with which every form, every dab of colour has been set down. Despite all the passion revealed in the dynamism of this picture, the desire for order and the intelligence that is striving to impose this order are evident. There is no contradiction here between a thoughtful, reflective method of creating and the dramatic quality of the resulting work; they constitute the poles between which a deeper tension makes its presence felt.

It is not yet certain in what direction the experiences gained from pictures of this kind will take the painter. There are pictures of the same period in which areas of colour seem to become independent, in which shapes become isolated as "signs", as though they were striving

Joy of a Little Girl before the Sun, 1960
Joie d'une fillette devant le soleil
Oil on canvas, 130 x 162 cm
Private collection

At the beginning of the 1960s artists took fresh pleasure in experimenting with the art of painting. This led to many exciting discoveries which often consisted entirely of broad movements and the spontaneously creative use of colour. In this painting Miró used a black surface on which he spread some white paint, making it appear thin and blue – like a spiral nebula in the vastness of space. Hovering above it is a large red figure with protruberances like pincers, encompassing in a broad gesture the entire space of the painting, or rather the "inner space of the world" (as Rilke put it), as if praying to cosmic forces.

Blue I, 4 – 3 – 1961
Bleu I
Oil on canvas, 270 x 355 cm
Hubert de Givenchy Collection, Paris

Miró's three large-format paintings *Blue I – III* are part of a series of triptychs which he painted at the beginning of the 1960s in his new studio in Mallorca. Having travelled around America in 1957 and experienced the great variety and intensity of American art, he expressed the jolt it had given him in these paintings. What is more, they look in two different directions, referring back to Miró's last pictures of the 1950s – full of sudden movements and primaeval symbols – while at the same time looking forward to a completely new artistic freedom, a spontaneous attitude towards the material and colours, in a hitherto unprecedented way. The three blue paintings have to be regarded as one. Seen separately, nothing

to break loose from the pictorial scaffolding of lines and perspective that lies underneath or is stretched over the top of them, as though the chromatic sensations derived from the shock of the encounter with nature were striving to become visual music.

Is not a similar striving after abstraction, after the dissolution of matter and the rational organization of the composition, manifest in the early works of Klee and Kandinsky? In Kandinsky's case, it sprang from the desire to realize the absolute expressive potential of colours and their interrelationships; in Klee's, the aim was to uncover the mystery of a phenomenon or a form. Miró, who was so attached to the terrestrial world and so deeply rooted in the Catalonian landscape, followed a third route. He was concerned to force the "effective reality" of his surroundings to reveal itself even more vividly in a picture. He liked to feel he was on the way towards a new kind of pictorial reality. Cubism encouraged him, but his most profound purpose lay beyond them; he was more attracted by synthesis than by analysis.

Miró's first landscapes, still-lifes and life drawings aroused the interest of the art dealer José Dalmau, who had shown pictures by Léger,

Duchamp, Gleizes and Juan Gris as long ago as 1912. Dalmau, who also championed the young Spanish painters, declared his willingness to exhibit Miró's works. This exhibition took place at the end of February 1918 and lasted two weeks.

The watchwords for possible discussion in the studios and cafés of the Catalan metropolis had been increased by one: by the name of Joan Miró! Miró had many friends, but the most zealous and faithful were and remained his former fellow students Joan Prats and José L. Artigas.

Miró now had his own studio; he had become an officially recognized painter, which in his case meant that he applied himself to his task with yet greater devotion. His friends foregathered in his studio. While they discussed the imminent outcome of the war in general and the fate of the new European art and Picasso in particular, they had to let *"amigo Joan"* paint their portraits. This was his contribution to their conversations, a contribution that was to outlast the decades.

When we compare the 1912 *Peasant* with these portraits, it is like comparing a blurred photographic negative with a clear print. That

Blue II, 4 – 3 – 1961
Bleu II
Oil on canvas, 270 x 355 cm
Pierre Matisse Gallery, New York

much seems to be happening on them. Set against subtle surfaces in different shades of blue, Miró distributed a very small number of precise symbols – black dots with either sharp or blurred contours, thin lines drifting diagonally through the picture, and finally some sharp red contrasts, partly as blurred spots and partly as sturdy beams. These few symbols, however, are sufficient to make the blue space pulsate and vibrate, turning it into an unfathomable depth so that the viewer's glance wanders about and eventually becomes totally absorbed by the forcefulness of the blue surface. The quality of the blue is unique. It is reminiscent of Miró's *Dream Paintings* of the 1920s, though those are even more

Blue III, 4 – 3 – 1961
Bleu III
Oil on canvas, 270 x 355 cm
Pierre Matisse Gallery, New York

complex and intricate. Should there ever be a history of the colour blue – as the poet Rilke once suggested after he had been inspired by Cézanne's landscapes – then Miró's triptychs would undoubtedly form part of it. The large modulations of this colour have been applied with an amazing degree of sensitivity so that the pigment is no longer noticeable at all. This makes it a spiritual colour, in keeping with Romantic colour symbolism – a symbol of the inner and cosmic night, of artistic creation and of spiritual purity, a blue which is also the colour of dreams. It is one of Miró's masterly achievements that he enlivened this colour with only a small number of symbols and opened up the vast infinity of imagination.

which formerly threatened to dissolve in the haze of Impressionistic colour now meets the eye of the beholder distinct in every detail. These figures stand out clearly against a colourful and richly detailed background. At first glance, one is tempted to compare them to Van Gogh portraits from his Arles period; then there are passages reminiscent of Cézanne, but a Cézanne coarsened by Cubism.

At the same time, the portraits have about them a touch of the naïve, overemphatic quality of peasant art. Period accessories are stressed to the point of burlesque. For example, we see a chauffeur wearing a striped jacket and a bowler hat, with the picture of a 1910 car hanging on the wall behind him. The markedly distorted features with protruding ears border on caricature; the thickfingered hands rest clumsily one upon the other.

The portrait of his painter friend Ricart (p. 15) shows a figure with crossed arms. The torso is enveloped in a black and yellow striped pyjama jacket. The outlines are drawn with powerful black dashes. The streaks of red, yellow and green create an iridescent effect. The chrome yellow wall in the background bears a palette simplified in

poster style, the brown of which is made to stand out from the pale background by a broad green outline. A Japanese woodcut of women in a castle park is pasted to the right half of the background wall.

Although the heads with their dark eyes and harsh features are full of expression, one does not have the feeling that the painter was concerned to grasp the psychological aspect of his model. Van Gogh's portrait of Dr. Gachet draws its life from other areas of the soul. Here we see the world that presents the person's formal existence untrammelled by psychological empathy. But it is precisely the forcefulness of this approach, its audacious directness, its archaic quality if you like, that conveys a sense of shock and makes us sit up and take notice.

The first life paintings also (see p. 19) date from this period. They are continuations of earlier studies and sketches, now transposed into the more fixed and final medium of oil paint. The female figures stand out in sharply modelled solidity against decoratively patterned backgrounds. The flesh glows yellow and orange, the shadows cobalt, green and violet.

The plentiful use of arabesques suggests a liking for Oriental decorative art. In fact Miró was impressed at this period by the playful expressiveness and formal richness of Japanese and Persian ornament; in the two big exhibitions of the Impressionists held in Barcelona during the war, he had been able to study the influence of Oriental art on French painting. *Art nouveau* also made use of ornamental motifs drawn from all the cultures of the world. But there was a great deal of romanticism, that is to say of literature, mingled with this return to the past, this eternal Gauguinesque yearning for the lost paradise in which the spirit of pre-war Europe, tired by too much reasoning, sought refuge. By 1918, however, the world seemed to have been cured of this romantic longing. Miró, to whom highly coloured decoration was familiar through the folk art of his Catalonian homeland, saw in these symbols the vigour of the primitive.

While he painted in his Barcelona studio pictures whose orchestration makes one think of music full of cymbals and trumpets, on returning to the quieter surroundings of Montroig he found tones and shapes reminiscent of chamber music. The art of the East is not confined to exuberant ornament, it also includes the delicate flowered fabric of

Mural, 1961
Peinture murale
Oil on canvas, 115 x 364 cm
Sert Collection, Cambridge (Mass.)

161

For Emili Fernández Miró, 22 – 3- 1963
Pour Emili Fernández Miró
Oil on canvas, 78 x 280 cm
Emili Fernández Miró Collection, Palma
de Mallorca

miniature painting. Thus we see Miró painting in his studio on his parents' farm, landscapes — see pp. 20 and 22, for example — whose forms, colours and outlines seem, in their loving detail, to have been embroidered with a needle on a blue ground. Despite this wealth of detail, the sovereign form of the composition as a whole is preserved. The colour of these paintings is as fresh as on the day the painter took it down from the easel.

These pictures are steeped in poetry of a strictly painterly kind. What Miró had in his mind's eye was not beauty, but poetry. Only after observing scenes of this kind in Miró's homeland can we appreciate how successful he has been in bringing about a new awareness of their beauty. He succeeded in doing what Van Gogh, too, was striving for: he freed the world from the dullness of over-familiarity. Seen from this angle, Miró's use of Oriental motifs also assumes a new significance. This procedure enabled him to present the old and familiar in a new and vivid guise.

Miró painted several landscapes that were variations on the theme of his parents' estate, the olive gardens round about and the view of nearby Montroig. It is evident from these landscapes that, while already in possession of an unmistakable style of his own, Miró is avoiding anything approaching a system. He is seeking, rather, to achieve a freer mode of expression, without sacrificing the sharp definition of individual forms.

He has worked out an armoury of "signs" — signs for a tree, a flower, a blade of grass, a ploughed furrow — and he concedes to each sign its own individual quality. He disposes of these properties with sovereign skill, distributing them over the picture surface until he produces a tapestry-like design.

The stresses of his pictorial logic have shifted. The picture's component parts are no longer arranged in accordance with the topographical data of the subject; they now obey the more subtle law of composition within the plane. The values that render an object visible to us in our physical environment have been transmuted into pictorial, plastic values. In the process, one form or the other may grow beyond its actual proportions, may become independent. The row of young plants in the parallel furrows of a flowerbed become ornamental ribbons, strips of cloud become fluttering banners, the compact cubes of houses become crystalline formations thrusting up through the green billows of bushes and trees.

Finally Miró began a large-scale work in which he combined all the experience he had so far accumulated to create a mighty spectacle, a hymn to the landscape of his youth. This picture, which was later called *La ferme (The Farm)* (p. 29), acquired the same importance in Miró's *œuvre* that *Les demoiselles d'Avignon* had for Picasso's. Miró was about to cross the Rubicon.

In 1919 a big art exhibition was held in Barcelona, in which Miró's works of recent years hung side by side with those of Manolo, Gris and Picasso. Miró's pictures added to the orchestra of the Spanish moderns a specific new note never heard before. A group of artists formed by Miró's friend Artigas, to which Miró himself belonged, called themselves the Courbet Group. The appeal to the master of French realism indicates what the young Spanish painters wished to oppose to Cubism: a new way of grasping and portraying reality. Too grandiloquent a name would not have suited the gay temperament of the young Catalan painters, so it must be pointed out that, as Artigas informed me, the word *curbetistes* also means in Catalan the "tie-wearers". As early as this, Miró was distinguished by his sartorial elegance.

Miró's portraits, still-lifes, nudes and landscapes of this period show that he was teady to take fresh decisions. The necessary impetus, however, could only come to him in a new environment — in Paris.

For David Fernández Miró, 29 – 12 – 1964
Pour David Fernández Miró
Oil on canvas, 75 x 280 cm
David Fernández Miró Collection, Palma de Mallorca

Paris

In March 1919 Miró made his way to the French metropolis of art. His luggage included several rolled-up canvases, among them the unfinished *Farm*. He had also found a place in his trunk for a few *xiurells,* those brightly painted pottery toys from Mallorca, and mementoes of the Montroig landscape in the shape of stones and plants.

Miró took a room in a hotel in the Rue Notre-Dame des Victoires. His first call was on Picasso. He knew Picasso's mother and sister from Barcelona, where he had been a frequent visitor at their house.

Picasso, who had just terminated the second phase of his Cubist period, was busy exploring the world of antiquity. After the asceticism of form and colour to which he had subjected himself during his Cubist experiments, he now preferred form that was animated by Eros and controlled by a Classical outline: The great figure painting *L'Italienne,* the *Landscape* with pines and southern houses in front of towering mountains, and the *Still-Life* with the enormous jug and the fruit bowl, reminiscent of Pompeiian painting, all dating from 1919 — these must have been the pictures which Picasso showed his young Catalan friend in his studio in the Rue La Boétie.

It may seem far-fetched to claim a connexion between Picasso's paintings of this period and the artistic impulse that moved Miró; these two Spaniards had totally different aims throughout their creative lives. But Picasso may have expressed in his pictures of this year something that was in sympathy with Miró's aims. It was as though, in these pictures, Picasso was thinking of the Mediterranean heritage in his blood. Play with ancient forms and southern folklore was, of course, a spontaneous act of his Protean nature for ever in search of some new metamorphosis.

If Picasso worked in the manner of genius, Miró remained perpetually naive. And yet it would certainly not be wrong to suppose that Miró's figures, still-lifes and landscapes to come displayed a certain affinity with the work of Picasso.

The true revolutionaries of the earliest post-war years were the Dadaists, who had transferred their headquarters from Zürich to Paris. Together with the Surrealists Max Ernst, Hans Arp, Marcel Duchamp and Francis Picabia they formed a very audible counterpoint to the former Fauves and Cubists, who were striving to clarify their pictorial form.

Here, as in his programmatic self-portrait of 1960, Miró puts the emphasis entirely on elementary, swift, sweeping movements. Against a broadly structured surface, with a few more colour spots rubbed into it, he painted a figure consisting of a small number of simple shapes: a red semi-circle at the bottom, linked to a a black circle by means of a black line. The black circle is intersected by a broad red line, with a black semi-circle at its top end.

To make the configuration more easily understandable, two black points and a short black line have been inserted into the black circle – rudimentary hints of a face. A yellow circle with a green nucleus pulsates inside the red semi-circle where flesh-and-blood creatures would normally have their heart. However, this figure does not follow anthropological concepts quite so closely. It is more related to a child's matchstick people and also the drawings in pre-historic sign language. What touches us so much is probably this very openness, oscillating between man's early history as an individual and his history as a species. Thus Miró achieved a completely new quality within his symbolic cosmos, far removed from those merely cheerful creatures which he had executed so smoothly in previous years.

Woman III, 2 – 6 – 1965
Femme III
Oil and acrylic on canvas, 115.9 x 81 cm
Fundació Joan Miró, Barcelona

At the same time, the poets Breton, Aragon and Éluard called for submergence in the world of dreams and hallucinations; like the painters, they dreamt of a "psychography", a form of automatic writing guided by the powers of the subconscious and by hidden sexuality, independent of the will. Psychoanalysis invaded the poetry of words and of colours.

Miró saw one and studied the other, without deciding in favour of any particular trend. But although he retained his own stylistic aims, he could not avoid being consciously or unconsciously drawn into the field of attraction emanating from the artistic climate of Paris during the years 1919/20. We shall see how his work was fertilized by the absorption of various stimuli. When we speak of the influences to which the artist was subjected, and which helped to mould his life and work, we must not forget those exercised by the environment of Paris.

That same year, Klee produced in Germany a piece of sculpture, an idol-like construction, that looks as though a stone found on the seashore had been placed on top of a tree root. A circular form has been carved in a cavity in the amorphous stone; two intersecting lines and two dots indicate the nose and mouth. Here an artist who has affinities with Miró has created something which, in subject and expression, anticipated the Spanish painter's future works by two decades.

Every young painter who sets up his easel for the first time in a small, uncomfortable room in a Paris hotel and faces the blank white surface of a stretched canvas cannot help feeling doubly abandoned. Miró's only escape from the inrush of so many new things was to begin with himself, with the contemplation of his own figure. The time of uprootedness is the hour of the *Self Portrait* (p. 6).

In front of a bare wall, the face, its forms clearly modelled as though carved by a sculptor, grows out of the open neck of a colourful knitted cardigan. The shapes of the strictly parted hair, the vast, curved forehead with a cleft between the bold sweep of the eyebrows, the nose markedly bent to the left and the compressed mouth with its full lips express discipline and drive.

For the first time, the influence of Catalonian Romanesque fresco painting is evident in the simplification of the features and the determined modelling and colouring. The faces of the saints in these frescos are animated by the same gravity, the same searching gaze.

In 1920 Miró painted several still-lifes; one of them was the large *The Table (Still-life with Rabbit)* (p. 27), which today is in the Zumsteg collection in Zürich. This large-scale painting attests Miró's liking for a new realism that has absorbed many of the discoveries of Cubism. In their baroque density, the objects therein portrayed seem to be bursting their frame. Albrecht Dürer did not depict his hare with greater love. The drawing and construction of the lively cock are reminiscent of the picture of a cock on the frescos of the National Museum, Barcelona. The background of the picture is a prismatically broken ochre: golden yellow and *caput mortuum* — the colours of the Catalonian landscape at the time when the heat of August scorches everything. The angular carved and turned table legs bear witness to young Miró's liking for the burlesque and the playfully coarse.

166

The world represented in this picture is not very different from that of the portraits and still-lifes Miró painted in Barcelona and Montroig. But what earlier was merely foreshadowed here comes to fruition. Before Miró conquered fresh domains of art, he had to halt and take stock, as though saying to himself and his friends, "Look, this is I!" Meanwhile, work was proceeding on the large painting of *The Farm*. In the summer of 1920 he returned to Spain. By autumn of the same year he was back in Paris. This time he lived in a hotel in the Boulevard Pasteur. "Here Paul Rosenberg came to visit me", Miró told me later. "He had heard of me from Picasso and Maurice Raynal. Soon afterwards the sculptor Pablo Cargallo let me have his studio at 45 Rue Blomet, next to the Bal Négre. The studio next door belonged to André Masson; there was only a partition wall between us. I painted the head of a Spanish dancer, which is now in Picasso's possession. Those were very hard times: the glass in my windows was broken; my stove, which I had paid all of forty-five francs for in the flea market, wouldn't burn. On the other hand, the studio was very clean. I did the housework myself. As I was very poor, I had to make do with one

Message from a Friend, 1964
Message d'ami
Gouache, 20 x 27 cm
Private Collection, Paris

Painting III, 12 – 7 – 1965
Peinture III
Oil on canvas, 19.2 x 27 cm
Fundació Joan Miró, Barcelona

midday meal a week; the rest of the time I managed on dried figs and chewed chewing gum …"

In the meantime *The Farm,* on which he had been working for almost a year, was completed. We need only compare it with the earlier landscapes to discover what new methods and insights Paris had given Miró in this short time.

The organization of the motifs, the relation established between the shapes and objects, with their precisely ascertainable reality content, still derive from the Montroig period; so does the way in which the component elements are grouped tapestry fashion. In the earlier pictures we can already discern a tendency for shapes to achieve a life of their own. The new painting shows the organization of these "signs" increasingly taking possession of the picture surface. As we look at the painting, we have only to forget the identity of the shapes with those of the subject matter in order to observe the "abstract" signs emerging alongside the representational elements of the picture.

We see ribbons, trapeziums, quadrilaterals like the flagstones of a crazy paving, circles and thrusting triangles rising from the centre of the lower edge. Each of these shapes has its "local colouring". For a moment we are inescapably reminded of Kandinsky's play with forms. If we allow our eyes to wander over the picture, we discern even

168

bolder constellations of forms and colours. Below the surface of the picture another picture lies concealed, which emerges more and more forcibly. As our senses roam across and through the various parts and levels of the picture, even the so-called realistic forms become abstract, the "real" and the "abstract" components enter into fresh relationships, one comes to stand for the other. We cease to be able to distinguish to which of the two interpenetrating sections of the picture individual shapes belong.

"A picture must be right, down to a fraction of an inch, it must be exactly counterpoised down to a fraction of an inch", Miró once said. What an armoury of stubbornly independent forms!" Yet we feel intuitively that they are in a state of perfect equilibrium. The picture exhales quiet; it is the silence of Pan in the August heat of the Catalonian landscape.

The painter's intellect dissolves the existence of objects and lends them a new unity: he renders the intangible sensible. "If the things of the world, instead of being inwardly interwoven, appear to us isolated, separated from one another, the first and decisive step towards this has already been taken in the act of perception", writes Bergson. The painter's task is to show us the path that leads from disintegration to the creation of a new reality — the reality of art. This picture of Miró's presents the familiar in a condition of unparalleled freshness and vigour. The excitement we experience on look ing at it proves that the power of its vibrations has reached our mind and our senses.

The Farm fascinated another fanatic for realism — Ernest Hemingway. This writer, who was living in Paris at the time, saw in this picture the embodiment of his own experience of the Catalonian landscape. The dealer who was exhibiting Miró's picture named a price that was very high for the young writer. Hemingway hurried into all the bars of the Left Bank of the Seine in which he guessed he might find friends, and borrowed money from them, until he had collected the necessary sum. Then he took the huge canvas, flapping in its frame, back to his hotel in an open taxi.

Miró painted further pictures in which the tension between abstract pictorial shapes and figurative signs assumed increasingly dramatic forms. A still-life with a table, a folded newspaper, a walking stick with a silver handle (Miró who was always dressed à la mode, used to take a stick of this kind with him when he went for walks) also displays for the first time a white glove. The sign of the hand was later to recur frequently in his pictures. Here the glove remains the realistic attribute of a very "real" *nature morte*.

During the years 1922/23, Miró painted *The Farmer's Wife* (p. 31), in which the female figure betrays the influence of Léger, Gris and Picasso. The hare she is holding in her powerful left hand we have already met in a still-life. The woman's feet, overlarge and distorted by a false perspective, protrude from beneath the hem of her skirt like the bases of huge pillars. To the left of the woman squats a big cat. The background of the picture consists of mighty constructions of coloured bands and roof-shaped beams leaning towards one another; the significance of these forms is not immediately discernible, but the spectator

Lovers in the Night, 3 – 1 – 1966
Couple d'amour dans la nuit
Oil on canvas, 22.5 x 33 cm
Lelong Gallery, Paris

As before, the most interesting feature about this painting is Miró's treatment of the surface. something which was always very important to Miró. After all, this was to provide the basis for that "shock element" with which Miró wanted to spark off the creative process.

Having created a thick, oily surface, Miró then applied a thin layer of watery paint. The tension between the two layers has resulted in chinks and gaps in the watery layer – like a garment full of holes – through which we can see the bottom layer. Miró then used this partly random, partly intentional texture to distribute his strong colour symbols and also some thin black lines which then combined to form the usual symbols. Again and again, it is amazing to see how Miró would use only a small number of means and yet manipulate the material in such a way that a variety of effects and artistic statements emerged.

has the feeling that he is looking at a female figure standing in front of the architectural components of a solidly built farmhouse.

"During the early stages of painting *The Farmer's Wife,* it struck me that I had made the cat too big, which upset the picture's balance. That is the reason for the double circles and the two bent lines in the foreground. They look symbolic, esoteric; but there is nothing imaginative about them", Miró confessed later. We see that Miró devised his pictures in a completely naive manner. Their shapes and colours sprang as if automatically from the actual process of painting. Yet he unconsciously admitted into his pictures something of the artistic climate of his time.

Miró once compared the effect exercised by a good picture to that of a blow with the fist: the spectator ought to feel the impact without having time to think about it. *The Farmer's Wife* has an effect of shock upon the spectator; it excites him by its directness, by the way in which something entirely real is presented to his mind and eye. This is all the more astonishing, because the painter has constructed the picture with thoroughly intellectual components: with elements drawn from his world of abstract signs.

The comparative historians of art will find no difficulty in establishing from which painter in his Parisian environment Miró has borrowed this, that or the other shape, or method of modelling. We find the

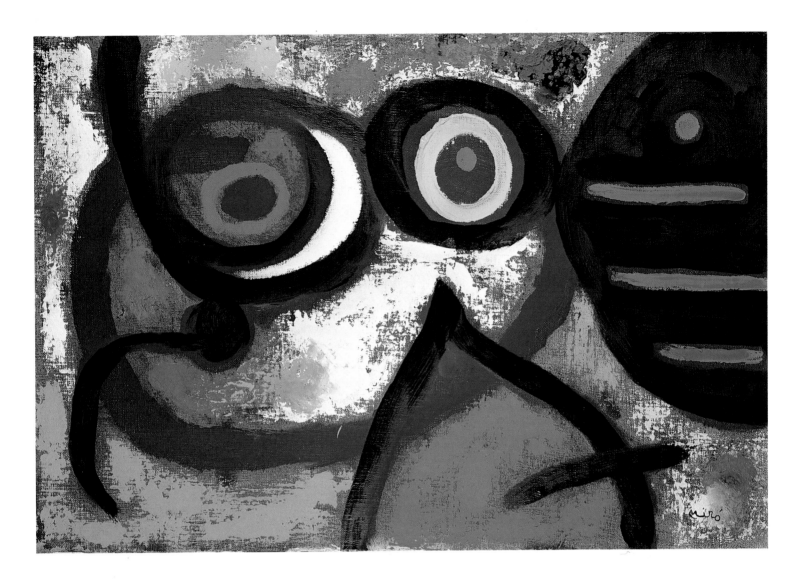

same "distortions" of form in Picasso, Léger and Gris — the same out-size feet, for example. In their case, these exaggerations spring from a new approach to problems of space and drawing. In Miró's pictures of this period, we have, rather, the feeling that he is assembling pictorial forms that he has already seen as "objects", as component parts of his environment. Imagination means the amalgamation of what has already been experienced into a new context of meaning. Picasso's celebrated dictum, "I do not seek, I find", might equally well have been uttered by Miró; only in Miró's mouth it would have had a different, a Miróesque meaning.

When confronted by the picture, the spectator does not stop to consider from how many and which sources the forms have been drawn. They have become subservient to a new unity. In spite of the way the painter calculates his forms, any expression of intellectualism is avoided. We need only examine the effect of each individual shape upon its neighbour to see how necessary, how irreplaceable it is. If we cover up the two beams of colour arched over the figure of the woman, this figure immediately loses monumentality. The disappearance of the funnelshaped form behind the cat would reduce this animal, which now seems so full of significance, to an unimportant decorative appendage. Without the sign made up of a double ring and a line with two bends in it, the spatial and psychic tension between the cat and the

Woman and Bird, 3 – 1 – 1966
Femme et oiseau
Oil on canvas, 50 x 72 cm
Lelong Gallery, Paris

There is a remarkably exotic quality about this painting, but although Miró enhanced the effect by one of his familiar eye creatures, he nevertheless took a completely novel direction with it. This can be seen in his very choice of colours, with shades that are totally untypical of Miró. There are the light purple stripes on a black surface in the shape on the right, a shape that looks like an African shield, and different hues of yellow and orange against a broken surface. This is a degree of variety which is rare in Miró's art. The eye creature itself is composed of a small number of basic, geometrical shapes, whose overlaps give it a primaeval posture so that it appears both highly subjective and at the same time universally meaningful.

PAGES 172-173
The Skiing Lesson, 1966
La leçon de ski
Oil on canvas, 193 x 324 cm
Lelong Gallery, Paris

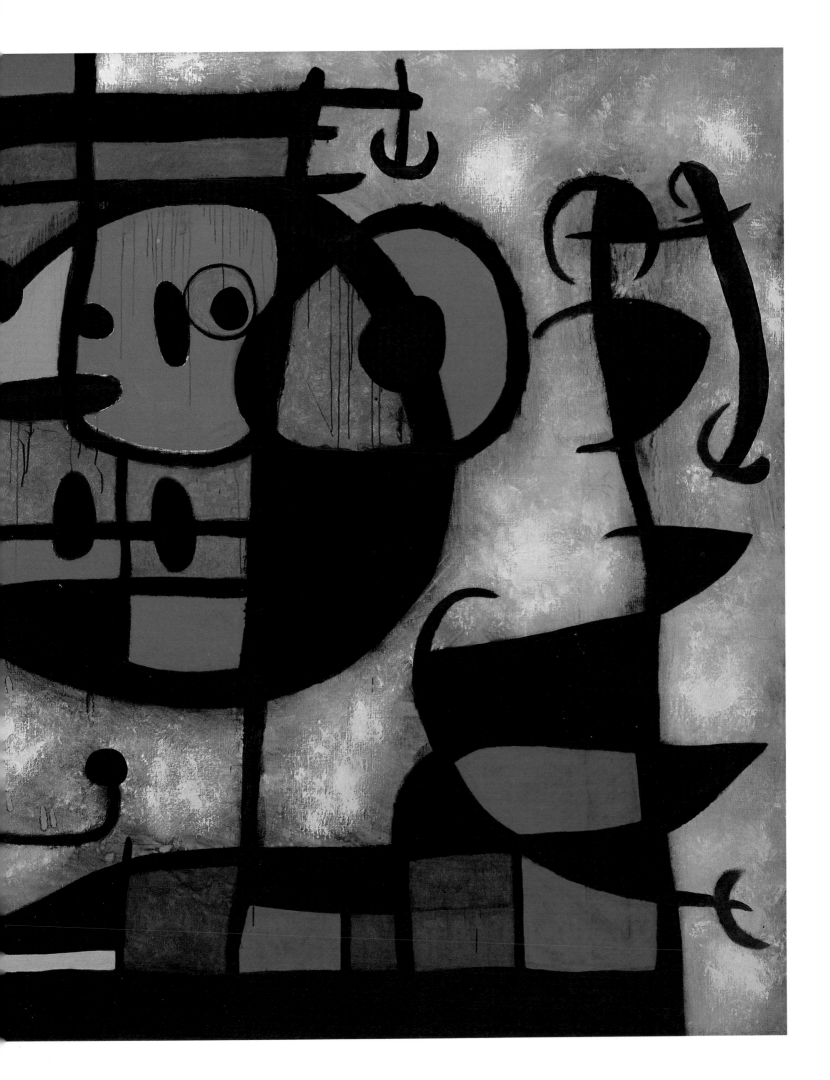

The Skiing Lesson (pp. 172/173) belongs to a series of condensed, narrative configurations and is less poetic and cosmological in character than other paintings of the 1960s. Set against a semi-transparent, milky-white surface, which still bears a number of white spots (a feature that may have contributed to the title), there are a number of symbols and colours. It does not take long to discern a large configuration in the right half of the painting which, in turn, seems to be inextricably linked to other patterns and surrounding shapes. It is as if, quite unintentionally and playfully, Miró had started from a centre and then generated more and more shapes and colours, sending them adrift into the space of his picture, so that they did not add up to a cogent composition until they had found their place within the general context. The colours, too, seem to have their starting point in a centre (belonging to the configuration on the right) – at least so far as their intensity is concerned. The symmetrical correspondences between the colourful areas, the contrapuntal relationships between light and dark, hot and cold as well as the contrasts of quantity and quality make this painting a masterpiece of colour.

Dusk Music V, 21 – 2 – 1966
Musique du crépuscule V
Oil on canvas, 19.3 x 33.3 cm
Fundació Joan Miró, Barcelona

figure of the woman would vanish. Miró has spoken of his concern to establish a state of equilibrium between the formal elements on the picture surface. But we can see that these formal elements here stand for tensions of a deeper kind.

The world, including the world of art, is not given, but has first to be discovered by the special media of cognition. "That artist will be the best of his kind whose power of invention and imagination combines, as it were, directly with the material with which he has to work", writes Flandrin. Here, by virtue of work accomplished, a new, effective reality has come into being. It was this realization that led Miró to write to his friends in Barcelona that in Paris he was working *"mas montrogins que hechos d'après nature",* more "Montroiginically" than he had ever done from nature.

In Barcelona and Montroig the young painter had always had a particular object before his eyes, whether it was a landscape, a human figure or a still-life. Topographical reality was now transmuted into the no less convincing reality of memory and dream. As a result, the various categories of pictures began to be mingled; remembered reality came into contact with the reality seen in dreams and day dreams, and these tensions opened up new dimensions of creative effort.

In the painting *The Tilled Field* (1923/24) (p. 32) Miró presents a scene which is at first glance reminiscent of pictures by Bosch or the facetious Mannerists of the Italian late Renaissance. The farmhouse, a tree, tall cactus leaves, parallel ploughed furrows and descending wavy lines, the birds in the sky, the eye and the ear which we saw in the self portrait, the newspaper that already enlivened the foreground of *The Farm* — they are all found together in this picture. But all of a sudden

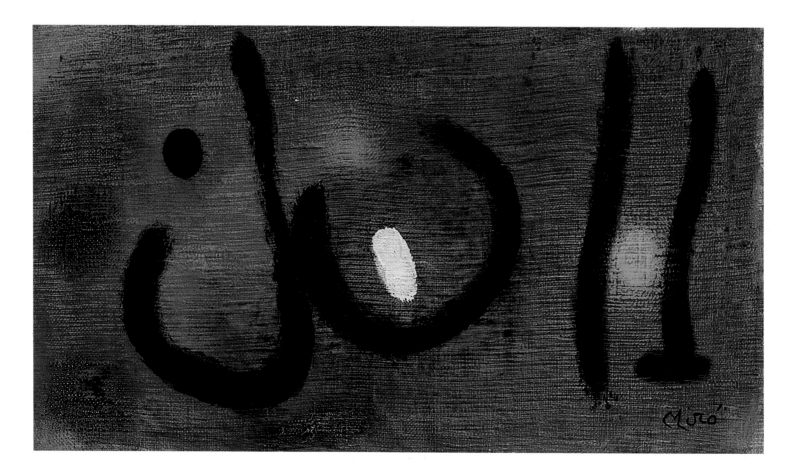

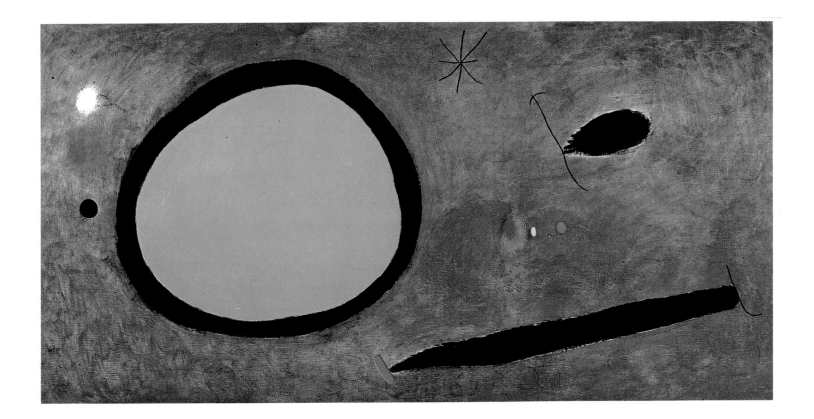

Bird's Flight in Moonlight, 3 – 10 – 1967
Vol d'oiseau au clair de la lune
Oil on canvas, 130 x 260 cm
Private collection

the eye is staring out from the green of the tree top, the ear is growing out of the obelisk of the trunk, fruits and flowers resemble anatomical organs, the leaves look like the prickles of marine plants or cilia. The sexual is allied with the naively burlesque; in the foreground the jack jumps out of his magical box; the tricolour flutters from an agave mast that towers up into the sky; at another point we see the crossed flags of Catalonia and Spain.

Despite the dreamlike quality of this painting, each shape is correctly placed "to the fraction of an inch" in relation to very other and so is the whole agglomeration of forms in relation to the background, which is divided by the line of the horizon. The figures of the snail, cock and fish resemble inflated rubber animals; the figure behind the plough echoes the outline figures in the cave of Altamira. The horse galloping in front of the farmhouse dissolves into baroque arabesques; in the distance, a delicate comma-like sign amidst the turmoil, the crescent moon hangs motionless above the line of the horizon.

With the painting *The Tilled Field* Miró had broken through the traditional unity of place, time and space. "I very soon realized", he once remarked, "that it was necessary to go beyond the spirit of the miniature, far beyond it. That it was necessary to extend the detail till it fused with the whole. In order to make people feel that it is there, even if it was previously not seen."

Untrammelled as the world of signs and figures in *The Tilled Field* appeared, it still remained attached to a milieu, to the Montroig farm and its surroundings. But the optically visible image was raised to the level of a simile. "The simile", writes the Surrealist poet Pierre Reverdy, "cannot spring from a comparison, but only from the juxtaposition of two more or less distant realities. The more remote the two realities and the more exact the connexions established between them, the

This late painting of Miró's has a wonderfully poetic quality about it, reminiscent of Asian art. Set against a light yellow surface, with a few white gaps to allow the canvas to "breathe", a number of stars and lines – as fine as hair – have been distributed, as well as some sombre, black dots, partly connected by some very fine lines.

A huge black sweeping movement lunges into the blue shape on the right. This shape, however, has not been painted on the yellow surface – which would have given it a distinct tinge of green – but has been inserted into an oval gap on the white canvas. The red dot in the top left corner has been painted in the same way. Thus these two colours keep their balance against the strong forcefulness of the yellow. A tiny green spot hovers above the blue oval, demonstrating a different method of painting – a gentle merging into the paint while it was still wet so that a blurred effect could be achieved. Furthermore, the blue shape has been painted with the circling movements of a semi-dry paintbrush so that the white surface has remained faintly visible and is particularly in evidence around the edge. The painting refuses to yield to any further description of its content or to any fixed interpretation. Its poetic effect is dependent on the balance of its colours, the composition of symbols as well as its complex structure as regards artistic techniques. It is from the artistic means alone that Miró developed a "content", without, however, creating a totally abstract painting. In his pictures of the 1960s Miró continued to develop his symbolic language with increasing elementary force and colourfulness.

The Gold of the Azure, 4 – 12 – 1967
L'or de l'azur
Oil on canvas, 205 x 173.5 cm
Fundació Joan Miró, Barcelona

more powerful will be the simile — the more emotive force and poetic reality it will possess."

After Miró had assured himself in *The Tilled Field* of the possibility of producing tensions by "the juxtaposition of two more or less distant realities", he inevitably felt the urge to devise more daring pictorial compositions. If he had succeeded in raising the landscape painting to the level of a surreal simile, he could now extend the same method to the nude.

We speak of a landscape of the soul, the domain of the psyche and — since Freud — the zones of the libido. During the late Middle Ages, before the Renaissance had breached the credulity of Gothic man, Hieronymus Bosch and Breughel gave visible expression in surreal montages to the psychic tensions that filled or threatened men. In peasant votive pictures the anatomy of sacred hearts is laid bare; rays blaze up from the stigmata towards the open firmament, out of which, enclosed within a triangle, the eye of God gazes down.

Images of parts of the body and internal organs, presented by believers who have been cured of their diseases, are suspended from the grilles of wire and iron in front of the altars of the patron saints in Barcelona cathedral, where they gleam with a ghostly glow as the candlelight falls upon them in the semi-darkness of the church. In the "Portraits" by Klee, Marcel Duchamp and Max Ernst there appear arrows, letters and figures, flying birds, flowers and stars. The beholder of such a picture embarks upon a vertiginous journey, like the diver gliding down through undersea zones.

"We are all living at the bottom of the sea — the sea of air!" says the poet Christian Morgenstern. The lover longs to plunge into the beloved, or to soar like a bird in his dream. Since Poe and Baudelaire, the practice of diving down into the human psyche has become a favourite pastime of romantic poets, though one not without danger to the nervous system. The Surrealists modelled themselves upon the Marquis de Sade and Lautréamont, the classical masters of anguished self-analysis. Mysticism and the method of representing the mythical world by stark symbols was familiar to Miró from Spanish folklore. Thus we see in the *Portrait of Madame K.* (1924) (p.178) a multifarious ensemble of signs condensed into the fauna of a female psyche.

What is the woman who closes her eyes and gazes into the darkness of her mind, while the reflections of the outer world burn upon her retina like pinpricks? What is she thinking? What apparatus is at work within her that finds expression in the pulsing of her heart? What is the effect of sounds gathered by the shell of her ear and passed on to her dreaming subconscious? Is it sensibility or matter that she feels in this silent immobility? What whips up and torments her inner self? What drives the blood through her veins while she abandons her face to the breath of the wind and the sound of flocks of birds? Mankind has always felt impelled to give shape in symbols to fragmentary presentiments and visions.

The topography of this ordnance survey map of the female psyche confronts the beholder with something insistently strange and different. It shocks as much as it invites him to pause and study the indivi-

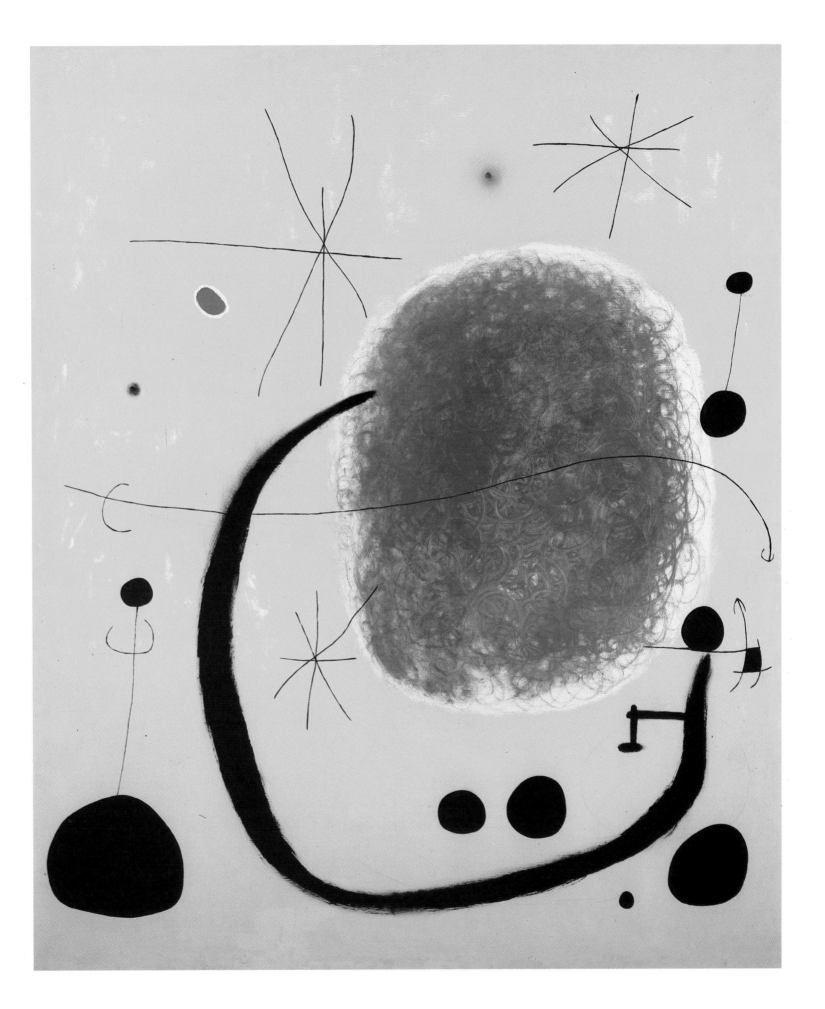

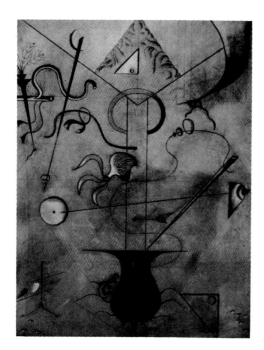

Portrait of Madam K., 1924
Portrait de Madame K.
Coloured pens, gouache and coal on canvas, 115 x 89 cm
Private Collection, France

dual symbols. It constitutes a puzzle, the solution of which is disclosed in a flash. There are anatomical forms, an ear, a head with hair, breasts, a heart and the pubic triangle; and other forms, the meaning and function of which are only revealed by contemplation of all the shapes as a totality. Among these are two thin, stick-like forms that represent arms and hands, and two triangles with an opening, one of which represents an eye and the other a libidinous detail. To these is added a system of graphic constructions, two parallel lines depicting the neck and torso, and two sides of a triangle portraying the legs. Between them hangs the ring of the pelvis. Animal and vegetable forms thrust upwards from the left and right of the lower edge towards the centre of this sensitive architecture, shapes that symbolize the menaces and seductions of sex.

This picture painted and drawn with gouache, coloured chalk and charcoal on canvas displays in the sfumato of the background prismatic refractions and a network of horizontal and vertical stripes. As the more strongly drawn shapes stand for the radii of tension of the various parts of the body, so the prismatic network underneath them hint at the existence of forces to which Madame K. is subject in her feminine moods and errors.

This surreal vision enlarged Miró's vocabulary of signs and added fresh dimensions to his pictorial expression. In this picture we no longer distinguish between foreground and background. The Renaissance game with the obligatory three dimensions has come to an end; solidity of structure, hitherto always evident in Miró's pictures, is now open to question.

Until now every picture has seemed to mirror an experience derived from the motif, to reproduce in art an object that has been experienced in reality. The earlier works revealed their meaning without intellectual manœuvring. Even the incomprehensible fragment remained part of the larger poetic harmony by virtue of the painterly qualities of the pictures.

In the *Portrait of Madame K., peinture* and pictorial metaphor, brushwork and graphic embellishment are not yet fused into a convincing unity. It is still thoroughly experimental in character. Madame K. is not yet Mrs Bloom from James Joyce's *Ulysses*. But just as the world of Mrs Bloom's erotic day-dream is steeped in the daily bustle and atmosphere of Dublin, so Miró's picture breathes the colour and air of the Catalonian landscape.

In spite of the fact that many of his pictures had been sold, Miró led a hard life in his studio in the Rue Blomet. "I used to come home in the evening without having eaten anything", he reported later, "and I wrote down my feelings. During that year I spent a lot of time with poets; because I felt it necessary to overcome the 'plastic' in order to reach poetry. I made a great many drawings for *Le carnaval d'Arlequin*, in which I gave expression to my hunger hallucinations... "After *The Farm, The Harlequin's Carnival* (pp.36/37) was to become Miró's second striking work. In it, painting and the graphic elements that run through the picture seem for the first time to be unified.

Woman and Bird, 9 – 1 – 1967
Femme et oiseau
Painting on crumpled paper, 91 x 74 cm
Lelong Gallery, Paris

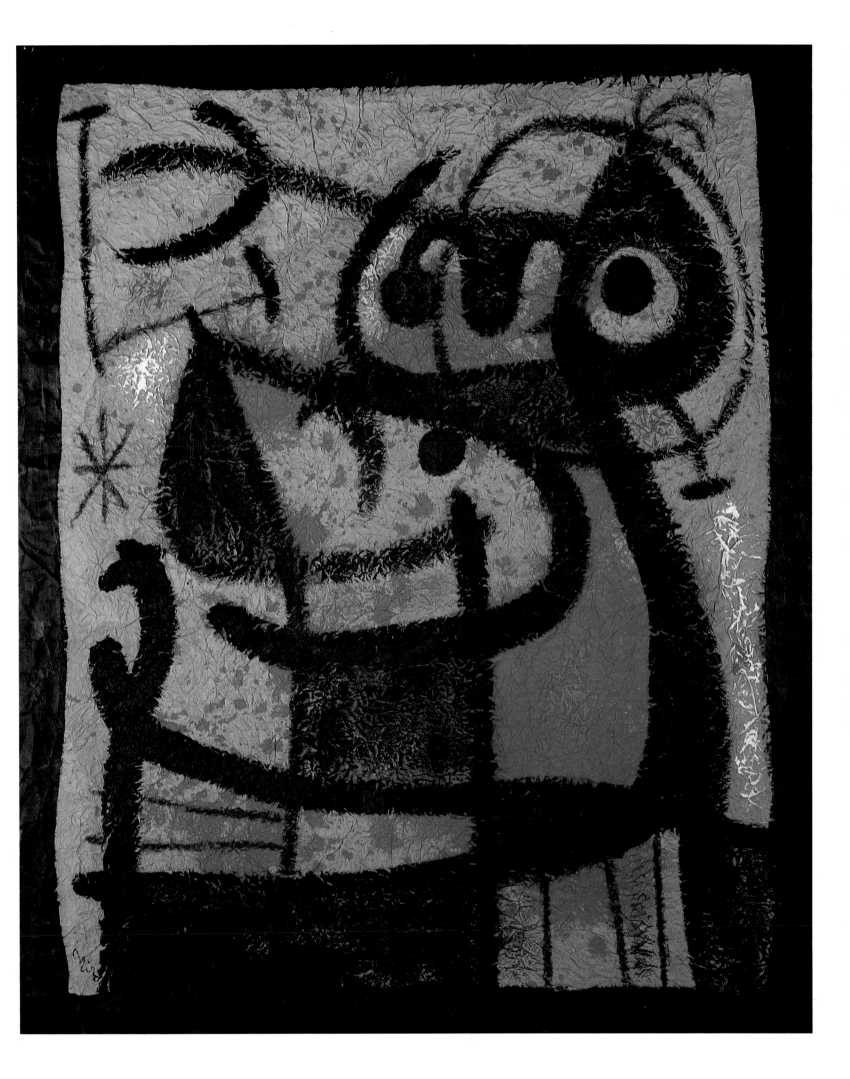

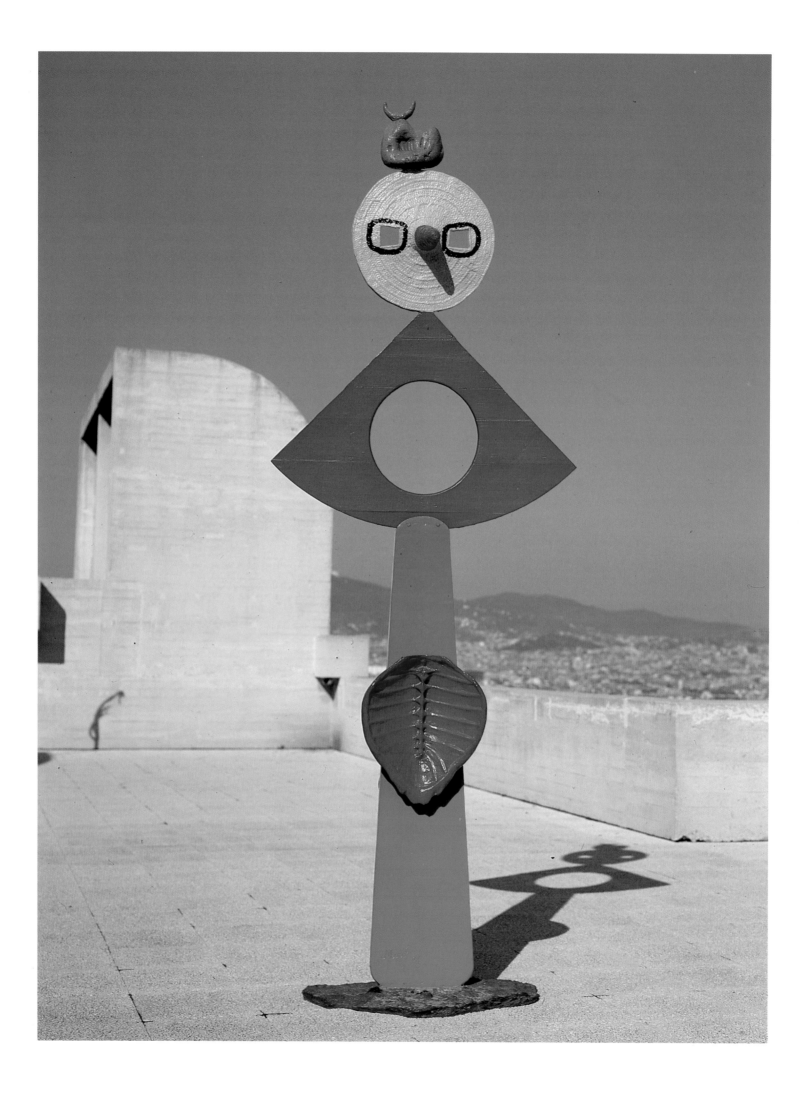

The Harlequin's Carnival

An elongated room, indicated by two contiguous areas of colour – the floor in a mixture of sepia and *caput mortuum,* the wall ochre-yellow with grey and green shadows. On the left-hand side, a narrow black triangle fitted into the seam between the two areas of colour creates the illusion of a side wall and of spatial depth. The idea of space is, however, produced less by this shape that creates a minimum degree of perspective than by the neutral tones, by the quadrilateral of the open window in the right-hand upper quarter of the picture and the brilliant blue of a theatrical-looking sky.

Among the identifiable props we must note the bright-blue trapezium of a table top that seems to be half floating and half supported by a notched, baroque leg, and a number of cubes, cylinders, pointed objects resembling sugar loaves, a wheel, a green ball, two vertical beams whose tapering upper ends are linked by thin rungs, which turn them into the uprights of a ladder.

Neither the eye nor the mind inquire which of the many phantasmal shapes carries the main weight in this surreal ensemble. At the first moment the gaze wanders from one "sign" to the other, both enchanted and baffled, seeking first to grasp the totality of the unfettered ballet. Only then is the individual component observed, and it is a pleasure to trace out the shapes and arabesques that ramify across the plane surface and in depth. What is at first bewildering takes on meaning, the apparently unordered parts coalesce into figures and objects.

What seemed at first to be a red and blue balloon turns into a face with two white eyelids and moustache ends drifting boldly away into space. The equatorial line of this toy planet is exended upward to form a vertical hair which – like the hat stands in Señor Prats's Barcelona hat shop – carries a kind of miniature admiral's hat. The same line runs out below like the handle of a rake, the five wavy teeth of which symbolize a straggling beard. Out of the tiny black orifice of the mouth grows the straight, thin tube of a tobacco pipe; the wall of the temple is transpierced by a pointed, hornlike structure, around which, like a paper streamer round a Christmas candle, there winds a serpentine form.

Let us study this figure, which takes on a life of its own as we scrutinize it. A curved, winged neck emerges from the head like a rubber

This outdoor sculpture is an impressive demonstration of Miró's assemblage technique. Using a number of totally disparate elements, he started by putting together a model. Many of the things were objects which he had found on the beach, e.g. the tortoise shell and the straw hat, full of holes, as well as some wooden boards which had drifted ashore, and an old table top. Imaginative as Miró was, he could use all these things for his sculptures. For Miró, these randomly collected objects had a charm about them the moment he saw one and provided a creative impetus. Their structures and shapes triggered off chains of associations in the artist, which Miró then pursued in sketches and models until they added up to a combination that matched his mental image. This reminds one of the Surrealist methods, which Miró had become familiar with during his years in Paris. Having made his choice among these (random) objects, he then subjected them to further processing, painting them white, perhaps, or giving them an appropriate shape, such as the table top which was sawn up and given a hole in the middle. And with two rectangular cuts and some red paint on top, the straw hat suddenly came alive. After these preliminaries the model was put together and handed on to the foundry, where a bronze statue was made on the basis of it. Finally, the finished statue was given a colourful layer of paint by Miró himself. And so a new homogeneous figure had come into being, a folk-tale creature whose origins in the sediments of civilization can hardly be recognized. The tortoise shell had become a female pelvis, the table top a female chest, the sun hat a preposterous grimace, crowned with a little blue bull whose horns form the matriarchal crescent of the moon.

The Caress of a Bird, 1967
La caresse d'un oiseau
Painted bronze, 311 x 111 x 38 cm
Fundació Joan Miró, Barcelona

This sculpture is a particularly witty assemblage. Miró must have started with the three-legged chopping block, which he had either found on one of his trips or obtained from a Spanish butcher. The three legs and the massive block alone suggest something figurative. Miró then put the lid of an old metal drum on top, inserted some supple material into its bottom, such as plaster of Paris, and scratched some simple physiognomical symbols into it. Finally, he crowned the figure with an old pitchfork, forming either an outstretched arm or a kind of "cock's comb". Then Miró gave it some cheerful colours, painting the chopping block red, the "face" yellow, blue and red, and the ambiguous pitchfork red. The final bronze cast turned it into a contemptuous little gnome who looks as if he had ruffled up his cock's comb or as if he were flapping his arms helplessly, possibly in view of all the female-type figures in Miró's pleasure park.

Personage with Three Legs, 1967
Personnage au trois pieds
Painted bronze, 217 x 47 x 39 cm
Fundació Joan Miró, Barcelona

hose. The wings might also be the bows of a tie. This neck thickens out at its lower end like the weak spots in the inner tube of a bicycle that has been pumped up too hard. The chessboard pattern drawn on this being's chest remind us of tattooing or the checks of a harlequin's costume. Thin arms stretch sinuously out from the incurving hips like an insect's antennae. The left seems to be catching a ball thrown to it by a winged grasshopper jumping out of a dice box. The right is holding a stick terminating in an upwards-writhing whiplash. The end of the lash becomes the tail of a dragon resembling the one with which Lucas Cranach signed the paintings in which he embodied his humorous dissections of human activities.

The parts everywhere strive towards a greater coherence, even if this is not immediately visible. Of the cat that Alice met in Wonderland, nothing remained among the branches of the tree but its smile; yet this minimum of optical reality was enough to demonstrate the animal's existence. Similarly, in Miró's panorama a whorl, a bladder shape, a dark, wavy line bear witness to enigmatic entities lying behind them. Meaningless as these beings built up of thin axles and retorts, of spirals and arteries, of expanding and contracting bodies and limbs may appear, everything finally coalesces to form the inhabitants of a hitherto unexplored world. The heads of cats or of fish, the heads of musical notes or spermatozoa – the one is simultaneously the other. The useless implements, the measuring instruments and the scales, the ladders and appliances, which condemn the winged demon in Dürer's *Melancholia* to inactivity and gloomy meditation, have here awoken to fresh and confident life. The anatomical and vegetal fragments in the pictures of Hieronymus Bosch have been resurrected. But they have lost their menace, they are no longer the product of tensions between paradisial pleasures and the terror of hell fire. They exhibit no trace either of brooding unease or of the macabre. The crazy laughter that echoes out of Poe's phantasmagoria has no echo here. These *personnages,* as Miró later came to call his figures, are lovable, they lack any temptation to evil. They are not comic, but grotesque. "In the laughter evoked by the grotesque there is something profound, unfathomable and primordial", writes Baudelaire, "which nourishes innocence and pure joy-in-living far more than the laughter induced by other forms of the comic."

Up to this point, Miró has painted pictures like a musician playing a tune with one finger. Now he uses all ten fingers as well as the pedal, he orchestrates a technically brilliant concerto.

We recognize in this picture a good many things we have already met in earlier ones: the great listening ear, the ladder, the open window, the cats playing with hanks of wool, the axles, the spirals and comets' tails, the tongues of flame, birds' necks and fluttering banners, the open white hand, the jack-in-the-box.

Mere enumeration of the elements tells us very little. More important than the visible form is what radiates from it, the independent life that links it with other forms. The painterly qualities assert themselves unfettered by considerations of "content". The lines scratched with a needle have the same intensity of expression as the larger forms. The

The Vowel Song, 1967
Chanson des voyelles
Oil on canvas, 350 x 144 cm
The Museum of Modern Art, New York

configurations that squander themselves in a riot of gesture neverthe-less retain that "peace in movement" which is essential to every pic-ture. The colour harmonies remain muted, so that the vermilion and steel-blue areas flicker like the St Elmo's fires in the yards of an enchanted ship.

The "content" of the picture can only be hinted at in words. Let us therefore call to our aid a poet obsessed by similar visions, Henri Michaux, that adventurer in the realm of metaphors who – after he had really crossed the oceans of our planet – invented the kingdom of the "Medosemes", in which the most improbable creatures and lands-capes are described with the precision of a modern reporter. Many passages of this "poetry in prose" could be illustrated by Miró.

"The Medosemes assume the shape of bladders when they want to dream; they assume the shape of lianas to excite themselves. Over there, leaning against a wall – a wall, by the way, which no one will ever see for a second time – one has taken on the shape of a long rope. It twines round itself. A few bundles that have fallen out of a cart, a piece of wire dangling down, a sponge that is drinking and already almost full, another that is empty and dry – a bloom on a disc, a trace of phosphorus – just look carefully! Great, graceful Medosemes, on their long, slender, spirited legs. With these hundreds of threads char-ged with convulsive electric tremors, with this vague network as a face, the frightened Medoseme strives calmly to observe the vast world surrounding it ... What Medosemian landscape would be without lad-ders? Wings without heads, without birds, only wings, set free from any residue of body, fly towards a summer sky, which is not yet shin-ing, but is struggling hard to shine ..."

"In the last resort", André Gide comments on Michaux's poetry, "all this which does not exist, might very well exist; and everything we are acquainted with and know, might very well not possess much more reality. What happens on our earth is, all in all, not much more reaso-nable than what the poet describes to us. In unsurpassable fashion he makes us feel intuitively both the strangeness of natural things and the naturalness of strange things".

In June 1925 the Galerie Pierre exhibited Miró's works painted up to this date in Paris. The pictures were assembled by Jacques Viot, who thus describes the now famous *vernissage à minuit;* "The contrast between Miró's outward appearance and his work was never greater than on the evening of his first exhibition ... The opening took place at midnight, a new departure. There was a fearful crush; Pierre was afraid the first-floor ceiling might give away. The majority of the public had come as if to a fair. The pictures on the walls dumbfounded those who looked at them. But I believe the painter surprised them even more, because they could see nothing in common between the painter and his work. Miró had made a tremendous effort to look smart. The problem of clothes had always preoccupied him, and moreover he had a weakness for wrist-watches. That evening he appeared in immacu-late 'official dress'. He wore a striped waistcoat, grey trousers and white spats. He was lavish with polite phrases, but so afraid of forget-ting them that he gave the impression of being nervous. Afterwards,

we all went to Montmartre, and I have a pleasant memory of this excursion! Particularly of Miró who, even more circumspect than before, danced a tango with a lady much taller than himself … Not a single *chasé,* not a figure, not the least step was left out. The other dancers stopped at the sight of so much effort. And Miró, all tensed up, continued his tango as though he had learnt it from a textbook … This small man, firmly planted on his legs, is nevertheless a typical painter. Just as sculptors generally look like "landlubbers", many of them exhibiting all the outward characteristics of "rabbit-catchers", painters for the most part represent the nautical type. One knows

The Lark's Wing, Encircled with Golden Blue, Rejoins the Heart of the Poppy Sleeping on a Diamond-Studded Meadow, 13 – 3 – 1967
L'aile de l'alouette encerclée de bleu d'or rejoint le cœur du coquelicot qui dort sur la prairie de diamants
Oil on canvas, 195 x 130 cm
Pierre Matisse Gallery, New York

185

many of them who display all the outward attributes of complete mariners. For this reason I find Miró very typical. He has the demeanour of a small urban sea-dog.'

Miró himself relates of these days: "After this (the exhibition) I entered an agreement with Viot, as a result of which I was able to keep my head above water. I rented a studio at 22 Rue Tourlaque, in the Villa des Fusains, where Toulouse-Lautrec and André Derain once lived and where Pierre Bonnard had his studio. At this time I was seeing a lot of Paul Éluard, Max Ernst, René Magritte and Hans Arp. I put a notice on my door that I had picked up from a secondhand dealer, 'Non-Stop Through Train'. Things were going better for me; but they were still difficult. One day I lunched on radishes and butter with Arp. As soon as I was able, I took a larger studio in the same house ..."

The Surrealists looked upon Miró as entirely one of themselves. We find Miró's name at the bottom of the First Surrealist Manifesto, dated 1924. In his book *Surrealism and Painting* (1928) André Breton writes: "There is perhaps only one desire in Miró, the desire to devote himself entirely to painting, and only to painting ... It is true that he may be considered the most Surrealist among us."

Miró did, endeed, evolve a Surrealist pictorial language of his own in the pictures he painted during the next few years. The proximity of the former Dadaist Hans Arp, who had distinguished himself equally as a poet, painter and sculptor, must certainly be regarded as a source of inspiration. Furthermore, his friendship with the German-born painter Max Ernst, with whom in 1925 he designed the décor and costumes for the ballet *Romeo and Juliet* for a performance by the Russian Ballet, must also have reinforced his natural tendency towards surreal forms of expression.

Painting meant for Miró to acquire, by diligent labour and profound study, the prerequisites for the externalization of inner visions; it meant, further, to create with these means a series of pictures and to bring these to the maximum degree of maturity; finally, it meant to manipulate his acquisitions until the repertoire of signs so far discovered, and their possible interrelationships, had been exhausted. Then a new process followed, a period during which he drew fresh breath.

From the period during which Miró painted his *Portrait of Madame K.* there exist other pictures with partially abstract and partially figurative elements, the associative significance of which is not manifest at first sight; among these is the painting *Motherhood* (p. 34) from the year 1924, which looks as though the shapes have been cut out coloured paper, pasted on the light background and linked by thin black threads stretched between one shape and another.

In a *Landscape by the Sea* the protruding tongues of land are at the same time real tongues; like other shapes in the picture, the form parts of human and animal faces. Additional linear constructions depict pendulum and arrow signs, the thin antennae of insects or the cilia of underwater creatures. In a picture called *The White Glove* a minimum of such signs and lines creates a surreal vision of tremendous power. We are reminded of the sort of encounters we experience while wan-

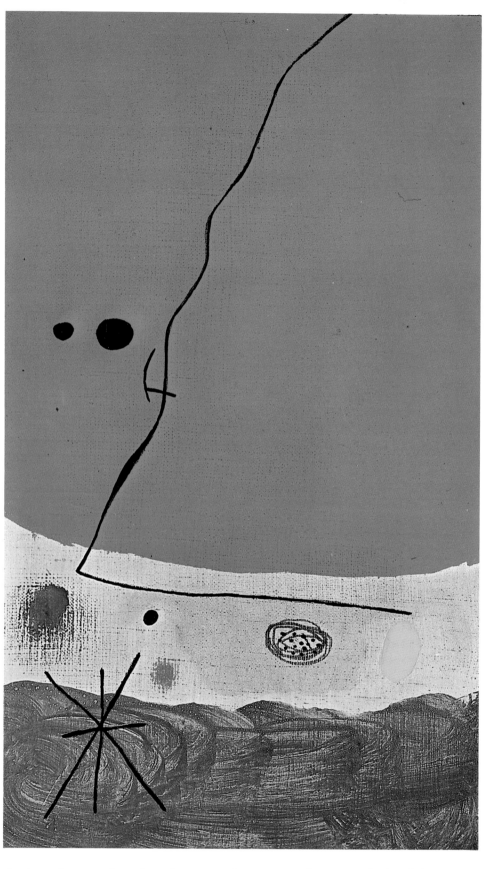

Bird in the Night, 23 – 5- 1968
Oiseau dans la nuit
Oil on canvas, 41 x 24.5 cm
Fundació Joan Miró, Barcelona

dering along a beach, where in the strip of no-man's-land between shimmering water and white sand washed smooth the imprint of birds' claws, the fabric of bleached seaweed or the few letters of a bottle label seem to be messages from another, more mysterious world.

All trace of any seen object is absent from the picture *Siesta* (1925) (p. 41). The background, a watery cobalt, is laid on as though in watercolour, with glazed passages and streaks that call to mind the

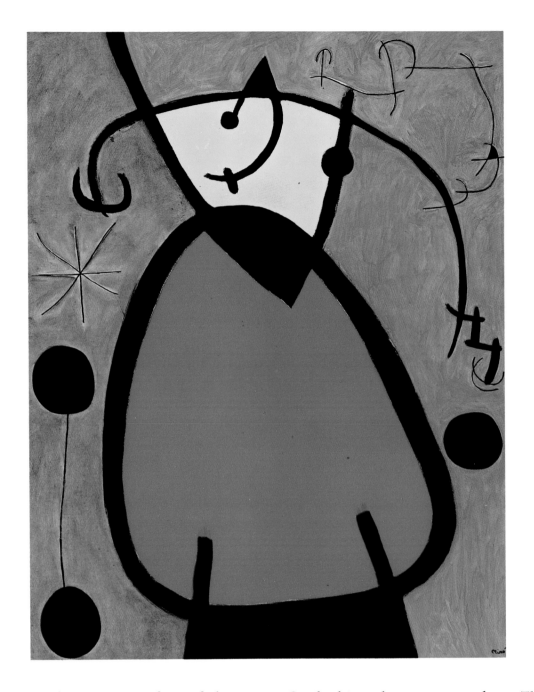

gently moving surface of the water. On looking closer, we see that there are four areas linked together by a scarcely visible seam, which gives rise to the idea of reflection, reflection on the surface of the sea, but at the same time creates an impression of depth, of transparency and mobility. Above this quartet floats a fluttering white shape and a serrated blue one. In addition, there appear a sooty whorl of cloud, a letter, a number and thin linear constructions.

These lines evolve their own mysterious language. They no longer have the function of an outline; they do not constitute the termination of forms frozen in the midst of movement; they have become movement themselves, a movement that leads the spectator's eyes and senses on their wandering through the picture. These lines, which are born before our eyes, swell up and fade away; they have a physiognomy, the expression of which alters from one fraction of an inch to the next. In the pictures of the Realists and the Impressionists, the lines came into being through the impingement of one colour upon another. The eternal counterpart of colour, they remained subservient

The Birth of Day, 26 – 3 – 1968
La naissance du jour
Oil on canvas, 162 x 130 cm
Pierre Matisse Gallery, New York

189

The painting derives its whole being from a wonderfully simple, but nevertheless effective emphasis on colour as its prime element. The horizontal division is reminiscent of Miró's *Landscapes* of the 1920s. Also, his choice of a small number of pure, elementary colours points in that direction. What is new, however, is the artist's use of black as a colour. Miró has filled the entire lower part of the painting and also further portions higher up with black. The black area at the bottom is counter-balanced by the light green at the top, which, in turn, forms a complementary contrast with the red shape that thrusts itself into the picture from the left. The yellow moon-like crescent also has a black bottom portion. The black area at the bottom of the painting includes a strong colourful contrast in the form of two rectangles on top of one another. Red and blue as a contrastive pair are among the most powerful colour polarities that one can perceive. They unite the most intensive hot-and-cold tensions as well as effects of light and darkness and the impression of being flooded by simultaneous optical phenomena.

It is from these colourful insertions alone that the entire composition derives its tension: the cheerful blue, which is of a similar hue to the green, forms a harmonious relationship with the yellow, and the red quadrilateral corresponds to the red shape in the middle left corner and lends a certain warmth to the large black area. Rather than diminishing the strength of each colour, the sharp contrast between black and bright colours brings out the true glow of these colours and emphasizes their intensiveness. Miró's title serves to underline the poetic abundance of this rich composition of colours.

Catalan Peasant in the Moonlight, 26 – 3 – 1968
Paysan catalan au clair de la lune
Acrylic on canvas, 162 x 130 cm
Fundació Joan Miró, Barcelona

to it for good or ill. In Miró's latest pictures the lines represent a very sensitive organism, which, like the descant in a musical phrase, is both independent of and coordinated with the other forms and relationships in the picture. Despite its abstract character, the picture nevertheless suggests a seashore landscape. Every "sign" encloses a smile, the breath of a breeze, a farewell, a tear.

In these seismographic documents the Surrealist poets and painters found their own intentions demonstrated in an instructive way. Their spokesmen pleaded for "automatism", for the recording of signals sent out by the subconscious without the intervention of conscious thought, the kind of signals emitted during daydreams or hallucinations.

In one essential point, however, the literary propagandists of Surrealism were mistaken. Miró was far too obsessed by an almost pedantic striving to determine and "delimit the extension of his shapes and lines to the fraction of an inch" to be satisfied with any such unverifiable language of symbols. The encounter with Surrealism had awakened latent impulses in Miró, but his genius as a painter was not bound to any "ism". He wanted his pictures to be understood as *poésie en peinture* and not as illustrations of a short-lived pseudo-philosophy.

During the years 1926/27 Miró painted a series of pictures on pale blue, yellow, ochre and brown grounds. We have already seen how he left peep-show space behind him and stretched his signs and lineations in an ether devoid of perspective and gravity. We see such views of reality when we look out from the seashore or a ship at the horizon and the shadows cast by the rigging, and the wings of birds draw fleeting configurations on the surface of the water. We receive the same impression of lightness stretched over menacing danger when we look at the floodlit dome over a circus in which the acrobats, balancing on glittering ropes, are preparing for the *salto mortale*. In the picture Miró now began to paint, the poetic sensations of sea and circus are transposed into the forms of painting.

In many of these paintings there appears the ladder which we first saw in *The Farm*. In the picture *Dog Barking at the Moon* (1926) (p. 48) it resembles a Jacob's ladder out of a modern fairy tale drawn by Walt Disney. One of the ladder's uprights glows chrome-yellow, the other a metallic white; the rungs in between are vermilion. This slender structure shoots up in strongly foreshortened perspective across the chocolate-brown of the lower half of the picture into the velvety black of the night. A dog-shaped creature in the contrasting colours of a Paris Métro poster is gaping at the moon, whose crescent is equipped with the attributes of the female sex. Here wonder at the magic of the night is translated into the burlesque; the painting poet has taken the sting from childhood fears and caught them in the spell of a simile that is not without profundity. The sight of a Mallorcan *xiurell* also arouses only a restrained smile; we know that its gay forms and colours have evolved through a long metamorphosis from something that originally struck terror.

The forms become weightier and more grandiloquent when they are grouped in the surreal monument of a *Nude* (p. 56); they resemble the

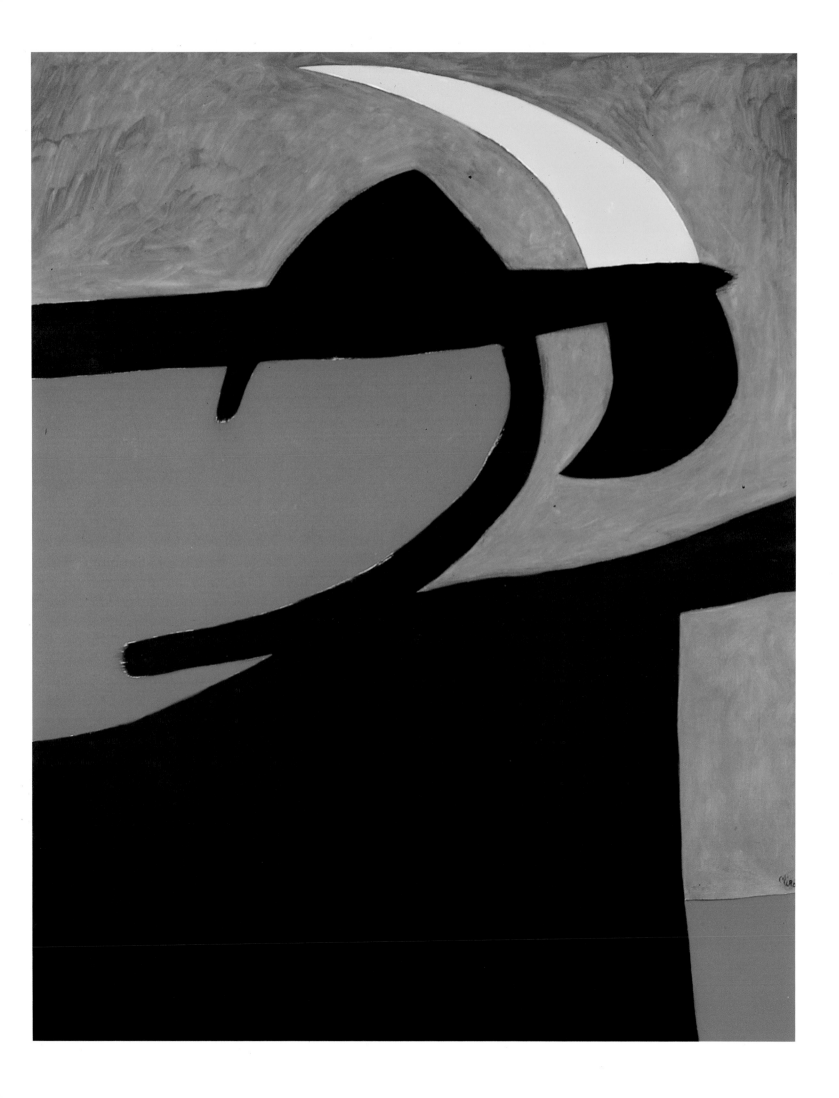

highly coloured and extremely simplified symbols of an anatomical chart on a black ground. The colours of this picture are those of signals or display figures; at first glance they seem crude, but something playful and humorous is once more concealed in their exaggeration which takes all ambiguity from the dialogue of erogenous zones. The lightly clad courtesan in Madame Tussaud's chamber of horrors is not an obscene figure; her ecstatic mien and the imaginary sigh rising from her waxen lips reconcile us to the offensive character of the historical facts. Miró's surreal portraits of women have been painted by a man possessed, who has the power to slip into the skin at one moment of a romantic and at another of a satirist. Their sigh is at the same time a smile, such as Leonardo caused to blossom on the face of the Mona Lisa four centuries earlier.

We have said that while looking at one of Miró's pictures it is impossible to imagine any increase in intensity or profundity. Nevertheless, we can see that Miró succeeded in intensifying the daring combinations of graphic and painterly forms, of real and surreal elements, in the *Portrait of Madame K.* to a yet higher degree of pictorial unity in the *Nude* of 1926. We have also pointed out already that Miró never invents anything and always allows himself to be influenced by the constellations of phenomena surrounding him.

The experience of a new reality, this time a reality already transposed into art, was to come to him on a trip to Holland. In the museums of Amsterdam he was particularly captivated by the Dutch masters of the 17th century. He found in their genre paintings a love of the robust, the real, the exactly formulated detail, that may have reminded him of his own endeavours during the painting of *The Farm* and the pictures preceding it. He bought a collection of picture postcards, which he brought back to Paris with him. They provided the stimulus for the series of "Dutch Interiors" (pp. 50, 54 and 55) dating from 1928.

In *The Lutanist* (p. 51) by Hendrick Martensz Sorgh, a 17th century genre painter, we look into an intimate stage set, a room whose left-hand wall is separated from the street with its narrow, Gothic house-fronts paling in the haze of a summer's day by a verandah-like balustrade with two highly polished, turned spheres and by a curtain that reaches up to the ceiling. In the room sit a merry couple. The man, wearing a velvet cap over long, loose hair, a lace collar and knee breeches, is singing and accompanying himself on the lute. A young woman, her left arm resting on the round table, is listening to his serenade. On the tablecloth that has been turned back stands a still-live group: a jug, a bowl of fruit and a wine glass. The foreground is enlivened by a dog and a cat. Above the woman's head hangs a black-framed picture below a leaded window, the struts of which – like the gables of the houses – end in pointed arches.

What did Miró make of this picture? At first glance we discern in his version a greater affinity with *The Harlequin's Carnival* than with Sorgh's picture. But closer scrutiny reveals that every one of the ludicrously inflated or contracted shapes has its counterpart in the Dutch model. We recognize the lute and the two arms that hold and play it. But the strings have been broken in pieces and stretched over the

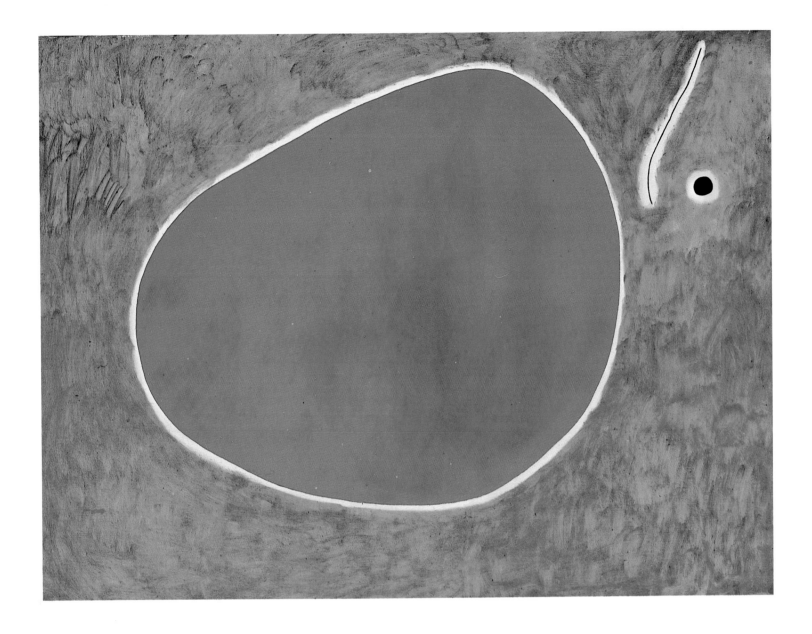

**Flight of the Dragonfly from the Sun,
26 – 1 – 1968**
Vol de la libellule devant le soleil
Oil on canvas, 174 x 244 cm
Private collection

sound-hole and finger-board like seams. The man's torso seems to have expanded into a white parasitic growth, in which the face with the open mouth is poised like a round, red moon. The cap is perched on the extreme outer curve of the gigantic egg-shape; five single long hairs dangle like bent music lines from the whorl of the ear on the left side of the face. The singer's trimmed beard has parted from the face and is drifting away like a merry punctuation mark that has broken loose from its sentence.

In Miró's picture, the man's thighs, the white table-cloth, the turned table leg and the beribboned shoes have become one. The female figure has been reduced to a minimum of form; so have the jug, the open music book and the wine glass. In the landscape on the left, we find the same correspondences; the dog in the foreground has become a Cerberus. The space between is seething with forms, the shapes of which are hinted at in the Dutch painter's picture, but which in Miró's have developed into independent symbols of an erotic character – after all, the picture is a love scene.

Here, as in *The Harlequin's Carnival,* an untrammelled world set free from the domination of reason is at work. Four centuries ago the pic-

193

tures of Hieronymus Bosch found their way to an enthusiastic royal collector in the Escorial. The Catalan Miró discovered an essential similarity in this interior from a bygone Dutch world that had absorbed so much that was Spanish into its outward appearance.

When I looked, with Miró, at a screen print produced in America after his Dutch Interior, he took out the yellowed picture postcard from the Rijks Museum and several pages torn out of a notebook, on which the first variations on the theme of the new picture were sketched in thin pencil lines. Comparison between Miró's work and its prototype shows in an instructive manner how completely Miró had freed himself from the peep-show picture of the Renaissance. The old Dutchman's picture, too, draws its life from the tensions of intimate interrelationships; in it, too, phenomena are caught up in a perpetual "dialogue". But some seconds of scrutiny are required before the spectator perceives the sounds and rhythms of this whispering. What first impresses itself upon him is the atmosphere of the genre scene, the snugness and a humour that is apparent only "between the lines". The eye requires time for its wandering through the constructed spaces of the picture. It experiences the sensations of the motif and of the plastic values one after the other. The atmosphere gives coherence to even the most heterogeneous elements in the composition.

Miró's picture with its three powerful major colours – a rich green, a neutral sepia and a harsh white, a chromatic triad reminiscent of harlequins' costumes – creates the first impression of a surface enlivened by vital rhythms and forms. Here it is above all the colours that create space – the retiring green inlaid with a still colder cobalt and the forward-thrusting orange of the lute. The white shapes create magically dominant accents.

What is revealed in the Dutchman's painting as the result of close study comes rushing out to meet the spectator with a sense of shock in Miró's: tumult and the triumphant laughter of beings and objects released from the domination of the causal, of space and time. It is true that here, too, there are zones of an almost spatial character. Each of these domains, however, has its own system of visual and vanishing points. Here the spectator feels compelled to change his standpoint before each section of the picture. If the effect the spectator receives from looking at Sorgh's painting resembles that of finding his way about a stage with the aid of a pair of opera glasses, thoughts and senses roam over the labyrinth of Miró's picture as though through one of those fairground mazes in whose myriad passages and chambers surprises await the unsuspecting visitor at every turn. In front of this picture the spectator does not feel invited calmly to survey the visible; on the contrary, the visible has emerged from its passive state and become active; subject, predicate and object have changed places.

During this period Miró several times drew his inspiration from paintings and fashion plates from the 18th and 19th centuries. There is a *Mrs. Mills in 1750 (after Constable)* (p. 57), a *Lady from the Year 1820* and even a *Portrait of Queen Luise of Prussia!* Each of these pictures looks like an improvized theme that will be treated with greater density of form and expression in years to come.

Poem I, 17 – 5 – 1968
Poème I
Oil on canvas, 204.7 x 173 cm
Fundació Joan Miró, Barcelona

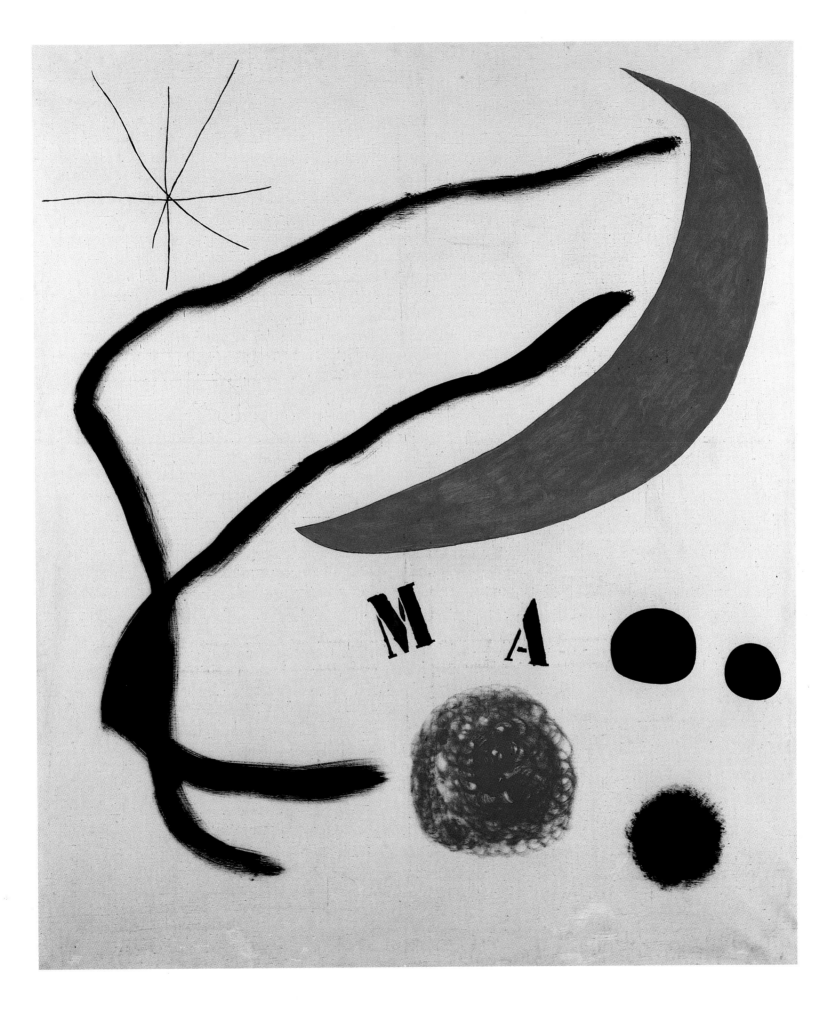

The execution of these latter works reveals how conscientious a craftsman Miró is, and they show clearly that the impulse behind his activities is a light-hearted one. This distinguishes Miró, in particular, from the Surrealists, who have lost in the chamber of horrors of their libido and complexes not their fears, but their laughter. How many of the Surrealists were only camouflaged Pre-Raphaelites and sentimentalists. Through the painterly space and sky before which Miró places his eccentric portraits and scenes there rings the liberating laughter of Mediterranean Pan.

It was the Surrealists' aim to create a world of art that cast doubt upon the rôle of causality in the relations between earthly phenomena and the reactions which these phenomena provoked in men. "Everything leads us to believe", says the Second Surrealist Manifesto, "that there exists a particular point at which life and death, real and unreal, past and future, the expressible and the inexpressible, the higher and the lower are no longer perceived as opposites, and it is fruitless to seek to detect any other impulse behind the Surrealist movement than the hope of establishing this point."

Such formulations could have little appeal for Miró, since no true art has at any time in its history desired anything but to approach this point. When Salvador Dalí defined his technique as a "method of spontaneous irrational cognition based on the critical and systematic objectivization of delirious associations and states", Miró could not help becoming sceptical, particularly when he saw that there was no correspondence between Dalí's antiquated, mannered technique and his declared aim of expressing a "paranoid" world. Miró was interested neither in the "active study of psychotic states" nor in the representation of "objects with a symbolic function" (Dalí, quoted by Dieter Wyss).

The Surrealists regarded the super-real as the extraordinary, as a phenomenon above and beyond the real. Miró on the contrary, saw in the super-real a condensed reality raised to the level of existence to it, a reality that is full of magic and life. His "Surrealism" was aimed at the kernel, at the marrow of the real. He has more in common with the magical supernaturalists of art history, Bosch and Grünewald, than with the "surreal" eclectics of the late Renaissance and Baroque.

This thesis is vindicated when we study the works which Miró undertook after the "Dutch Interiors" and the figure paintings of the same years. His new works do not exhibit – as might have been expected – an intensification of the surreal setting in the direction taken by his countryman Salvador Dalí. They manifest, rather, a tendency to occupy himself more intensely than ever with the true problems of painting. It has been asserted that Miró saw works by Klee and Kandinsky in Paris round about this time and that this encounter added depth to his artistic expression.

The painter lives in a perpetual state of critical debate with his work and his environment, in which we must include his artistic environment. Every contact with another painter's picture will bring him back to his own work. Only a progressive and productive interaction between the three mutually stimulating constituents gives the painter the

196

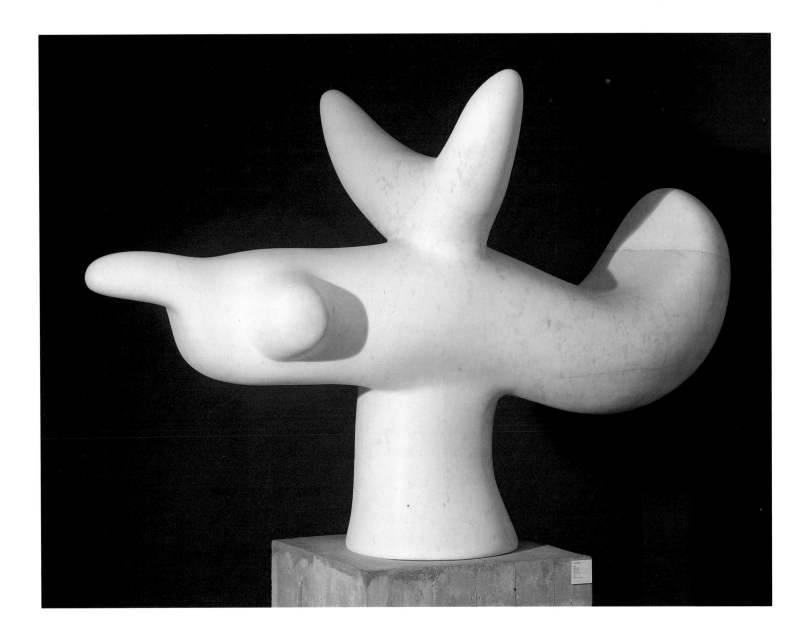

incentive to present the world of his artistic visions more precisely and more poetically.

Another question is the extent to which certain pictorial "manners" come to be adopted by various painters quite independently at the same time. The urge to employ such a "manner" seems to be in the air; it is generally idle to inquire who used it first.

During the ensuing period Miró tried to render the ground of his pictures more sensitive and suggestive by loosening the brushwork. He laid in bands of glazed or impasto colour on the surface and then countered them with similar bands running in the opposite direction, so that his surfaces became charged with tensions. Into this lively background topography he wrote with the brush linear constructions that entered into contrapuntal relationships with the areas colour underneath them. These animated areas of colour share their suggestive force with the lineation stretched over them which increasingly loses its graphic character and becomes an integral part of the painting as such.

One example of this approach is the picture entitled *Seated Woman* (1931) (p. 63). An overlying circular shape, a dot set down in a blank

Sun Bird, 1968
Oiseau solaire
Carrara marble, 163 x 146 x 240 cm
Fundació Joan Miró, Barcelona
Courtesy Marguerite and Aimé Maeght

197

area of the background, a series of shorter dashes intersecting the main lines are not merely "abstract" shapes, but rather a head, an eye, hairs and wrinkles. We can almost watch the first lines put down acquiring extra weight as outlines of parts of the body. Areas of colour and lineations combine into configurations that live and grow into the picture space, until they fill this space and threaten to burst it asunder.

As we follow the genesis of such a picture, we must once more wonder at the painter's intuitive intelligence; the conception and execution of his picture are never the outcome of fortuitous manipulations; a presentiment of the finished work is already latent in the first bands of colour to be laid on. In his watercolours of the same period Miró roughened the paper with emery paper, to give a more lively texture to his colours. He transferred the same expressiveness of texture to his oil paintings, in which he gave more and more life to the painted surface. In a picture called *The Two Sisters* (1931) the colours vary very greatly in character. At one point they run together with blurred outlines, forming cloudy veined patches. In this atmospheric area other chromatic constructions are placed: an oval of opaque pastel green with ragged, cottonwool edges inky blue depths like ponds by night, sooty shapes that seem to be curling up or falling apart. Then come carefully drawn triangles of pure vermilion and lemon yellow. Between these coloured shapes, adapting themselves to the specific character of the colours and forming new areas of composition, wind black lines in the shape of ribbons or tubes. They grow out of indigo-blue patches into the more airy, cloudlike shapes. Earth, sea and air are distinguished from each other as the hard and rigid on the one hand, and the soft and alive on the other. Finally the apparently disparate elements unite to form shapes resembling figures, in which we can, without difficulty, recognize the *personnages* of the later Miró. Such a work proves, on analysis, to constitute a miniature history of Miró's creative development. Last of all, we see that the two figures are leaning towards one another and we become aware of tensions of a formal and psychological nature. Our imagination is stimulated by these tensions springing from the fragmentary constituents of the picture, we listen to the poetic dialogue of the two sisters.

The Dadaists and Surrealists were in the habit of incorporating in their pictures paper cut-outs, illustrations taken from newspapers and steel engravings from adventure novels; to these they added lengths of cord, corks and pieces of cigar boxes with the label on them. They replaced artistic sensibility in the handling of paint by the manipulations of objects that had been worn-out by use and hence achieved their full "reality". They strove to give their pictures a startling strangeness. At the same time, they were of the opinion that the applied objects only acquired their true expressiveness through the vicinity of drawn and painted shapes. They wished to deepen the expressive power of their pictures by dimensions that were more of a psychological than of an aesthetic nature.

Up to now, painters had striven to transmute their experience of the world into the transcendental, with the aid of the "chemistry of colours". The Surrealists took no interest in the permeation of matter

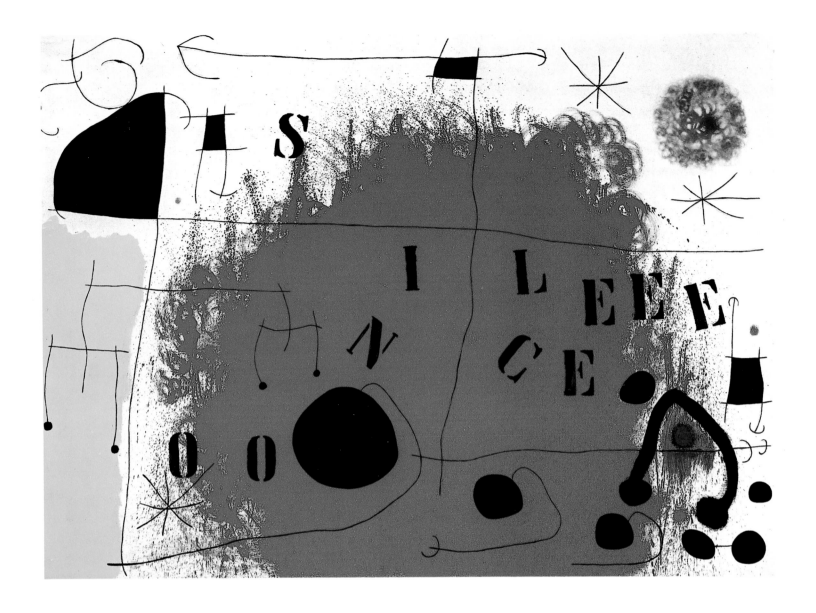

by spirit; on the contrary, they sought to register the specific stimulant quality of matter. Since, however, the function of the applied objects was at the same time to create a sense of strangeness, they acquired an altogether new significance: the commonplace object became a fetish.

Silence, 17 – 5 – 1968
Silence
Oil on canvas, 174 x 244 cm
Private collection, Paris

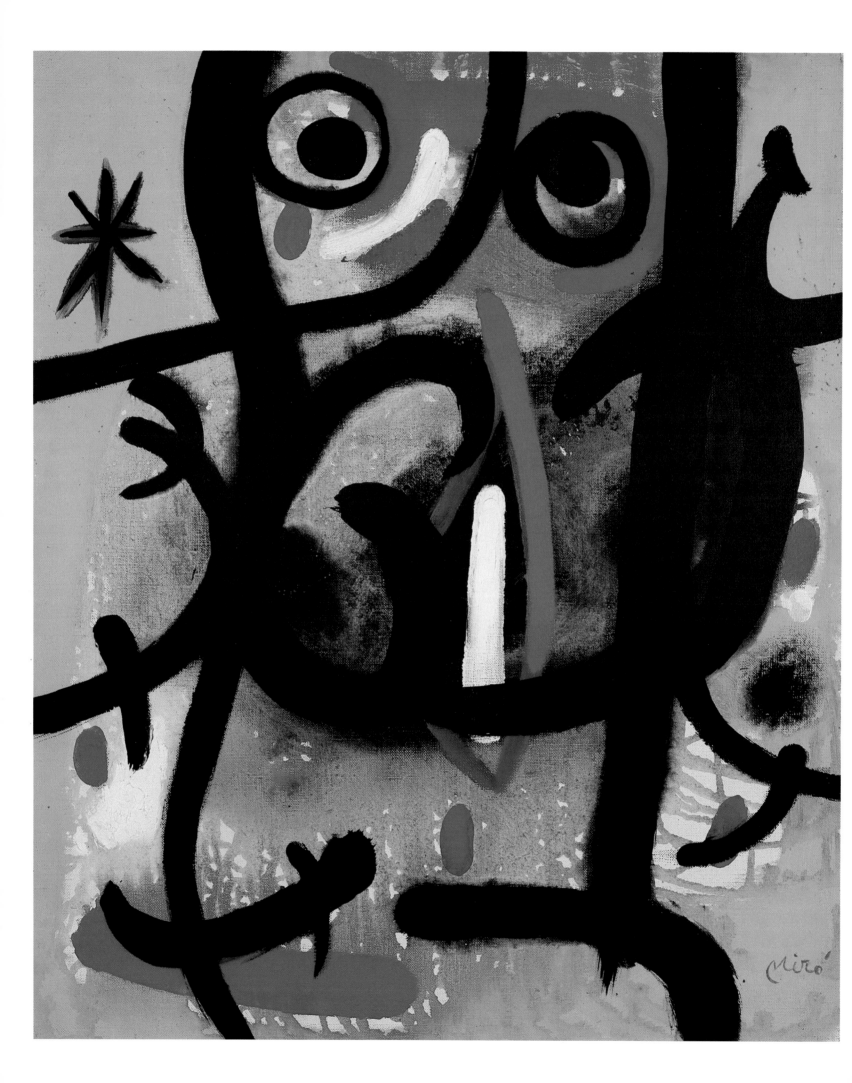

The Soul Laid Bare

At the beginning of the Thirties Picasso created drawings, paintings and sculptures with strongly projecting noses and cheekbones and protruding eyes, reminiscent of prehistoric idols. A few years earlier – after a protracted stay in the Northern French seaside resort of Dinard – he had painted pictures with figures resembling monuments made up of blocks of stone piled one upon the other. Among these paintings is the famous *Woman Sitting by the Seashore,* a statuesque construction of interlocking shapes that symbolizes the loneliness of a creature exposed to the expanse of sea and sky. With this picture displaying a figure so simplified as to be almost a skeleton are ranged others containing expansive forms of archaic vigour. Picasso must certainly have drawn inspiration from stones washed up on the beach that had been shaped by the action of the sea.

We know that Miró collected on the shore at Cambrils and in the mountains at Montroig stones whose physiognomy and expression impressed him. In 1935 he painted a *Man's Head* that looks like one of Picasso's sculptures struck by lightning. The powerfully modelled "head" stands out against a cloudy and threatening background. Forehead, nose, eye, the line of the cheek, lips and chin are glowing as though lit by an inner light. By comparison with Miró's earlier pictures, this work is set in a graver key. Playful humour has been replaced by a harsh ferocity that has all the magic of the bygone countenances of mythology.

In the *Still-Life with Old Shoe* (1937) (p. 83) Miró actually approaches the kind of realism he was practising at the time of the early still-lifes, except that here the forms assume monumental proportions and fill the wide expanse of a landscape beneath hurtling storm clouds.

In a mural by Miró, *The Reaper,* which, like Picasso's *Guernica,* hung in the pavilion of Republican Spain at the Paris World Fair, this magically illumined realism has assumed looser, more abstract forms, without the figure with the sickle losing any of its forcefulness, which is here both earthly and mythological. In this mural we see the first hint of the *peinture sauvage* style which Miró was to develop much later.

The extent to which Miró was concerned with the problem of fashioning a more definite form of reality is evident from the over-life-size *Self Portrait* (1937/38) (p. 84), which is more like a large coloured drawing than a painting. Here the lineations that outline and mould

Miró's symbols seem to have inscribed themselves into the spotty brown surface with a brute, elemental forcefulness. Convulsive, crossed or forked lines converge at narrow angles which have been partly filled, and encircle a centre, characterized by the dense colour of its surface and, above all, by a black splotch which has been hurled onto the canvas. It is surrounded by several emphatically colourful elements – circles, lines and dots in Miró's basic colours red, yellow, green and bluish purple.

Despite its broad movements, the picture does give the impression of being carefully composed, especially when we consider the distribution of symbols around a centre, which almost amounts to a classic method of composition. The multiply broken and sprayed surface seems like a three-dimensional foil on which the symbols are in suspension, without forming a firm part. On the other hand, the general character of the painting is mythical and primaeval – like those early drawings which had always inspired Miró to invent his own symbolic language.

The different periods of mankind seem to have converged in these late paintings of Miró's. The earliest has become the latest, and the mythology of our modern age has linked itself to the myths of mankind's history. This picture may indeed contain the evidence that the most elementary symbols have never changed but have always crossed man's conscious mind by re-activating those deeper levels of pre-conscious and pre-linguistic perception.

Woman in the Night, 26 – 11 – 1970
Femme dans la nuit
Acrylic and oil on canvas, 55 x 46 cm
Fundació Joan Miró, Barcelona

the features are set down upon the ground of the picture with unparalleled frenzy. The firm fabric of the epidermis in the earlier self-portrait has become transparent; we are now able to glance into the anatomy of a psyche strained to the utmost. Pitiless strokes sketch out the topography of a landscape laid waste and denuded, behind which, however, powerful forces of resistance make their presence felt. This self-portrait is a *Guernica* of the human psyche. With it Miró proved himself the chronicler of an age threatened by impending horrors.

"The main thing is to lay bare the soul," Miró declared in a conversation with George Duthuit. "Painting and poetry are like love – an exchange of blood, a passionate embrace, without restraint, without defence … The picture is born … of an overflow of emotions and feelings. It is nothing else than the product of an act of self-expression, to which we never again return."

These last paintings have shown us that Miró is more than a Jonathan Swift or a Rabelais in paint. Perhaps the satirical and grotesque in his previous pictures was no more than a mask, of which he made use until he knew himself to be in possession of all the plastic devices that would enable him to express what he most deeply yearned to express: the poetic. "I consider it necessary to overcome the 'plastic', in order to attain to poetry." This utterance of Miró's applies especially to the last phase of his work, though it is clear that the concept of poetry, as seen and portrayed by Miró, has nothing to do with the customary notion of the romantic idyll. Miró's poetry is born of formal tensions, in which the frightful and terrifying are as fruitful as the gentle and endearing.

We have already pointed out that Miró thinks and works in terms of series. There are certain series of pictures that extend over several periods of his œuvre. Thus in 1938 he returned to the theme of two parallel planes that had been first strikingly formulated in the painting *Dog Barking at the Moon*. The 1938 painting bears the title *Les flammes du soleil rendent hystérique la fleur du désert (The Flames of the Sun Make the Desert Flower Hysterical)*. Henceforth his pictures frequently have a longish title in the shape of a line of poetry laden with metaphor, which is virtually untranslatable.

The surface of the desert, broken by the dunelike elevation in the centre of the horizon line, evokes the idea of a wide expanse vibrating in all its particles. From the right the wheel of the sun comes rolling across with its pointed tongues of flame, the symbol of ever-renewed elemental force. The lower edge of the picture is enlivened by an ecstatic conformation of petals, pistils, stigmas and stamens that coalesce into the shape of a female figure. This conformation resembles one of those organisms that are midway between animal and vegetable. In this picture, the light acquires particular significance as a factor of expression. It is not the chiaroscuro which the Impressionists sought to analyse, however, but the mystic radiance that pours down out of medieval Catalonian frescos.

Sky, earth, sun and flower! As we gaze upon this picture nothing else exists but the emotions, the reactions and stimuli arising out of the encounter with these primordial phenomena of myth. It is as though

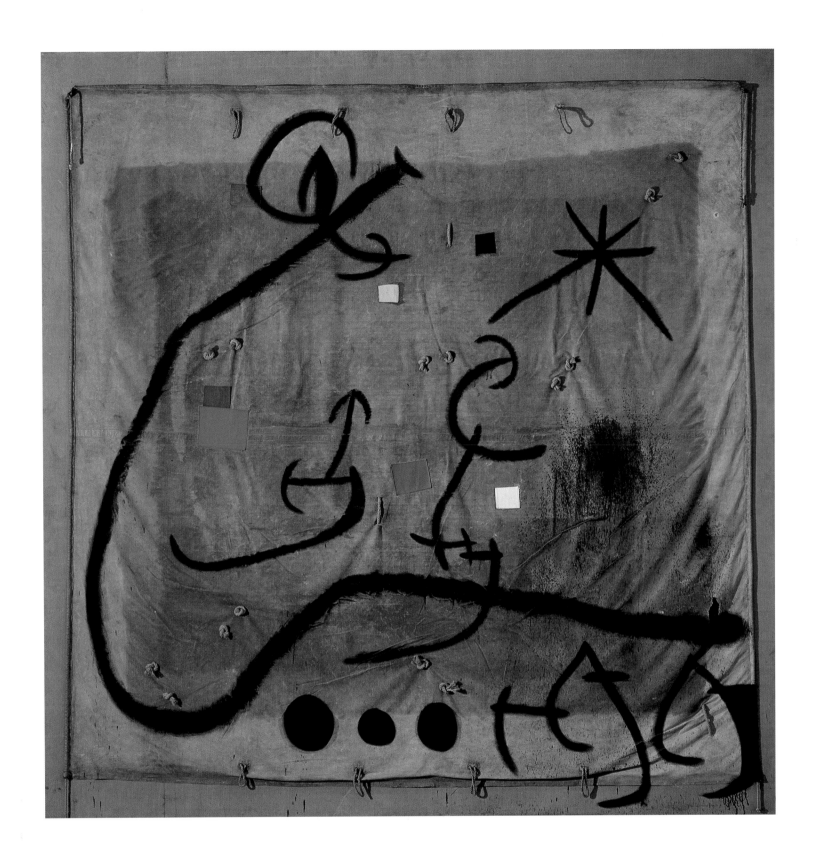

Woman Surrounded by a Flight of Birds in the Night, 28 – 5 – 1968
Femme entourée d'un vol d'oiseaux dans la nuit
Acrylic on cloth, 336 x 336 cm
Fundació Joan Miró, Barcelona

the painter had entered into the nature of the dizzily awakening desert flower and was chronicling this awakening as one of the events that have moved mystics since time began.

In the painting Personnages devant la lune from the same year we are witnesses of a mute dialogue that links astonished beings in the borderland between dream and reality. William Blake, Caspar David Friedrich, Vincent van Gogh, Odilon Redon and Paul Klee have celebrated the rapture that comes over creatures as they feel a presentiment of the mystery. "If we do not endeavour to discover the religious essence, the magical significance of things, we shall merely add to the sources of stupefaction, so freely proffered to man in our day," declares Miró in his essay *On The Meaning of Painting* written in 1939.

In the pictures painted during 1938 he proves himself not merely the documenter of visions that give concrete and imperious expression to coming horrors: he simultaneously holds up to mankind a world that demonstrates in which domain the roots of its existence are to be found.

In 1940 the German troops occupied France. Miró moved first to the South of France, then to Barcelona, where for a short time he lived and worked. Finally he withdrew to Palma de Mallorca. In the course of the two decades and more during which he lived in Paris, he made repeated visits to his Catalonian home, often for long periods at a time; he had never lost his inner contact with it. But now he returned as a refugee.

He had left a world over which the clouds of disaster and terror were gathering, and found his way back to a landscape in which everything was the same as when he had left it as a young man. The painter's outward and psychic eye experienced the same creative reactions; but the familiar images came to a man who had constructed an artistic world-view and invented a poetic language that many people on the European continent and across the Atlantic admired and loved. Among others, there was a book about him in Japanese, of which he was exceedingly proud; after all, the written characters of that language had a great deal in common with the symbols that appeared in his pictures.

Miró was no longer searching; he now related the messages conveyed to him by phenomena to a world-view that was already mature. The time of seclusion and separation from his friends was a time of consolidation and introspection. "In the year 1940 I am really beginning to achieve my aims, I am beginning to become aware of my own language", he declared at this time. He became aware of the continuity that ran from *The Farm* to the last pictures he had painted in Paris.

The ensuing works represent new versions of a poetry in paint that is disclosed in their very titles: Le bel oiseau révélant l'aube à un couple d'amoureux, L'étoile matinale, Éeil à l'aube. "I find my titles according to the manner in wich I am working, the manner in which I add one thing to another on my canvas," Miró once said. "When I have found the title, I live in its atmosphere. The title then becomes for me a hundred per cent reality – as the model, a sleeping woman for example, does for other painters. The title is for me *une réalité exacte!*"

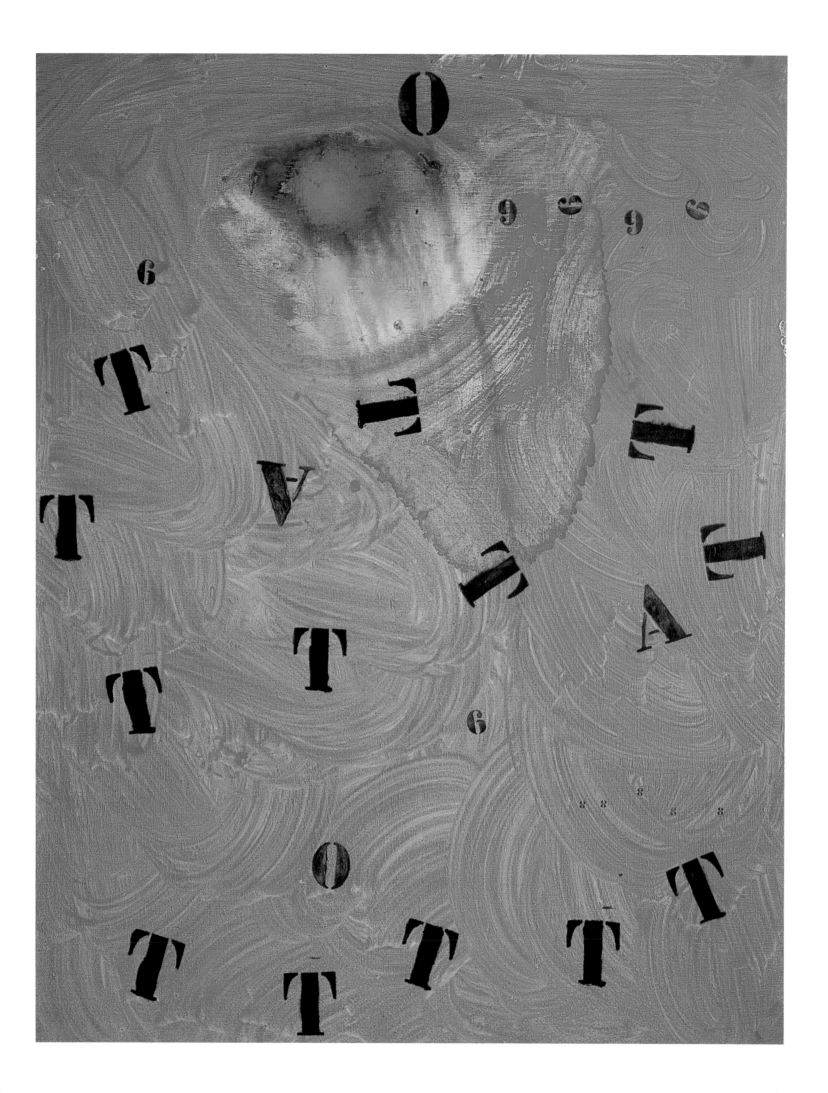

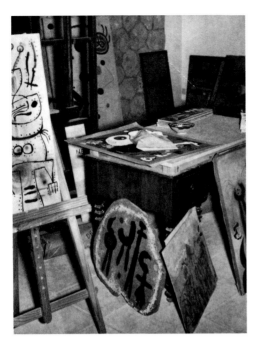

At the studio

The language of forms, colours and lines in these new pictures has a playful looseness; there is nothing to remind us of the sombre visions of the two preceding years, which bore witness to the fact that Miró in his heart of hearts is a pessimist, a tragedian. The background of these last pictures and those that followed them is bright, flooded by light. He frequently worked with water paints or pastels on paper, that is to say with media appropriate to the gay and poetic character of his compositions.

In Miró's studio I saw a number of small pictures painted on sheets of wood or hardboard, which he had begun at this period and which bore the collective title *Constellations*. The lines were carefully drawn with a sharp pencil. These works, to which Miró again and again returned, have still not been brought to completion. The name *Constellations* is also applicable to the other works from the same period, and this designation reminds us of the time when the young Miró studied the heavenly bodies in the night sky over Montroig through his father's astronomical telescope.

In these pictures the vibrant dots, circles, stars, crescent moons, darting flames, peering eyes, faces with long noses, and sexual symbols, are linked to one another by sensitive lineations – as on mediaeval star charts. It is the same world that delighted us in *The Harlequin's Carnival;* only here the pictorial language behaves less eccentrically, the outcome of combining many heterogeneous elements is painted poetry rather than a Surrealist phantasmagoria. In *The Harlequin's Carnival* there was still a hint of three-dimensional space; here everything has been transposed into a zone devoid of space or time, in which objects and beings are mute, whereas the connexions established between them begin to produce an audible music. The many rhythmic relationships with which these pictures are filled, the wealth of possible variations on the linear configurations and the counterpoint of chromatic effects recall the language of music. In actual fact Miró concerned himself more closely with music at just this time. "Bach gives me a magnificent lesson in architecture. Mozart conjures up love with his purity, his magnanimity and his tenderness. They all help us to be able to live in the midst of so much baseness and meanness!" (from a conversation with Georges Duthuit).

If Miró was now desirous of creating "reality", it could only be that kind of reality which drew its energy and substance from his new poetic cosmos. It was a magical and mystical reality, but its attainment did not take Miró away from the visible reality, that surrounded him by day and night; on the contrary, it helped him to get under the skin of the phenomena around him and so reach their essence.

Once when I was talking to Miró about the pollution of everyday life by the noises of the radio and the record player, he replied that people whose ears and senses had been drenched by these mechanically produced noises no longer heard the quieter music of existence: the breath of the wind, the rustle of leaves, the music of distant surf, the jubilation of birdsong or the sound of cart wheels on a sandy track, sounds that had great significance for him and immediately transposed themselves into images of a plastic nature. He was profoundly

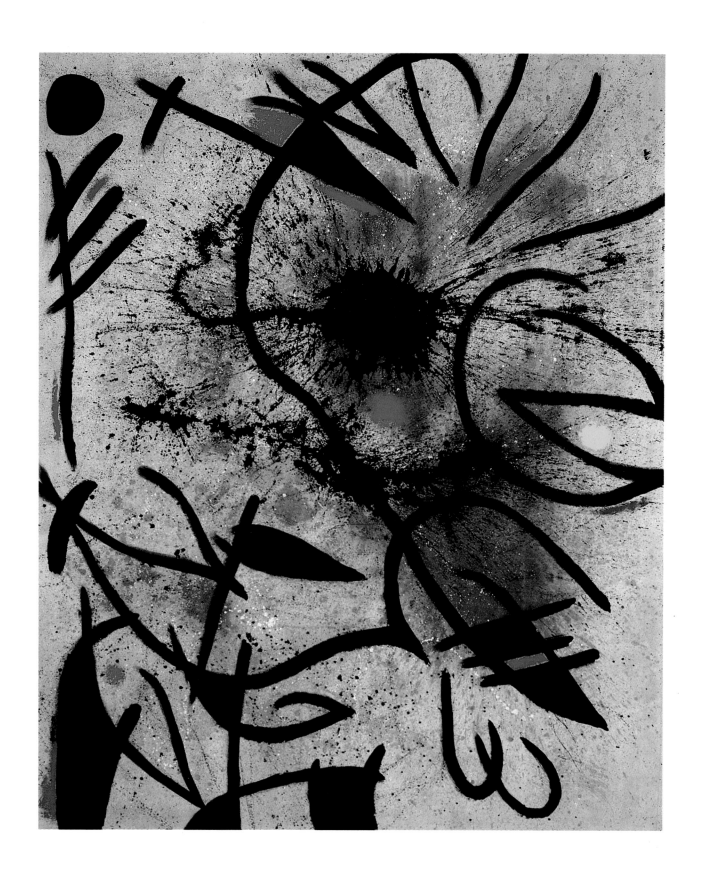

Birds at the Break of Day, 1970
Oiseaux à la naissance du jour
Oil on canvas, 220 x 261 cm
Pierre Matisse Gallery, New York

This picture seems like an obituary of the student revolts in Paris in May 1968. Miró always saw himself as a "man in revolt", revolting against apathy and hypocrisy. The burst splotch of black reminds one of the bursting bags of paint and also the explosive energy and imagination that was set free. These are fireworks of colour, celebrating that power of artistic imagination which the freedom of the spirit alone can savour to the full. Miró's hand prints form imploring gestures, primaeval symbols of fear and danger, but also of self-confidence and strength. Miró's universe is untouchable. His revolution has taken place on the playing field of the canvas. However, it continues to make itself felt in our minds.

excited by the "eloquent silence" extolled by the mystic, John of the Cross.

If we wish to reach an understanding of Miró's pictures, it is good to bear in mind all those mute dialogues overheard particularly in the early morning or at nightfall – at the moments when things gaze at us, material objects burst into song and the silence is full of messages. Now it is no longer things that speak, but the tensions between matter, the senses and the spirit.

When we stand in front of a "realistic picture", the landscape of the painting expands and swells out until it reaches and encircles us and draws us into itself as partners, taking hold of that part of our being which the picture also expresses in its forms and constellations. The picture will never do more than confirm that element in ourselves which it portrays: in this case the outward aspect of our existence, which we can verify at any time by simply looking in the mirror.

Miró's pictorial space encircles us in the same way, here too we participate in the events taking place in the picture. But the signs and plastic sensations in these pictures call upon the spaces, structures and particles of a hitherto concealed part of our existence, which correspond to those of the picture. The domains of our being and dreaming brought into consciousness by the encounter with the picture exist – like the picture by which they are aroused – beyond the dictatorship of time and space.

Employing the technical means he had now acquired, Miró embarked upon a series of paintings, mostly on porous grounds, which today we term his "Classical Period". Many of them have a monochrome, but always lively ground of sandy brown or ochre, smouldering yellow or pearly white, shot through here and there with blue, green or violet veining. The superimposed lineations cross and interpenetrate, they create areas and segments that are filled in with strong, opaque colours. These colours – orange, vermilion, green, violet and black – form powerful chords now and then given increased tension and sensibility by the insertion of a segment of pure cobalt or lemon-yellow. Often a piece of radiant pure white is also added. All trace of intermediate grey is avoided: there is neither chiaroscuro nor modelled form, space is henceforth the product solely of tensions between cold and warm colours, the neutral background linking them and the lineations that wind in and out over this background. After many eventful expeditions through the world of artistic forms, Miró has returned to the lapidary simplicity of expression that characterizes the works of folk art and the Catalonian frescos. This return to simplicity, however, did not mean any diminution of sensibility and vigour after so much previous effort. On the contrary, we can see how Miró seeks, as he advances from picture to picture, to convey new artistic "realities" in the process of which the means become more sparing, the expression more charged with meaning and associations.

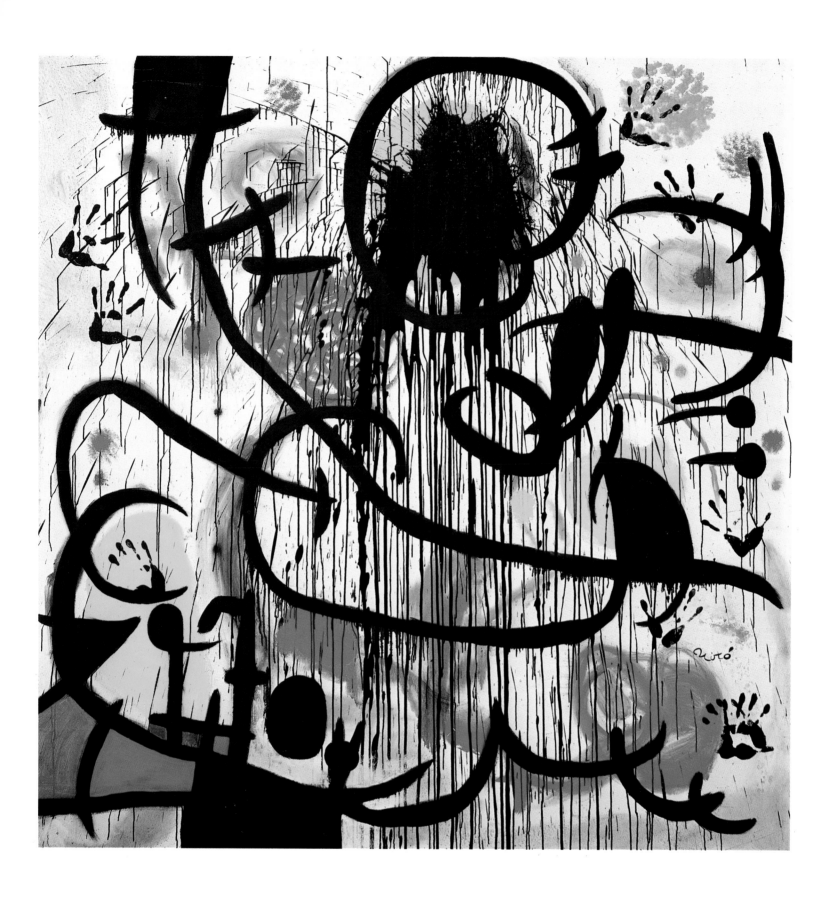

May 1968, 1973
Mai 1968
Acrylic on canvas, 200 x 200 cm
Fundació Joan Miró, Barcelona

New Artistic Realities

New artistic realities – that is to say, new aspects of plastic expression – are not only the result of strenuous thinking and planning. The thinking out of new pictorial methods goes hand in hand with the trying out of new materials. We have seen how Miró varied, extended and deepened his artistic language by employing different techniques and working on different surfaces. Against the walls of his studio stood irregularly shaped pieces of asbestos sheeting and hardboard, which he might have found on the beach or a building site. These finds, which had been "prepared" by the effects of damp, heat and many other external influences, stimulated him. He covered them with his "signs" and finally grouped several such painted boards on the flagstone floor of his workroom; always the various sets of signs combined to form surprising constellations. These in turn inspired him to new pictorial compositions.

There is a painting dating from 1945 that bears the title *Woman Hearing Music*. The spectator sees only the end-result of all the preliminary stages of experiment, juxtaposition and contemplation. What were formerly individual pictures are now fused into the greater unity. They stand out as light areas from the deep black ground and are linked together by connecting lines. Nevertheless it is not difficult to trace back the phases in the picture's evolution from the finished work to its origins, and it is not necessary for this purpose to know the story of the juxtaposed boards on the floor. The structure of a face gives us a hint of the stages of development that have fashioned this physiognomy, even if we have no precise knowledge of the phases it has passed through.

From 1945 onward, Miró, in collaboration with his friend the master potter Artigas, took up pottery and modelling. Pots, jugs and vases made to his specifications by Artigas, Miró decorated with his "signs", patches of colour and linear patterns. He also painted these on large tiles, to which, as to the vases, he often added details in relief. Finally he modelled idol-like forms, half animal, half plant of fruit, depicting those indefinable figures, the *personnages*. At one time Miró felt a need to handle the objects he was about to paint or draw, in order to grasp their structural qualities. Now he proceeded in the opposite direction: inspired by formal ideas, he imposed upon unformed matter the mark of his constructive will.

Miró outside the portal of Tarragona Cathedral, 1955

Head, 1 – 3 – 1974
Tête
Acrylic on canvas, 65.1 x 50 cm
Fundació Joan Miró, Barcelona

211

In his choice of material Miró frequently used his sense of touch as the starting point. This can be seen particularly clearly in his ceramics. In the 1960s, however, he directed his attention to the amazingly inexhaustible abundance of different materials and techniques, which is very much in evidence in this work of art, inspired by Catalan *sobreteixims* i.e. heavy, decorative double-woven cloth. However, he enhanced the variety of these imaginative creations of his home area even further. The piece of cloth that he used as the support had to bear the most diverse objects: ropes from aboard a ship, colourful twine, fishing nets – everything that caught his eye (and that he could lay hands on) on the beach of San Augustin seemed to be a welcome opportunity to exercise his creative playfulness. In addition, there are of course several elementary symbols, partly painted, partly woven into the material, rounding off the heterogeneity of this tapestry in a pictorial cosmos that is typical of Miró again.

From all these experiments Miró acquired knowledge and experience which in turn manifested themselves in his painting and drawing. Alongside lineations of an abstract character appeared others that make no attempt to conceal their origin in modelling. Henceforward, we also find in his canvases constellations of colours that show a resemblance to the colour effects Miró discovered and studied in connexion and mingled with one another: modelling was enriched by colour and line, without losing its characteristic quality; the picture gained by the introduction of forms of expression that had come to Miró through his work in modelling and pottery.

To these were added the "objects" that Miró put together out of the most heterogeneous things and materials, those montages which are so reminiscent of Miró's Surrealist period and which we have already mentioned while describing his studio. If Miró was once stimulated by contemplation of the phenomena in surrounding nature, nature was now extended by the configurations he created. Since he studied these, too, as a part of nature, they were likewise incorporated in his painting. In this way Miró composed for himself a rich scale of creative techniques.

During the ensuing years, until about 1950, he painted a series of pictures, many of them large in scale, which first spring to the art lover's mind when he hears the name Miró. Among these are the long horizontal murals in a hotel in Cincinnati and in the Harvard Graduate School, which date from Miró's stay in the United States during the years 1947 and 1948.

In these works Miró attained a pictorial language of classical balance, a style of expression that was at once monumental and playful, gay and restrained – direct to the point of brutality and once more interlaced with configurations of Terpsichorean grace. Heaviness is always confronted by its mirror image, thereby gaining an appearance of liberation; the delicate trembles in the presence of so much heaviness, thereby looking twice as fragile and exquisite.

Miró thinks and works in "series", which is not synonymous with schematic variations of style. He brings each of his works to the maximum degree of maturity, both as regards technique of execution and intensity of plastic significance. He frequently gives the ground of his pictures the texture of exquisite fabrics. Upon this prepared ground he draws in the lineations with such care that the spectator feels doubtful whether a brush stroke can have conjured up such a delicate line.

The colours that fill the areas formed by these lineations are likewise laid on with the greatest possible care; the surfaces frequently display such a dense structure that no trace of a brush stroke is visible. And yet every square inch of paint is vibrant with life.

The vitality that informs the play of colours is present with equal intensity in the play of the expressive lines, curves and spirals that sweep freely over the picture surface. Every line conveys an attitude. Consider the picture *Les ailes de l'oiseau glissant sur la lune pour atteindre les étoiles* (1953). The play of lines on the left-hand side of the picture is rich in poetic movement. There are lines that coalesce to form a long

Sobretexeim No. II, 1972
Acrylic and other materials, 254 x 195 cm
Lelong Gallery, Paris

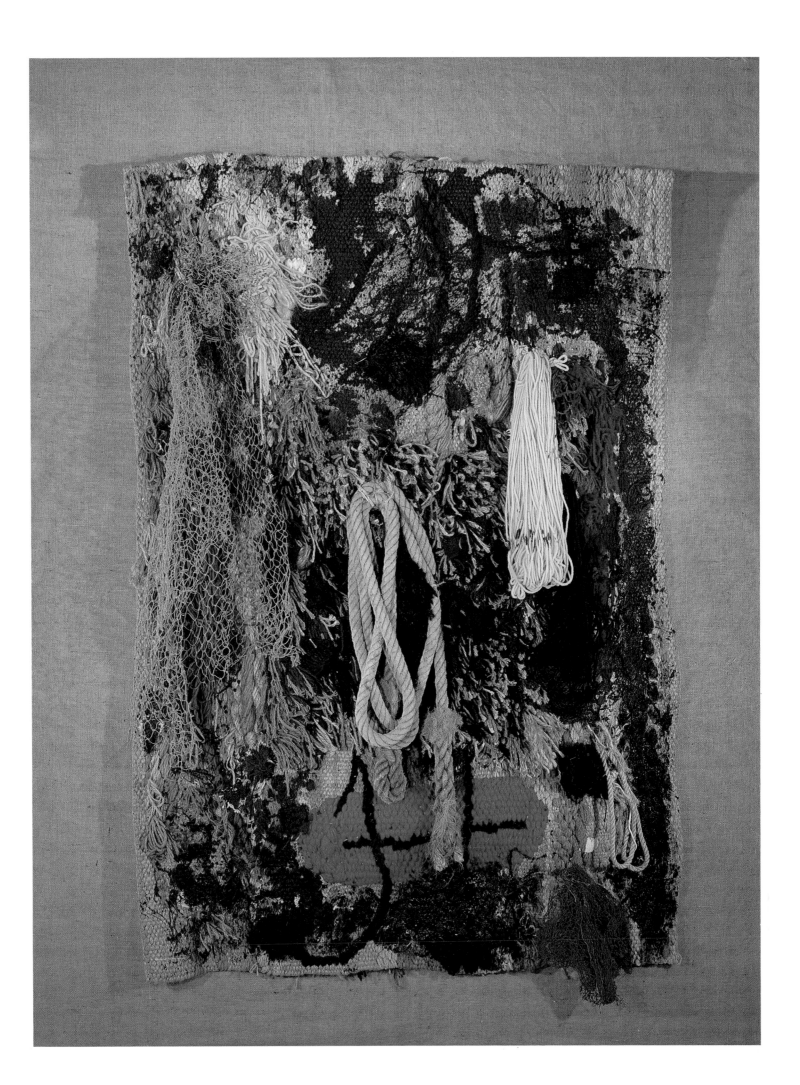

This painting – one of Miró's late works – is dominated entirely by black. The horizontal division seems to suggest a landscape, but this impression is literally cancelled by two large black symbols in the top half, which unload a shower of black colour particles onto the entire field. The violence of this discharge is emphasized even further by an equally violent red dot on the left. Despite their vehemence, the symbols which thrust themselves forward into empty space are unambiguous enough to be recognized. There is a sickle, resting on the black ground and, crossing it, a symbol which is oval at one end, with two prong-like protruberances, of which the top one has an animal-like quality and looks as if it were going to jump. A further constellation in this picture, which otherwise derives its structure from the sprayed black particles, is formed by two black dots. These symbols crash down with brute force, and their violent impact is muted only by the black ground which provides a comforting counter-balance. These powerful symbols seem like warning signs in the sky, accompanying a bursting star, and the crescent-shaped symbol, which so strongly suggests a sickle, may well point to an eschatological interpretation.

Bird, Insect, Constellation, 1974
Oiseau, insecte, constellation
Oil on canvas, 130 x 97 cm
Pierre Matisse Gallery, New York

bird's neck proudly arched. The right-hand line looks more confident than the hesitant one on the left; a third line cuts across the "body" formed by the first two and runs out into an exquisite spiral. This "bird shape" has feet as well. The first and shorter one feels its way timidly forward, slightly bent, as though to overcome an obstacle; the other is thrust more forcibly backwards. It ends – ironically – in a distinct, if rather helpless full stop.

This shape is not necessarily a bird, of course, even if it does depict a possible version of a bird's appearance. A poetic shape has many meanings, its contents and forms are interchangeable. We stand before the painting, gazing – like the *personnage* at the right-hand side of the picture – with eyebrows raised in astonishment. Above this puzzle made up of metaphorical confusions and identifications soars the blue crescent moon, beams the star, Miró's favourite symbol.

"It sometimes happens", Miró once wrote, "that I illustrate my pictures with poetic sentences and vice-versa – did not the Chinese, those grand *seigneurs* of the spirit, proceed in the same manner?"

In *Peinture* (1953) (p. 34), an elongated painting resembling a mural, background patches of colour and lineations are laid on in a broader, more painterly fashion. In this picture three birdlike creatures are strutting as though in an enchanted garden by night, each of them animated by different feelings, moved by different impulses.

In a Miró exhibition I saw children standing in front of this picture, at first helpless, then exuberant. They began to lift their feet, to lean their heads back and to spread out their hands and arms like wings. After this, thinking themselves unobserved, they strutted round the museum hall in its noonday silence playing at "birds" with a grace in no way inferior to that of Miró's figures.

Cannot the same thing that happened to the children, happen to us? And if the picture had no other task than to make us forget that we are what we believe ourselves to be – dependent upon time, space and powers that presume to turn us into slaves – would not this function alone justify its existence?

A realistic picture in these days, no matter how full of feeling its forms may appear, will always reduce us to despondency and melancholy, because it seeks to transfigure precisely that which causes us suffering. Yet the wish that our sensibilities, our soul should acquire wings, that our inner self should identify itself with the longing for freedom, for the winning of new realms of poetry – which, according to Baudelaire, are the only necessary reality – is no sentimental escapism, but rather its opposite. Whenever I think of this picture, I remember the moment during our walk round the port of Andraitx when I discussed with Miró the notion of the *coup de grâce*. In front of this picture I received the answer which at that time I so ardently hoped Miró would give me.

The pictures of those years bring before my eyes Miró and his surroundings as I saw them on Mallorca; it was pictures such as these that I saw around him. His way of thinking and of looking at things, I found confirmed in precisely these canvases, ceramics and drawings. This Miró was no longer the extravagant young man with the bowler

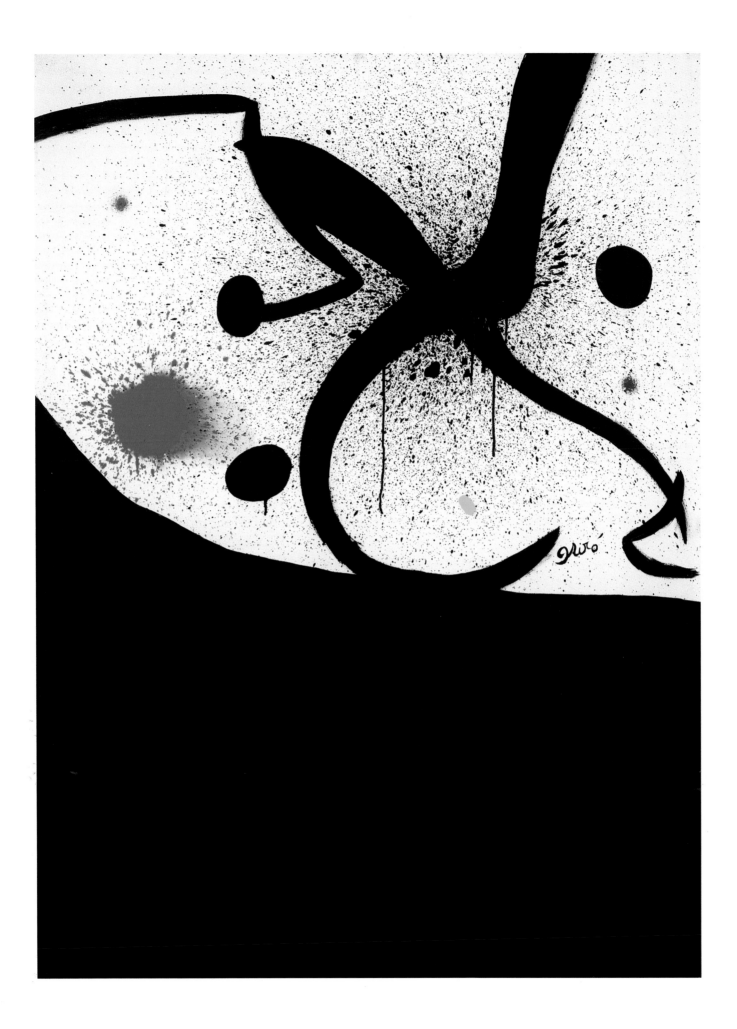

hat, monocle and walking stick, as his friends knew him in Paris in the twenties. Nor was he the *homme d'avant-garde* sitting on a wooden stool in the middle of his bare studio as though ready to spring, with rolled up shirt sleeves, a white face and piercing eyes – as we see him in a flash photograph taken in his Barcelona studio at the beginning of the First World War. He did not say to me that "our generation is lacking in heroism and any deeply revolutionary spirit" (from a conversation with Georges Duthuit, 1936). I met the sage, the contemplative poet, on whose desk lay Leonardo's sketches and the visions of the Spanish mystics.

Miró's visual poetry is a *poésie ininterrompue,* a continuous poetry, as Miró's friend Éluard called one of his poems. His pictures, too, are *"stupéfiantimages",* bemusing images, their contents do not represent "excerpts", "scenes" or "a piece of nature seen through the lens of a temperament". "To make us see", says Gaston Picon of Éluard's poetry, "the poet does not always express himself through visual images: the simplest juxtaposition causes things to light up one after the other, as though bathed in the glitter of their own dew." This also applies to Miró's painting.

Early morning and nightfall, the bay of Calamajor drenched in moonlight, the lights on the magic mountain behind the village of Genova, the figures of memory and the echoes of dreams – these are the "contents" of the pictures painted during 1953 and 1954.

If we call to mind how Miró started out from reality conceived exclusively as form and matter and advanced step by step via the fortuitous arrangement of its outward appearance to its core, its poetic significance – always keeping a tight hold on both his visual perception and his artistic media – it is evident that he could have no desire to create a pseudo-mystical space, that misleadingly illumined void which is the last refuge of the sentimentalist and the "abstractionist". Miró's fantasies always bring us back to the earth from which they started. But after looking at one of Miró's pictures we see reality from a new angle. This painter has pushed aside the scenery that reason and complacent compromise have set up in front of the real world.

Miró has painted a whole suite of these festally illumined compositions that demonstrate the painter's poetic, musical and – if the word be not too presumptuous – religious outlook particularly strikingly. (Once when I showed Miró a book of intriguing photographs from the microcosmic world, which displays so much similarity to the pictorial world of his last period, he cried *"C'est vraiment un livre religieux!")* The painter, like the poet, is certain of achieving new realities so long as he can embody his vision in fresh, unhackneyed forms. The moment he exhausts his means of representation, he looks around for new methods and procedures. The newly created world of images will in any case – in obedience to the universal canon of stylistic change in the plastic arts – be the antithesis of the one that preceded it.

We can therefore understand how it came about that the "contents" of the pictures Miró painted between 1955 and 1958, after he had celebrated the cosmic constellations, show a return to the tangible phenomena of earth. What Miró had in mind during these years was a very

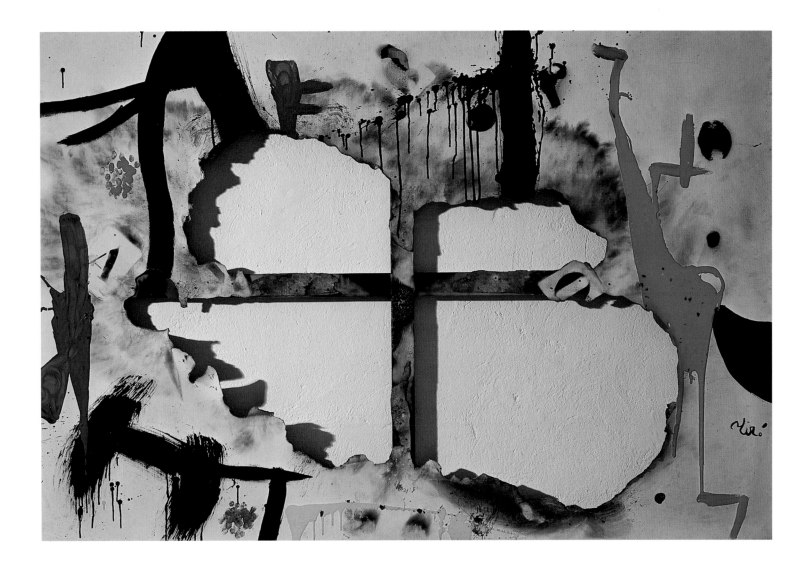

Burnt Picture I, 1973
Toile brûlée I
Acrylic on canvas, then partly singed and
burnt, 130.5 x 194.6 cm
Fundació Joan Miró, Barcelona

eloquent, direct method of capturing the shock effect of earthly phe-
nomena in forms and configurations that had the ambiguity of the
Gorgons' heads, the physiognomies of earth spirits and sibyls.

A change in Miró's style does not mean, however, that he gives up a
world he has gained for himself in favour of a new one yet to be won.
What has already been won is overlaid by the addition of a new
dimension of expression. Thus the colours and forms of the new pic-
tures remained irradiated and illumined by the refulgence of the "Star
Series". The apparent brutality of these chthonic beings and monsters
is thereby spiritualized, the all too earthly is touched by the frisson of
that which does away with the earthly and transforms it into the magi-
cal, the mythological.

The experiments with pottery that Miró carried out – once more in
collaboration with Artigas – were also directed towards an intensifica-
tion of the expressive potentialities of these *terres de grand feu* in the
direction of the *peinture brute* at which Miró was aiming. Miró's pur-
pose was not to make the beholder forget the earthly origin of the
material; on the contrary, he made use of it to give an added tactile
effect to the shock produced by the reality-quality of his works. Of his
activities at Gallifa he relates: "It is a mighty landscape of rocks; the
shapes of the mountains remind me of those at Montserrat, which
have always gripped me; the mountains of Montroig are also the same

vinegar-red colour. Before I actually carried out any pottery, I began by painting direct on huge rocks; I wanted to make myself thoroughly familiar with the elements of the landscape, by putting my stamp on them. I worked in a monumental spirit, thinking of combining my results with architecture. This would be a possible way of ennobling mass-produced buildings and ceasing to treat the people who have to live in them as unfeeling robots!" (from a conversation with Rosamund Bernier).

From these ceramics to the monumental murals on the new UNESCO building in Paris (pp. 146 to 149), the cartoons for which were shown to me by Artigas, was only a logical, if arduous step. The mention of these cartoons brings me back to the beginning of my notes on my "rendezvous with Miró".

Naturally, at this point, as I bring these notes to an end, I ask myself whether it has proved useful to combine the account of a personal meeting with the artist with a study of the chronological development of his oeuvre. Both approaches to the subject represent no more than an attempt to enter into those verifiable domains from which alone it is possible to gain an insight into the unverifiable realms of experience that open up to us when we stand before the works themselves.

The biographical data of the artist's life, a knowledge of his origins and the influences hes has undergone, are undoubtedly helpful. But how this knowledge melts away at the moment when contact between work and spectator strikes the spark of intuitive understanding! At this point of sudden tension there are neither milestones, signposts nor ticking stopwatches. Here reigns the silence that Miró found in communion with things and not in the noisy society of human beings.

Yet the "objects" with which Miró has enriched the world of phenomena and thereby the landscape of our existence, both the inner and the outer landscape, do not shut out the man who will listen to them quietly. Each of these *objets peints,* as Miró often calls his pictures, invites the beholder to associate himself with it, to find his way into it, in order to grasp the secret of his own existence through this meeting with the unknown. Perhaps the inevitable vacuum that arises between the description of the painter as a man and the description of his work can only be filled and brought to life by him who contemplates the picture itself with the vigorous vision and judgment of the unprejudiced spectator. Perhaps it can best be filled by that man, woman or child who catches sight of the vast ceramic on the Unesco building amidst the din of Paris and whose sceptical face, after a momentary shock, finally lights up in happy appreciation and a smile whose effect is enduring.

The Hope of Someone Sentenced to Death I – III (Triptych), 9 – 2 – 1974
L'espoir du condamné à mort I – III
Acrylic on canvas, 267 x 351.5 cm,
267.3 x 351 cm, 267 x 350.3 cm
Fundació Joan Miró, Barcelona

Hajo Düchting:
Miró's Late Works

When Miró moved to his large new studio near Palma de Mallorca in 1956, it was the fulfilment of his long dream of a spacious house, designed by the architect Sert. His move from Barcelona to Palma was a new beginning in every possible respect. Miró had become an internationally famous and renowned artist, taking an active part in marketing the flood of poster designs, lithographs and etchings, that he produced in the years 1954–1959. His fame had already been established during his lifetime, perhaps rather too firmly, in fact.

In 1959, on the occasion of his second great retrospective exhibition, Miró travelled to America for the second time. Thanks to his first exhibition at the Pierre Matisse Gallery in 1932 and, above all, his first retrospective at the Museum of Modern Art in New York in 1941, he had become one of the best-known and most widely recognized artists in the States. Abstract American art of the 1940s had in many ways been influenced by Miró's works.

Now, for the first time, Miró was able to see the full extent of this development – the gigantic formats and monochrome colour fields of Marc Rothko and Barnett Newman, the broad, sweeping brushstrokes of Jackson Pollock and Robert Motherwell's paintings – artists who admitted that they had been influenced by Miró at important stages in their development. Miró's second retrospective, too, was to leave its mark on the further development of American art, as can be seen in "post-painterly abstraction", the idea that the canvas itself is an object, and the use of paint in automated processes (Helen Frankenthaler, Kenneth Noland, Jules Olitski, Morris Louis). However, the encounter was even more important for Miró, who now began to take an interest in the interaction between his own art and American art. Having completed a large-scale public commission – a ceramic wall for Harvard University (p. 154) – Miró returned to Majorca and took up painting again.

Miró's late works were marked by a great variety of technique and form, and his *Self-Portrait* (p. 138) almost functioned like a motto which dominated this entire period. Miró used a copy of his surrealist *Self-Portrait* of 1937 (p. 84) and painted over it with some thick black lines and a few splotches of colour, creating another of those eye creatures which populate the world of his paintings. However, Miró's expressiveness and liberal treatment of colour demand a new understanding of the art of painting.

Woman, 13 – 2 – 1976
Femme
Oil on canvas, 100 x 81 cm
Lelong Gallery, Paris

221

And so Miró returned to the art of painting again, taking new liberties in his treatment of the material and colours. In line with informal art, which dominated the whole of Europe, and also American "action painting", Miró began to regard every picture as his own personal adventure, a playing field and the "soil" of his spontaneous expressiveness. His starting point was the "shock" that happens when the material and the painting instruments melt on the canvas.

Instead of carefully placed lines and colour fields and preconceived ideas of painting – as prevailed in the 1950s – these new pictures are dominated by broad, sweeping movements, spontaneity, impulsively hurled splotches of colour, a generally informal method of painting and experiments with the material. Having prepared a multiply processed surface in this way, Miró then proceeded to implement his repertoire of symbols, though more crudely and in a more primaeval form, without the smooth refinement and the usual elegance which had made his paintings so famous.

The white paint, squirted onto a dark surface, in Miró's *Red Disk* of 1960 (p. 156) forms a fluid field that stretches in all directions and contains Miró's symbols and colours, including a large red disk. If it were not for the meticulous symbols, the painting could easily fit into the context of informal art.

Miró's 1961 triptych *Blue I – III* (pp. 158 – 160) seems to have been influenced even more greatly by the artist's experience of large-format American art. Three large canvases with a light-blue texture (reminiscent of Motherwell's "Open Blue" series) bear a number of sparsely placed ovals, brightly red beams and – in the first and last paintings – some fine black lines.

These pictorial symbols had already occurred in other works of the artist. The fine black lines, for example, often signify hairs, which gives them a sexual aspect. However, singled out in such monumental proportions, they far exceed their fixed symbolic meaning. In these paintings they have entered into a new context of artistic syntax, serving as structural components within a widely open pictorial space. Comparable elements in Miró's previous works can only be found in his monochrome paintings of the 1920s, such as the *Bathing Woman* (1925, p. 40) where a single-coloured surface, treated in a similarly subtle way, bears no more than a few sparse symbols. However, the pictorial symbols in these paintings are closely related to one another, both in their semantic and syntactic functions and are mostly derived from a more literary imagination. The symbols in his triptychs of the 1960s and 1970s (such as *The Hope of Someone Sentenced to Death*, 1974, pp. 218/219) are more open in character. They are more fluid and less fixed to narrow contextual meanings. Even his use of colour is no longer a matter of sparsely distributed accents, but has become more independent and freer in its expressiveness.

A new feeling for the substantial quality of colour characterizes many other paintings of this period. In Miró's *Gold of the Azure* of 1967 (p. 177), the yellow surface is condensed in the form of a glowing colour field, with its luminescence further re-inforced by the black symbols. Apart from the black dots and some very fine lines tend to be star-

Carpet, 1974
Wool, 660 x 1100 cm
Port Authority, New York

shaped, the picture includes two fixed colour points, a small red dot in the top left-hand corner and a large blue spot, consisting of lightly executed, blue, circular brush-strokes which – together with the golden yellow surface – determines the general colour effect of the picture. Both spots of colour were not put onto the yellow surface directly, for this would have weakened their independent colourfulness, but inserted into white fields that had been left open on the canvas. "Captured" in this way, the colours acquire a gem-like, sparkling quality, and also seen suspended behind the foremost level of the picture.

An even subtler colour effect has been achieved in paintings such as *Hair Followed by Two Planets* (p. 187). The focal point of this large, upright painting, with its shades of light green, is in the top left portion, where a golden ochre dot merges into its green surface. It is accompanied by three tiny symbols, two black dots, the planets, and a crooked black line to indicate wavy "hair". In the rest of the painting, a few spatters of golden ochre provide a subtle harmony of colours and a vividly sensitive field which is given depth by the spatters.

Another masterpiece of colour which Miró created during this time is his painting entitled *Lark's Wing Encircled with Golden Blue Rejoins the Heart of the Poppy Sleeping on Diamond-Studded Meadow* (p. 185). A thickly applied and saturated area of intense yellow is separated from another colour field, above it, by a thick black beam in the upper third

223

of the painting. The other field consists of thinly applied shades of green. However, the association of a landscape is counter-acted by splotches in the colour fields that break directly through gaps in the surface where the canvas shines through. Also, there is a black beam, surrounded by blue, in the bottom yellow field, and a red splotch in the green field at the top. The mood which is brought about by this sparing use of colour is one of poetic tranquillity. Similar effects are achieved by the *Bird's Flight in Moonlight* (p. 175) and *The Flight of the Dragonfly from the Sun* (p. 193).

The seeming discrepancy between the highly poetic titles of such paintings and the artist's economy of artistic means can be understood if we look at Miró's intention: "I always feel an urge to achieve a maximum of intensity with a minimum of means. This is, in fact, what has made me more and more economical in my art." And indeed, this reduction of pictorial elements is more likely to communicate the desired measure of poetic content than Miró's paintings of the 1950s, which were filled to the brim with symbols. It is precisely this new free space gained from the symbols which helps the viewer develop his own imagination. It is not bound by certain predefined symbolic concepts, but can either develop free associations with reference to those few symbols or lose itself in the broad expanse of the colour fields.

This poetic background in Miró's works received a fresh impetus from two exhibitions in Tokyo and Kyoto in 1966. His subsequent paintings show how much Miró felt inspired by the Japanese art of calligraphy. In 1967 he created a series of lithographs entitled *Haiku* – a clear indication of his openness to Japanese influence. The poetic titles of this time may be references to their affinity, as Miró saw it, with the Japanese *Haikus* (e.g. *Bird Awakened by the Cry of the Azure Flies Off Across the Breathing Plane*, 1968).

However, Miró's love of poetic titles and his idea of painting as a kind of visual poetry were nothing new and had not just arisen from his contact with Far Eastern art. They had been a typical feature of his works since the 1920s. At that time Miró was associating with a group of poets and painters around Masson and the *Groupe Blomet* who agreed that three-dimensional solidity (i.e. Cubism, which they regarded as too formal) must be overcome in order to reach the level of poetry. Once Miró was acquainted with the most significant directions in the avant-garde, he became increasingly aware of the limitations posed by an art that was purely dominated by formal criteria, be they colour, as in Fauvism and Delauney's art, or form, as in Cubism.

"Unless we make an effort," Miró wrote in 1939, "to find out the religious essence, the magic meaning of things, we will only add new sources of stupefaction to the ones that are already being offered so abundantly."

This animist view of the world was linked with a highly symbolic sensitization of artistic means in paintings such as *The Harlequin's Carnival* (pp. 36/37) and *Catalan Landscape: the Hunter* (p. 33). Finely drawn lines, circular and almond shapes are charged symbolically within a certain context, adding up to figures, such as a woman, a bird, the moon, stars and eyes. These permeate Miró's works in innu-

Woman, Bird 1974
Femme, oiseau
Oil on canvas, 216 x 174 cm
Private collection

merable variations. We can understand the genesis of this symbolic language even better if we have some knowledge of his underlying literary imagination. Like all painters who moved in Surrealist circles, Miró was quite familiar with contemporary poets such as Guillaume Apollinaire, Alfred Jarry, Blaise Cendrars as well as his poet-friends Eluard and Tzara. His favourite poets, however, included the symbolists Arthur Rimbaud and Paul Verlaine. A picture of the 1960s, *The Vowels' Song* (p. 184) shows this affinity to Symbolist poetic theory very clearly. Against a dark blue background we can see a shower of round and lance-like shapes in glowing colours, accompanied by further dots and lines in white. This painting, with its totally abstract effect, goes back to Rimbaud's poem *Voyelles* (1871), in which the most diverse parts and sexual attributes of the female body each correspond to a vowel. The picture is therefore not an unrelated, purely abstract piece of work within Miró's œuvre, but it derives its meaning from precisely this theory of correspondences, though with a gently hovering musicality and openness.

The avant-garde at the beginning of the 20th century saw the dissolution of boundaries between different genres and the merging of the arts as the beginning of a new era. Music, painting and poetry had a mutually evocative effect on one another, and their influence was all the more powerful whenever the formal language of their own medium was particularly "pure".

A playful variant on this basic avant-garde position was the *tableau-poème* i.e. poetic words and lines which had been put into pictures. In the 1920s, for example, this was particularly popular at soirées by the Delaunays and their circle of Dadaist and Surrealist poet-friends. (Sonia Delaunay had been inspired by Tzara to produce her "robes-poèmes" – clothes designs in matching colours, combined with poetic fragments of sentences.) Robert Delauney painted a water-colour as early as 1914, entitled *Black Art of the Word*, in which he picked up the vowel-colour correspondence in Rimbaud's poem in a text of his own.

Inspiration also came from Apollinaire's *Calligrammes* and Marinetti's *parole in libertà*. Miró was profoundly impressed by these poetic experiments, as can be seen in his own pictorial poems of the 1920s (*Le corps de ma brune* p. 44), where he connected the initial lines of poems or folk songs with his own pictorial vocabulary.

Miró's so-called "letter paintings" of the 1960s (*Letters and Numbers Attracted by a Spark I* 1968, p. 205) are also rooted in poetic theory. Seen against a streaky surface (which has been achieved with a piece of cloth), there are several black letters and smaller numbers dancing around a centre that has been marked yellow. There can hardly be a more obvious way of demonstrating the theory of Symbolism, which maintains that all manifestations of the human mind are related to one another and that they are nourished by a common source of creation which must be re-discovered in the creative process of art.

Several small pictures entitled *Dusk Music* (p. 174) must be seen within the same context. These are calligraphic miniature paintings with blurred surfaces and several strong colourful accents shining through. Another series, called *Poem* (p. 195), consists of several

paintings with small, but emphatic symbols and letters against a white surface.

The kinship of Miró's figurative language with music – and even dance – was recognized quite early. This can be seen in a comment by Léonide Massine, who had helped Miró obtain the commission for the stage-design in the ballet "Jeux d'enfants" performed in 1932: "Miró's art is like choreography: the immense power of imagination in his forms and the persuasiveness of the lines and space in his paintings both enhance and emphasize the movement that takes place on their surfaces. Miró's colours are magnificent, and their harmony gives depth to the three-dimensional dynamics of choreography ... When one looks at the harmonious relationship of colours and forms, one feels a spontaneous urge to dance for joy ..." Against this background we can also understand the following statement of Miró's, which summarizes the whole of his work like a motto: "My work is intended as a poem translated into music by a painter."

Model for «La Défense», 1975
Painted polyester, 273 x 127 x 140 cm,
300 x 160 x 140 cm
Fundació Joan Miró, Barcelona

This aspect of musical and poetic enhancement continued to prevail in Miró's new, experimental paintings of the 1960s and 1970s. And the symbols suspended on the intensely colourful surfaces are given a new level of meaningfulness by this element. Although Miró gave a great deal of autonomy to colour and form, he never treated them as an end in temselves, but as subject to a fundamentally poetic understanding of art.

This was the case even in his most abstract paintings. In an interview in 1958, Miró expressed himself rather sceptically about a "narrow" understanding of art in terms of purely formal criteria, no matter how generous and expressive they might appear: "In recent years so many doors have been slammed shut in art. And nobody has the courage to open any of these doors. Most artists are afraid that if they start painting figuratively again, they will be criticized for turning into reactionaries. Modern art is moving along an increasingly narrow path."

However, alongside such colourfully poetic paintings, Miró also created other pictures during this new period which struck a more sombre note. They form a coherent series, dominated, above all, by black, either as the colour of the symbols – which continue Miró's well-known configurations – or as an independent, autonomous colour. His rather casual choice of titles (formed from the nouns "woman" and "bird") betray none of the powerfully dramatic impulsiveness that breaks forth. Although the titles and configurations are reminiscent of previous subjects, they have been used more expressively and more literally here. Miró's former, almost elegant combination of playful lines and shapes of colour – akin to a Klee-style pictorial polyphony – now made room for very direct forms, devoid of any smoothness. The surfaces were often subjected to multiple processing. Before the expressive symbols were inserted with a truly elementary forcefulness, each surface was given a splotchy, relief-like structure and treated with swift, sudden brush-strokes. Occasionally other grainy materials were added to it. In these "fast" paintings, Miró did not pursue any aesthetic aims whatsoever. Each painting is a self-contained entity, the result of a primaeval treatment of the painter's materials and Miró's underlying themes.

The painting *Woman III* (1965) (p. 164) shows a transparent figure, who looks more like an insect than a human being, against a splotchy, multi-coloured surface. The artist's elementary brush-strokes followed a strong, inner impulse, with a raw energy that was left unrefined and without further rational processing. The elementary symbols are only loosely connected, without any congruence that could be justified in aesthetic terms, and yet they have preserved that "anthropomorphic" character which dominates the whole of this series and which can also be found in man's early incantations and projections of his anxieties. Perhaps it was with these "wild" pictures, in particular, that Miró achieved a degree of intensity and emotional depth that was totally new to him and could only be attained at the end of a long life – a life in which he had set himself the aim of fathoming the very roots of life, against all conventions and obligations.

Woman in the Night (p. 200) is another painting which is anything

but cheerful and idyllic, whatever the title might suggest. An erect construction on stilt-like objects – recognizable as a female figure by its two eyes/breasts – reaches in vain for the stars, which have already fallen to the ground. This is indicated by the glowing red constellation. Man is shown as a fallen creature, under the ban of sexuality, from which he cannot escape but remains tied to his earthly fate.

These obvious tragic notes reveal a pessimistic world view which had only manifested itself occasionally until this period. A tragic vein is of course often ascribed to the mature work of a great artist, and it is seen as the artist's memento mori in the face of his own impending death. However, this does not really do justice to Miró, when we consider the sudden occurrence of his cheerful creatures, which were often used to pin him down artistically. Such a view is one-sided and overlooks the fact that even his so-called "cheerful" paintings of the 1940s and 1950s always have something bizarre and alien about them, i.e. the potential of changing into something totally unfamiliar. To anyone familiar with Miró's symbolic language and its genesis, the colourful edges round the eye shapes, for example, should have revealed quite clearly that they were derived from female reproductive organs. And indeed, in many of his paintings the aspect of femininity is shown as frightening, rather than agreeable. His painting *Man and Woman in Front of a Pile of Excrement* (1936, p. 80) is a case in point. People often attempt to explain away such awkward pictures as being influenced by the history of the time, but this ignores the fact that Miró used to keep a critical distance towards current affairs.

If, however, we see this aspect as part of a mythical attitude towards women, based on a century-old Catalan tradition of matriarchal structures, then it can no longer be regarded as an "aberration of taste", but a deeply-rooted and constant psychological factor, which is particularly wide-spread in Mediterranean areas. This is where primaeval cults and rites around the "Great Mother" once prevailed and where people worshipped the goddess of fertility and also the "terrible, devouring mother" (Isis-Osiris, Kybele, as well as Cretan and Greek mother goddesses).

Miró always felt deeply rooted in the culture of his home area. As an artist, he was a metropolitan, but as a private individual, he remained a Catalan. Just as, from a formal point of view, he would partly derive his inspiration from the cultural heritage of his people (from cave drawings to the Taull Frescos, from the *Xiurells* to the fantastic buildings of Gaudí), the content of his paintings was equally dominated by a primaeval myth which held him in thrall. Both elements – the cheerful as well as the tragic and cruel aspect – are mutually related sides of a dualistic world view that gives Miró's paintings their real and more profound meaning.

There are other paintings where these ominous signs are calmer and more relaxed, where they stand against the monochrome surface like cyphers of a secret language, as for example in *Silence* (1968, p. 199). Or they form larger complexes, filled with colour, which tend towards that other, more "cheerful" side of Miró's, as in *Woman, Bird, and Stars* (1978, p. 235).

Miró's late abstract paintings – such as *Birds in Space* (p. 233) – are reminiscent of Klee, a modern painter whom Miró valued very much indeed and towards whom he had felt in many ways an affinity from the very beginning. However, unlike *Polyphonies*, which Klee painted in the Bauhaus days, there is no conscious dependence here, but rather a parallel artistic development that sprang from a similar power of imagination. Klee and Miró are artists with a profoundly sensitive symbolic repertoire, who have had a lasting influence on the history of art.

However, whereas Klee would derive his symbols from a formal and logical procedure, Miró's symbols were saturated with experience. Not only did they come from Miró's own environment, his day-to-day relationships and his child-like curiosity for the bizarre beauty of the world, but they also reached him from those deeper levels of the human mind where the primaeval structures of symbols are formed.

The symbolic language in Miró's paintings of the 1960s and 1970s seems rather more personal, and at the same time more general, more engaging, than the refined culture of symbols in his earlier works. The

Mask (Blue), 1977
Plaque-masque (bleu)
Ceramics, 49 x 51 x 4 cm
Museo de Cerámica, Barcelona

ambivalence of his signs was emphasized by Miró in an interview with Y. Taillandier in 1959: "Great artistic periods have always been dominated by anonymity. It is becoming more and more necessary today. At the same time, however, one also needs a totally individual gesture, one that is completely anarchic from a social point of view. Why? Because a deeply experienced individual gesture is anonymous. And, being anonymous, it opens the door to universality. I am convinced that the more limited something is, the more universal it becomes."

This adds an interesting emphasis to the theory that Miró's symbols are identical with pre-historic cave drawings, though one must not understand this as naive imitation, but rather as a deliberately chosen affinity – the emergence of a former proto-language that has been latent in the body's memory and which can be re-awakened by means of hallucinations or meditation. How else could one explain the fascination of these forms with their lack of aesthetic charm, if not by the fact that the chord which they strike in the human mind is a common, phylogenetically programmed structure?

Miró's colours, too, function on this level of depth psychology. He continued to use his combination of basic colours – red/green/blue/yellow – which he had started in the 1940s – a series of colours that not only structures our perception, but also corresponds to a symbolism of proto-colours as well as Miró's own personal colour symbols.

The glowing red, which he often used in the form of suns, can mean "power, fire, procreation". And in connection with green – often used as the colour of the moon and that of the "maternal basis" of material life – it combines to form a symbolism that expresses the dynamics of life (giving and receiving, growing and dying).

Blue is characterized as the colour of the soul, giving access to the realm of the spirit (or the unconscious mind). In a painting of the 1920s, *This is the Colour of My Dreams* (Pierre Matisse Gallery, New York), the symbolic content is indicated by a blue spot of colour in the bottom right-hand corner. This spot does not signify the colour blue as an autonomous colour value, but the notion of a certain blue which does not even exist as a pigment, but opens up and symbolizes a spiritual dimension. By contrast, the written word "Foto" denotes an imitation of reality which Miró had long translated into his own symbolic language.

Yellow – an active, emphatic and life-affirming colour – is the fourth basic member of Miró's symbolic colour scheme. Taken together, yellow and blue form a complementary, mutually related unity of worldly *joie de vivre* coupled with a yearning for transcendence. These colour symbols held in suspension are independent of Miró's interpretable symbolic objects (such as the sun and the moon) and were used for large contrastive fields in the 1960s. Also, they are not derived from any theory of art or colour that might therefore have necessitated a reduction, but are deeply rooted in archetypes that correspond to Miró's graphic symbols.

In the history of modern art only Van Gogh and Mondrian have developed similarly emphatic (and graphic) colour symbolism. Miró was never concerned with the "purity of methods". Always true to his

Birds in Space, 5 – 6 – 1978
Oiseaux dans l'espace
Acrylic on canvas, 33.1 x 23.9 cm
Fundació Joan Miró, Barcelona

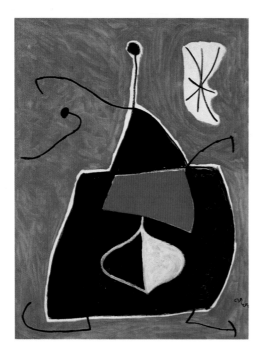

Woman, Bird, Star, 1978
Femme, oiseau, étoile
Acrylic and oil on canvas, 115.5 x 89 cm
Fundació Joan Miró, Barcelona

perception of the fullness of life, he created a complex symbolic language, consisting of colours and graphic symbols, a language in which he could adequately express the most salient elements of our human existence. Miró's artistic achievement lies in the concatenation of colours and symbols and in forming a homogeneous pictorial language that relates these elements to one another, so that the artistic methods became flexible enough to serve generally semantic purposes.

Miró continued to used these basic colours with their inherent symbolic values throughout his mature period. However, unlike the tidily executed colour fields of the 1940s and 1950s, he now preferred to apply the paint more impulsively and spontaneously. Although there were still quite a few thickly painted, clearly delineated colour fields, these mainly served as contrasts with the soft, loosely painted colour spots or even elements of action painting.

Miró demonstrated the new potential of his colour technique in a series of small-format pictures, called *Painting* (p. 168). It is likely that Miró first primed the canvas with plaster of Paris before mounting it on wood. He then considerably diluted a few oil colours with turpentine, let them run out on the canvas and simply left the resulting formations as they were. These exist side by side with more impasto spots of colour, which were either left to dry or washed out with turpentine as soon as they had dried a little. Miró's fourth method was to apply a spot of colour dry, undiluted and with clear, unblurred contours. This option was exclusively used for black. Other black spots were rubbed onto the canvas with a dry paintbrush. Miró's later painting methods also included a technique whereby he would squirt some thick white paint out of a tube onto the canvas, as well as his use of a long, thin, black line, slightly bent in relation to the colour contours and functioning as a counterpoint to the colour fields. These pictures also show the significance of black for the artist – not merely as a contrapuntal device, but also as an independent colour value and – like white – one of the extreme points of the colour scale. Black as the darkest and deepest colour and white as the lightest and highest one constitute opposite, complementary ends of Miró's colour symbols, thus expressing his dualistic way of thinking. But even in this seemingly pure demonstration of Miró's painting techniques and his use of colour we can discern the philosophical background which permeates his entire work. Miró's creative process, with all its diversity of techniques and methods, took place between two opposite poles that were nevertheless inextricably linked to one another: Man is seen as trapped by his own instincts, subject to unavoidable laws of Nature and placed in a world full of contradictions, while at the same time striving for perfection, transcendence, for purity of soul and spirit. He is both spirit and a creature with instincts, and for Miró these double roots explain the full tragedy (or comedy) of human life.

Again and again, we come across a yearning for salvation in Miró's late paintings, as for instance in *Towards the Infinite* (Fundació Joan Miró, Barcelona). On a subtly structured, vertical-format canvas, a weak, black line runs vertically from one edge to another, with a few coloured spots on its left and right. The sparseness and openness of

this virtually infinite line speaks of Man's inextinguishable endeavour to leave behind the material world with all his burdens and to attain pure spirituality. The broad, black lines against the primed canvas in Miró's triptych *The Hope of Someone Sentenced to Death* (pp. 218/219) can be interpreted in a similar way. This ascetic, spiritual element can be found in many paintings of Miró's late period.

One of the most extreme examples is undoubtedly Miró's *Burnt Picture* (p. 217), executed with broad movements and with a large, gaping hole burnt into the middle, as well as several little ones besides.

What seems like an act of desperation – as if the artist had reached "rock bottom" – takes on a different meaning against the background of Miró's philosophy. The energy of the symbols, their poetic essence, has burnt itself into the painting, shed its material nature and turned into pure energy. As a visible results there is this state of "nothingness", the dissolution of all tensions in a Nirvana. Miró was not an enthusiastic follower of Eastern philosophy, but these ascetically "empty" paintings show an amazing affinity with such teachings, which may have been reinforced by his visit to Japan, his sympathy for Haiku and calligraphy.

Miró's broad brush-strokes, hurled down at the speed of lightning, his sudden decisions to attack the canvas with disparate, yet "suitable" instruments (while at the same time being very sparing in his choice of artistic means) is far more reminiscent of Zen-based calligraphy than the existentialist "confessions" of informal painting, an art form which only ever threatens to degenerate into an egocentric, fetishist obsession with the material. The violently hurled brush movements of Karl Otto Götz and K.R.H. Sonderborg soon acquire an element of randomness, an aimless virtuosity reflected in the artist's self-centredness. Miró's brush-strokes, on the other hand, were controlled by his urge to go "beyond himself" and to shed his dependence on his own ego. They were aimed at a superior level of consciousness where the swiftly executed symbols became transparent, pointing to a universal and fundamental ground of creative energy. "In order to become truly human, we have to rid ourselves of our false ego. In my case, this meant that I had to stop being Miró … In other words, one has to aim at anonymity," says Miró. It is only in the combination of personal involvement and the suppression of subjective, self-centred distractions that an artist can reach this anonymous state of his symbolic language, a state which is not dependent on recognizable features but which promotes universal communication among people, no matter where they come from or where they are going.

During the last years of his life Miró devoted himself exclusively to enhancing the expressiveness of his symbolic language. His inventiveness continually increased and became inexhaustible, and his search for new, expressive materials to emphasize the significance of his symbols was impelled by an untamable curiosity. Not only did Miró concern himself with the impulsive, uncontrolled application of paint and the use of painting instruments (from hand to foot) and materials (from jam to excrement), but he directed his attention above all to the support on which he was going to paint and on different ways of pre-

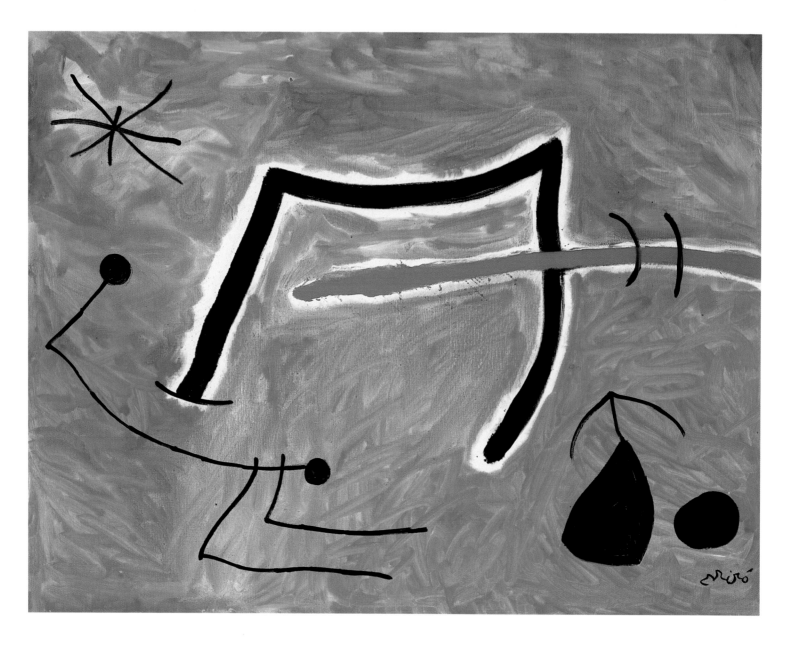

Personages, Birds, Star, 1978
Personnages, oiseaux, étoile
Acrylic on canvas, 88.7 x 115 cm
Fundació Joan Miró, Barcelona

paring it. Miró's interest in a diversity of supports (paper, cardboard, wood, masonite, celotex and copper) dated back to his creative crisis of the 1930s, when he had developed a Dadaist impulse. This impulse had given rise to "anti-paintings", which he would also process in different ways, i.e. by beating, piercing, crumpling, burning and patching up the ground. It is impossible to estimate the extent to which Miró has enriched the creative techniques of modern art. Even "Combine Painting" (the combination of objects and painting) in American Pop Art in the 1960s, had been anticipated by Miró as early as the 1930s (*Rope and Personages*, 1953, Museum of Modern Art, New York).

Even in his late work Miró continued to use all his power of imagination to find new materials and creative methods, trying out a number of supports and treating them with a variety of materials. Apart from different canvases, he used untreated sackcloth and similar fabrics, which he only primed incompletely, so that the surface was emphasized as a coherent texture, as in *Woman and Bird* (p. 171). This, incidentally, was also an important principle in American colour field painting. He painted on hammered wooden boards and loosely-hung nettle fibre, without putting it on a wedged stretcher, as in

Woman Surrounded by a Flight of Birds in the Night (p. 203), where knots and plaited ropes, woven into the fabric, add a further dimension of material symbolism. The supports were treated and primed in a variety of ways so that the character of the colours turn out differently each time (dull, absorbent, pale, shiny, sparkling, etc.). They were glued onto other materials, hung loosely, tied together with string or stretched tightly with nails. One can merely speculate how many totally novel artistic methods Miró anticipated during this richly creative phase, e.g. that of testing the relationship between the surface and the support material, which was taken up in the Support-Surface Movement of the 1960s. Indeed, many of his innovations are still waiting to be developed further. But it was undoubtedly in Miró's animal hides that he found the closest possible correspondence between surface and symbolic language. Having painted big, strong symbols and colours onto a hide, he would then nail it to the wall (or a wooden board) as if it were a relic from pre-historic times.

This material aspect of Miró's work is easily forgotten, in view of his ascetically abstract paintings of the 1960s. But during those years, in particular, Miró continued to develop his three-dimensional work in quite an amazing way. After all, he had discovered ceramics as early as the 1940s, when he was inspired by his long-standing friend, the ceramic artist Artigas, and he was able to work and paint on it with a variety of different methods. At first it was only small objects, pots and plates from Artigas' workshop, to which Miró merely added a few symbols and colours. Soon, however, he developed his own feeling for the potential of the material, how to control the firing process and the secrets of glazing. Co-operating closely with Artigas, who could respond flexibly to his ideas without leaving the solid ground of craftsmanship, Miró began to produce large ceramic objects – real creations, straight from Miró's own hand, with all the bizarre manifestations that formed part of his artistic universe. Some of these objects, which were put together with Dadaistic playfulness, were given the title *Project for a Monument* (p. 141), which points to Miró's plans for an elaboration of his sculptural ideas in the form of large monuments. And in a number of cases he did indeed manage to bridge the gap between a swiftly executed *bozetto* and a large sculpture, especially in his designs of female figures. These are figures in which the entire Mediterranean abundance of ancient maternal goddesses breaks through. Clinging to these simply shaped figures there are fertility and phallic symbols, birds, stars and cosmic symbols. The bodies are hollow, like grottos or caves. And it is no more than appropriate that these archetypal figures are put up in parks, as parts of fountains and in large, open spaces. In this way, they merge into their natural environment, forming that unity between Art and Nature which Miró endeavoured to achieve and in which Man is at peace with the forces of Nature. Miró's large ceramic sculpture at the Maeght Foundation (Saint-Paul-de-Vence, 1963) – *The Goddess* – shows the matriarchal element and natural symbolism in Miró's works very clearly. Based on the shape of a pumpkin or an amphora – generally regarded as a fertility symbol by the pre-historic Mediterranean population - the sculpture has an oval form, which is

Miró at work in his Montroig studio.
Photograph by Erben

Miró outside his house in Montroig.
Photograph by Erben

the characteristic female sexual symbol in Miró's art, opened here like a crater, with a kind of leaf or tongue hanging out. Further marks of a fertility idol are the breasts on its sides and the phallic arms and heads.

At first sight, Miró's bronze sculptures of 1966 and 1971 seem to be more complicated and daring. In the first group of colourfully painted sculptures one can easily discern Miró's models. They are assemblages of objects found on the beach, stones, branches, parts of cactuses and everyday objects, such as a pitchfork, a chair and kitchen implements. Having put together these objects in a playfully random way and produced a bronze cast, Miró then painted it, creating a vividly animate construction (*Figure with Three Legs*, p. 183).

In these weird and wonderful works, Miró yielded entirely to the unpredictable lure of the fantastic, following the famous words of Lautréamont, who described the surprise element in art as the "unforeseen encounter of an umbrella and a sewing machine on a dissecting table". Miró could use any object, no matter how banal, to receive that "shock" which he needed to trigger off his creative process. Visitors to his studio in Mallorca were surprised by the fairy-tale abundance and variety of the surrounding objects, which somehow did not really match the image of an avant-garde artist in white-washed rooms. However, Miró needed this motley array of pebbles, drift wood, children's toys, objects collected on the beach, *Xiurells* and other folk-tale figures. And indeed, when he surrounded himself with these objects, he did not do merely do so because he loved his home area and his native country. "The smallest thing in Nature is a whole world in itself. I find all my subjects in the fields or at the seaside. Parts of anchors, starfish, oar blades, tillers - all these things find their way into my compositions, and the same applies to the odd hat-shapes of toadstools and the seventy-seven different kinds of pumpkins."

The unique diversity of forms in Nature filled Miró with awe and amazement, and it was with this animist attitude that he created his world of symbols which was so elementary, yet rich in content. And, as we saw in his painting experiments, he was equally inspired by handling, working with and re-fashioning the material. Miró loved the roughness of irregular surfaces, because they expressed a touch of days gone by, even transitoriness, rather than smooth newness. For his ceramic walls, Artigas had to use a wide variety of firing and glazing methods before he was pleased with the weather-beaten, crust-like surface and could give it the mark of his symbols. A group of small bronze table sculptures shows this aspect of treating the material. Quite often, he would simply play with small shapes, moulding the raw material almost unintentionally into bizarre gnomes or heads. Having cast them in bronze, he did not paint them, but treated their surfaces in a special way so that they looked like old "objets trouvés" dug out of the ground. Like Miró's large paintings, these small sculptures were fashioned with swift movements of the artist's hand and are therefore still full of that initial spontaneity and randomness. However, there is also another group of large sculptural monuments which are dominated by a more rigorous desire to impose a form. The artistic combination of seemingly incompatible objects turned them into

238

homogeneous figures as soon as they were cast in bronze, figures which can unmistakeably be recognized as female idols. Again, the most fantastic figures can be found alongside very simple ones.

One achievement of the imagination that can hardly be surpassed is called *The Caresses of a Bird* (p. 180). Only Miró could use such a diversity of real-life objects - a tortoise`shell, a straw hat and a table top full of holes – to create such a primaeval, sexual being as this. Miró's imagination seemed to be genuinely unlimited, especially when it came to finding the symbolic equivalents of female sexual features. Indeed, in his sculptures of this time, Miró yielded to an openness in his use of sexual symbolism which had only ever been present in a subliminal and encoded form in his paintings and drawings.

Miró's large sculptures *Sun Bird* and *Moon Bird* (1968, p. 197), which are made of Carrara marble, belong to a completely different sphere. Both are situated in the park of the Maeght Foundation. These smooth, white figures with their horns and spikes protruding into space probably display the closest kinship to Mallorcan *Xiurells,* which Miró used to collect and then use for form and colour studies. These creations, which have very little in common with birds, seem more like pre-historic cult figures to invoke various divinities - undoubtedly fertility gods.

In his last great plastic sculptures, which were part of his work on the maze for the Maeght Foundation, Miró pursued this line even further. The grotesque sexualized figures, one of which was quite deliberately called *Père Ubu* do not form a general synthesis of Miró's sculptures, but a variation of the artist's antagonism to the norms and rules of this world, an element which is always present in his works. Miró himself commented, "I have turned increasingly into a Man of revolt. I am rebelling more and more against the world as it is."

Finally, there is Miró's large sculpture in the Parisian district La Défense. It is completely devoid of figurative allusions or symbolic associations (see design, p. 227), and the excessive forms, colourfully painted, may well be the three-dimensional equivalents of the shapes in his paintings. They are bizarre growths which give the impression that one of Miró's pictures has come alive as a sculpture and is now trying to show mankind the right way, i.e. into the realm of unfettered imagination. In view of the ghastly lack of imagination with which the town planners irritated not just the poor inhabitants of La Défense, it was quite a successful practical joke. Then there is the artist's three-dimensional legacy, a gigantic sculpture called *Woman and Bird* (1981/2), at the Joan Miró Park in Barcelona. It was fitted by Artigas with thousands of colourful ceramic tiles on which Miró immortalized his message. This 71-foot figure (22 metres) represents the universal, all-encompassing life force which is not only the erotic impulse, but was understood by Miró in a comprehensive, cosmological sense, the fundamental substance of all existence, to which Man, too, owes his existence and to which he feels an urge to return.

Miró's urge to expand did not stop at any material or experiment. Apart from his numerous ceramic and sculptural works of these last years, Miró also made use of the most ancient crafts of mankind, plait-

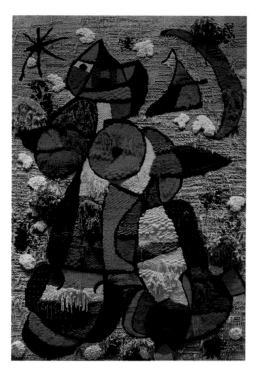

Tapestry at the Fundació Joan Miró, 1979
Wool, 750 x 500 cm
Fundació Joan Miró, Barcelona

ing and weaving, which had retained their immediacy and freshness particularly in his native Catalonia. Again, Miró took his first inspiration from the products of folk art, but was then seized by a feverish joy of discovery. He used Catalan tapestries called *sobretexeims* which consisted of double-woven cloth with a strong texture as the support. Into this fabric he incorporated the most diverse materials, such as strips of sackcloth, cotton fibre or hemp rope, leaving some of it hanging loose, then painting and singeing the fabric until a tapestry-like object emerged that was no less inventive and bizarre than his sculptural innovations. It even went quite far at times, so that some objects which were totally different in character – such as metal buckets and umbrellas – were made to embark upon an adventurous journey into the realm of the imagination (p. 213).

There can hardly be a better conclusion to this chapter and indeed Miró's work in general than the beautiful, gigantic tapestry at the Fundació Joan Miró in Barcelona (p. 240). The foundation, which was established by Miró himself, includes not only his own works but also those of modern artists whom he particularly valued. Furthermore, it is meant to be a meeting point for the exchange of intellectual and creative ideas, a laboratory of the creative spirit which unites people and brings them together. Miró's universe is neither childish, infantile or immature; nor is it abstract and hermetically self-contained, like that of so many of his contemporaries. It consists of the extreme poles of human existence, the motive forces of mind and matter. And in order to fathom these two vital principles, Miró created his emphatic and universally communicable symbols. His art leads to the fundamental roots of human existence. It derives its very existence from this experience and allows everyone (of goodwill) to take part. Looking at these works of art, steeped in human experience, we may be able to recover some of that innocence of heart and purity of spirit which we possessed as children.

The author and the publisher wish to express their gratitude to the museums, galleries, archives, photographers and private collectors for their kind help in providing photographic material and their permission to reproduce it. In particular, we would like to thank the Kunsthaus Zurich; the Lelong Gallery, Paris, their Miró research manager, Jacques Dupin, as well as Ariane Lelong and Françoise Gaillard; the Fundació Joan Miró, Barcelona, their director Rosa Maria Malet and Carmen Escudero i Anglès. We are indebted to Konrad Klapheck, Düsseldorf, for his invaluable advice. This book could not have been published without the generous help of these people and institutions.